Synchronicity, Science, and Soul-Making

Synchronicity, Science, and Soul-Making

Understanding Jungian Synchronicity through Physics, Buddhism, and Philosophy

VICTOR MANSFIELD

OPEN COURT

Chicago and La Salle, Illinois

To order books from Open Court, call toll-free 1-800-815-2280.

Open Court Publishing Company is a division of Carus Publishing Company.

First printing 1995
Second printing 1996
Third printing 1998
Fourth printing 1999

Printed and bound in the United States of America.

Library of Congress Cataloging-in-Publication Data

Mansfield, Victor, 1941–
 Synchronicity, science, and soul-making : understanding Jungian synchronicity through physics, Buddhism, and philosophy / Victor Mansfield.
 p. cm.
 Includes bibliographical references and index.
 ISBN 0-8126-9304-3 (pbk. : alk. paper)
 1. Coincidence. 2. Coincidence—Psychic aspects. 3. Quantum theory. 4. Causation. 5. Jung, C. G. (Carl Gustav), 1875–1961.
 6. Psychoanalysis and philosophy. I. Title.
 BF 175.5.C65M36 1995
 115—dc20 95-32103
 CIP

Contents

List of Figures and Illustrations

Acknowledgments

One of the greatest pleasures in writing this book is having the opportunity to thank publicly the many people who gave me so much help and encouragement. Although discussions about the importance of interdependence in psychology, physics, and philosophy fill this book, writing it gave me a priceless personal experience of the truth of that great principle. My dependency upon so many and the depth of their generosity helped me overcome my natural lone wolf tendency and deepened my gratitude for scholarly, psychological, and spiritual friendship. Over the years I got help in understanding everything from the subtleties of nonseparability in quantum physics and the rigors of modern analytical philosophy to the power of depth psychology and the sublime mysteries of mystical philosophy.

I especially thank the Jungian analyst, author, and dear friend, Dr. Marvin Spiegelman, who stimulated my interest in many problems addressed in this book, provided many useful comments on an early version of this book, and offered much encouragement throughout. Professor John McRae of the department of Asian Studies at Cornell University, friend in the *dharma,* has also provided much help and encouragement by carefully reading and commenting upon an early draft of the book. I also thank Rev. Robert Stefanotti, O. Carm. of Washington, D.C. and Dr. Jenny Yates, Jungian analyst and Professor of Psychology and Religion at Wells College, Dr. Joanna Rankin, Professor of Astronomy at the University of Vermont, and my old and dear friend Dr. David Hollenbach of the NASA Ames Research Center for useful comments upon an early version of this manuscript. I offer a special thanks to Dr. Marie-Louise von Franz who, despite her ill health, read the entire manuscript and offered encouragement.

Open Court Publishing has been a pleasure to work with from the submission of the initial manuscript through to the final book production. I offer warm thanks to Kerri Mommer for her help at every stage of the process and especially her careful editing. Special thanks is due to the three anonymous reviewers for Open Court Publishing for their careful reading and helpful comments.

I thank Colgate University for the opportunity to teach several courses over the last two decades in our General Education Program. In those courses I could share many of

these ideas that are well outside my specialties of physics and astronomy. Colgate, especially its Research Council, has also generously supported this book and my previous work through several financial grants over the years. The Colgate students who have taken my courses deserve special praise. Their sincerity and persistence often forced me into a clearer understanding and improved my ability to articulate these difficult ideas. I also thank the astronomy department at Cornell University, especially its chairman, Professor Yervant Terzian, for being my generous host over the last several summers while I worked on this book.

I am grateful to Dr. Fritjof Capra for reading and commenting upon the manuscript and for a stimulating exchange of letters. I am especially grateful to Michael Toms of New Dimensions Radio in San Francisco. His support, encouragement, and valuable suggestions at several stages along the way were a great help.

It's a great pleasure to thank my fellow members of Wisdom's Goldenrod Center for Philosophic Studies for their friendship, intellectual stimulation, and for forming a spiritual community. Over the years, and especially in the summer of 1993, I had the privilege of sharing many ideas in this book in seminars at Wisdom's Goldenrod. The comments, suggestions, and encouragement from those seminar participants have been invaluable in helping me clarify my comprehension and articulation of the ideas in this book. I especially appreciated the extensive comments on an earlier draft of this manuscript by Jonathan Back and Sam Cohen. Randy Cash deserves special thanks for his careful reading, extensive comments, and many useful suggestions at a late stage in the preparation of this book. To those who offered written statements of their synchronicity experiences, I am particularly grateful. Reflecting on and writing about these experiences, although always meaningful, was demanding and occasionally painful.

My intellectual companion, lover, and best friend—my spouse, Elaine—deserves a very special appreciation for her help, inspiration, encouragement, and detailed suggestions over the years. She has read and commented upon several early drafts of this book and made innumerable helpful suggestions throughout. Her suggestions contributed enormously to humanizing my writing. Without her I would never have even finished my Ph.D., let alone wandered this far from my native specialty.

I offer my deep gratitude to the late Paul Brunton for spiritual inspiration and for suggesting the general problem of linking science with mystical philosophy. Finally, I offer my deepest gratitude to the late Anthony Damiani, founder of Wisdom's Goldenrod, whose wisdom, compassion, and breadth of vision galvanized our interest in the intellectual understanding of philosophy and psychology and inspired us to seek some inner realization of its great truths—all this without limiting us to any one tradition or compromising our spiritual independence.

1 Introduction

In writing this paper I have, so to speak, made good a promise which for many years I lacked the courage to fulfill. The difficulties of the problem and its presentation seemed too great; too great the intellectual responsibility without which such a subject cannot be tackled; too inadequate, in the long run, my scientific training. If I have now conquered my hesitation and at last come to grips with my theme, it is chiefly because my experiences of the phenomenon of synchronicity have multiplied themselves over the decades, . . .

<div align="right">

C. G. Jung[1]

</div>

Although I don't encourage students in my first year writing seminar to discuss personal matters, in the fall of 1992, a student began her paper by recounting the following dream:

> Clumps of orange-tinted clouds partially obscured the moon and thick fog blanketed our unfamiliar path. My cousin, Carl, and I were running for our lives. I heard our feet pounding on the slick earthquake shattered pavement. The sound of a different set of feet slammed down in hot pursuit. Seizing the opportunity of darkness, Carl ducked into the first alleyway, pulling me in after him. Our backs to the crumbling brick wall of a warehouse and only a few feet from the entrance of the alleyway, we melted into the haven of darkness. Carl squeezed my hand reassuringly and gently guided me to kneel among the scattered trash as our pursuer raced past our hideaway. Barely breathing, I listened intently to the departing footsteps growing fainter. I smiled; we were safe for the moment. "Carl," I began, but felt my hand empty, his reassuring grip gone. A bottle at the other end of the alleyway spun on its side. I snapped my head toward the sound. Horrified, I saw my cousin's silhouette round the corner. I tried to lunge for him, to stop him from leaving, to ask him why he was leaving, to feel again his strength in my palm. I couldn't reach him. Darkness overpowered my world the instant he turned the corner. Shaking with terror, I awoke at 12:32 a.m.

Early the next morning, my father knocked on my bedroom door. Bleary-eyed, and exhausted from that night's dream, I rolled over to see what Dad wanted so early in the morning. His face was long and his eyes were bloodshot and wide with shock. He began with difficulty, "Your cousin, Carl, committed suicide last ——."

"What time?" I asked even before he could finish his sentence.

Confused by my initial reaction he answered, "Around 12:30 this morning."

In the midst of a long session of grading first semester college student writing, you can hardly imagine how startling and poignant I found this story. In her experience the inner psychological state (the dream) meaningfully correlates with the objective outer event (the suicide) without the inner state causing the outer or vice versa. Like Jung, I use cause in the conventional sense of one well-defined thing producing or effecting a change in another well-defined thing through exchange of energy or information. For example, high wind caused my apple tree to blow over, the news caused me great sorrow, or my anxiety caused me to forget his name. Clearly the dream and the suicide were meaningfully related, but neither the dream caused the suicide nor is it likely that the suicide caused the dream. Jung called such meaningful and acausally related correlations between outer and inner events synchronistic.

I have encountered too many synchronistic experiences, both in my life and that of others, to ignore them. Yet these surprisingly common experiences pose tremendous psychological and philosophical challenges for our world view. They are especially troubling experiences for me as a physicist trained within the culture of scientific materialism. In that world view all subjects and objects, all persons and things, are ultimately reducible to a complex of matter—elementary particles choreographed by the laws of physics. Within materialism how can we discover what meaning or purpose such an experience has for this young woman? Does such a question even make sense within that view? As for the student, the experience is charged with psychological significance—even if articulating it takes her decades. From the philosophic side, such unforgettable synchronicity experiences force me to question the relationship of the inner psychological states to their correlating outer events. If I obstinately cling to my academic heritage of materialism, these experiences pose enormous problems. Within any philosophic orientation, synchronicity experiences force me to ask: What is the relationship between mind and matter or inner and outer experiences? Does causality alone fully characterize their relationship?

Despite appearances and the daring title of this book, I am a conservative person and, like Jung in the opening quotation, approach the challenging topic of synchronicity with hesitation and caution. However, along with my experiences of synchronicity, obscure yet powerful forces relentlessly drive me out of my comfortable specialty of theoretical astrophysics into depth psychology and Eastern philosophy. I have been fortunate in both science and my other interests to have had gifted teachers. Partly because of them, it has been possible in the last several years to give my daimon his due and attempt to integrate my disparate interests. I appreciate both the wariness expressed in the opening quotation

above from Jung and the same traits in the general scientific community. Steven Weinberg, a Nobel laureate in physics, echoes this caution saying:

> This is often the way it is in physics. Our mistake is not that we take our theories too seriously, but that we do not take them seriously enough. It is always hard to realize that these numbers and equations we play with at our desks have something to do with the real world. Even worse, there often seems to be a general agreement that certain phenomena are just not fit subjects for respectable theoretical and experimental effort.[2]

Although synchronistic experiences are often the most memorable and meaningful events of a lifetime, for many in the scientific community (including Weinberg) they fall in the category where there is "a general agreement that certain phenomena are just not fit subjects for respectable theoretical and experimental effort." I believe that, instead of shying away from the many difficult problems they raise, synchronistic events deserve reverence—both from a personal and a scientific point of view. If we treat synchronicity with care, we are unlikely to subscribe to Weinberg's depressing credo: "The more the universe seems comprehensible, the more it also seems pointless."[3]

I follow Weinberg's sound advice and take the science, both the quantum physics and the depth psychology, very seriously. I start with the orthodox view of physics and the standard understanding of Jungian psychology; however, I work out their implications with daring rather than my native caution. Both the physics and the psychology help me develop a philosophic view that heals the traditional split between mind and matter. This view is different from that of Jung, but similar to that of some great physicists such as Schrödinger, Eddington, and Jeans as well as some well-known Eastern traditions. Readers need no technical background in physics or philosophy to follow my discussion.

Revising Beliefs about the World and Ourselves

To appreciate the meaningful world view implied by synchronicity, we must radically revise some powerfully held beliefs about the world. Since these beliefs are often unconscious, we project them upon the world. I use the term projection in the usual depth psychological sense of unconsciously and affectively attributing qualities to persons or things that we fail to recognize as originating in ourselves. That is, we unconsciously attribute qualities to persons and things that they do not in truth have—or at least to the extent that we believe they have. These projections cloud our vision and bind us to the object in love-hate relationships. Such obscuring and compelling projections rob us of rationality, freedom, and self-knowledge. To make things even more difficult, we have not the slightest doubt that the projected quality fully resides in the object, is out in the world where we have no control over it. Of course, just removing obscuring projections from other persons, let alone the world, is demanding psychological work. Yet any increase in understanding of another person, any appreciation of their true nature, requires the removal of our projections upon them. In contrast, every projection that remains unconscious obscures the true person and emotionally fetters us. Removal of projections

upon family, friends, and neighbors yields a corresponding increase in self-knowledge—something never bought cheaply or easily. In a similar way, any hard won increase in knowledge of the outer world demands a removal of our projections on the world and correspondingly liberates us and increases our self-knowledge.

In the last few centuries, science has accelerated this process of removing obscuring projections upon the world. Yet these gains in knowledge involve obvious losses. My life expectancy increases with each advance in medicine, yet even in this post–cold war era enough nuclear warheads exist to annihilate the world's population several times over. In the midst of dazzling technological advances, strident voices beset me on all sides about diverse ecological disasters fueled by an exploding world population.

Ironically, a painful and far-reaching consequence of our recent increase in knowledge about the objective world has been our disorientation toward and estrangement from that same world—from the living nature we seek to understand. In other words, scientific and technological advances bring us new knowledge and many real benefits, yet they have helped sever us from a vital relationship to nature. Scientific knowledge does not usually enrich us beyond the material level. Furthermore, our disconnectedness and alienation from nature have their roots in an even deeper malaise. For most modern people nature is no longer an exemplification of cosmic intelligence, a display of divinity, but something to be conquered and manipulated for our satisfaction. Domination and control overshadow reverence for nature and the powers it exemplifies. Let me illustrate how alienated we are from our despiritualized world by contrasting our modern attitude with a traditional Native American view.

We are moved, perhaps with envy and longing but unfortunately with little shared commitment, when the great Oglala Sioux holy man Black Elk says in describing the sacred pipe:

> But these four spirits are only one Spirit after all, and this eagle feather here is for that One, which is like a father, and also it is for the thoughts of men that should rise high as eagles do. Is not the sky a father and the earth a mother, and are not all living things with feet or wings or roots their children? And this hide upon the mouth piece here, which should be bison hide, is for the earth, from whence we came and at whose breast we suck as babies all our lives, along with all the animals and birds and trees and grasses. And because it means all this, and more than any man can understand, the pipe is holy.[4]

For most people, science and the general torrent of modernity have greatly increased our material knowledge and power. They have helped us remove projections from nature and ourselves. But they also helped deprive us of "that One, which is like a father" and our thoughts rarely "rise high as eagles do." Of course, it would be sentimental to neglect the suffering endured by pre-technological people, such as Black Elk's tribe, even before the coming of the Europeans. Nevertheless, unlike Black Elk, we alienated moderns live in a world devoid of divinity.

To add insult to injury, psychological knowledge deprives us of even the modest satisfaction of believing that we despiritualized moderns are free of projections. As Jung so often said, "we are still swamped with projections."[5]

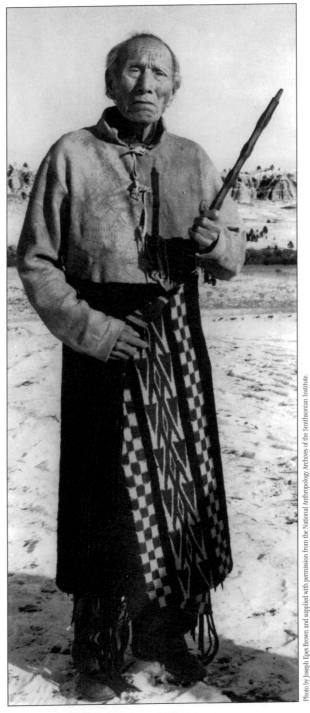

1. Black Elk with the sacred pipe

Lessons from Synchronicity

But, occasionally, in our fragmented and impersonal world that so often seems indifferent or even hostile to us, we have synchronistic experiences—numinous events where the outside world meaningfully relates to our inner psychological states. For example, Jung writes:

> As it is not limited to the person, it is also not limited to the body. It manifests itself therefore not only in human beings but also at the same time in animals and even physical circumstances. . . . I call these latter phenomena the synchronicity of archetypal events. For instance, I walk with a woman patient in a wood. She tells me about the first dream in her life that had made an everlasting impression upon her. She had seen a spectral fox coming down the stairs in her parental home. At this moment a real fox comes out of the trees not 40 yards away and walks quietly on the path ahead of us for several minutes. The animal behaves as if it were a partner in the human situation.[6]

Perhaps such experiences were common for Black Elk, but they stun most of us. As several examples discussed below will show, some synchronistic experiences seem to offer a glimpse of a higher reality or knowledge. Occasionally they may even seem like an epiphany—a flash of intuitive insight or a bestowal of grace. We can, at our peril, dismiss these occurrences as merely extraordinary coincidences, products of chance. However, for Jung and others, synchronistic experiences happen far too often and are too meaningful to be mere chance coincidences. Yet the inner experience in Jung's example above (the fox dream) surely did not cause the outer event (the fox appearing on the path) nor vice versa. Neither did the student's dream cause the suicide nor is it likely that the suicide caused the dream. However, it's possible that cousin Carl's powerfully concentrated thoughts before his suicide caused my student to dream of him. This possibility complicates the matter. If we could determine that some form of causal thought transference occurred, then the dream-suicide experience is not an example of acausal synchronicity. (Later chapters carefully distinguish synchronicity from other types of psychological experiences and extra sensory perception or ESP.) Rather than such causal connections, Jung understood synchronicity as *an acausal connection through meaning*. The analysis and examples below show that the meaning in synchronicity is an expression of the process of individuation—the very heart of Jung's view of depth psychology. Synchronicity is soul-making in action.

Besides its immense significance in the therapeutic process, synchronicity had great theoretical importance for Jung. Clinical experience with synchronicity led Jung to understand the archetypes underlying synchronistic events as psychoid, as structuring patterns for both psyche and matter. Here Jung moves beyond a concern for the structuring principles of the psyche to the structuring principles for the outer world. Therefore, the archetypes underlying synchronistic events are of immediate interest for both the psychologist and the physical scientist. The archetypes are then bridges between the inner world of the psyche and the outer world of matter. The eminent physicist, Werner Heisenberg, echoed this idea when he said, "The same organizing forces that have shaped nature in all her forms are also responsible for the structure of our minds."[7]

Because synchronistic experiences suggest a unity between psyche and matter, they invite us to remove one of our most powerful projections upon ourselves and the world—the belief in their fundamental separateness and independence. Although modernity has increased our belief that the inner world of feeling, imagination, ecstasy, and longing is fundamentally different from the impersonal material world guided by mechanistic laws, synchronicity contradicts this view by revealing *meaningful connections between the subjective and objective worlds.* Yet this suggested hidden unity of the inner and outer worlds, this view of man and nature rooted in what Jung called the *Unus Mundus,* is not easily understood or experienced. I argue that it requires us to transcend the psyche, to consider ourselves more than finite psychological beings. Yet how can this unified understanding exist within fragmented modernity and especially modern science, which has evicted the gods from stars, planets, and nature and left us as solitary wanderers out among the 10^{10} galaxies in the unimaginably vast universe? As Robert Frost laments in his poem[8] "Lessons for Today":

> Space ails us moderns: we are sick
> with space.
> Its contemplation makes us out as
> small.
> As a brief epidemic of microbes
> That in a good glass may be seen to
> crawl
> The patina of the least of globes.

Toward Healing the Split between Mind and Matter

I hope the following chapters provide at least a partial solution to this feeling of being "The patina of the least of globes." I frame my answer to this troubling view of ourselves as alienated wanderers in a despiritualized world by building a three-part harmony with a psychological soprano, a scientific baritone, and a philosophic bass.

First, the soprano takes the lead when I examine synchronicity through a psychological lens. I begin with a review of Jung's central ideas of unconscious compensation and individuation, since only within that context can we understand his notion of meaning that is so pivotal to synchronicity. With both analysis and examples, I clarify the idea of synchronicity as acausal connection through meaning and stress its role in individuation. Contrary to all previous writing on the subject, I argue against considering parapsychology as a form of synchronicity.

The synchronicity analysis and examples compel us to investigate four fundamental themes: the nature of *meaning,* the *space and time* transcendent aspect of synchronicity, the role of *acausality,* and the implied *unity of the inner and outer worlds.* These four themes act like powerful cables binding this interdisciplinary work together. My three voices are always addressing these four themes as they weave their way toward a unified

understanding of synchronicity by interlacing psychological, physical, and philosophic melodies together. We hear the clear soprano voice from the realm of soul throughout this book. She resonates with special warmth in the fourteen previously unpublished first-person accounts of numinous synchronicity experiences distributed throughout its pages.

Second, the scientific baritone appears early in the book, but makes his major contribution to its middle section. We must hear his song, because the world view challenged by synchronicity is one powerfully conditioned by science. If we are to effect some unification of inner and outer, or mind and matter, we must learn a radically new view of matter from quantum mechanics, drastically different from the materialism enshrined in Newtonian physics and our unreflective ideas about matter. In addition, Jung believed that profound connections exist between depth psychology and modern physics. For all these reasons, I turn to modern physics.

However, there is no question of physics "proving" the validity of synchronicity or the world view implied by it. Instead, through examining the four themes of meaning, space and time, acausality, and the unity of the inner and outer worlds within modern physics, I show how the most significant recent findings about physical nature support the transformation of our understanding needed to appreciate synchronicity. The notion of meaning has evolved significantly in the scientific revolution of the last three centuries. Unfortunately, the modern emphasis on strict objectivity makes it much more difficult to understand truly subjective principles that are central to appreciating synchronicity. Since synchronicity often involves startling access to knowledge that violates our common sense notions of space and time, I examine their role in contemporary physics. Turning to acausality, we find that some consider it a road block with a sign reading, "Here ends science and rationality." In contrast, I show that acausality provides rich new possibilities for understanding that were previously blocked by the strict causality in Newtonian physics. Then, by way of simple laboratory experiments, two nontechnical chapters discuss the conceptual foundations of quantum mechanics. Here we encounter nonlocality—what many consider the most profound aspect of the quantum view. The counterpoint between elegant theory and experiment makes these songs both comprehensible and compelling. Thanks to the enormous effort expended to understand the famous work of the late John Bell,[9] physicists widely agree that we understand these crucial issues much better today than the founders of quantum mechanics did a half century ago.

One of the great founders of quantum theory, Wolfgang Pauli, had a long relationship with Jung that deeply influenced Jung's ideas, especially about synchronicity, but Pauli did not have the good fortune to study quantum mechanics in the last two decades. These last two decades have revolutionized our understanding of the philosophic foundations of nature, *independent of the present formulation of quantum mechanics*. Because our understanding of these philosophic aspects of nature has become secure independent of any particular theory of nature, we have much greater confidence in the result and a deeper appreciation of its significance. I'll discuss this work and show how it significantly contributes, as synchronicity does, to removing one of our most intractable projections upon nature and ourselves—the belief in their separate and mutually isolated existence.

As I'll show, we are closer today to realizing Pauli's wish for a unity between matter and mind expressed in his statement: "It would be most satisfactory of all if physics and psyche could be seen as complementary aspects of the same reality."[10] Although I treat the physics with care, like Pauli and Bohr shown on the next page spinning a top (which has a connection with quantum mechanical spin) my presentation is often playful.

Third, we hear from the bass voice in the last part of the book when I place the discussion of synchronicity in a philosophic context. I begin the philosophic discussion by showing that the recent deepening of our understanding of quantum mechanics has an intimate connection to the foremost Buddhist principle of emptiness. The Buddhist view of emptiness directly challenges the deception of separate or independent existence. According to the Buddhists, this deception is the root of all suffering and I show that it also blocks our understanding of quantum mechanics and synchronicity. I apply insights from emptiness theory to persistent problems in both quantum mechanics and depth psychology. To develop these insights from Buddhism, I then examine what Jung calls his "psychological standpoint." Although Jung never considered it his task to develop a fully consistent philosophic view for depth psychology and synchronicity, important clues for such a vision lie in his psychological standpoint. Taking these clues and combining them with implications from synchronicity, physics, and Buddhism, I develop a comprehensive philosophic model for both the psychology and the physics.

These various disciplines, from psychology to physics to liberation philosophies such as Buddhism, form an interlocking mosaic of mutually supportive ideas and experiences. Just as we need to understand a drastically different view of matter from the old Newtonian idea, so too we must appreciate a radically different view of mind from the one that takes our personal mind as the fullest expression of mind. With these revised notions of mind and matter I use arguments and empirical data, to show that the world is *idea-like* rather than *matter-like*, mind-like rather than material, and that our individual minds are simultaneously gateways to the experienced world and the infinite intelligence embodied in this world. Within this expanded conception of mind we can understand that our individual mind is both the primary instrument for scientific knowledge and the means of our ultimate spiritual attainment promised by the liberation philosophies.

My philosophic analysis extends Jung's ideas about the *Unus Mundus*. Perhaps my extensions will help provide a model for this unifying principle underlying both psyche and matter and show how it might act in our individual lives, show how the inner lunar realm of imagination, longing, and creativity connects to the solar world of objectivity, facts, and quarks. If these three voices make harmony rather than cacophony, maybe we can even get a glimpse of the modern philosophic truth in Black Elk's unified and divinized world view. Or perhaps we can get a deeper appreciation of what Albert Einstein meant when he said, "Body and soul are not two different things, but only two ways of perceiving the same thing."[11]

As I discuss synchronicity, those familiar with Jungian thought will find the discussion familiar. Although I make an important clarification regarding the relationship of synchronicity to paranormal phenomena, my treatment of synchronicity follows Jung's

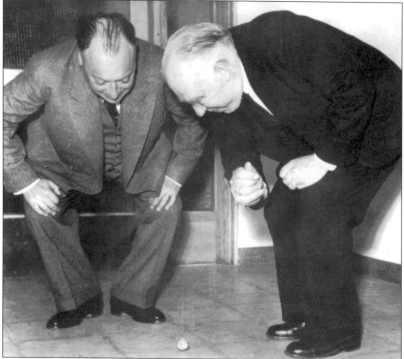

2. Wolfgang Pauli and Neils Bohr spinning a top

original formulation. Though the soprano sings standard Jungian thought, I make her sing an octave higher toward the end of the book. I always make it clear where my views differ from Jung's. Similarly, those with a background in the philosophical foundations of modern physics will recognize the scientific baritone. He sings melodies familiar to physicists working on the conceptual foundations of modern physics. Although the bass voice of philosophy is the most radical in its conclusions, it actually sings ancient melodies from the East, which will be familiar to some. What is new and unfamiliar are the details of each melody (especially my clarifying and refining of synchronicity) and particularly my harmonizing these three voices and extending the psychological and scientific outlooks into an encompassing and unified philosophic vista. Along the way, I also address what practical psychological and moral implications flow from the unified view of ourselves and the world. Theory must issue in practice.

Jung's pioneering essay on synchronicity had three primary inspirations: clinical experience, quantum physics, and Eastern thought (primarily the *Tao Tê Ching* and the *I Ching*). My three inspirations are similar. I rely heavily on first-person accounts of synchronicity but concentrate on very recent developments in quantum mechanics. Rather than ancient Chinese thought, I employ Middle Way Buddhism as an introduction to a philosophic view that suggests an explanation of synchronicity. I attempt to show that these three inspirations mutually reinforce and encourage the revision of some of our most

powerfully held beliefs—thereby radically transforming our vision of the world and ourselves.

Science clearly needs a new philosophic framework, a new world view, within which to advance. Despite the immense power and brilliance of modern science, it's at an impasse. As I'll show, this is especially so at its conceptual foundations. For example, by any measure, there has never been a more successful theory of nature than quantum mechanics, and yet, from a conceptual standpoint, there has never been a less well-understood theory. I, along with others, believe that much of our bewilderment at the foundations of physics directly results from our inadequate philosophic world view. Furthermore, history teaches that truly fundamental advances in science always go hand in hand with a revolution in our philosophic world view. My hope is that the present book, with its radically nonmaterialistic world view inspired by Eastern thought, will contribute to the paradigm shift needed for the next great advance in science.

Even more urgently, the world view within which science is done, scientific materialism, is a dead and deadening vision of reality. Not only does it despiritualize nature, but it reduces humanity to "The patina of the least of globes." Science and technology transform the world at many levels, but they often do so more negatively than positively. Many share my perception of crisis in which our materialistic world view is contributing to a physical, psychological, and spiritual catastrophe. Our very survival as a species demands a new view of humanity, nature, and their interplay. Again, my hope is that this book can contribute toward the renewal and healing we so desperately need.

In writing this book I have placed a heavy burden upon myself. First, I want it to engage the heart and mind of the reader with an interest in depth psychology and its spiritual and philosophic implications. I partly accomplish this by not assuming a technical background in either science or philosophy and by frequently using emotionally compelling case material. Second, I want my colleagues in physics to agree that my treatment of the science is accurate and balanced, even if they cannot embrace the world view offered. Third, I want philosophically sophisticated readers to agree that the philosophic analysis is reasonable, even if they cannot accept every argument and the world view implied. My largest burden comes from my desire to appeal simultaneously to the feelings and the intellect—to pay homage to both Dionysus and Apollo.

2 Individuation and Unconscious Compensation

As a rule, the unconscious content contrasts strikingly with the conscious material, particularly when the conscious attitude tends too exclusively in a direction that would threaten the vital needs of the individual. The more one-sided his conscious attitude is, and the further it deviates from the optimum, the greater becomes the possibility that vivid dreams with a strongly contrasting but purposive content will appear as an expression of the self-regulation of the psyche.

C. G. Jung[1]

Modern Cosmology as Metaphor

Few questions are more archetypal and mythological than asking how the universe began, how it evolves, and what is its final state. (Perhaps the only inquiry more obviously archetypal is asking the same questions about ourselves.) In the last half century astronomers have developed the big bang model for the birth, evolution, and death of the universe. Although like all earlier cosmologies it has archetypal and mythological dimensions, modern cosmology solidly rests on the interplay between Einstein's elegant theory of general relativity and observations from a variety of dazzling modern telescopes. In standard big bang cosmology the universe began about fifteen billion years ago in an unimaginably hot and dense condition and then exploded, cooling, and forming galaxies that still recede from each other today. Although this model seems firmly established, like all scientific theories it could be overturned tomorrow.

Early in this century it was clear that the average mass density of the universe (the mass per volume) was the critical parameter determining the ultimate fate of the universe. If the average density is smaller than a certain defined critical value, found by a combination of theory and experiment, then the universe will expand forever; all galaxies continually recede from each other endlessly, eventually cooling into the dead cinders left over from stellar evolution. On the other hand, if the density is greater than the critical value, at a certain time the recession stops and reverses. The galaxies then fall back together at ever increasing velocities into a cosmic inferno, the "big crunch." Thus the average

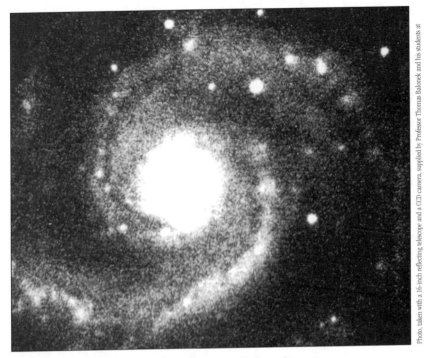

Photo, taken with a 16-inch reflecting telescope and a CCD camera, supplied by Professor Thomas Balonek and his students at Colgate University.

3. Galaxy as photographed from Colgate University

mass density of the universe decides whether it ends with a whimper or a bang, or more properly a diffuse, deathly cold universe or a cataclysmic big crunch.

In the last couple of decades it has become firmly established that the visible universe—everything seen by employing the entire electromagnetic spectrum from radio wavelengths to gamma rays—represents less than one-tenth the total mass of the entire universe. For example, the spiral galaxy shown in the photograph is overwhelmingly composed of unseen or nonradiating matter. The visible universe, of consuming interest to us since our Neanderthal ancestors gazed heavenward, is truly like the tip of an iceberg. There are typically 10^{11} stars in a galaxy and about 10^{10} galaxies in the visible universe, yet all these galaxies, stars, and gas clouds visible in any part of the electromagnetic spectrum make up only from one-hundredth to one-tenth of the total mass of the universe.

Since the great invisible bulk of the universe largely determines the average density, the invisible matter mostly decides the evolution and ultimate fate of the universe. Modern studies also suggest that our universe has an average density equal to the critical density. If the density is critical then, although the luminous part of the universe is less than a tenth of the total, its presence is still crucial. This is because a little more or less of the visible matter would change the total to above or below the critical value.

Given that the great bulk of the universe is invisible, how do we know it is present? The gravitational effects on the visible matter imply the presence of the invisible matter.

For example, gravitational effects on the motions of galaxies and clusters of galaxies imply the presence of much invisible matter.

This modern cosmology provides a strikingly apt metaphor for the relationship between the conscious and unconscious aspects of the psyche. The realm of the visible, of images, known contents, feelings, thoughts, and desires—what Jung calls the realm of consciousness—makes up only a small fraction of the total psyche. Like the luminous galaxies in the universe, it's enveloped by a much larger invisible component—the unconscious. The conscious part of the psyche is like a tiny volcanic island heaved up from the ocean bottom and surrounded by a vast expanse of water, which, like the unconscious, is extraordinarily rich in different life forms and occasionally threatens to destroy its own creation.

Just as invisible matter dominates the physical evolution of the universe, so does the invisible component of the psyche—the unconscious—dominate psychological evolution. Yet the conscious part of the psyche plays a critical role because the unconscious is often reacting to it. Although our interest in visible ego consciousness has consumed us, depth psychology has clearly shown that the dark, invisible aspect of the psyche—the unconscious—displays a profound wisdom in directing our evolution.

Just as the cosmologists infer the presence of the invisible matter by studying the detailed behavior of the visible matter, the presence of the unconscious is inferred by carefully observing its effects upon consciousness. In cosmology the gravitational interaction governs the interplay between visible and invisible matter, while in depth psychology the interaction between consciousness and the unconscious is largely through unconscious compensation—the "self regulation of the psyche" mentioned in the opening quotation by Jung.

An Example of Unconscious Compensation

I'll develop the idea of unconscious compensation referred to by Jung in the opening quotation with some personal case material. The tale revolves around shoes. Feet and their accouterments matter a great deal to us Pisces.

Since Jung taught us that important dreams are largely compensations and reactions to the conscious situation at the moment, it's always necessary to appreciate the conscious background for a given dream. Furthermore, if we want to understand the dream images symbolically, we also must know the dreamer's associations and relations to the dream images. Symbols, although rarely as obvious as in the following example, are the best possible expression of an unknown content, which seeks expression or revelation to consciousness. Their meaning is never fixed, but depends upon the detailed associations and history of the dreamer toward them. For truly archetypal dreams, personal associations are often missing or inadequate and then mythological and cultural amplification is necessary. However, for the present example, I only need to supply some historical background to show how the unconscious is applying its compensation, how it's attempting to balance my conscious attitude, to regulate my development.

My graduate career in physics and astrophysics started strongly, but my soul cried out for other kinds of development. After several upheavals, I left graduate school in the middle of writing my Ph.D. dissertation. With a furious immersion in various forms of psychology and a job in an experimental ward in a mental hospital, heavily influenced by Jungian psychology, I plunged deep into the world of the unconscious. It was exhilarating excavation that nearly transformed me from a staff member to a patient in the hospital. My possession of the keys to the ward doors was often all that distinguished me from the patients. Eventually I returned to finish my Ph.D., but the road was not smooth. I was pulled in several ways at once and it was difficult restarting graduate work. I often felt out of place and undeserving of my generous fellowship. Things got so bad that one day when my graduate advisor was walking toward me in the hall, I ducked into the men's room to avoid him. I didn't want to admit I had made so little progress since last seeing him. While lurking around in the men's room waiting for my advisor to pass, I tried to decide whether my psyche or my graduate work was in worse shape. Things soon turned around and eventually I finished the Ph.D. in fine form. During my low point I bought a very fashionable pair of Italian shoes. They were ankle-high with a pointed toe, a slightly raised heel, and very shiny. Putting on these dressy boots made me feel like a macho Ph.D., not some inadequate neurotic ducking into the men's room to avoid people.

Before the shoes had gotten scuffed, Colgate University hired me for a tenure stream position. My research was moving along nicely, teaching was going very well, everyone seemed pleased with me, and even my meditation seemed to deepen. I thought with great satisfaction, "At this rate I'll be president of the university in a few years!" During that time a particularly belligerent person called to hassle me, but I was in the shower. I knew this phone call would be a difficult struggle, so I jumped out of the shower and jokingly prepared myself by putting on my "power boots." I stood there naked, except for my shoes, and argued forcefully on the phone while my wife held her sides laughing. Then the following dream occurred:

> I was visiting a mental hospital and noticed several deeply disturbed people around the periphery of the room. I then began an animated conversation with a pig who stood upright on his hind legs and wore a stylish three-piece suit. I was amazed, but humoring him and carrying on the discussion seemed important. He bragged about being a spiritual titan, having an IQ of 110, and being very popular with the ladies. I listened politely and examined him carefully. I noticed his impeccably tied necktie and the meticulous cut of his suit. My eyes followed his legs downward and I noticed to my great surprise that his cloven hooves were standing in my favorite boots!

I awoke laughing from this delightful dream and got the point immediately. It was the pinprick needed to burst my psychological inflation, my completely unrealistic assessment of my abilities. Well before this experience, I had learned the subjective method

of interpreting dreams, which views each element of the dream as a projection or personification of our psychological structures at that moment. Each aspect of the dream symbolized—was the best possible expression of—an aspect of my personality. It was inescapable; this simple but powerful dream was applying a much needed corrective to my psychologically unbalanced condition. If my wife had said, "You need a more realistic assessment of yourself. You are inflated—a pretentious pig," you can imagine what my response would have been. At best I would have been resentful and defensive. However, the unconscious cornered me with this preposterous pig symbol expressing my unflattering psychological truth. As Jung says in the opening quotation, "The more one-sided his conscious attitude is, and the further it deviates from the optimum, the greater becomes the possibility that vivid dreams with a strongly contrasting but purposive content will appear as an expression of the self-regulation of the psyche."[2] After that dream, interest fell away from what I then called my "pig boots." Wearing them any more was impossible.

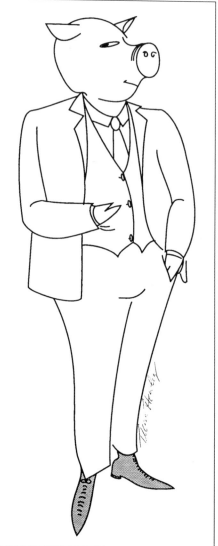

4. Vic's close friend

Unconscious Compensation as the Foundation for Individuation

Jung called this self-regulating function of the psyche "unconscious compensation." This principle largely governs the relationship between the conscious and unconscious aspects of the psyche, as the gravitational interaction mediates the interplay between the visible and invisible matter in the universe. Jung often used a biological metaphor in describing unconscious compensation, saying it was the psychological equivalent of the

body's self-correcting tendency, like a fever or the swelling of an infected wound. However, it's much more than a striving for psychological equilibrium. Merely striving for equilibrium would be a recipe for boredom and stagnation, not growth. Instead, Jung found by examining long series of dreams that he could clearly discern an overall pattern, a purposive guidance, playing itself out in the life of the dreamer. The unconscious, through a series of specific compensations, like carefully directed rocket bursts, guides the person along a particular trajectory, unique to that person. Through symbolic understanding of our dreams, fantasies, and emotional responses to the inner and outer world we discover this dynamic process and attempt to cooperate with it. In this way, that immense, not directly knowable part of the psyche—the unconscious—guides our evolution as the invisible matter in the universe decides its overall evolution. But unlike the universe, which according to general relativity only has a few end points, the unconscious guides each person to a unique expression of wholeness, particular identity, what they are meant to be, an expression of the divine ray within—the self. Jung says:

> This phenomenon is a kind of developmental process in the personality itself. At first it seems that each compensation is a momentary adjustment of one-sidedness or an equalization of a disturbed balance. But with deeper insight and experience, these apparently separate acts of compensation arrange themselves into a kind of plan. They seem to hang together and in the deepest sense to be subordinated to a common goal, so that a long dream-series no longer appears as a senseless string of incoherent and isolated happenings, but resembles the successive steps in a planned and orderly process of development. I have called this unconscious process spontaneously expressing itself in the symbolism of a long dream-series the individuation process. [3]

Of course, not every compensation is a deflation as in the previous example. Unconscious compensation takes extremely varied forms. As some dream examples later in the book will show, it can range from succoring a suffering ego to throwing new light on an old, recalcitrant psychological attitude. Both the needs of the moment and the long range purpose of the unconscious—the individuation process—determine the form of the unconscious compensation.

The archetype of the self is the intelligence expressing itself in the individuation process. Like every universal archetype it provides the psyche's nodes of meaning and springs for action. Besides structuring our meaning and behavior, the archetypes account for the detailed structural similarities in worldwide myths and fairy tales. For Jung, the self is primarily the archetype of meaning and its meaning is usually infused with numinous feelings. Consciously actualizing and expressing the self's intent in life is the process of individuation—our highest good.

The personal realization that there is an intelligence superior to our ego, to our personal will, that works through unconscious compensation to guide our development is one of the greatest joys of inner development. As Jung stressed, it's the psychological equivalent of the Copernican Revolution. The self replaces the ego as the center of life. In this psychological revolution we do not look through Galileo's telescope to see the phases of Venus or the moons of Jupiter. Instead we learn the symbolic method and peer into the depths of our own soul and there discover the traces of the self, its urgings, hints, and

sometimes imperious decrees. What a relief and inspiration to know we are guided by a wisdom greater than our ego's drive for self-aggrandizement. Each contact with that guidance, that self as the archetype of meaning, renews and inspires us and moves us toward our unique wholeness. Though many unconscious compensations thwart our personal desires, each experience of that process strengthens our belief in the meaning and purpose of life. Here numinous psychological development moves toward religious transformation.

Considering the archetype of the self as a purposive intelligence or meaning, as expressing itself in an unfolding "vision" of what we are meant to be, is a truly revolutionary idea. Only when we seek to make this process conscious and intentionally attempt to actualize this meaning, this vision, to bring it into concrete reality, does it truly become the individuation process.

From the perspective of individuation, we do not reduce our childhood traumas and early experiences to the building blocks of the personality. Instead, we understand life in all its dimensions, including its problems, as the self's attempt to actualize this timeless vision of what we are meant to be—an actualization that uses the raw material of our entire being and its experiences. My childhood experiences are no longer merely a set of joys, traumas, and formative experiences that shape me as an adult. They are that, but even more so they are the earliest expressions of my wholeness, my unique identity. These childhood experiences are partial, often distorted, and occasionally even painful expressions of the self. They take on much deeper significance when we see them as the fledgling expression of our unique identity, our attempt to soar on immature wings.

For Jung, activating and implementing the individuation process is the highest goal in life. The ego must develop a dialogue with that primordial wisdom or meaning, that ray of divinity within us, the self, and consciously realize its vision of wholeness in our everyday activities. This is the alchemical opus, the transformation of the base metal of our unrefined psyche into spiritual gold, a process honored in worldwide myths. The case studies presented in this book dramatically illustrate episodes in this process.

Of course, meaning is a broad term and usually has a very personal component. We can endure almost any kind of suffering and hardship if we can grasp its meaning, if we can somehow connect the pain with some deeper significance. On the other hand, an outwardly comfortable life can be unendurable misery without an adequate sense of meaning. For Jung, meaning, individuation, and synchronicity are most intimately related—a theme I stress throughout this book. For example, his close associate Marie-Louise von Franz says:

> For Jung, individuation and realization of the meaning of life are identical—since individuation means to find *one's own* meaning, which is nothing other than *one's own* connection with the universal Meaning. This is clearly something other than what is referred to today by terms such as *information, superintelligence, cosmic* or *universal mind*—because feeling, emotion, the Whole of the person, is included. This sudden and illuminating connection that strikes us in the encounter with a synchronistic event represents, as Jung well described, a momentary unification of two psychic states: the normal state of our consciousness, which moves in a flow of discursive thought and in a process of continuous

perception that creates our idea of the world called "material" and "external;" and of a profound level where the "meaning" of the Whole resides in the sphere of "absolute knowledge."[4]

It is important to stress that the meaning expressing itself in the individuation process, or in a particular synchronicity experience, "*one's own* connection with the universal Meaning," is not a construction or an invention of our ego, our empirical personality. Yes, this meaning has a personal aspect because it's intimately connected to our ego and of the utmost significance for us personally. But the meaning expressing the self, the transpersonal intelligence manifesting through unconscious compensation, is not the work of the ego. The ego cannot compensate itself. The ego is *in need* of the compensatory meaning, not the source of it. Our ego suffers the intrusion of the self's meaning, the self's demands. Yes, it is true that the particular meaning in an unconscious compensation is finely tuned to our very personal development and we as fallible, striving individuals must concretely implement this meaning in our daily lives. It's also true that, like any other revelation of the unconscious, our ego may pervert or distort the meaning of the unconscious compensation. Nevertheless, the meaning itself is neither our personal production nor our wish-fulfillment. Jung is serious about the birth of individuation being analogous to the Copernican revolution. We can no more consider the meaning to be a function of the ego's desires or demands than we can consider the earth to be the center of the universe. As Jung says, "For you only feel yourself on the right road when the conflicts of duty seem to have resolved themselves, and you have become the victim of a decision made over your head or in defiance of the heart. From this we can see the numinous power of the self, which can hardly be experienced in any other way. For this reason *the experience of the self is always a defeat for the ego.*"[5]

Before directly discussing synchronicity and the notion of absolute knowledge, it's important to notice two closely related principles that play a central role in Jung's view and also in this book.

Two Theoretical Points

First, for Jung, purpose or intent is more important than causality or what immediately generated the psychological event. (Following Jung, I'll always use the word "cause" without any modifier such as "final" or "purposive" to mean the conventional cause that involves energy, forces, or some information exchange—either physical or psychological.) Both Freud and Jung understood dreams symbolically, as pointing to meanings beyond the surface images or manifest content. Unlike Freud, Jung did not believe that a few primitive drives in the psyche caused dreams. He did not reduce the meaning of the dream to one complex such as incest or other oft-repeated sexual theme. Rather than viewing psychological phenomena as merely causally produced, Jung understood them as purposive, having an intent, as striving toward some goal, some as yet unattained objective. Rather than stressing the *proximate causes* of psychological phenomena, he was more concerned with their *final causes*. Simply put, it's not so important to understand what causes my neurosis, but to determine its intent. Where is it trying to lead me? What does

it demand of me? As Jung said, "By finality I mean merely the immanent psychological striving for a goal. Instead of striving for a goal one could also say sense of purpose. All psychological phenomena have some such sense of purpose inherent in them,"[6]

In his principle of synchronicity Jung also turns away from any mechanistic notions of causality and instead appeals to final or purposive causes. Since for Jung synchronicity is not an expression of proximate causes, or any type of cause attributable to energy exchanges or forces, either physical or psychological, he described it as acausal. To avoid confusion let me repeat: the causality denied in calling synchronicity acausal is the conventional form of causality familiar to Newtonian mechanics (gravity causes the apple to fall on my head) or psychodynamics (fear caused my trembling.) As we'll see, final or purposive causes are inherent in synchronicity since it's an expression of individuation, of the transcendent self.

Second, a final or purposive cause always implies some transcendent principle. Inherent in Jung's notion of unconscious compensation is the idea that there is some final cause operating in me, some foreknowledge of what I am meant to be. Otherwise how could the unconscious "know" what is an appropriate attitude or psychological orientation for me or how to guide me along my unique path? If the process of individuation implies some vision of what we are meant to be, one that we must discover and help unfold, then this inexorably implies some timeless knowledge. To pursue my metaphor with the universe, once given the average density of the universe, the timeless laws of nature inexorably determine the ultimate fate of the universe. In depth psychology, this timeless knowledge, implicit in the individuation process, reveals itself to the ego through unconscious compensation and occasionally through synchronistic experiences. As Jung says,

> Whether we like it or not, we find ourselves in this embarrassing position as soon as we begin seriously to reflect on the teleological processes in biology or to investigate the compensatory function of the unconscious, not to speak of trying to explain the phenomenon of synchronicity. Final causes, twist them how we will, *postulate a foreknowledge of some kind.* It is certainly not a knowledge that could be connected with the ego, and hence not a conscious knowledge as we know it, but rather a self-subsistent "unconscious" knowledge which I would prefer to call "absolute knowledge."[7]

I'll return later to Jung's notion of absolute knowledge when considering synchronicity in more detail. Now it's enough to appreciate that the notion of unconscious compensation has transcendent presuppositions inherent in it and requires some final or purposive form of causality. Even if Jung had never developed the notion of synchronicity he was committed to some timeless, eternal vision of our wholeness, the self, which unfolds through meaning in the unique path of our individuation.

Finally, let me draw attention to a slight subtlety. Synchronicity is an *acausal* connection of inner and outer events through meaning. No mechanical or energic causes connect the inner and outer events. The inner does not cause the outer nor vice versa. Nor, as Jung repeatedly stressed, do the archetypes or the unconscious cause the synchronicity experience. Nevertheless, since synchronicity is an expression of individuation, of

soul-making, then some teleology, some higher purpose, or final causality operates in this expression of the self. There is no conflict here. Denying causality in the energic sense in synchronicity does not negate the final causes or teleology of individuation. All this will become clear after a few examples and some analysis.

SYNCHRONISTIC POSTSCRIPT

Perhaps I still haven't got the message of my pig dream after all. Within two hours of putting the final touches on this chapter, a good friend, a Pisces artist turned farmer/ winemaker, dropped by to see me. He was wearing a very old pair of dress shoes he now only uses for rough field work. They looked strikingly like my old "pig boots." He stayed for supper and I told him about the dream.

3 Synchronicity: Acausal Connection through Meaning

The synchronicity concept is, arguably, the single theory with the most far-reaching implications for Jung's psychology as a whole, particularly for his psychology of religion, yet both within and outside the Jungian circle it remains perhaps the least understood of Jung's theories.

R. Aziz[1]

Defining Synchronicity

The well-known rock music group, the Police, made a popular album in 1983 entitled *Synchronicity*.[2] If we needed any proof, this shows how synchronicity is becoming a household word. Despite the almost offhand use of the term, most people poorly understand the idea. Aziz tells us in the opening quotation that, "both within and outside the Jungian circle it remains perhaps the least understood of Jung's theories." This is a serious problem for two reasons: First, because synchronicity has the most far-reaching implications, both for psychology and fields well beyond it; second, because in the minds of some of the best depth psychologists, it's the outstanding problem in the field. For example, Marie-Louise von Franz, whose contribution to our understanding of synchronicity is second only to Jung's (see, for example, her recent book *Psyche and Matter*[3]) said in a recent Dutch television interview: "The work which has now to be done is to work out the concept of synchronicity. I don't know the people who will continue it. They must exist, but I don't know where they are."[4] The photograph of von Franz shown here was taken the day she made this statement.

The easiest approach to understanding synchronicity starts with a dramatic example from Jung's synchronicity essay—the scarab beetle. Jung considered this example as the paradigm for synchronistic experiences. With this example in hand we can refine our understanding of this elusive principle. Then we can apply this understanding to the case material presented in the next chapter and throughout the rest of the book. Jung writes:

> My example concerns a young woman patient who, in spite of efforts made on both sides, proved to be psychologically inaccessible. The difficulty lay in the fact that she always knew better about everything. Her excellent education had provided her with a weapon ideally suited to this purpose, namely a highly

Photo supplied by Philip Engelen of Ikon TV, The Netherlands.

5. Marie-Louise von Franz

polished Cartesian rationalism with an impeccably "geometrical" idea of reality. After several fruitless attempts to sweeten her rationalism by a somewhat more human understanding, I had to confine myself to the hope that something unexpected and irrational would turn up, something that would burst the intellectual retort into which she had sealed herself. Well, I was sitting opposite her one day, with my back to the window, listening to her flow of rhetoric. She had had an impressive dream the night before, in which someone had given her a golden scarab—a costly piece of jewelry. While she was still telling me this dream, I heard something behind me gently tapping on the window. I turned round and saw that it was a fairly large flying insect that was knocking against the windowpane from outside in the obvious effort to get into the dark room. This seemed to me very strange. I opened the window immediately and caught the insect in the air as it flew in. It was a scarabaeid beetle, or common rose-chafer (*Cetonia aurata*), whose gold-green colour most nearly resembles that of a golden scarab. I handed this beetle to my patient with the words, "Here is your scarab." This experience punctured the desired hole in her rationalism and broke the ice of her intellectual resistance. The treatment could now be continued with satisfactory results.[5]

In studying Jung's writings (both case studies and theoretical formulation) and the examples in this book, two essential features of every synchronistic experience emerge:

First, an objective event or series of outer events meaningfully relates to a subjective psychological state (dream, fantasy, or feeling). Another impartial observer could easily verify the objective event. However, such an observer might be unable to verify the meaningful correlation or correspondence between the objective outer event and the individual's inner psychological state. Such deep significance or meaning connecting the outer event and psychological state is archetypally structured and yet very personal. Although it's personal, the meaning is not merely subjective, as I stressed in the previous chapter. The meaning expressing itself in both inner and outer events is an archetypal expression of the self in an unconscious compensation. It's a guiding of the ego and not a production of the ego. In Jung's paradigmatic example, the objective event is the scarab beetle flying in the window while the patient recounts her dream. This startling event has a meaningful connection to her dream, the psychological state.

> "I had to confine myself to the hope that something unexpected and irrational would turn up, something that would burst the intellectual retort into which she had sealed herself."

The second essential feature is the lack of causal connection between the outer event and the subjective inner state. As stressed in the preceding chapter, I follow Jung and use causality in the conventional and scientific sense of one well-defined thing effecting or producing another well-defined thing through energy or information exchange, whether it's gravity causing me to fall down stairs or guilt inducing me to confess my misdeeds. In this sense, neither the outer event (beetle) causes the inner (dream) nor vice versa. Instead, they are acausally related through meaning and not simply a chance coming together of outer events and inner psychological states.

The individual events within an acausal synchronicity experience usually have conventional causes. For example, perhaps light or warmth or a particular color attracted the beetle. We might also trace the dream to a unique set of circumstances or the state of the patient's analysis. However, the beetle's entry and the dream are clearly not causally related, but we relate their coming together in time and place through the archetypal meaning of rebirth, which has a particular relevance for the patient at that time. Of course, skeptics say that the whole thing is merely an extraordinary coincidence, a matter of chance, and to make more of it is unfounded at best. But Jung and many others in depth psychology experience these synchronistic events far too often and are too struck by their uncanny meaning to dismiss them as accidents of nature, as mere chance coincidences. For Jung, synchronicity implies that something distinct from linear causal explanations must be invoked as an explanation.

Jung stressed that neither the individual's unconscious nor the archetypes cause synchronistic experiences. He was not interested in replacing material causality by some new form of psychological causality. Instead, Jung understood acausal connection through meaning, or synchronicity, as complementary to causal explanations, as offering a new explanatory principle for events. Synchronicity does not replace or contradict causality but

Photo by Yousuf Karsh and supplied with permission from Woodfin Camp, Associates, New York, New York.

6. C. G. Jung

supplements it to provide a more encompassing view of experience. Believing that causality produces synchronistic experiences would be a primitive, magical view of synchronicity that Jung always avoided. As Marie-Louise von Franz says:

> According to the Jungian view, the collective unconscious is not at all an expression of personal wishes and goals, but is a neutral entity, psychic in nature, that exists in an absolutely transpersonal way. Ascribing the arrangement of synchronistic events to the observer's unconscious would thus be nothing other than a regression to primitive-magical thinking, in accordance with which it was earlier supposed that, for example, an eclipse could be "caused" by the malevolence of a sorcerer. Jung even explicitly warned against taking the archetypes (of the collective unconscious) or psi-powers to be the *causal agency* of synchronistic events.[6]

The acausality in synchronicity rules out both vertical and horizontal causality. By vertical causality I mean that the higher causes the lower; that the archetypes or collective

unconscious, which are transcendent to particular experiences, cause the events in the empirical world. By horizontal causality I mean that the inner psychological state (dream, fantasy, or feeling) causes the outer event or vice versa. In this sense the acausal nature of synchronicity rules out both vertical and horizontal causality.

An important implication of acausal connection through meaning is that *in synchronicity the meaning is primary while the objective and subjective events that correlate are secondary and contingent.* Let me explain using Jung's paradigmatic example. The critical point in this example is the archetypal experience of rebirth, the bursting of "the intellectual retort into which she had sealed herself." The necessary unconscious compensation could be accomplished in many ways—with or without synchronicity—although a less dramatic example may not have sufficed for this woman. So the beetle entering while she was telling the dream and Jung handing her the beetle as a waking parallel to being given a dream scarab—all this is contingent, accidental, nonessential, or not determined. So too were the exact details of her dream, for example, that a scarab beetle was a prominent symbol. If we maintained that just these particular outer events were necessarily correlated with just this exact dream, that precisely these outer and inner events were essential for this synchronicity experience, then we would be implying that the archetype of rebirth caused this synchronicity experience in all its details. But Jung continually warns us against this vertical causality, this taking the archetypes as the causal agents of the synchronicity experience. So again, the exact outer and inner events that meaningfully correlate are secondary and accidental to the archetypal meaning manifesting in the synchronicity experience. Unfortunately, the synchronicity literature does not stress that the same meaning could manifest through different circumstances. This omission has led to an overemphasis on the contingent aspects of synchronicity and a continual confusion of it with causal processes.

When I ask people if they have synchronistic experiences they often retort, "I have them every day. For example, I was thinking of my friend and she called me on the phone." Here some objective event (the phone call) correlates with an inner psychological state (thinking about the friend). Furthermore, there is no horizontal causality. Thinking of the friend does not ordinarily make her call, nor does her intent to call necessarily make us think of her. Nevertheless, the pivotal component of meaning, significance, or purposive import is, if not missing, at least deficient. Here we have difficulty even conceiving of some vertical causality, since no archetypal meaning manifests. In contrast, the archetypal meaning in the scarab beetle example is the primary point. This experience "broke the ice of her intellectual resistance" and allowed the therapy to proceed. This meaning is deepened because, as Jung notes, the scarab beetle is a classic symbol of rebirth.[7]

Difficulties in Understanding Synchronicity: Meaning

Synchronicity is much more difficult to understand than need be for two reasons. First, Jung never gave an adequate sense of what the meaning was for individual synchronistic events; second, he mixes an entire zoo of paranormal phenomena with synchronicity,

thereby making both classes of experience more mysterious. In this section I explore Jung's insufficient treatment of meaning. I deal with the paranormal in the following sections.

Even in his paradigmatic example, Jung gives only the barest outline of the meaning of the event for his patient. His other examples have even less discussion of the critical component of meaning. Although I disagree with Robert Aziz's interpretation of synchronicity,[8] I fully agree with two of his points: first, that synchronicity is best understood through unconscious compensation and individuation; second, that synchronicity rescues Jung's psychology of religion from psychologism, i.e., from treating truly metaphysical principles as mere psychological phenomena. I treat the issue of psychologism differently later. Regarding the lack of meaning, Aziz laments: "That Jung regards synchronistic events as very meaningful occurrences is an indubitable truth. When one does seek, however, to determine how exactly these events are understood by Jung to be meaningful, confusion does arise. Here, Jung's exposition is not easily followed."[9] Aziz then quotes Michael Fordham's very similar point, "His examples do not always make it evident in what his idea of meaning consists."[10]

> "When one does seek, however, to decide how exactly these events are understood by Jung to be meaningful, confusion does arise. Here, Jung's exposition is not easily followed."

Aziz's book attempts to remedy this lack of meaning. Unfortunately, he makes his task very difficult by relying entirely upon Jung's published case material (which by Aziz's own admission is "not easily followed") rather than bringing in fresh material with which he might be more intimately acquainted. By contrast, in what follows, I'll present a variety of previously unpublished synchronistic experiences from my life and those of my close friends and make explicit the meaningfulness of the events discussed.

Because the self is the archetype of meaning in our lives and meaning is constitutive of synchronicity, it's no surprise that the self and the process of individuation are always at the core of synchronistic events. In harmony with Aziz, I'll argue, using the diverse examples of synchronistic experiences discussed in this book, that the root meaning unfolding outwardly and inwardly is an expression of unconscious compensation and the individuation process—synchronicity is soul-making in action. Surprisingly, Jung and most writers on synchronicity do not adequately stress this point.

The Paranormal Is Not Synchronicity: Dissent or Clarification?

Let me now consider the second difficulty in understanding synchronicity from Jung's pioneering essay. He consistently considered paranormal or parapsychological phenomena as synchronistic phenomena. Paranormal or parapsychological phenomena fall into several broad and occasionally overlapping types. The main types are: extra sensory

perception (ESP)—acquiring information by means other than the known sensory channels; telepathy—communication between two minds by other than the normal sensory channels (thought transference); psychokinesis—mentally influencing objects in ways inexplicable by known physical means; clairvoyance—acquiring information from locations inaccessible to known sensory channels; and precognition—acquiring knowledge about events before they happen.

In this section I break with previous Jungian writings on synchronicity and argue that paranormal phenomena are not examples of synchronicity. Initially this seems like a significant departure from Jung's understanding, but I hope my discussion about the relationship between the paranormal and synchronicity will finally seem like a helpful clarification rather than a radical dissent. This section presents the controversial side, while the next section provides for the harmonizing aspect of my idea.

Let's consider a specific example. The research of J.B. Rhine[11] deeply impressed Jung and he referred to it repeatedly throughout his essay to garner support for his new principle of synchronicity. One experiment that impressed Jung involved statistical correlations between two isolated subjects. Subject A flips randomly ordered numbered cards each with one of five possible simple images on them. (See the images in figure 7.) They record the order of the flipped cards. The other isolated subject, B, guesses the order of these images. Some subjects got no better score for the order of cards flipped than that expected from random guesses. However, Rhine got statistically significant correlations for some pairs of subjects.

Timing variations in some versions of the experiments, such as guessing the cards before they are turned, showed that no energy transmission or mechanical agency could account for the correlations. Because the guesses were made before the cards were turned, Rhine reasoned that these statistical correlations are acausal. Subject A's turning cards *after* the guesses by subject B could not have caused the guessed images to arise nor could the images arising earlier in subject B influence the order of the cards turned later by subject A.

However, *these ESP events are not usually meaningful connections* or correlations as Jung usually defines meaning as an expression of the self— as unconscious compensation propelling individuation. Therefore, in contrast to Jung, I propose we clearly distinguish paranormal phenomena from synchronicity. It's true that paranormal phenomena may often be arresting and alert us to the possibility of acausal processes in nature—no mean realization. I also recognize that for some rare persons such an acausal paranormal occurrence might

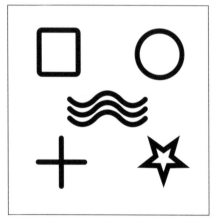

7. *ESP symbols*

be a numinous experience providing an important unconscious compensation, one deeply meaningful for that individual. This would be a genuine synchronicity experience, but then its paranormal nature would be incidental rather than necessary. I also appreciate that the subjects who showed statistically significant results could usually do so only when their interest was high, when their feelings were aroused—in other words, when the unconscious was activated. Nevertheless, I suggest that for most persons this and similar parapsychological phenomena have nothing to do with their individuation, the self guiding them toward wholeness, or their unique path to a meaningful life.

I take Jung seriously when he defines synchronicity as an acausal connection through *meaning* and interpret the meaning (along with Jung) as a specific unconscious compensation for the individual at that moment in their development. If, as Jung claims,[12] some transcendental meaning is manifesting in both the inner and outer world, then we can interpret the synchronistic experience symbolically just like a numinous dream—as a specific expression of the guidance of the self. We could hardly say this of Rhine's ESP experiments or the more modern and much more exacting parapsychology experiments carried out at the Princeton Engineering Anomalies Research Laboratory in the past fifteen years or so by Robert Jahn and his collaborators.[13]

We would not accept an interpretation of a symbolically rich and numinous dream as complete or satisfying if it merely reaffirmed the existence of the unconscious. That would hardly illustrate how this numinous dream is a specific expression of that person's individuation. Similarly, I suggest we not accept paranormal phenomena as synchronistic merely because they illustrate acausal connections between a subjective psychological state and an objective event. I propose that we reserve the word *synchronicity* only for those acausally connected events that express some specific meaning, some particular display of unconscious compensation. Jung's categorizing paranormal phenomena as synchronistic is not fully consistent with his own definition of synchronicity as acausal connection through meaning, where meaning is an expression of the self directing our individuation. Figure 8 summarizes my simple classification scheme.

Precise boundaries rarely exist in psychology. The stippled area separating synchronicity from paranormal phenomena is a diagrammatic attempt to recognize that the

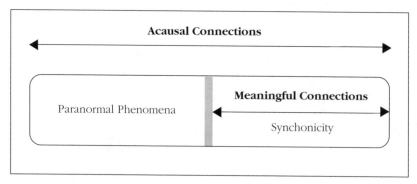

Figure 8. Paranormal phenomena and synchronicity

distinction between these phenomena may not always be precise. It's sometimes difficult to distinguish a genuine synchronistic experience from the rather commonly occurring psychological experiences with objective correlates (such as thinking of a friend and her calling). This problem occasionally occurred when I was searching for case material for this book. The acid test for all synchronistic experiences is whether they contain some dramatic expression of unconscious compensation, some genuine guidance from the unconscious. By strictly applying this criterion I have eliminated some paranormal experiences that Jung would consider synchronistic. This problem is compounded because the meaning might actually be there—if only we had the eyes to see—but I didn't accept potential or possible meaning in choosing examples. It's true that even if we cannot articulate the significance of a psychological experience, it can often still be transformative. The unconscious compensation may still be effective. Nevertheless, without my strict interpretation of synchronicity we are constantly in danger of confusing synchronicity with all sorts of psychic and paranormal phenomena. This would result in a great loss in clarity, especially since our present understanding of synchronicity is so rudimentary.

I cannot understand Jung when he says, "Rhine's experiments confront us with the fact that there are events which are related to one another experimentally, and in this case *meaningfully*, without there being any possibility of proving that this relation is a causal one, . . .[14] (the italics are Jung's). How could he be using "meaningfully" in this quotation? Yes, a greater than chance correlation has some meaning in the conventional sense of the word. We can analyze it mathematically. We can speak intelligibly to others about it, and so on. However, this is a conventional and trivial use of the notion of meaning and not at all the way Jung normally uses the term. In discussing Jung's notion of meaning, Marie-Louise von Franz says, "The realization of 'meaning' is therefore not a simple acquisition of information or of knowledge, but rather a living experience that touches the heart just as much as the mind."[15] Can we say that Rhine's statistical correlation "touches the heart as much as the mind?" Are these statistical correlations an expression of the archetype of meaning—the self? Are they some unfolding of my unique wholeness, of what I am meant to be? Surely, they are none of these things. Although it's not essential for the reader to agree with me here, I part company with Jung on this issue. On this point I also differ with all the subsequent literature on Jungian synchronicity that, to the best of my knowledge, also follows Jung in combining synchronicity with the paranormal.

The Paranormal as General Acausal Order: Harmony and Clarification?

If we examine Jung's more inclusive notion of general acausal orderedness, of which synchronicity is a part, perhaps we can harmonize my strict interpretation of synchronicity with Jung's use of the term. Jung describes his more inclusive acausal ordering principle when he says:

I incline in fact to the view that synchronicity in the narrow sense is only a particular instance of general acausal orderedness—that namely, of the equivalence of psychic and physical processes where the observer is in the fortunate position of being able to recognize the *tertium comparationis*. But as soon as he perceives the archetypal background he is tempted to trace the mutual assimilation of independent psychic and physical processes back to a (causal) effect of the archetype, and thus to overlook the fact that they are merely contingent. This danger is avoided if one regards synchronicity as a special instance of general acausal orderedness.[16]

Jung considers the synchronicity I have been examining in this book ("synchronicity in the narrow sense") as a special case or a subset of a much broader phenomena "of general acausal orderedness." The "equivalence of psychic and physical processes" is an equivalence of their meaning that provides the *"tertium comparationis,"* the third comparison term. The phrase "they are merely contingent" refers to the psychological and physical process. As I stressed earlier, the archetypal meaning is the primary and essential aspect of a synchronicity experience while the psychological and physical correlates are contingent and accidental. In other words, the same psychological lesson or unconscious compensation could be manifested in a variety of contingent ways. According to Jung, into the category of general acausal orderedness fall *"apriori* factors such as the properties of natural numbers, the discontinuities of modern physics, etc. . . . [and] constant and reproducible phenomena."[17]

Jung did not explain his notion of general acausal orderedness, but Marie-Louise von Franz, who worked closely with Jung on synchronicity gives us some help when she describes it as: "a regular omnipresent just-so-ness, such as for instance, the specific speed of light, the quantization of energy, the time-rate of radioactive decay, or any other constant in nature. Because we cannot indicate a cause (for these regularities), we generally express this just-so-ness by a number, . . ."[18] Here and elsewhere she emphasizes the just-so-ness, the brute fact that some fundamental things are as they are without any deeper cause. In one of her major works, *Number and Time,*[19] von Franz studied the properties of natural numbers as examples of acausal orderedness, of acausal just-so-ness.

Because Jung and von Franz are not familiar with the technical details of modern physics, most of their examples are inappropriate. Let me consider two of their examples of general acausal orderedness: the constants of nature (such as the speed of light) and the quantization of energy in quantum mechanics.

First let's examine the issue of the constants of nature by imagining that we live in Galileo's time and are students of general acausal orderedness. Galileo's work deeply impresses us, showing that all bodies near the surface of the earth freely fall with the same acceleration, $g = 32$ feet/sec/sec $= 9.8$ meters/sec/sec. This extraordinary result says that whether we drop a bottle of Chianti or a cannon ball from a tower, as long as we can neglect air friction, they will fall with the same acceleration and hit the ground in the same time. Even if we first have a dinner party with Galileo as guest of honor and empty the wine bottle and then do the experiment, the accelerations of the empty Chianti bottle and the cannon ball are the same. Being contemporaries of Galileo we are not aware of

Newton's formulation of gravity so we believe that g is a deep fact of nature without any causal explanation, that it's an example of "acausal just-so-ness."

However, when our grandchildren study Newtonian gravity and learn calculus they can calculate g from the mass distribution of the earth and much more fundamental principles of Newtonian gravity. In other words, this constant of nature, which previously seemed fundamental, we now understand as following from much deeper underlying principles in nature. In a natural sense of the term, deeper principles cause the special value of g. These deeper principles may or may not be acausal themselves. Nobody is confused today about how fundamental g is, but this example illustrates the difficulty of considering a particular constant of nature as an example of acausal just-so-ness. The problem has become more acute lately, because in the last few years physicists have developed a class of theories that seeks to unify all the forces of nature in one powerful and elegant set of equations. These unified "theories of everything" provide compelling explanations for many constants of nature that previously seemed fundamental. So today's constants of nature are likely to be seen tomorrow as consequences of more profound laws of nature and therefore we should be reluctant to consider them as examples of general acausal orderedness.

Next consider the "discontinuities of modern physics," as Jung calls quantization in quantum mechanics, or the more specific "quantization of energy" referred to by von Franz. These are also not good examples. Quantization finds a very direct and clear explanation in some simple facts about the mathematical laws of quantum mechanics.[20] (Quantization is actually analogous to the property that piano wires exhibit when they vibrate at fixed frequencies or tones. This is caused by the wires being firmly fixed to the piano frame.) Therefore, this quantization is not acausal. Even the "time-rate of radioactive decay" referred to by von Franz needs clarification to be a good example of acausal orderedness. The *rate* of radioactive decay is not an example of general acausal orderedness. However, that there are in principle no causes for individual decay events, yet these events display structure through their well-defined statistics, is an expression of acausal orderedness.

Despite this confusion, Jung and von Franz are quite right to appeal to quantum mechanics. Innumerable quantum phenomena are acausal in the strict sense of having no specific cause for an individual event or even group of events and yet these events display a rich and detailed structure, a genuine acausal orderedness. Some of these phenomena are discussed later in this book. Although history teaches us caution when we attempt to make predictions about future developments in physics, both theory and experiment converge in making the prospect of a causal explanation for these phenomena seem exceedingly unlikely.

I suggest that paranormal phenomena be considered an example of general acausal orderedness, but not of synchronicity, which I strictly define as an acausal exemplification of meaning in the inner and outer world. Paranormal phenomena are acausal in that no energy or information exchange can be responsible for the correlations measured, but they lack the meaning associated with synchronicity. Furthermore, paranormal phenomena, like similar quantum phenomena, are "constant and reproducible," as the

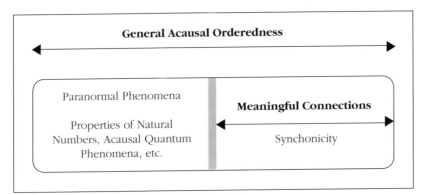

Figure 9. Reclassification of paranormal phenomena and synchronicity

more modern and rigorous study of these phenomena by Jahn and co-workers in the Princeton Engineering Anomalies Research Laboratory have shown.[21] This reproducibility is in further contrast to the sporadic, unpredictable, and unique nature of the more narrowly defined synchronicity. Reclassification of paranormal phenomena out of synchronicity and into general acausal orderedness modifies the previous classification in figure 8 to the form shown in figure 9.

I view the paranormal as being like expressions of mysterious laws of nature, expressions of general acausal orderedness and not synchronicity. It's entirely fitting that Dr. Robert Jahn, an engineer and not a psychologist, should be doing the most careful studies of these phenomena. Jahn's finding of controlled reproducibility over long periods of time for randomly chosen subjects makes it even more plausible that he is studying something like a law of nature, like general acausal orderedness, rather than nonreproducible synchronicity laden with archetypal meaning for the individual involved.

A Speculation as to Why Jung Linked Synchronicity and Parapsychology

I think that the hostile intellectual climate in the early 1950s, when Jung wrote his essay on synchronicity, partially motivated his linking of synchronicity with parapsychology and his appeal to Rhine's experiments. Although Jung was nearing the eighth decade of his life, he was still concerned about the acrimonious debate he knew his idea of synchronicity was sure to generate in some circles. The scientific paradigm of controlled experiments and statistical analysis seemed to grant reality and legitimacy to Rhine's parapsychological phenomena. For example, Jung says, "Decisive evidence for the existence of acausal combinations of events has been furnished, with adequate scientific safeguards, only very recently, mainly through the experiments of J. B. Rhine . . ."[22] Though many today would dispute that there were "adequate scientific safeguards," nevertheless, claiming that synchronicity was a class of these phenomena thereby garnered support for the reality and legitimacy of Jung's new principle. Jung sought a similar support in scientific procedure when he attempted his fruitless astrology experiment in the same essay. Scientific

procedure is appropriate for the study of general acausal orderedness, for finding "evidence for the existence of acausal combinations of events" such as Rhine's ESP, but not for synchronicity as I strictly define it. Since synchronicity seeks a transformation of the ego, it's not subject to our will. Thus, controlled experiments are an inappropriate way to study synchronicity.

The scientific method, with its demands of reproducibility, completely controlled environment, and quantitative measurement, is only one way of interacting with nature. Science is not a pure revelation of nature in isolation, but nature's response to our particular form of questioning. As a later chapter on measurement in quantum mechanics will show, science is in part an expression of a unique interaction between nature and ourselves. In quantum mechanics, to our great distress, we cannot say what nature is like independent of that interaction. The scientific method has often been likened to a fishnet that captures certain kinds of aquatic life but allows many interesting forms to pass right through it. Because an extraordinarily beautiful little fish or alga escapes the net, should we deny its presence or reality in nature's ocean? Such elusive life forms might hold the key to a great deepening of our understanding. Similarly, because synchronistic experiences elude the scientific method should we deny their reality? Obviously not, but gathering anecdotal evidence and relating it to a person's individuation hardly fit the scientific method. Yet if we do not understand the limits of the scientific method then we are doomed to apply it where it hinders our understanding rather than enhances it.

I believe that controlled, repeatable experiment and mathematical analysis are entirely wrong methods for understanding synchronistic phenomena. Confusing genuine milestones in individuation, such as the examples of synchronicity discussed here, with parapsychological phenomena, whatever their legitimacy, is misleading—especially at this stage when we are trying to build some understanding of synchronicity. Unless there is an expression of deeper meaning, acausally connected events belong to the large jungle of psychic and paranormal phenomena, to general acausal orderedness. Or, sometimes, they may only be coincidences. I'm not in the least interested in exploring this jungle and trying to sort out the genuine psychic experiences from the mere imaginations. I only consider the small clearing in the jungle that makes up meaningful synchronistic experiences.

Most spiritual traditions strongly advise the aspirant to avoid cultivating para-psychological powers for their own sake, for they can easily lead us astray. In contrast, the unconscious compensation inherent in a genuine synchronicity experience can be our spiritual guide. For this reason alone, we should clearly distinguish between these phenomena. So for all these reasons I focus exclusively on synchronicity within the context of individuation and avoid any consideration of parapsychological phenomena.

What Synchronicity Is Not

In surveying the literature on synchronicity and soliciting examples, it became clear that several common misconceptions about synchronicity flourish. In the hope of clarifying the definition, I'll enumerate some common misconceptions and give examples.

1. SYNCHRONICITY IS NOT SOLELY SUBJECTIVE

Every synchronicity experience must have a meaningful correspondence between an inner psychological state and some objective event or events in the outer world. Having just a powerful inner experience alone, no matter how stupendous the revelation or transforming the experience, does not count as synchronicity. A simple rule of thumb, as I suggested above, is that another impartial observer could agree that the objective events happened, even if the other observer did not know about the inner states that meaningfully correspond to the outer event. The Jungian analyst, Robert Aziz, seems unclear about this point. For example, Aziz claims that Jung's experience after the death of his mother was a synchronistic experience.[23] To support his example Aziz quotes the following passage from Jung's autobiography:

> I went home immediately, and while I rode the night train I had a feeling of great grief, but in my heart of hearts I could not be mournful, and this for a strange reason: during the entire journey I continually heard dance music, laughter, and jollity, as though a wedding were being celebrated. This contrasted violently with the devastating impression the dream had made on me. Here was gay dance music, cheerful laughter, and it was impossible to yield entirely to my sorrow. Again and again it was on the point of overwhelming me, but the next moment I would find myself once more engulfed by the merry melodies. One side of me had a feeling of warmth and joy, and the other of terror and grief; I was thrown back and forth between these contrasting emotions.[24]

From Jung's description we have no reason to believe that someone else could hear or record the music with standard equipment. Without an objective component this experience cannot be synchronistic—despite how moving and important it was for Jung. However, the quotation above mentions a "devastating" dream that Jung had the night before his mother died. Although not mentioned by Aziz, Jung realized the dream clearly portended a death. This dream with his mother's death the following day was more likely a synchronistic experience. Here was a meaningful correspondence between a dream and the objective event of his mother's death. Jung's subjective experience of music on the train is lacking an objective correlate, and therefore is not an example of synchronicity.

2. SYNCHRONICITY IS NOT MAGIC

By magic I do not mean sleight of hand or illusion, but rather producing effects by charms, spells, incantations, ritual, or mental effort of the magician. There is then a causal relationship between the actions or thoughts of the magician and the produced results. In other words, the magician attempts to produce effects through the exertion of personal will. If the causal connection is not strong, we judge the magician a charlatan or at least a weak practitioner. Therefore, because synchronicity is acausal, not an expression of causes generating effects, it cannot be an expression of magical causality as von Franz stresses.

Jung titled his pioneering essay "Synchronicity: An Acausal Connecting Principle," and stressed acausality throughout his essay. Yet if we do not read Jung closely, he appears at one point to come perilously close to suggesting that synchronicity might be understood magically. When discussing the importance of affect in synchronicity, he quotes Albertus Magnus as saying that "I found that emotionality of the human soul is the chief cause of

all these things, whether because, on account of her great emotion, she alters her bodily substance and the other things towards which she strives, or because, on account of her dignity, the other, lower things are subject to her, . . . we [in consequence] believe that what this power does is then done by the soul."[25] With a sufficiently exalted view of soul (not confusing it with the ego) this quotation can still be understood acausally and Jung does seem to imply that. In discussing this quotation he says that the images are "prompted by God and do not spring from our own thinking."

The important point is to realize that although synchronicity often springs up in times of emotional excitation, *our personal desires or expectations are not the cause of the outer events.* Of course, the acausality in synchronicity also implies that the outer events are not the cause of the inner experiences. For example, Jung's mother's dying did not cause his dream on the previous night. Rather, this was a revelation of what Jung frequently calls "absolute knowledge."

3. THE MEANING IN SYNCHRONICITY IS NOT A PRODUCT OF THE EGO

It should be clear by now that Jung understood synchronicity to be an expression of transcendental meaning, as an expression of the archetype of the self. As Jung says, "Although meaning is an anthropomorphic interpretation it nevertheless forms the indispensable criterion of synchronicity."[26] The meaning is certainly anthropomorphic, because without humanity it's an empty concept. However, because the meaning is a form of unconscious compensation that seeks the transformation of the ego, the ego cannot be the source of the meaning—although, as always, it can distort it. By *distort* I mean that the true meaning is often overlaid by our lusts, vanities, and the perversions due to our ego's innate desire for self aggrandizement. Nevertheless, the ego cannot compensate itself and thus it cannot be the source of the meaning of a synchronicity experience. The next chapter will imbed the notion of meaning in some actual case material.

4 Synchronicity: Examples and Analysis

If, therefore, we entertain the hypothesis that one and the same (transcendental) meaning might manifest itself simultaneously in the human psyche and in the arrangement of an external and independent event, we at once come into conflict with the conventional scientific and epistemological views.

<div align="right">

C. G. Jung[1]

</div>

In this chapter and interlaced between the following chapters of this book I anonymously report synchronicity stories from close friends. Along the way, I also anonymously narrate a few of my own synchronicity stories. Anonymity seems important because of the very personal nature of much of the material. Excepting the student mentioned in the introduction and one other person, I have known all these people for more than two decades. All but the student seriously study philosophy, psychology, and religion, and they all practice meditation. They have all spent many years devoting themselves to the individuation processes, to soul-making, and can articulate the psychological meaning of their experiences. Most are married, raising children, and pursuing careers. Many of them are students of the late Anthony Damiani, founder of Wisdom's Goldenrod Center for Philosophic Studies.[2] Goldenrod is not associated with any particular religious group or philosophic movement, but it has been a site of meditation and serious scholarship in comparative philosophy and psychology for more than two decades.

I have asked each writer to discuss the meaning of the experience—how it relates to their particular psychological and spiritual development. For the sake of clarity I often asked them to amplify some parts of their stories or I suggested editorial changes—all of which the author approved. Although the selection of which stories to use was mine, I tried hard not to intrude on the stories. In keeping with the anonymity of the authorship, I changed all personal names in the stories. With these exceptions, the descriptions are in the words of the protagonists.

Although the collection of synchronicity stories in this book covers the entire spectrum of human experience and is the richest collection in the published literature, it's in no

sense a statistically significant or complete data set. At this stage in our understanding I doubt that we could develop such a data set, although we can hope for it in the future. I have chosen stories primarily based on two criteria. First, I selected examples only when the protagonist could articulate some significant meaning. Of course, it's a personal judgment deciding what is "significant meaning." Besides a few general remarks after the stories, I have resisted extensive interpretation of these experiences beyond the written accounts. I would frequently encourage the author to think about what the experience means for their individuation, but I would resist making elaborate interpretations beyond those given by the writer. It's simply poor taste and even worse psychology to impose my limited interpretations upon a close friend's powerful synchronistic experiences. As I have stressed, although the meaning manifesting in a synchronicity experience is very personal it has an objective and transpersonal quality in that it's an expression of the archetypal self, the transcendent wisdom expressing itself through our individuation. Because of this objectivity it may happen that meaning is actually present in an experience, but we are too obtuse to notice. My selection criteria rule out such "unconscious synchronicity." Second, I looked for dramatic examples, leaving aside the surprisingly more frequent but less arresting and less clear everyday occurrences of synchronicity.

Values and Pearls

I recounted this story to a friend of mine. He believed that trolls were behind synchronistic events. He himself looked a bit like a troll, in fact.

My first lesson in value that I can remember came when I was about six or seven years old. I traded rings with a girl in my Sunday School class. Although mine was a genuine pearl ring in a 30-karat gold band, I didn't much care for it. I much preferred my friend's pretty shiny red ring (that I realize now was most likely from a 10-cent bubble gum machine.)

When we both got home, our parents were shocked and I remember the girl's parents coming to the door, apologizing profusely, and the dramatic exchange of the appropriate rings took place. It was almost ceremonial. Obviously I had done something quite wrong. But I had no idea what it was since I had no conception of collective value at the time. All I knew was that hers was shiny red, and in my opinion much prettier than my dull white one with the thick gold band. This event had a huge impact on me. After it I only wore the ring a very few times as a little girl, kept it in my jewelry box most of the time, and never thought much about it again.

As a young adult in my twenties, I was involved in a serious love relationship. It had reached a stagnant point where I knew that if things didn't change, it wasn't going to last. Another man arrived on the scene. He was foreign, quite exotic, and very attractive. I absolutely delighted in the excitement of being around him and

started wondering if I should abandon my long-term relationship for an exciting fling.

One afternoon I was thinking about the coming evening and a possible date with this new person. I had left the evening open just in case something would arise. I started actively entertaining this possibility. I got out of my car, reached into my pocketbook for parking meter money, and pulled out the very pearl ring from my childhood. To this day I have no memory of how it got into my pocketbook. As I retrieved the ring, it was instantaneously clear to me that if I were to have this affair, I was going to once again trade my pearl for the flashy imitation. This time however, I had a very meaningful relationship to lose in the process. I knew somewhere deep inside that the benefits gained from sticking with my meaningful relationship (although not totally apparent to me then) were ultimately more valuable than possibly losing it to a whirlwind short-lived passion.

Photo by Victor Mansfield.

10. The pearl ring on her daughter

How did the ring get there? I have no idea. I must have gone to my parent's apartment sometime before this event and brought back several items from my past—or then again, it may have been the trolls.

This lesson of seeing deeper value in life has been a continual theme for me. I am continually placed in situations where I have had to be very aware of the flash and glitter of appearances. It seems to require an inner self-reflection to discern the deeper meanings in experiences. Often in my life, I have learned about the deeper meanings from choosing the flashy red bubble gum rings and have been terribly disappointed. My experience of pulling out the pearl ring fifteen years later also had a profound message for me. I recognized at that moment of holding the ring in my hand that I was at a turning point and that I could no longer be naive about the choice I was making. By the way, I did choose the long-term relationship.

A further synchronistic item: Vic Mansfield built a computer program that uses a random number generator to choose a "random" paragraph from many thousands of possibilities in Paul Brunton's book *Inspiration and the Overself*. The program is set up so that each time I turn my computer on a "randomly" selected paragraph displays on the screen. As I turned on the computer to complete the editing of my synchronicity story, the following paragraph was displayed:

The Sufi-Muhammedan sage-poet, Ibn al-Arabi:
O Pearl Divine!
While pearl that in a shell
Of dark mortality is made to dwell,
Alas, while common gems we prize and hoard
Thy inestimable worth is still ignored!

Although she humorously offers the "troll theory" of synchronicity, it's worth noting because it's a typical causal explanation resorted to in our desperation to find an explanation for synchronistic experiences. We imagine elfin entities moving things like rings about so that they can have a meaningful relationship to our inner psychological state. The trolls are hidden causal agents. But this causal view, where one thing acts directly upon another through some material or energic mechanism, is incompatible with the acausality of synchronicity. There is no horizontal causality; there are no inner states causing outer events to arrange themselves in a particular way or vice versa. Being unconsciously fettered to causality, we revolt against Jung's claim that there is an acausal relationship of meaning linking the inner and outer events. Since no energic or material relationship exists between them, it seems like no relationship exists at all.

If, on the other hand, with Jung "we entertain the hypotheses that one and the same (transcendental) meaning might manifest itself simultaneously in the human psyche and in the arrangement of an external and independent event, we at once come into conflict with the conventional scientific and epistemological views."[3] Even if we resolve the conflict with these conventional views, we can easily succumb to the temptation of attributing a

causal power to the transcendental meaning—to then subscribing to vertical causality. Old beliefs and commitments do not die easily.

It's important to notice that this synchronicity example does not involve any dreams. A cursory study of synchronicity can easily mislead us into believing that synchronicity always involves a relationship between a dream and an outer event, such as the student's dream and the suicide or Jung's patient and the scarab beetle.

This last example shows that the meaningful connection between inner psychological states and outer events was expressing a clear intent, a recognizable urging from the unconscious—an unconscious compensation. The lesson was a deep one about values, and it expressed itself in a synchronicity experience on two levels: the obvious interpersonal level—here between lovers—and a lesson about properly valuing our relationship to the highest in us. Both lessons exemplify the archetype of value and both employ the symbolism of pearls. The Ibn al-Arabi poem that came up through the "random" selection process during the final editing raised the issue of value to a higher octave. The poem used the symbol of "Pearl Divine" for our highest self that gets associated with the body—"in a shell of dark mortality is made to dwell." All too often we overvalue trinkets and "O Pearl Divine! . . . Thy inestimable worth is still ignored!"

Healing Old Wounds

This happened twenty-one years ago, four weeks after the birth of my first son. I was a twenty-nine-year-old graduate student living in an idyllic cottage on Cayuga Lake. My wife and I were luxuriating in being parents, our healthy new son was greedily nursing, and the fall leaves swirled round us with vibrant colors.

In two successive nights I had very similar dreams of my father. I had never dreamed of my alcoholic father in my life, nor have I since. He left me as an infant and had almost no contact with me. My mother lovingly raised me entirely by herself and remarried when I was twenty-one. In my mother's eyes he was justifiably evil incarnate. Occasionally when she was at the height of her anger because of some bad behavior of mine she would say, "You're just like your father!" That was the nuclear weapon of curses.

Both these vivid dreams portrayed my father in a very favorable light. In the dreams he told me that he was a sensitive and poetic person who found it impossible to live with my headstrong, aggressive mother. He claimed that it really was not his fault that he left. The two successive dreams seemed very peculiar to me, especially since they were so alike. I attributed them to my becoming a father, but they were still mysterious.

The day after the second dream, my father's brother called me on the telephone; a real shock, since I had nothing to do with anyone in my father's family and had

no contact with them for fifteen years. He told me my father was dying in a Veterans Administration Hospital in Washington, D.C. and that I should go and visit him. I angrily blurted out, "Would he come and see me if I were dying?" I told my uncle I had no interest in seeing him now after all these years.

I hung up the phone. Rage, bitterness, and self-pity enveloped me like live steam. Where was he when I needed him? How come I had to take my mother's brother to the father and son banquet when I got my letter in high school football? How come my most vivid early memory of him was his stumbling into my mother's apartment and vomiting explosively all over the bathroom walls? Ferocious fights between my father and mother, face scratching, me standing there in helpless fear saying, "Mommy, I'll get you my hammer to hit him . . . "—all this washed over me. That rotten bastard! No, he made me a bastard! He cheated me of a normal childhood. He would not even pay the $5.00 per week of child support awarded by the divorce court. Maybe the half-brother I had never met, sired while he was married to my mother, would visit him in the hospital. How embarrassing it was being investigated by welfare workers to see if my mother and I were eligible for aid. After all those years of telling people my father died in World War II, that stupid bum writes my high school and asks how I am discharging my military obligation. He never even sent me a Christmas card! Why did he screw me up like that? Let the son-of-a-bitch die by himself as he deserves!

I wandered around all that beautiful fall day with hot tears streaming down my face, alternating between bitterness and sadness. Gradually I became torn about whether I should see him after all. I started thinking how I would enjoy telling him he was a grandfather. I didn't know what to do. The battle raged. I had been reading some Jung and experimenting with the *I Ching*. I consulted it in desperation. The hexagram "Gathering" came up. Part of the inter-pretation reads, "The family gathers about

11. "Gathering" hexagram

the father as its head." I was dumbfounded! That hexagram, plus the repeated dreams, decided it for me. I realized with an uncanny certainty that something bigger was operating in these events than just my fury and self-pity. We all piled into my little car and sorrowfully drove to Washington, D.C.

The intensive care nurse asked me if this man was my father. I confessed, with embarrassment, "I don't know." In fact, that ashen gray man with tubes running into his head was my father. I told him who I was and that he was a grandfather.

He said, "When I get better I'll make it up to you." He was always making alcoholic promises he could never keep right to the very end. I wept for him, for me, for my mother, for the family that never was. I wiped blood oozing from his mouth. I felt him suffer and watched my bitterness and self-pity dissolve in sadness for us all. I said a tearful good-bye and never saw him again, since he died in a few days. Nor did I ever again feel that bitterness and anger toward him. Yet those old wounds still bleed a little.

The night after that hospital visit I dreamed of a beautiful old black car from the nineteen-thirties carrying me up a stream bed behind my maternal grandfather's house. I remember the house from living there in my infancy. Although I could make no sense of this short dream, I felt very comforted by it. I always remembered the feeling of it and wondered what it meant. Twenty years later, among the half-a-dozen pictures containing my father, I saw that beautiful black car. In my childhood I had seen that picture a few times. (See the accompanying photograph.)

This photo, taken circa 1941, is from the family album of the author of this synchronicity story.

12. Father and son

My father stood in front of it with his left foot on the running board and me cradled in his arms. That handsome young man seemed to beam with pride and affection for me—and perhaps some anxiety about his looming responsibilities. That is the only picture I have of me and my father.

What does it all mean? Certainly my bitterness about my father needed to be overcome, both for my sake and that of my family. Although my life has been very good, a hard knot of rage, hatred, and shame was poisoning me. It had to be dissolved.

There is another dimension. Through the genuine need for self-reliance and as a defense against my pain and vulnerability I had built some heavy armor around me. Through time the wounds of my childhood had largely healed, but at the expense of a large build up of hard scar tissue, a sort of encasing shell. Directly experiencing my loss and my father's suffering cracked the armor and reopened the wounds. Thanks to the preparation of the dreams and the urging of the *I Ching,* the wounds could heal more thoroughly with less hard scar tissue. The curious thing about armor is that it keeps the outside world from harming you, but it also prevents you from expressing much tenderness or from letting the world in. Overall, it's a heavy burden to carry around.

Of course, the experience made me question my relationship to the world. What in me "knew" my father was dying? What knew that my encrusted bitterness needed softening through those extraordinary dreams of my father? How can coins "randomly" thrown connect so meaningfully to my psychological state then? I only have partial answers to these questions, but they will not go away.

Later, when I spoke to my teacher, Anthony, about this experience, he only said, "Unless we can learn to forgive others, we'll never forgive ourselves." Perhaps that is the best lesson.

Meaning, Spacetime Transcendence, Acausality, and Unity of Inner and Outer

The case materials above, and those that follow, show that synchronicity experiences revolve around issues of meaning, spacetime transcendence, acausality, and the unity of psyche and matter. They always pivot around some critical meaning closely associated with the person's individuation at that moment. A period of intense emotionality often precedes them. "Values and Pearls" and "Healing Old Wounds" are clear milestones, focal points for the process of individuation. Without connecting these experiences, and the ones that follow, with the details of soul-making, the events would only be anomalous experiences—freaks of nature. Instead they are revelations of the self in both the inner and outer world, revelations of meaning seeking to transform the individual.

Often there is also a clear expression of spacetime transcendent or "absolute knowledge"—a knowledge unobtainable through normal sensory channels or reasoning. For example, in "Healing Old Wounds" the repeated dreams prepared the individual for healing before he knew anything about his father's fatal illness. Examples later in the book show more dramatic examples of space and time transcendent knowledge, which challenge our absolutist notions of space and time.

Even in "Healing Old Wounds," the precognition implies that the empirical personality, the ego, occasionally has access to some transcendental or "absolute knowledge" as Jung calls it. Rather than call it absolute, I suggest that we have sporadic access to knowledge that surpasses the ego's normal sense channels and modes of reasoning. As Jung says,

> The "absolute knowledge" which is characteristic of synchronistic phenomena, a knowledge not mediated by the sense organs, supports the hypothesis of a self-subsistent meaning, or even expresses its existence. Such a form of existence can only be transcendental, since, as the knowledge of future or spatially distant events shows, it is contained in a psychically relative space and time, that is to say in an irrepresentable space-time continuum.[4]

These synchronicity experiences offer evidence that psyche and nature or mind and matter are not separate and dissimilar realms. Some profound relationship or interconnection between them seems to allow the soul to instantiate the same meaning in both realms. As stressed in previous chapters, because synchronicity is acausal, we are not to think that the self or the soul meaningfully manipulates matter to correspond to our inner states. Instead the meaning is primary while the outer and inner events embodying it are secondary, contingent, and accidental. Nevertheless, this acausal unfolding of meaning in both realms brings about some needed transformation of the individual while simultaneously implying a unity of psyche and matter.

Both the powerful affects along with the perception of meaning in synchronicity point to the underlying archetypes of the collective unconscious. The archetypes not only structure our behavior and feelings but they provide the fundamental units of meaning for psychological life. Because these synchronicity experiences suggest a unity of psyche and matter, Jung considered the associated archetypes as "psychoid" in nature, structuring both matter and psyche, but transcendent to both. Through the archetypes Jung breaks out of a purely subjective and psychological study of experience and opens up possibilities for us to transcend our psychological confinement.

In other words, Jung's repeated experiences of these meaningful connections between mind and matter forced him to move from a purely psychological standpoint to a philosophic and metaphysical one, wherein he postulated an underlying unified reality, the *Unus Mundus*. He did this despite repeated assertions that it was wrong to make metaphysical statements. For example, he says, "Psychology accordingly treats all metaphysical claims and assertions as mental phenomena, and regards them as statements about the mind and its structure that derive ultimately from certain unconscious dispositions."[5] Or again, "our metaphysical concepts are simply anthropomorphic images

and opinions which express transcendental facts either not at all or only in a very hypothetical manner."[6] I'll follow Jung and violate his admonition to avoid metaphysical statements when I extend his notion of the *Unus Mundus* in a later chapter.

Intellectual Impediments to Understanding Synchronicity

When the external world relates to the psyche we usually believe the relation is a causal one. That is, outer events causally connect to my psyche, since they directly induce a response in me. A simple example of this is the common view that I receive sensations from the outer world that then turn into perceptual images in my psyche. But a noncausal or acausal relationship of meaning between the world and my psyche, one where the outer event does not cause the psychological state nor does the psychological state cause the outer event, is very difficult to understand or consider real or authentic. Not only is the reality of a thing compromised if we cannot discover its causal roots, but the very notion of "explanation" normally rests on a causal foundation. Therefore, both synchronicity and quantum mechanics are difficult to appreciate and integrate with our normal world view, despite their impressive empirical evidence that challenges our deeply held beliefs about the supremacy of causality.

The modern scientific view, beginning in the sixteenth century with Kepler and Galileo, developed an idea of causality as the inexorable unfolding of impersonal mechanical laws. This view was astonishingly successful in describing a wide array of phenomena from the motion of planets to the workings of the machines that powered the Industrial Revolution. As this understanding of causality became more entrenched, many found themselves trapped in a mechanistic universe without meaning. We developed the notion of causality and then became bound by it. We fashion our own chains. Conceptual though these chains may be, they increasingly defined what could be considered a meaningful explanation. Although Albert Einstein himself was deeply committed to causality he realized that "Concepts which have proved to be useful in ordering things easily acquire such an authority over us that we forget their human origin and accept them as invariable."[7]

One of Jung's chief goals in his pioneering essay was to establish synchronicity as an explanatory principle not in competition with the usual causal explanation but complementary to it. He wanted to extend the very idea of what constituted a satisfactory explanation for an event. He understood through the physicist Wolfgang Pauli how both waves and particles are complementary aspects of the phenomena of elementary quantum entities. Neither waves nor particles can separately explain all the phenomena, nor can one be reduced to the other, nor can they simultaneously manifest in the same system. Yet both complementary views are essential for a full understanding of quantum phenomena. In a similar way, Jung sought a principle like synchronicity that might complement causality and, in combination with causality, offer a more comprehensive explanation of experience—one predicated upon the acausal meaning of correlated inner

and outer events. But several of our most deeply held preconceptions about the world block such a development.

One of the chief obstacles, besides our excessive commitment to causality, is the deeply held belief in the split between mind and matter, the genuine difference in kind between the inner world of psyche and the outer world of material facts. This view of the mind as a self-contained and autonomous principle that gazes upon the very different mechanistic material world was first fully articulated by René Descartes in the seventeenth century. He initiated the modern era of rational skepticism and laid the philosophic ground plan from which sprung the development of classical science. His exaltation of mind as an independent rational center different from the outer material realm proved extremely influential and enduring. However, an exclusive commitment to this view has in it the seeds of the alienation and isolation of the subject from the larger material world, an alienation from nature keenly felt in our time. What is more, such a view makes it impossible to understand acausal connections of meaning between the mind and the material world or how synchronicity implies a unity of psyche and matter. Whether we like or admit it, this Cartesian view has conditioned most of us. We believe in this radical split between mind and matter. Although Cartesianism is a familiar target for much modern criticism, as long as it holds us in its enchanted grip it denies us an understanding of synchronicity.

Another closely related impediment to understanding synchronicity concerns our belief in how objects seem to exist in the world. Let me illustrate by example: Imagine asking a philosophic fish to describe water. He would have a difficult time, not because of any linguistic or intellectual deficiencies, but because water surrounds him every moment of his life. He is so familiar with the medium that it escapes his notice. In a similar way, we take no notice of our belief in being completely surrounded by

13. A philosophic fish

Uncopyrighted drawing from Microsoft Word 2.0 courtesy of Microsoft Corp.

independently existent objects and persons. We take for granted that these entities are fully separable from their surroundings and relations, whether among themselves or with us, and especially that they are mind independent—that they can exist completely independent of any thinking of them. An independently existing object is what we usually consider a "real" object.

For example, most people would agree that the computer on which this book is being written is an independently existing object. It's quite incidental that I happen to own it, that it sits in a particular place in my office, or that it's loaded with my software and fingerprints. Its true nature would remain unchanged if owned by someone else, moved to another office, and with different software and fingerprints.

If we reflect, as we ask our philosophic piscine friend to do, most would agree that objects surely have relationships, but that these relations are not primary, not as essential

as the object's freestanding being, its isolated existence. In other words, we uncritically believe that the essence of a thing, its fundamental nature, is free of relationships, or at least that its relations are a much lesser reality than its separate existence. However, when we hold this belief in the isolated and independent existence of things, synchronicity, with its profound relatedness and implied underlying unity between the psyche and the world, will make us feel like a "fish out of water."

As I'll show, the analysis of nonseparability in quantum mechanics reveals that often the relationships, the interconnections, the dependencies, are more fundamental, more real, than the isolated and independent existence. This is entirely the reverse of our normal beliefs—our commitment to the ideology of separateness. This unconscious commitment to the ideology of separateness enslaves us to causality and makes it extremely difficult to understand both quantum mechanics and synchronicity.

The root of the word *synchronicity* and a few of Jung's remarks might suggest that simultaneity is critical for synchronicity. However, simultaneity, as Jung made clear in several statements, and as the examples to follow will show, is secondary. Instead, synchronicity experiences often violate our normal sense of time or sequence (causes before effects) or at least in the revelation of their "absolute knowledge" they suggest a tremendous elasticity to space and time. Yet, nearly all of us have a very "Newtonian" conception of time and space as absolute. We unconsciously believe in rigidly fixed time dictated to us by truly accurate digital clocks and equally unyielding space measured by platinum bars exactly one meter long under vacuum jars in some bureau of standards in Paris.

In the following chapters I will address all these intellectual impediments and show that the rich tapestry of synchronicity is woven with threads of meaning, spacetime transcendence, acausality, and the unity of psyche and matter. I'll develop these threads into cables that bind together the analyses from psychology, physics, and philosophy.

Despite the risk of fragmenting this book, I will interweave synchronistic case material between the theoretical chapters that follow. I hope they will provide a refreshing change of pace and continually remind us of the empirical roots of the study and what we are trying to understand. For there to be a real harmony, the soprano must continuously weave her inspiration between the baritone and the bass.

The class of synchronistic experiences described in this book are uncommon events. Few persons have the kind of experiences reported here and even among those that do, they are usually rare and special experiences. Many people regularly have smaller and often very arresting psychological experiences, but not of the magnitude or significance of the ones we will meet in this book. Why some have these more dramatic synchronistic expressions of individuation and others do not, I cannot say. Having them is not a measure of psychological or spiritual development. Does their rarity make them unfit data from which to draw conclusions? No. Psychology and spirituality have long histories of attempting to understand ordinary life by studying rare and extraordinary phenomena, whether they be psychotic episodes or mystical experiences.

The Bridge to Physics

Either from recalling your own synchronicity experiences or from reading the fourteen very different accounts reported in this book, it is clear that they are always arresting events. Whether a scarab beetle bursts into the room or a childhood ring turns up at an uncanny moment, we are aware that something strange and important is happening, that there is an intrusion of higher meaning. But besides the immediate and often numinous experience of an unconscious compensation, synchronicity directly challenges our views about how the world works. We are compelled to question many of our unconscious presuppositions about the world and our relation to it (which sometimes masquerade as scientific facts).

Synchronicity challenges our views about meaning, causality, space and time, and whether objects exist separately in the world—views deeply conditioned by our scientific beliefs and commitments. Most of us unconsciously interpret the world through the eyes of classical or Newtonian physics. That is, we believe in the universal applicability of objectivity, strict causality, absolute or fixed space and time, and in independently existing objects. But modern physics forces us drastically to revise our views on all these points. Understanding these revisions can help us better appreciate synchronicity and the challenges it raises. For that reason I want to construct a bridge between the findings of modern physics and the passions of the individuating soul revealed in synchronicity experiences. Although it's a difficult task, I want to build a bridge between what takes place in the physics laboratory and what goes on in the depth of my own being, between the austere beauty of theoretical physics and the dark gropings of the evolving individual.

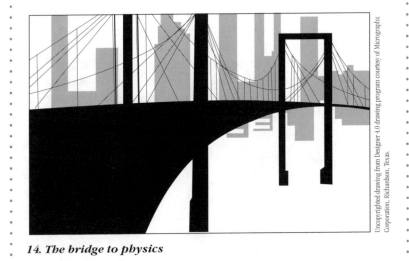

Uncopyrighted drawing from Designer 4.0 drawing program courtesy of Micrographx Corporation, Richardson, Texas.

14. The bridge to physics

Most people like bridges, but some of us suffer from vertigo. Others fear the trolls that often live under bridges. The trolls go by the names of *abstraction, foreignness,* and *higher mathematics.* Without trivializing the physics, I've tried to present it so that the nontechnical reader does not suffer from vertigo, from feeling too high above the solid earth of everyday experience. I've completely banished the troll of higher mathematics. Even the trolls abstraction and foreignness are kept under control, although you can never entirely rid yourself of the pesky goblins when discussing modern physics.

To make this bridge from depth psychology to physics easier to cross, I'll concisely describe the approach and content of the next five chapters. I hope this brief sketch of the intellectual terrain will serve as a simple map that can make our excursion more enjoyable and informative and maybe even diminish the troll threat. Before making the outline let me stress, at the risk of being boringly repetitive, that none of these scientific views offers any explanation or proof for the reality or legitimacy of synchronicity. Instead, the revising of our scientific world view prepares us to relinquish some of our most intractable projections upon nature and thereby to work toward a world view that is both more accurate and more accommodating to synchronicity and the unified world view I am attempting to build. Let me give the briefest outline of the next five chapters.

In chapter 5, "From a Medieval to a Modern World View," I make a small foray into the history of Western ideas by discussing the scientific revolution that catapulted us from the medieval world of the Christian Church into the scientific world of the Industrial Revolution. As a literary device I take a short pilgrimage to Florence, Italy to pay homage to two famous representatives of these eras: Dante and Galileo. This gives me an opportunity to discuss the shift in world view from Dante's geocentric, God-permeated universe—one congenial to synchronicity— to the heliocentric, secular world view initiated by Galileo and others in the scientific revolution. This chapter begins the discussion of objectivity in science and shows how this notion powerfully conditions our entire approach to what constitutes meaning. I argue that because of our culture's unreflective commitment to scientific objectivity we consider real only what we can turn into objects, what we can make a quantitative item of scientific scrutiny. Then subjective principles, whether archetypal meanings or the unobjectifiable essence of mind, are considered unreal fantasies unworthy of our attention. At the least, such ideas are not in any narrowly defined "scientific" world views. Such a rigid notion of objectivity is clearly unfriendly to synchronicity and the meaning expressed in it.

In chapter 6, "Causality and Acausality in Nature," I review the idea of causality in Newtonian physics. I show how the ideas of strict causality and independently existing objects in Newtonian physics evolved into an impersonal and machinelike world. Here are the roots of our present alienation from nature. I then describe

how quantum mechanics drastically modifies this view to one that in principle excludes causes of individual events and in which objects only come into actuality through interacting with them. I discuss how acausality plays an equally prominent role in quantum theory and in synchronicity. The lessons of acausality in quantum mechanics are clearly helpful for understanding synchronicity.

In chapter 7, "Elasticity of Space and Time," we take a playful excursion to Las Vegas. Through some badly placed wagers with Spacetime Sam we learn something about the modern mysteries of space and time. We find that our rigid notions about space and time are completely inappropriate for understanding the revolution Einstein brought into the twentieth century, a revolution that partly inspired Jung's ideas about synchronicity. Understanding precisely what the relativity of space and time means helps us appreciate their surprising elasticity in many synchronicity experiences.

In chapter 8, "A Participatory Quantum Universe," I examine a famous class of experiments that reveal the complementary nature of quantum systems. We go to the heart of the quantum mysteries by grappling with wave-particle complementarity. We find that, rather than living in a world populated by independently existing and isolated entities, we must participate in the world's definition, in its very unfolding in spacetime. This participatory universe, which emphasizes dependency upon our interactions with nature, is a long way from the causal interactions among independently existing entities found in Newtonian physics in chapter 6.

Chapter 9, "Nonlocality in Nature," is both the most far-reaching of the science chapters and the most prone to troll attacks. Accordingly, I have relegated the most technical material to an appendix at the end of the book where, without any mathematics beyond simple counting, I derive a special version of Bell's Inequality. Many consider Bell's Inequality the single most profound discovery in our long attempt at understanding the conceptual foundation of physics. Normally we all unconsciously believe that objects can be localized within some well-specified boundaries of space and time, that their existence is confinable to finite regions. However, in this chapter I discuss physics experiments which prove that this cannot always be so. We find that *independent of the present formulation of quantum mechanics nature is nonlocal.* The interconnections and interdependencies are so immediate and so complete that the relationship between objects is more important than their separate identities. The experimental revelation of nonlocality introduces us to an entirely new level of interdependence and interconnectedness that we cannot understand using ideas from classical physics. This unambiguous proof of ubiquitous nonlocality suggests that we must radically revise our old notions about objects and objectivity.

5 From a Medieval to a Modern World View

All things, among themselves, possess an order; and this order is the form that makes the universe like God.

Dante[1]

Philosophy is written in this grand book the universe, which stands continually open to our gaze. But the book cannot be understood unless one first learns to comprehend the language and to read the alphabet in which it is composed. It is written in the language of mathematics, and its characters are triangles, circles, and other geometric figures, without which it is humanly impossible to understand a single word of it; without these, one wanders about in a dark labyrinth.

Dante[2]

Florentine Pilgrimage: Dante (1265–1321)

To appreciate how the opening quotations by Dante and Galileo express an enormous shift in world view, we can make a brief pilgrimage to the Church of Santa Croce in Florence. There, the transition from the brilliant Italian sunshine to the gloom of a gothic interior leaves us momentarily blind. In a little while we notice shafts of light from high windows illuminating several tombs from Machiavelli to Michaelangelo. Low murmurs of pilgrims admiring the religious art echo off the high vaulted ceilings. We seek the tomb of Dante, despite his being buried in Ravena. The photograph of his tomb on the next page shows a sad and distant Dante with a depressed anima figure in the foreground. Perhaps he is downcast because of his two-decade exile from his beloved Florence, which resulted from being on the losing side of a political power struggle. His *Divine Comedy* refers to exile in *Paradiso* XVII, 55-60:

You shall leave everything you love most dearly:
this is the arrow that the bow of exile
shoots first. You are to know the bitter taste
of other's bread, how salt it is, and know

how hard a path it is for one who goes
descending and ascending others' stairs.

Dante's exile may be the reason for his melancholy, but I'll suggest in a few pages that there may be more profound reasons. First let's briefly discuss his greatest literary creation.

Dante's majestic epic poem, *The Divine Comedy,* soared to unprecedented heights of artistic grandeur in its synthesis of classical Greek thought, Aristotelian-Ptolemaic science, and Christian theology. For both the intelligentsia and the popular imagination, his unification of God with the cosmos and humanity was the definitive expression of the

Photo by Victor Mansfield.

15. Tomb of Dante

medieval world view. To achieve it Dante built upon Thomas Aquinas's harmonizing of the legacy of Greek reason with Christian faith. However, Dante went much further by poetically welding this reason-revelation synthesis with the Aristotelian-Ptolemaic astronomy of the day. This Earth-centered model of the universe offered a compelling scientific explanation for our everyday perception of a fixed Earth with revolving heavens. Despite the ungainly constructions of epicycles, equants, and eccentrics required for the model to fit detailed astronomical observations, it had coherence and satisfying predictive power.

In Dante's vision each of the traditional crystalline spheres for the elements, planets, and stars was populated by appropriate heavenly figures and spiritual scenes from both the contemporary and ancient world. (See figure 16.[3]) The nine levels in both the inferno

Figure 16. Dante's view of the world

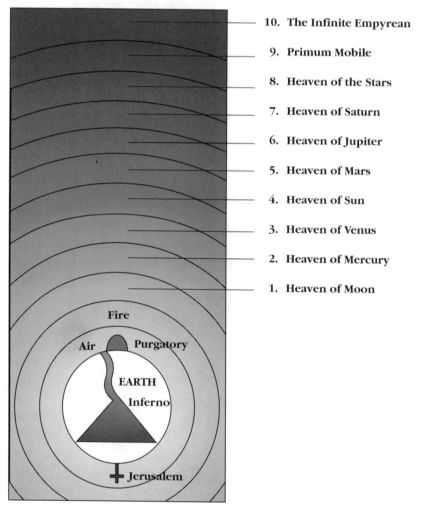

10. **The Infinite Empyrean**

9. **Primum Mobile**

8. **Heaven of the Stars**

7. **Heaven of Saturn**

6. **Heaven of Jupiter**

5. **Heaven of Mars**

4. **Heaven of Sun**

3. **Heaven of Venus**

2. **Heaven of Mercury**

1. **Heaven of Moon**

Fire

Air Purgatory

EARTH

Inferno

✝ Jerusalem

and purgatory (not shown in the figure) were filled with sinners of a particular type undergoing apt, yet horrific, punishments and purifications. Never before and never since has an astronomical model of the universe been woven so tightly with a Western religious world view. Poetry, theology, ethics, Aristotelian science, and geocentric astronomy were blended with penetrating psychological insight into an exalted vision of drama and power.

For Dante the entire cosmos, including all its creatures and humanity, is an expression of the divine. As he says in this chapter's opening quotation, "All things, among themselves, possess an order; and this order is the form that makes the universe like God." The nested crystalline spheres of the heavens, the nine levels of purgatory, and nine levels of the inferno, each with their unique experiences depending upon a person's actions on Earth, are all an expression of the divine order. As the geocentric view proclaims, all this detailed structure and order is focused here on Earth for the edification and spiritual education of humanity.

The last lines of the poem describe Dante's stupendous vision of how God's essence holds the effigy of humanity, how we are made in the image of God. No matter how debased we may become, our essence is still an expression of divinity as are all structures and movements in the universe. The opening line of the *Paradiso* declares, "The glory of the One who moves all things permeates the universe but glows in one part more and in another less." From our inmost essence to the farthest heaven, all this is divinity embodied. As Dante sings in *Paradiso* XXIV, 130–47:

I believe in one God—sole,
eternal—He who, motionless, moves all
the heavens with His love and his desire;

.

This is the origin, this is the spark
that then extends into a vivid flame
and, like a star in heaven, glows in me.

In this way the loving womb of God envelops us. All nature has meaning, all movement has a purpose, even if we are not wise enough to comprehend it. *The Divine Comedy* unrolls this cosmic tapestry before us in accessible language, because, unlike others of his day, Dante used the vernacular rather than Latin. We may not have a good Florentine astrologer to demonstrate the wisdom of the heavens to us, or a feminine spiritual guide like Beatrice to reveal mystic truths to us, but if Dante's luminous poetry can inspire us, then it may take us up with him to get a glimpse of this divinely ordered universe, this unfolding and enfolding of God's wisdom and love.

The medieval Church granted the efficacy of astrology[4] and thus thinkers of that age accepted the continuous expressions of meaningful correspondence between the movements of the planetary spheres and our inner states. If the planets are considered causative agents of the inner states then this is not synchronicity in the strict sense of acausal orderedness. However, if they symbolically interpreted the planetary configurations

as announcing the cosmic or archetypal meanings manifesting in both the inner and outer worlds, then Dante's universe was one continuous expression of synchronicity. When the individual is not aware of the meanings manifesting, then astrology is an expression of general acausal orderedness. When the meanings become conscious, then astrology with its objective events (the planetary configurations) and the person's correlated inner psychological states become an expression of synchronicity.

However Dante and his contemporaries interpreted astrology, it's clear that in a universe permeated by God's intelligence, acausal orderedness was the rule, not the exception. Section 3 of Jung's synchronicity essay, entitled "Forerunners of the Idea of Synchronicity," appeals continually to the world view sketched here. It was obviously congenial to Jung and he often drew inspiration from it.

Florentine Pilgrimage: Galileo (1564–1642)

Near Dante's tomb we find Galileo's, shown in the photograph below. Rather than the brooding image of Dante with a melancholy anima figure, we see a Promethean Galileo triumphantly arrayed with his books and telescope. Galileo, like Dante, suffered from the authorities of his time. Because of Galileo's support for the Copernican or sun-centered view, he was kept under house arrest for suspicion of heresy by the Roman Inquisition for the last decade of his life. Despite this severe punishment from the Church he loved, the tomb shows a victorious Galileo in sharp contrast to the gloomy portrayal of Dante. I'll soon suggest a way to interpret this contrast, but first let's discuss some of Galileo's important contributions. Let me begin by recounting a famous incident in Galileo's scientific career.

One day Galileo was sitting in church (it may have been Santa Croce) watching the swinging of a chandelier. Perhaps it was a particularly boring service. In any event, he timed the swinging of the chandelier using his pulse. Galileo dared to venture beyond the dogmatic speculations of Aristotle dominating contemporary science that said that all motion must be ultimately traceable to the Prime Mover in the ninth celestial sphere. Galileo believed that in science it was more productive to appeal directly to careful observation of nature and mathematical analysis than to metaphysical final causes. For example, let's imagine he counted the total number of pulses occurring during five complete oscillations of the chandelier. (A complete oscillation is the movement from one extreme position to the opposite one and then back to the original position.) Dividing the total number of pulse counts by five would then give a good estimate of the number of pulses per complete oscillation, called the period of oscillation. After several timings he noticed that the period of oscillation did not vary with the amplitude of the oscillation. In other words, when the chandelier was barely swinging it had the same period as when it was making significant excursions from equilibrium. After leaving church he set up a much more accurate experiment to confirm his initial findings. Rather than use his pulse, he devised an ingenious clock based upon the flow of water. He later built upon these pendulum results to develop fundamental ideas about the mechanics of motion.

In this pendulum example we see three important characteristics of Galileo. First, in stark contrast to Dante, Galileo wanted to abandon all authorities such as Aristotle and completely separate science from both theology and philosophy. In fact, the doyen of Galilean scholarship, Stillman Drake,[5] makes a convincing case that it was not Galileo's overzealous championing of the Copernican view that got him in trouble with the Inquisition but his desire to separate science completely from the authority of all philosophy and theology. According to Drake, Galileo was intent upon protecting the Church from all the difficulties that would follow by not separating theology and science. Whether this is truly the case, it's certain that in his scientific career Galileo wanted this separation and attempted to achieve it. However, he was not always successful. For example, early in his career in 1588 he gave two lectures on the location, size, and arrangement of hell in Dante's Inferno.[6]

Second, Galileo was an extraordinarily careful and ingenious experimenter. In contrast to the speculative and deductive way science was done by the Aristotelian natural philosophers, Galileo appealed directly to careful measurement. In 1605 he caustically said, "What does philosophy have to do with measurement."[7]

Third, regardless of how clever the measurement, Galileo always employed mathematics to quantify his observations and reveal the underlying laws of motion, for as he says in the opening quotation of this chapter, without mathematics "one wanders about in a dark labyrinth." He used mathematics quantitatively to reveal laws about nature and avoided the more mystical and symbolic approach of the Platonists who used it to grasp archetypal truths about the divine. These three principles—freedom from authority, appeal to careful and repeatable measurement, and mathematical quantification of results—are cornerstones of the scientific method that Galileo helped build.

By today's standards the amplitude independence of the pendulum period found by Galileo is a very modest piece of knowledge. Nevertheless, Galileo's genius in this example deeply impresses today's scientists, especially because he was one of the first to break free of speculation and dogma and turn to careful quantitative measurements for the study of natural phenomena. Through observation and the employment of mathematical methods, he revealed an objective truth about nature. By objective truth I mean one independent of the preferences or presence of Galileo or anyone else. Furthermore, it does not matter whether the pendulum is in a cathedral in Florence, Italy or in an undergraduate lab in Hamilton, New York. As long as the pendulum is free from interfering effects (like wind or bearing friction) the behavior is independent of the surroundings and whether or not it's being measured or observed.

In church, while worshipping the old Christian God, Galileo was laying the foundation for the new god of modern science, one worshipped with meticulous observation supplemented by mathematical quantification. He was igniting the revolution that ushered in the scientific age. The critical thing for this revolution is the objectivity of the findings. We don't need faith or similar religious or philosophic beliefs as Galileo, but adequate training so that we can duplicate the analysis and learn the same objective facts. (Johannes Kepler was developing a similar approach to planetary motions.) We must sacrifice faith,

17. Tomb of Galileo

scripture, dogma, speculation, and subjectivity in the fires of meticulous observations and mathematics to learn the scientific truth about the world, about objective nature.

Another important principle issuing from Galileo's work, especially his telescopic sightings of sunspots, the phases of Venus, and craters on the moon, was that celestial matter is the same as terrestrial matter—subject to irregularities, imperfections, and change. In contrast, Dante and his contemporaries believed the material in the planetary spheres to be perfect, immutable, and fundamentally different from the imperfect material found here in the "sublunar realm." Galileo's denial of the difference between celestial

and terrestrial matter prepared the way for Isaac Newton to apply his laws of mechanics—known to apply to earthly matter—to the movements of celestial matter, to the planets.

In this brief homage to Galileo I'll discuss one final contribution: his distinction between the phenomenal sense qualities and the true properties of objects studied in science. Galileo says: "I think that tastes, odours, colours, and so on are no more than mere names so far as the objects in which we locate them are concerned, and that they reside only in consciousness. If living creatures were removed, all these qualities would be wiped out and annihilated."[8] Galileo made a sharp distinction between primary and secondary qualities, as they later came to be called by John Locke. The true or primary properties of objects for Galileo were those that we could measure and quantify such as size, shape, number, position, and velocity rather than our secondary or subjective sensations such as taste, colors, and so on. The "deep realities" of nature after Galileo are no longer our sense perceptions but the objects of mathematical physics, those material structures not always perceptible to the senses but deterministically governed by the equations of physics. It's not quite fair to say that by making this distinction Galileo divorced science from humanity, but he certainly helped the process along. His distinction emphasized the superiority of objective and quantifiable properties, material objects of mathematical physics, over subjective sense data.

In recognition of Galileo's great contributions, and especially his early observations of the moons of Jupiter, an interplanetary space probe was named after him. On its way to observing Jupiter and its moons, it took the photograph of the Earth on December of 1992 shown here. When the space probe soared from the Earth's gravitational field toward Jupiter nobody was surprised that there was no sound of shattering crystal from the crystalline spheres that Dante believed surrounded the Earth.

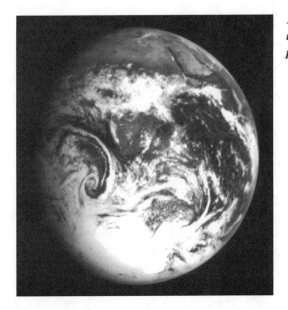

18. Earth from interplanetary probe Galileo

Uncopyrighted photo supplied by the Cornell/NASA Space Craft Planetary Imaging Facility.

Although I truly revere Dante, he was greatly mistaken in many aspects of his world view—especially in the way he wed theology with philosophy and science. We can learn at least two important lessons from his mistakes. First, we must exercise extreme care in attempting any connections or bridges between science and a particular world view, whether religious or philosophic. Science is a moving target always undergoing constant transformation. Thus we guarantee obsolescence to any world view intimately connected to the details of a particular science because the next scientific revolution is always just around the corner. Second, we must be careful not to confuse the psychological and the physical, to merge the symbolic and the literal. Yes, we are the center of our experience, and, as Jung and others teach us, all life's adventures ultimately focus on our personal development. Nevertheless, we should not project these psychological and moral facts into physical cosmology, into a geocentric view. I'll keep in mind these lessons as I try to bring harmony to the psychological soprano, the scientific baritone, and the philosophic base.

To conclude our pilgrimage to these cultural heroes let me discuss their very different tombs. In my fantasy, Dante realized that his world view crumbled after the scientific revolution and this is why he is depicted on his tomb as dejected. In contrast, the victorious Galileo was a chief architect of the scientific revolution, now an accomplished fact. His work laid the foundation for René Descartes and Isaac Newton who developed a compelling and comprehensive materialistic and mechanistic cosmology. With their developments the universe became for centuries a gigantic clock governed by mathematical laws, and they saw the divine clockmaker as having retired to the background once all was set in motion. With the growing secularization of Western thought, concern about the clockmaker waned—at least in scientific circles. Perhaps Dante foresaw this eventuality, further adding to his depression.

Our current cosmology not only displaces us from the center of a much larger universe, but thanks to Darwinian evolution, also portrays us as only a small part of a much larger biological evolution. In the first chapter I quoted Robert Frost as contemplating humanity as "a brief epidemic of microbes/ That in a good glass may be seen to crawl/ The patina of the least of globes." A material universe populated by mathematical abstractions governed by impersonal and mechanistic laws replaces Dante's deified and organic cosmos. Not only is humanity displaced from the focal point of this cosmos, but we realize that our normal sensory modes of perception are secondary and inadequate to comprehend the deeper mathematical realities of nature—the objective facts of science. Since Descartes's influential analysis that made a radical separation between mind and matter and formed the philosophic background for classical science, we are further cut off from the objective material cosmos that surrounds us. No wonder Dante is so depressed!

It's fashionable in modern philosophy to criticize Descartes's radical division between the thinking-knowing subject and the mechanical-material universe, including our own bodies. Although it's true that his very influential analysis generated many intractable philosophic problems, nevertheless, Descartes laid the foundation for the philosophic view that guided the development of classical science. Simultaneously, his approach also

initiated what became modern critical and analytical philosophy. Obviously, our debt to him is large. Still, his radical separation of the mind or the thinking subject from nature, or from our body and the world surrounding us, is a deeply troubling legacy. This Cartesian dualism, this legacy of classical science, within which we are both consciously and unconsciously steeped makes understanding synchronicity nearly impossible. Later chapters develop a more unified view of mind and matter, but for now it's enough to recall how influential this split was in the development of science and how it continues to dominate us.

Twentieth-century science significantly modifies the world view of classical physics that is so deeply indebted to Descartes. Despite the modifications of modern science, we are still a long way from Dante's unified and organic universe. Yet, it's within the more complex and troubling modern view—not the medieval one congenial to synchronicity—that we must attempt to understand acausal connections through meaning.

The intellectual hegemony of science is nearly as complete as the dominance of science and technology over religion. For example, the objective mode of analysis, pioneered and extolled by Galileo, so dominates modern thought that if something cannot be objectified and brought into the field of scientific objects—that is, cannot be quantified—then it's either devalued or denied existence altogether. In other words, splitting mind from matter has evolved into a full denial of the reality of any subjective principle. This is a natural outcome of scientism, the belief that we should apply the principles and methods of the physical sciences to all other areas of knowledge. A particularly pernicious outgrowth of scientism is embodied in the slogan, "That which cannot be objectified does not exist." This prejudice is clearly antithetical to such subtle topics as the nature of mind and the archetypal meanings manifesting in synchronicity. Jung was well aware that depth psychology was replete with principles that could not be fully objectified and therefore he developed the symbolic method. With symbolism we can gain knowledge about such principles as archetypes, which in themselves are transcendent to the psyche and inherently unobjectifiable. I know of no person who actually lives by this slogan, "That which cannot be objectified does not exist." Nevertheless, in the next section I show some common embodiments of this sentiment, this excessive allegiance to the god of objectivity.

Excesses of Scientific Objectivity

The success of the approach pioneered by Galileo and others was so dramatic, so enviable, that many other disciplines well beyond physics began to emulate its fundamental assumptions and methodologies. This emulation continues today and there is little doubt that it bears rich fruit. However, significant truths are neglected, if not lost, when we worship exclusively at the altar of objectivity. Neglecting these truths diminishes our ability to understand synchronicity. One-sidedness, whether psychological or philosophical, always blinds us to certain truths, and the problems that follow from this blindness eventually force us to redress the imbalance. Consider two examples of the excess of scientific objectivity from two distinct but related fields: the modern philosophy of mind (the branch

that emphasizes a scientific and biologically oriented study of mind) and artificial intelligence (the science of building complex machines that appear to display human intelligence).

Modern Philosophy of Mind

I'm neither inclined nor able to review the vast modern literature on the philosophy of mind and show its deep commitment to the objective assumptions of classical science. Although not all modern philosophers of mind subscribe to unrestrained objectivism, it's worth looking at one very influential example of modern thinking, the book *Consciousness Explained* by Daniel Dennett.[9] Dennett seeks to provide a full explanation of mind and its higher functions, such as consciousness, solely based on brain functioning—a materialist explanation of mind. For Dennett there is no separate mental principle; all that we consider mental functions are a production of brain functioning.

A critical component in Dennett's explanation is the "heterophenomenology" of mind. This tongue-twisting term just means that we make an inventory of mental phenomena from whatever we or others might report is happening in the mind. We make no judgments and impose no restrictions on the responses of reporting individuals. The verbal text of their reports, including their subjective reactions, is our raw data upon which we impose no theoretical constraints or judgments about what is real. We just let subjects report their experiences without constraints. Based on this data we draw our inferences and make our models of consciousness. As Dennett says, "You can open up subjects' skulls (surgically or by brain-scanning devices) to see what is going on in their brains, but you must not make any assumptions about what is going on in their minds, for that is something you can't get any data about while using the intersubjectively verifiable methods of physical science."[10]

At first glance this may seem like a very liberal and nonjudgmental approach to the study of higher mental functions such as consciousness. Dennett urges us to minimize our theoretical prejudices and stay close to the data reported upon by our subjects. Even if the person reports, "My subjective reaction to this event is . . ." we record it and work on it without prejudging. But a serious problem lies hidden here because Dennett builds a significant theoretical presupposition about objectivity into heterophenomenology. Some of the most profound aspects of mind cannot be verbally articulated; by their deeply subjective nature they cannot be objectified in any way. Yet Dennett wants us to maintain our impersonal third-person perspective and use the "intersubjectively verifiable methods of physical science." In other words, all aspects of mind must be objectifiable.

To dramatize the problem with his approach, I'll briefly sketch a view of mind that cannot be fully encompassed in heterophenomenology. I'll develop this view of mind in more detail in later chapters. Now I ask the reader's indulgence for the sketchy treatment given here. However, for the present purpose we only need to understand some simple ideas about this view of mind to show that a purely objective approach could never adequately comprehend it.

To get a quick taste of a view of mind incompatible with the objective standpoint, consider dreams. Here I'm not interested in the psychological aspect of dreams as symbolic windows into the unconscious, but rather in how they instruct us in the knowing process. That is, I'll consider dreams epistemologically, as hints about how we know what we know.

Imagine a dream in which you are an early Christian being thrown to the lions in the Roman Colosseum. The crowds are roaring, the lions pace malevolently in their cages, and you are contemplating your imminent martyrdom. Again, I am not interested in the possible psychological significance of this dream. Instead, let's investigate the existence or being of the objects in the dream. Everything in the dream, from the bloodthirsty crowds to the growling lions, is a complex of images or thought-constructions in the dreamer's mind. Of course, this is not apparent while the dream is unfolding, but we recognize this truth upon waking. There was neither lion nor Colosseum; everything, despite the vividness while the dream unfolded, is a thought-construction, a creation in the imagination. What is more, any dream subject such as the trembling Christian, including her most intimate thoughts and feelings, are also images or mental constructions. In short, all subjective and objective phenomena in the dream are nothing but thought creations—complex images in the mind.

While the dream is occurring, it's a complete or self-contained world. Let's not complicate matters by considering so-called lucid dreams, where dreamers are at least partly aware they are dreaming and can control or distance themselves from the dream. Instead, imagine that in this normal dream the Roman centurion asks you, the imminent martyr, if there is another world or state of consciousness besides the one you are experiencing in the Colosseum. You might try to imagine such a world or state, but the very act of thinking about it incorporates it into the ongoing dream. As the dream proceeds, it's totally inclusive. There is no outside. Anything considered outside by the imminent martyr is clearly part of the dream.

Now let's imagine that *in the dream,* just before the lion tears you apart, the scene suddenly switches to Daniel Dennett explaining that you are part of a philosophy of mind experiment. He tells you that in fact you were really experiencing a computer generated virtual reality, one full of vivid sights and sound, but one totally composed of computer-controlled signals. You are surprised and relieved. Then Dennett asks you to report everything you experienced, all the subjective reactions you had as well as the details of the lion and so forth. He wants a full heterophenomenological report. (All this is still part of one dream.)

I hope it's clear that no matter what account you as the dream subject give dream Dennett, there is no chance that the dreamer's mind, the principle that created the entire drama out of its own substance from lion to imminent martyr to dream Dennett, can be part of the heterophenomenological report. Yes, all the contents, all the objects, subjects, and their relationships appearing in the report are expressions of the dreamer's mind, but that mind itself, that consciousness that manufactured the entire dream, that projected it all into spacetime existence, can never be an objective content, never an element in heterophenomenology. Simply put, we can never fully objectify the dreamer's mind, the

consciousness unfolding as the dream. So what chance does a purely objective approach have of truly understanding the mind that brings all objects and subjects into being?

Along with many schools of thought, both in the East and in the West, let's entertain the possibility that such an idealistic view of a mind holds for waking consciousness too. In other words, let's consider the idea that all experiences, both subjective and objective, both in waking and in dream, are nothing other than a complex set of images or thoughts in a larger mind. I'm not suggesting that waking experience *is* a dream, but that *it's like a dream because it's totally an experience in thought,* and nothing but thought. Yes, objects exist outside my body, but both my body and the world it interacts with are thought into being by some mind more encompassing than my individual personality. Even my personality or my individual identity is a complex series of thoughts in this more encompassing mind. Then in perfect analogy with the dream example, some larger mind thinks our experience, including our psychology and body, into being. Then such a larger mind can never be objectified, since any attempt to do so would only generate more thoughts within this larger mind. Whether this view of mind appeals to you or not it must be admitted that only the *expressions* of such a mind, the outer or objective manifestations, could ever be a content of a heterophenomenological report. Much more needs to be said to justify the possibility of such a mind and answer the many questions raised by introducing it. I'll attempt that in later chapters. Now it's enough to appreciate that the essence of this cosmic intelligence manifesting as my inner and outer world is never objectifiable and can never be comprehended by an objective analysis. Such a mind can be verbalized, spoken *about,* but never fully objectified and consequently never "explained" as in Dennett's *Consciousness Explained.*

Artificial Intelligence

Not that I have done justice to Dennett or allowed for a rebuttal from his camp. Nevertheless, I want to turn briefly to another example of how powerfully the objective attitude of classical physics bewitches modern thinking. This example comes from artificial intelligence (AI), a field allied with the modern philosophy of mind, which seeks to build complex machines that mimic human intelligence. Some controversy exists about how successful such an endeavor can ultimately be. The more optimistic branch of AI believes that a sufficiently powerful and complex machine can mimic anything we might consider human intelligence. This idea smacks of materialist reductionism. Simply put, this means that since chemistry and biology are just complex arrangements of matter, then psychology, which they believe is essentially electrochemical processes in the brain, should also be reducible to material process. These material brain processes are fundamentally computations. Therefore, we can in principle build a computing machine at least as intelligent as a human. From this perspective the brain, equivalent in its functioning to the mind, is nothing but a "computer made of meat."[11]

AI uses the famous Turing test to define human intelligence. The modern version of Alan Turing's idea is to imagine a human subject with a computer screen, speaker,

microphone, keyboard, and pointing device. We then allow the subject to use all this equipment in any way she wishes to pose questions and interact with a machine connected to this equipment, but out of sight in an adjoining room. If the human subject cannot tell through an arbitrary series of subtle and complex interactions whether it's a machine or a human in the adjoining unseen room, then AI researchers claim that the machine has fully mimicked human intelligence. The belief that they can eventually build machines to do this is referred to as the Strong AI Hypothesis. Given the power of today's machines and those just on the horizon, along with the progress already made in this young science, the Strong AI Hypothesis seems eminently reasonable to many researchers.

In the Strong AI Hypothesis, just as in heterophenomenology, there is a commitment to objectivity that precludes studying the deepest and most fundamental aspects of conscious subjectivity or of intelligence. Even if we ask the machine the most ingenious questions and it's intelligently built to give us subtle and human-like answers, we have no direct evidence for a conscious inner life, for the ineffable experience of subjective awareness at the root of intelligence and human consciousness. The objective mode can never grasp this central fact. Introspection (much maligned by the scientific method) is the only avenue to a direct investigation into the deeper levels of subjectivity. Yes, books and even AI machines can help our search, but the direct, living experience of the core of conscious mind, of subjective awareness, is only available to immediate introspection. Such introspection knows not by objectification but by union, by becoming what it knows— the aim of most advanced meditation techniques. An explanation or a definition of mind that neglects its unobjectifiable core cannot fully explain consciousness or the intelligence that expresses it. Of course, the mind undisciplined in the art of concentration, the holding of one thought to the exclusion of all others, cannot properly undertake such an introspective study. Yet, even the best trained mind cannot do the investigation if only the objective methods so successfully employed in classical physics are used. Consequently I believe, along with Erwin Schrödinger, that the current objective methods of science will never find the true conscious subject.[12] Worse yet, the blind allegiance to objective methods conceals and even denies the very existence of such a subject.

Constellating the Opposite

Jung teaches us that any time we identify too exclusively with one member of a pair of opposites we inevitably constellate the other. If, for example, we cultivate only the masculine side of the male-female polarity, then the female side will inevitably and insistently make its demands on us. Usually the neglected member of the pair of opposites erupts with primitivity if not violence, with poorly adapted and undifferentiated affect-laden contents over which we have little control. The assimilation of the neglected member of a pair of opposites is at the center of individuation. The problem of opposites, their differentiation and synthesis, was at the core of Jung's work.

As I have tried to sketch in this chapter, the scientific revolution has given us a new and profound appreciation of the value of objective knowledge. Unfortunately the

pendulum has swung too far from a balance between objectivity and subjectivity. Our culture has emphasized the objective side of the objective-subjective pair of opposites so heavily that we have relegated subjective principles to an inferior status, to a lesser reality. If Jung is correct, then the suppressed member of the pair must manifest itself and often in an inferior and painful way. I think it's reasonable to interpret some of the passion for religious cults and certain unsophisticated "new age" thinking as a primitive eruption of the subjective side of the psyche. But just as in individual psychology, when the neglected member of the pair erupts to insist on its assimilation, upheaval and even destruction of what has been previously established through hard work can occur. In other words, when the subjective side of our nature insists upon its rights then objectivity and all associated with it can suffer devaluation and destruction.

Any enterprise as important as science deserves constant and thoughtful criticism. Some criticism is both responsible and penetrating. On the other hand, some criticism seems like an emotional expression of a primitive demand for assimilation of a long neglected member of a pair of opposites, here the need for appreciating the value of the subjective. Although it would take me too far from my primary goals to explore in detail these varied criticisms of the objective mode, let me give one particularly instructive example.

One of my heroes, Vaclav Havel, fearless political dissident, host of the Dalai Lama, poet, playwright, and lately President of the Czech Republic extols the subjective and strongly criticizes our worship of objectivity, especially in science. In the March 1, 1992 Sunday edition of the *New York Times*[13] Havel wrote an article entitled "The End of the Modern Era," in which he says:

> The fall of Communism can be regarded as a sign that modern thought—based on the premise that the world is objectively knowable, and that the knowledge so obtained can be absolutely generalized—has come to a final crisis. This era has created the first global, or planetary, technical civilization, but it has reached the limit of its potential, the point beyond which the abyss begins. The end of Communism is a serious warning to all mankind. It is a signal that the era of arrogant, absolutist reason is drawing to a close and that it is high time to draw conclusions from that fact. . . .
>
> Traditional science, with its usual coolness, can describe the different ways we might destroy ourselves, but it cannot offer us truly effective and practicable instructions on how to avert them.
>
> . . . We treat the fatal consequences of technology as though there were a technical defect, that could be remedied by technology alone. We are looking for an objective way out of the crisis of objectivism.

After further delineating what Havel calls the "crisis of objectivism," he suggests that politicians must "lead the way" toward a solution. I have difficulty imagining politicians taking the lead in the spiritual transformation advocated by Havel. Nevertheless, he says,

> Soul, individual spirituality, first-hand personal insight into things; the courage to be himself and go the way his conscience points, humility in the face of the mysterious order of Being, confidence in its natural direction and; above all, trust in his own subjectivity as his principal link with the subjectivity of the world—these are the qualities that politicians of the future should cultivate.

Although much of Havel's counsel is wise and uplifting, when he advises the politician to "above all, trust in his own subjectivity" we can clearly see a repressed member of a pair of opposites demanding its rights in a primitive and inferior way. For any person, especially politicians who are under immense pressures, merely to trust their own subjectivity without adequate self-knowledge and self-reflection is a recipe for all sorts of excesses, evils, and errors. I agree with Havel that we have overemphasized objectivity, but an unreflective appeal to a politician's subjectivity can hardly be the way to redress the balance.

Havel's denunciation of science and his set of prescriptions for reform in a newspaper that finds its way into the hands of many scientists in America raised some hackles. In August 1993 it was the centerpiece of a rejoinder in *Physics Today*, the Journal of the American Institute of Physics, by the well-known physicist Daniel Kleppner who comments upon Havel's remarks by saying, "It is absurd to argue that the fall of Communism is a sign that modern science ('the premise that the world is objectively knowable') has brought us to a final crisis. The fall of Communism is a sign that a self-perpetuating tyrannical regime dedicated to the suppression of freedom can sustain neither a viable economy nor a decent society."[14] I agree with Kleppner that Communism fell because of its tyranny and economic contradictions, but Havel still has a valid point. After all, Communism is firmly built on dialectical materialism, a perverse application of classical physics with its commitment to objectively existing realities.

It deeply disturbs Kleppner that Havel's ideas have been taken up by Congressman George E. Brown, Jr., Chairman of the Committee on Space, Science and Technology of the United States House of Representatives. Congressman Brown's article "The Objectivity Crisis" in the September 1992 issue of *The American Journal of Physics* pays homage to Havel's ideas and uses them as a springboard from which to reconsider the role of science in society. What formerly may have been seen as merely an intellectual dispute about the level and extent of objectivity in modern science, has now become a central issue in science funding policy-making at the highest levels of government. The anti-objectivity and anti-science sentiment is now translating into funding policy—something that arouses even the least philosophic physicist.

I'm firmly in favor of both criticism and reevaluation of science in society. My point however, is that much of this criticism, and especially its emotionality and the uncritical call to subjectivity, is really coming from the insistent need to revalue and reestablish the subjective pole of experience. Our collective soul cries out for a more balanced attitude toward the subjective, the victim of uncritically applying the objective attitude to all aspects of life—scientism. Because of the severity of our unbalance this cry is often anguished, primitive, compelling, and unreasoned. How else could it break through our unbalanced conscious attitude and be fulfilled?

Our challenge is to answer this need for appreciating anew the subjective without diminishing the values, virtues, or accomplishments of the objective, and especially its prime example—modern science. It's silly to think that merely studying synchronicity

can do this. Nevertheless, synchronicity involves a unique interplay between the objective and subjective factors, between the world of fact and the world of meaning and subjectivity. Understanding how the objective world and the subjective world can be united through an acausal connection of meaning may help us move toward a more comprehensive, a more whole, attitude toward the primal dualism of subjective and objective. I'll try to honor this goal of reconciling the demands of these primal opposites throughout this book. With this in mind, let's examine some synchronicity examples that remind us of the formidable task we have of understanding them within a modern scientific world view.

Synchronistic Interlude 1

Recognition and the Self

I was in my middle forties, separated from my local professional organization, happy with my work and my family, but feeling that I had not achieved the professional recognition I had expected. After working on this problem without much success, I got on my bicycle, as I often did, and rode up to Mulholland Drive, hoping that a long ride through the hills would soothe my spirits. After some minutes, I was feeling a bit better, and then I suddenly saw an old chum from high school, walking with his dog. He had become famous in my field and was living in high style. I stopped to chat with him. He told me a story of discontent with his marriage and his subordinates and of being cheated in a European country where he had a second headquarters. As he spoke, I realized how lucky I was, on many counts, and how shallow were his contacts, his concerns, and his life. All the same, I felt empathy for him and grateful that I had thus met him, in "meaningful coincidence" during the difficult reflections I had just been going through. I left him and continued on my ride, feeling better, but still pained at my professional aloneness, my lack of recognition.

Some fifteen minutes later, I came face to face with a large buck deer. Now, I had occasionally seen deer in the hills of the area, but only when I was walking in them, and never on a road. Neither had I ever seen a buck like this with large antlers and an imposing presence. I got off my bike again and simply stood there, staring at the stag and deeply moved at his grandeur and serenity. Moved by his presence, I bowed slightly to him and—was I right?—he seemed to bow back! I even imagined a kind of crown on his head. After a few moments, he walked slowly off the road and back into the hills and I was again feeling right and whole.

19. A stag in the suburbs

The meaning, for me, of the above encounter, was not only the relativization of the value of fame—given to me by the encounter with my old high school friend—but, even more so, the vision of the buck. He lived in the midst of the city, alone and apart from all human strivings, in dignity and in harmony with Nature and Nature's God. It gave me the sense of dignity, contentment, and even a bit of grandeur in going my own way. With both the friend and the deer, it felt like a true synchronicity.

The unconscious compensation in this experience, that there are more important things than collective recognition, that individuation sometimes involves estrangement from community values, is delivered here by a majestic stag, an ancient and well-known symbol for the self.

Let me briefly amplify the stag symbolism. As our protagonist says, "I even imagined a kind of crown on his head." The surroyal or crown antler fully forms on the male deer after its fifth year, after which time it's known as a hart. We read in the Old Testament, in Psalms 42:1: "As the hart panteth after the water brooks, so panteth my soul after thee, O God." Here the hart symbolizes our thirst for divinity. It powerfully reminds him of the importance of the living waters of the self, especially in contrast to "my professional aloneness, my lack of recognition."

Since this synchronicity story is so concise, I would like to add another by the same person. Here we will see some themes that overlap with the above example.

Synchronistic Interlude 2
Appreciating Community

As my thirtieth birthday approached I was in Zurich beginning my studies at the C. G. Jung Institute as I had longed to do for many years. I had several weeks of analysis and was well into it. Then I dreamed of observing a marvelous ant colony and being deeply impressed with its structure, devotion, and the hard work of the ants. The next day, before I arrived at my analyst's office, I sat on a park bench, thinking that I would do some active imagination with this dream. As I began, however, a whole line of ants began to walk across my dream book. That struck me of course, since it was extremely unlikely for such an event to take place in that way. When I went up to my analyst's office—it was now spring time—we went out on his porch to work. His apartment/office looked out over a wooded area, though it was in the midst of the city. As I started to read this dream to him, he said, "Look here!" Several ants were walking along the little table between us. He had never had such an experience with ants before.

My understanding of this event was that here I was in a marvelously *whole* place for me. I had experienced "community" only in my summers at camp, from ages 10 to 16. Now I felt spiritually, emotionally, and physically united, not only with the beauty of this European city, Zurich, but also with the great variety of foreign students at the Institute and the tremendous depth and scholarship of the faculty. Besides that, I was again about to delve deeply into my soul, something I did not do for the past two years while in the army. So those years in Zurich brought me the only other experience of union with both an inner and outer life of community (like the ant colony). It also brought me the hard work and devotion to the "higher cause" that I cherished.

Professionally and personally this person has struggled throughout life with the joys and sorrows of being both included and excluded from community. Relationship to community is a theme that finds its way even into many of his professional publications. This memorable synchronistic experience early in the training analysis (in his professional childhood) was like a powerful childhood dream that enunciates a theme that organizes the entire life. The synchronicity experience symbolizes the theme in both the inner and outer worlds through one of the most highly organized and industrious forms of community on the planet—ants. An isolated ant is an impossibility. Unlike a stag, which upon reaching maturity can live entirely on its own, an ant's very survival depends entirely upon the community and the role it plays within it.

6 Causality and Acausality in Nature

On his side, Einstein mockingly asked us whether we could really believe that the providential authorities took recourse to dice-playing (". . . ob der liebe Gott würfelt"), to which I replied by pointing at the great caution, already called for by ancient thinkers, in ascribing attributes to Providence in every-day language.

Niels Bohr[1]

Lawfulness, Chance, and Destiny

Lawfulness, chance, and destiny—topics of special interest in this book—find a particularly powerful expression in the *Mahabharata,* the longest, and to many eyes, the world's greatest epic poem. This ancient epic is more influential in India than even *The Divine Comedy* is in the West. In any Indian hamlet you could randomly select several people each of whom could tell you long tales from the *Mahabharata.* This Indian classic, filled with gods, extraordinary mythological beings, love, battle, wisdom, and mysticism, is the poetical history of humankind. In it the Pandava brothers, sired by gods, rule the earth in a golden age until cheated out of their entire kingdom in a game of dice. After years of forest exile they regain their kingdom in a Pyrrhic victory, in which rivers of blood flow on both sides. This titanic struggle is immortalized in the *Bhagavad Gita,* surely the greatest piece of Indian religious-philosophic writing. I see the entire *Mahabharata,* including the *Bhagavad Gita,* as the clash of the great triumvirate of lawfulness, chance, and destiny.

Lawfulness appears throughout the epic. It is codified in the Indian idea of *karma,* expressed in Christianity by, "As you sow, so shall you reap." Karma is the moral equivalent of the causality or determinism found within classical mechanics—the mechanics of Galileo and Newton. In classical mechanics, inflexible laws bind all nature, decreeing the precise outcome of all evolution. In fact, for many, the notion of law presumes strict causality or determinism. In the *Mahabharata,* the inexorable engines of karma propel all the characters throughout the epic, punishing the evil and exalting the noble. The king of kings, the head of the Pandava clan, is an avid upholder of lawfulness.

Despite the king's love of lawfulness or causality he repeatedly succumbs to his only weakness—games of chance. In games of chance the outcome is entirely unpredictable, acausal, like a quantum mechanical experiment. In the West, except for Native Americans, we have no myth of comparable stature to the *Mahabharata* involving games of chance. Instead, our youths show their reverence for the principle of chance by hanging dice from their car's rear view mirror as they struggle against the lawfulness imposed upon them by parents and society. Thus, in both the East and the West, we find lawfulness and chance forming a primordial pair of opposites. The king's behavior reminds us again that any excessive identification with one side of a pair of opposites always constellates the contrary side—here his helpless addiction to gambling, his worship of chance.

The interplay of the opposites is essential to individuation, to becoming whole, to fulfilling our destiny. This third great principle of the triumvirate, destiny, compels the king to involve himself in games of chance. The king's enemies arrange a dice game, his favorite, the Gate of Paradise. Through the dice game and with the help of cheating enemies, he loses his entire kingdom. Everything is lost—all his wealth, his own freedom, and even the beloved wife of the five brothers. Destiny decrees the return of the five sons, the wife whom they all share, and their freedom. Yet both destiny and karma compel the king to risk all a second time in yet another game of chance. He reasoned that he must give his enemies, the cheaters (those who break the law while playing games of chance), a second opportunity. Otherwise, his enemies have no opportunity for redeeming themselves from the horrendous fate awaiting them through the relentless agency of karma. He loses the second game and suffers many years of exile in the forest with his brothers and their wife, after which the three great principles—lawfulness, chance, and destiny—play themselves out on the blood-drenched battlefield.

Earlier chapters discussed the principle of destiny through Jung's idea of individuation; here I examine the great principle of lawfulness or causality in classical physics and discuss how our intellectual servitude to causality makes it nearly impossible to appreciate the other great principle, acausality, in either quantum mechanics or synchronicity. Just as the *Mahabharata* has permeated all areas of Indian culture, so too have the ideas from classical physics permeated the collective psyche in the West. While the Indian reverence for the *Mahabharata* with its prominent games of chance makes it clear how much they appreciate acausality, we are largely unconscious of our idolatry toward determinism or causality. Yet a little thought shows how our Judeo-Christian heritage with its political outgrowth of Roman Law found a powerful incarnation in the causality of classical physics. Our worship of causality is so powerful and largely unconscious that it is very difficult to free ourselves from it to consider acausality seriously. It is difficult to entertain the possibility that there is no well-defined cause or set of causes for each event—that "God does play dice" or that psychological events may connect through acausal meaning as Jung maintained.

Our excessive Western identification with the causality side of the causality-acausality pair of opposites results in our powerful emotional reaction and resistance to acausality in quantum mechanics and synchronicity. Just as the king's excessive love of lawfulness

contributed to his gambling addiction, our obsession with causality requires us to come to grips with acausality in quantum mechanics and synchronicity. As Jung says, "What Kant's *Critique of Pure Reason* failed to do is being accomplished by modern physics. The axioms of causality are being shaken to their foundations.[2]

As I stressed in discussing Dante's cosmology, connecting synchronicity closely to any science guarantees the obsolescence of the analysis, since science is constantly evolving. For example, Jung repeatedly speculated that there were profound connections between depth psychology and quantum mechanics. If I were to substantiate his speculation

Photo by Victor Mansfield.

20. The god Ganesh, scribe for the Mahabharata

through detailed analysis, what becomes of it all when a more comprehensive theory replaces quantum mechanics as it inevitably must? Would we be any better off than Dante with his geocentric view of the universe? If we are to avoid having the analysis become obsolete, we cannot build intellectual sand castles that dissolve in the incoming tide of new scientific development.

However, in the last decade or so it has become possible to do what the distinguished physicist-philosopher Abner Shimony[3] calls "experimental metaphysics," to perform laboratory and related theoretical analysis of metaphysical principles, *independent of any formulation of quantum mechanics.* That is, we can now determine if nature embodies certain metaphysical properties so that they must occur in *any* empirically adequate theory of nature, now or in the future. Such an extraordinary and unprecedented breakthrough has occurred because of the theoretical and experimental developments surrounding Bell's Inequality—work resulting from Albert Einstein's lifelong criticism of quantum mechanics. This chapter provides some historical and philosophical background for the Bell Inequality analysis developed in detail later.

Causality in Classical Physics

There are two great intellectual streams in physics. The first and oldest stream is classical physics. Galilean-Newtonian mechanics is the headwaters for this stream with thermodynamics and electrodynamics forming major tributaries. This great river carried us through the industrial revolution and culminated in Einstein's general relativity.

Newton dazzled the intellectual world with his mechanics, a theory that quantitatively predicts the detailed fall of apples, the moon's orbit around the earth, and the presence of unseen planets. It provides the intellectual support for the rest of classical physics, and its view of causality, more properly determinism, has burned itself into our collective psyche. In Newtonian mechanics, separately and independently existing objects act upon each other in a fully predictable way. A well-defined agent invariably and predictably produces a well-defined effect. Whenever the proper conditions and causes occur, the effect must always follow and the effect is not produced without the cause. Bringing pure liquid water to a temperature lower than zero degrees Centigrade always causes the water to freeze and freezing does not occur unless its temperature is below zero.

In Newtonian mechanics, the most fundamental entity is the objectively existing indivisible point particle. If we know the position and velocity of a group of point particles at some time (the initial conditions) and the relevant forces among them, then the theory precisely predicts the future evolution of the system. Classical physics fully embodies determinism—that the same initial conditions and forces always give the same evolution. For a long time, the determinism embodied in classical physics was considered the paradigm of science and the goal of all scientific explanation. In fact, for some, deterministic theories are still considered the proper goal of science.

Pierre Simon de Laplace, a titan of theoretical physics and mathematics, was second only to Newton among the stars of classical science. He deepened and extended Newton's

work on mechanics and removed all the known ambiguities and anomalies of Newtonian theory, thereby greatly enhancing belief in its soundness. Laplace presented his treatise on celestial mechanics to Napoleon Bonaparte. The emperor, an accomplished mathematician himself, asked why the book contained no reference to God. Laplace told Napoleon, "Sir, I have no need of that assumption." Before Laplace, as mentioned in the previous chapter, the great natural philosophers understood the world to be like a gigantic clock, made and set into majestic motion by God, the great clockmaker, and then allowed to run along under its own laws. The clock metaphor was the defining technology of the day and humanity has always seen fit to envision nature, and especially itself, through the reigning technology.[4]

Today we model the brain and cognition using the computer, also deterministic in the classical sense—given the same initial input data and algorithms, the computer always evolves to the same state. This inanimate and deterministic model of the brain, which for its proponents is synonymous with the mind, is surely the modern and completely fashionable counterpart to the clock. Although there were immense philosophic and theological difficulties with this Newtonian clockwork universe and its relationship to the divine, it was still very influential. Laplace saw that it was only a small step in this model to do away with the clockmaker, with God, who had provided meaning and succor for the medieval mind.

Laplace drove home his point about causality in Newtonian mechanics with memorable force:

> We ought then to regard the present state of the universe as the effect of its anterior state and the cause of the one which is to follow. Given for one instant an intelligence which could comprehend all the forces by which nature is animated and the respective situation of the beings who compose it—an intelligence sufficiently vast to submit these data to analysis—it would embrace in the same formula the movements of the greatest bodies of the universe and those of the lightest atom; for it, nothing would be uncertain and the future, as the past, would be present to its eyes.[5]

Laplace did not want to establish a vast godlike cosmic intelligence "behind the clock." He only intended to make a point of principle—that the model of a rigidly deterministic clock embraced the entire world, including all the individuals contained within it. For this imaginary supercomputer, "nothing would be uncertain and the future, as the past, would be present to its eyes." At one stroke, he demolished free will. Even our discomfort with the lack of free will is determined. We only have the illusion that there is genuine choice, but that too is a complex product of the deterministic laws of nature. The monster of determinism let loose by classical mechanics had devoured the cosmos.

Today most of us have a more subtle view of causality, in part because the monster has had his fangs removed by the indeterminism of quantum mechanics. Even within classical physics, the new study of chaos[6] shows that quite simple mechanical systems are in practice indeterministic. Thus, despite Laplace's tremendous influence, he was deeply mistaken. Nevertheless, just judging from the resistance many modern physicists have toward acausality, determinism clearly holds sway to a surprising extent. From a

psychological point of view, this follows from its archetypal nature. The mind is predisposed to conceive of a deterministic world as the quintessential act of reason. Kant, deeply influenced by Newtonian mechanics, argued that causality was a fundamental category of thought employed in every act of thinking. In other words, just as the mind must put its perceptions into space and time, so too must it employ the category of causality. Is it any wonder that with this classical heritage and psychological predisposition we resist noncausal theories such as quantum mechanics and synchronicity? Should it be a surprise that we resist thinkers like Jung and Niels Bohr who attempt to erect acausality as complementary to causality?

Acausality in Quantum Physics

The other great intellectual stream in physics is quantum mechanics, with its headwaters being the nonrelativistic version developed by several workers in the late 1920s. This stream's major tributaries are relativistic quantum mechanics, quantum statistics, various quantized field theories, and so on. This river spawned the technology for the communications and information revolution of our present era. Strictly, my river metaphor breaks down a bit here, because quantum mechanics grows out of and extends classical physics. Nevertheless, because the quantum mechanical world view is so different from that of classical physics, considering the streams as separate is still reasonable and worthwhile.

As we'll see in the next chapter, Jung claimed that relativity theory, which is a part of the classical stream, was an important inspiration for synchronicity. Even more important to Jung's formulation of synchronicity was his appreciation of the noncausal nature of quantum mechanics. This understanding came to him through his long and intimate relationship with Wolfgang Pauli, a primary developer of quantum mechanics. In fact, the first publication of Jung's synchronicity essay, in both German and English, was combined with Pauli's essay on archetypal thinking in Johannes Kepler in their joint book entitled *The Interpretation of Nature and the Psyche*.[7] In his

21. Wolfgang Pauli

synchronicity essay Jung warmly acknowledges important discussions he has had with Pauli on "questions of principle."[8]

Jung begins his synchronicity essay by discussing acausality in quantum mechanics and returns to parallels with physics throughout his essay. His discussion illustrates both the influence of quantum mechanics upon him and his lack of clarity about the fundamental issues in physics. Rather than point out his particular misunderstandings, I'll simply discuss acausality in modern physics.

From its inception in the late 1920s, quantum mechanics always denied determinism. At the quantum level, which is usually the atomic level and below, causality as envisioned by Newton, Laplace, Kant, and so many others simply does not hold. (Now we know quantum mechanical effects are significant even for macroscopic systems and we are now applying quantum mechanics to cosmology, the study of the structure and evolution of the entire universe.) For an example at the nuclear level, consider a radioactive nucleus. Quantum theory cannot say when the decay of a particular nucleus will occur. The theory claims that *in principle* it is not possible to know when an individual decay will occur. There is no deeper level wherein lies the secret time of a nuclear decay. The statistical average of how many decays occur in a given time, summarized in the half life, is all we can ever know.

This forced renunciation of determinism for individual events is a revolutionary idea, especially in light of classical physics. Rationality recoils at the idea that *in principle* a causal explanation cannot be found. This violates the Western devotion to rationalism, the foundation for science and analytical thought in general, whether in philosophy or literary criticism. We ask: How could there not be some mechanism, some physical process at a deeper or more comprehensive level that holds the secret of why the particular nucleus decayed then?

Largely because of his association with Pauli, Jung became keenly aware of what a significant development the abandonment of strict causality meant in the history of ideas. For example, the physicist who began the quantum revolution with the discovery of the discrete nature of electromagnetic radiation, Max Planck, said, "Once we have decided that the law of causality is by no means a necessary element in the process of human thought, we have made a mental clearance for the approach to the question of its validity in the world of reality."[9] Jung realized that physics cleared the way for considering acausal processes in other areas of human experience. Quantum mechanics now liberates us from slavery to Newtonian causality. Rather than causality being understood as an inviolate law of nature, we could now see it as one way—but not the only way—of organizing our understanding of the world. Or in Niels Bohr's words, "Causality may be considered as a mode of perception by which we reduce our sense impressions to order."[10]

Despite these statements from leading lights in physics, for many people acausality is still repugnant to their deepest beliefs about the nature of the world (or, we now know, our most dearly beloved projections upon the world!) and several prominent scientists violently resist the idea. Einstein is famous for believing that acausality is not a fundamental fact about nature, but is some limitation, some incompleteness, built into

our present formulation of quantum mechanics. His much quoted "God does not play dice" is both a reaffirmation of his worship of rationality and a repudiation of the present formulation of quantum mechanics.

This powerfully held set of commitments motivated alternatives to standard quantum mechanics—so-called hidden variable theories that postulate a deeper layer of reality. At this deeper level, for example, nature supposedly specifies the exact time of a nuclear decay. Poetically we can imagine that at some deeper level a little timer is set, telling exactly when a given nucleus will decay. The reasoning is that our present version of quantum mechanics does not have access to this level and so it can only give us averages of these little timer settings. This view holds that in principle, the time of a decay is well-defined and exists objectively within nature.

The relationship between classical thermodynamics and statistical mechanics inspires this kind of thinking. Thermodynamics concerns itself with such macroscopic quantities as pressure, temperature, and energy of a gas and gives no details about any possible deeper level structures. In contrast, statistical mechanics focuses on the detailed statistical properties of the population of particles making up the gas. For example, statistical mechanics pays much attention to the distribution of velocities of the particles in the gas— what fractions of the particles have what velocities. From these velocity distributions, we then derive the macroscopic quantities in thermodynamics from averages over well-defined states of large numbers of particles. Let me caricature both classical physics and the social sciences by saying that thermodynamics is like the sociological approach where the emphasis is upon group behavior with no deep concern for individual psychology, while statistical mechanics is like psychology that explains both individual and group behavior by focusing on individual properties.

The argument for these alternatives to standard quantum mechanics is that our present theories are, like thermodynamics, an average over more fundamental and "hidden" variables that have a precise, objective value in nature. These hidden variable theories attempt to reinstate both causality (determinism) and quantum objects as existing with well-defined properties completely independent of measurement.

But thanks to recent work we now know Einstein and many others were simply wrong. No deeper layer of nature exists with both determinism and independent existence. This is not merely a limitation upon our present formulation of quantum theory. This must be so for any empirically adequate theory of nature—now or in the future. The gods of rigid rationality are in retreat. At the quantum level no well-defined cause exists for why an atom decays at one time, and one can never be found. There is no "relativity" of the laws involved as Jung would say. No law for individual events exists. What an affront to the Judeo-Christian worship of reason!

Einstein's great criticism[11] of the conceptual foundation of quantum mechanics began with his challenge in 1927. In 1935 Einstein, Podolsky, and Rosen wrote a powerful critique of quantum mechanics.[12] Niels Bohr,[13] the single most influential voice in the interpretation of quantum mechanics, quickly rebutted this paper and generally most physicists agreed with him in what became the standard interpretation of quantum mechanics. But some

22. Niels Bohr

of the most important founders of the science such as Schrödinger and De Broglie still agreed with Einstein. Judging from the volume of papers on the interpretation of quantum mechanics and the intensity of the debate, the key issues are not yet fully resolved.

Distinguishing Chance and Acausality

Although chance and acausality are often used interchangeably, they truly refer to very different ideas and sets of commitments. Here I'll make my distinction between chance and acausality in both physics and psychology. First, take physics. If we flip an ordinary coin ten times in a row there is only a 1 in 1024 chance that ten "heads" will come up in a single sequence of ten flips. (This follows because $(1/2)^{10} = 1/1024$ is the probability that exactly ten heads in a row will turn up.) Let's say a classical physicist comes into my office and flips a coin ten times in a row and they all came up heads. He says, "It was by chance." He means that if we could investigate in detail the exact way the coin was flipped—exactly how it was spinning, the air currents in the room, any defects in the coin's structure, and so on—we could causally explain exactly why ten heads came up. It was an unusual set of combinations of events that causally generated the unlikely run of heads. It was just chance. So we see that implicit in the usual use of the word *chance* is a deep commitment to causality.

Next a quantum physicist, a proponent of acausality, comes into my office with a Geiger counter, a device that detects the naturally occurring radioactivity in the concrete walls and the ground beneath the building. He says that no amount of investigation can reveal, in principle or in practice, the exact time of individual decays. No specific cause or causes for individual events exist. They are acausal. His view involves no implicit or explicit commitment to causality.

In physics, saying that something happens by chance just means we are ignorant of the underlying causal mechanism. Sometimes our ignorance of the details is expressed in probability statements as with the coin flipping example. But when we say that quantum events are acausal, we mean that no underlying causal structure can account for the individual event. It's true that probability statements are also used in these contexts. However, here probability just gives the average results expected from a large number of identical measurements. For example, if an identical system were repeatedly prepared and measured in an identical way then a very large number of measurements would, in the limit, be given by the probability distribution. In quantum mechanics probability is not merely an expression of ignorance of causal details, but is the maximum we can say about the system.

Let's turn to the psychological use of these terms. In using the word *chance* as in "it was a chance coincidence that the scarab beetle banged on the window while the woman was telling Jung her dream," there is an implicit or hidden commitment to causality. The implicit belief is that causality fundamentally governs both the beetle and the woman and that it was just an unusual coming together of independent circumstances at that unique moment that produced what Jung called his paradigmatic example of synchronicity. A classical physicist would be happy with this interpretation. He would say that it was just a more complex example of getting ten heads in ten coin flips—just an unusual combination of causal events.

When Jung, however, says that the scarab beetle experience was acausal, he means no causal explanation for the event is possible (either vertically or horizontally). In this sense he parallels the quantum physicists. But, when he also says that synchronicity is an acausal expression of meaning there is an implication of a final cause or some teleology. Of course, since Galileo's time we have abandoned final causes in science so here is a clear difference. Therefore Jung can draw intellectual inspiration from quantum mechanics, especially its unchaining us from strict causality, its freeing us from exclusive servitude to determinism. However, if he goes farther than this he cannot directly call upon acausality in physics to guide his understanding of synchronicity. Simply put, no physics, classical or quantum mechanical, can give us a complete understanding of synchronicity. Yet, both relativity and quantum physics can help prepare us to understand the mystery by freeing us from bondage to absolute views of spacetime, causality, and an excessively objective attitude toward nature—all legacies from classical physics.

A Quantum Parallel with Archetypes in Synchronicity

In quantum mechanics the mathematical structure that gives the maximum information we can have about the system is the wave function, Psi (Ψ). The equations of quantum mechanics, such as the Schrödinger Equation, govern how Ψ evolves with time for a given system. Ψ acausally relates to events in spacetime. It does not in any way cause either individual events or series of events, yet the absolute value squared of Ψ

gives the probability distribution for any possible measurement. Although Ψ is much more abstract than an ordinary wave such as a water wave, because it shares many mathematical similarities to waves, we often refer to Ψ as the wave function, or as a probability wave. It does not refer to objective spacetime entities, but to the possibilities or probabilities for objective events to occur in a measurement. Although Ψ does not cause events, since there are no causes for individual events, it is acausally related to the individual events since it is the underlying probability structure or order manifesting in all events. Verifying the theory involves making a large number of identical measurements and comparing these results with the probability predictions derived from Ψ. Though Ψ represents the maximum specification of a system, we can never directly measure it. In summary, we never directly observe Ψ, the maximal specification of a quantum system. Instead it is an acausal probability structure referring to possibilities for measurement.

In Jung's depth psychology, the archetypes are the most fundamental structures. They give us the essential meanings and they structure our behavior and thoughts. Besides providing meaning, the archetypes can act causally in some psychological phenomena— although not in synchronicity experiences. For example, we could say, "The mother archetype transformed the woman's thoughts and actions." However, we never directly experience the archetypes, since they are universal and transcendent principles, yet they live themselves out through us. We imply the archetype's existence by transcultural studies of mythology and ritual along with the innumerable dreams of people throughout the world. In other words, from numberless indirect experiences with the archetype we imply its nature, despite that we can never directly experience it in itself.

The role of the archetype in synchronicity parallels the role of the wave function, Ψ, in quantum mechanics. In advising us to resist the temptation to see the archetypes as causative agents in synchronicity Jung says, "The archetype represents *psychic probability*."[14] (Italics are Jung's.) Jung's use of the adjective "psychic" here has nothing to do with paranormal or ESP phenomena. He is merely saying that an archetype is a probability structure in the psyche, that it manifests probabilistically and not causally. Although the archetype provides the fundamental meaning or intellectual structure for a synchronistic event, it is not causative of the specific event. As I have stressed, a large range of different experiences can manifest the meaning inherent in an archetype. Yet, not just any experiences will do, since they must be able to incarnate the meaning in the archetype. In this sense, "The archetype represents *psychic probability*." As Ψ is the acausal mathematical structure for a specified range of possible measurements, so the archetype acausally provides the meaning for a range of possible synchronicity experiences. However, neither Ψ nor the archetypes are directly observable.

There is also a critical difference between the relationship of the wave function and the acausal quantum events on one hand and the archetype and the synchronicity experiences on the other. In the quantum phenomena, since we are speaking about general acausal orderedness, there is no meaning involved in the sense of unconscious

compensation. We are just considering an impersonal law of nature, an acausal example of just-so-ness. In contrast, when an archetype manifests in a synchronicity experience, meaning is the critical point. The meaning is both transpersonal, since it is rooted in the archetype, and deeply personal through connection to our individuation. I doubt that Jung had the idea of the wave function in mind when he was considering the role of the archetype in synchronicity, but the parallel between the two acausal structures nevertheless holds.

In the synchronicity story that follows we see the archetype of the self acausally manifesting psychologically and physically to provide a needed unconscious compensation. Because the archetype is not causative, a different set of outer or inner events could have provided the occasion for the unconscious compensation. However, the meaning must be the same. In a parallel fashion a system with the same Ψ governs a large set of possible experimental results, but the same structure or order is expressing itself in all of them.

Synchronistic Interlude 3
Omnipresence of the Self

I had not given up on the quest because of sheer stubbornness. I was just going through the motions—meditating, studying, attempting to live an ethical life—but there was no discernible progress, no inspiration or sense of a meaningful transformation. Stagnation and confusion were my faithful companions. I was blocked both in the inner world and in the outer world, where I had been unsuccessfully trying to embody some inner intuitions. I would not exalt my state by claiming it was the "dark night of the soul," but I certainly was down. I was like the weak and weary old king of the fairy tales. Nothing could cheer me or cure me. It had gone on for so long that I believed that this is the way it would always be. I was resigned. Then the following dream occurred.

> Anthony, my late teacher, visited me. I was overjoyed to see him. We intimately discussed philosophic matters and my personal development. I basked in his kindness and concern. He disappeared and my wife came on the scene. I told her excitedly, "Anthony was here! It was not a dream or a vision. Look, you can be sure he was truly here because he left a crumpled napkin in his coffee cup to the right of his chair."

I awoke with gratitude and joy and a strong sense of Anthony's presence. Although I had previously had dreams with Anthony in them, the idea that "Anthony was here!" particularly fascinated me. What did that mean? Why was I so taken with that idea in the dream that he was really here? On my long drive to work that morning I decided to listen to a tape of one of Anthony's classes. I just wanted to hear his voice and embrace the lovely mood of my dream. Fifteen unfamiliar ninety-minute tapes of his classes with his other group in Columbus, Ohio had just been lent to me. I randomly selected a tape toward the end of the fifteen, hoping for a summary of some kind. The tape immediately plunged me into Anthony's commentary on Herbert Gunther's article on Kun-tu bzang-po.[1] Anthony started by saying, "I want you to forget everything I've ever said before and just listen to what I am telling you now. This is extremely important." That certainly piqued my interest. He then read some of the translation about Kun-tu bzang-po, the great Tibetan Buddhist guru.

Anthony explained how believing that the guru, the symbolization of our higher self, is limited to his spacetime form is precisely the idea that prevents us from breaking free of *samsāra,* the endless cycle of birth, suffering, and death. In an instant I understood the meaning of my dream, especially that "Anthony was here!" I was stunned. How did this ten minute section out of some twenty odd hours of classes get played right at this precise moment?

Although I was in a hurry to get to work, because as usual it was late and there was much to do, I wanted to hear the tape again without the competition of road noise. The tapes were audible, but not great. I pulled into a doughnut shop, got a coffee and a doughnut, and in the parking lot listened intently to that critical ten minutes. The message of my dream and the tape were identical! The higher self is omnipresent. Its embodiment is not limited to the spacetime form of the guru—that very belief chains us to *samsāra.* I then glanced down and noticed my crumpled napkin in my coffee cup to the right of

my seat. Although it was of my own doing, it seemed like another small reminder of the message of the dream. I was filled with gratitude and wonder.

Since then, the gloom has noticeably lifted. Of course, the usual frustrations and disappointments still beset me, but this experience persists and both my inner and outer lives have moved ahead. It's not easy, but I am trying to cultivate the idea that the true teacher is continuously present in both the inner and outer worlds.

Photo by Jan Hollien of Sweden. Used with permission.

23. Anthony Damiani

This meaningful connection between the numinous dream and the outer event of the "chance" playing of that particular ten minute section of those twenty-two hours of tape and the epiphany of the napkin in the coffee cup provided a powerful experience of the omnipresence of the self, an archetype at the heart of synchronicity. This ability of archetypes to operate meaningfully in the inner and outer world is precisely why Jung considered them psychoid—structuring both psyche and matter.

Besides confronting us with the limitations of causality stressed in the previous chapter, the most riveting aspect of these synchronicity experiences is that they challenge our deepest commitments about the world and our relationship to it. It's difficult to realize that the self is not merely a shadowy reality only indirectly working within the depths of our inner life. The vivid realization of its ever present reality encompassing both the outer and inner world challenges many of our naive beliefs about the separateness of ourselves and the world. Like the philosophic fish questioned earlier in chapter 4, we unconsciously live within the belief in the separability and independence of objects and subjects in the world. I'll return to this point in a later philosophic discussion.

7 The Elasticity of Space and Time

Professor Einstein was my guest on several occasions at dinner . . . These were very early days when Einstein was developing his first theory of relativity, [and] it was he who first started me off thinking about a possible relativity of time as well as space, and their psychic conditionality. More than thirty years later, this stimulus led me to my relation with the physicist Professor W. Pauli and to my thesis of psychic synchronicity.

C. G. Jung[1]

In man's original view of the world, as we find it among primitives, space and time have a very precarious existence. They become "fixed" concepts only in the course of his mental development, thanks largely to the introduction of measurement. In themselves, space and time consist of nothing. They are hypostatized concepts born of the discriminating activity of the conscious mind, and they form the indispensable coordinates for describing the behaviour of bodies in motion. They are, therefore, essentially psychic in origin . . .

C. G. Jung[2]

Our attitude toward synchronicity is deeply conditioned by our understanding of space and time, which is in large part shaped by science and technology. Like it or not, consciously or unconsciously, we are followers of Newton. That is, we believe space and time are absolute—fixed and the same for everyone at all places and time. For example, we believe that one hour for me is the same for you and read out with precision on our identical digital watches. Or, if I say event A happens before event B, then it must be so for all observers. Our experience with the products of technology whether the odometer in my car, the digital watch on my wrist, or the bell tower on campus tolling out the hours reinforces these beliefs.

In this chapter I give a nontechnical presentation of special relativity by way of a well-known paradox informally attributed to Einstein. Perhaps Einstein discussed this very paradox with Jung in the early days when they had dinners together. After the discussion

of this little paradox and its resolution, we can assess whether modern physics supports Jung's radical description of space and time as given in the opening quotation. Would physics agree that "in themselves, space and time consist of *nothing*. They are hypostatized concepts born of the discriminating activity of the conscious mind, . . . essentially psychic in origin, . . . "? Maybe we can learn the answer to this question in Las Vegas.

A Sure Bet in Las Vegas

Causality, chance, and dreams are all of interest to friends of depth psychology and habitués of the casinos of the desert kingdom of gambling—Las Vegas. (Perhaps even the Pandava king of the *Mahabharata* would enjoy the games of chance in Las Vegas.) This city of neon lights, blackjack, compulsion, incurable optimism, and romance is the site of an apocryphal tale about gambling and spacetime. In one of the most famous casinos, lounging underneath a full-scale replica of Michelangelo's David, we find Spacetime Sam. Although we know that fast-talking characters in tight-fitting polyester suits and strong cologne are never to be trusted, we find him a charming sort and decide that little harm can come from just chatting with him.

Sam has a walking stick and a little box about the size of a pack of playing cards. The box has some ultra high-speed doors fitted at each end. The walking stick is one meter long and the box is one-tenth of the length at .1 meters long. Figure 24 is a sketch of Sam's stick and box. He wants to bet us that without in any way harming, mutilating, or damaging either the box or the stick he can get the entire stick inside the little box. Sam claims he can get both doors of the box shut at once with the stick fully inside—between the doors! Having just won a large pocketful of money on the roulette table, we are willing to place a little wager with Sam. If any bet seems like a sure thing this must be it, especially since Sam has agreed to let us videotape the experiment with our special high-speed video camera.

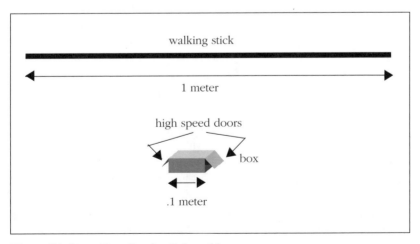

Figure 24. Spacetime Sam's stick and box

What is Sam's scheme? Surely, a man who lives by his wits must have a way of getting that one-meter stick inside a .1-meter box without harming the stick or the box. Among his many accomplishments, Sam prides himself in being a student of Einstein's special relativity—his "first theory of relativity" as Jung calls it in the quotation at the beginning of this chapter.

At the feet of Michelangelo's *David,* Sam places the box so that its long axis is parallel to the stick. He then moves the stick toward the box at speeds greater than 99.5% the speed of light or .995c, as shown in figure 25. Here c is the speed of light. (Don't worry about how Sam gets the stick to move this fast. He has connections in the physics community and they get particles to move much faster than that every day. See the accompanying photo.) At this speed the stick, *as seen from the point of view of the box,* has a length less than the box. Sam, therefore, gets the stick entirely inside the box at one instant. All this happens without harming either the stick or the box. The stick then passes out of the box through the door opposite the entering door. Yes, it will only be entirely in the box for the barest fraction of a second, but if we are quick we can videotape the doors shutting and the stick getting entirely inside for an instant.

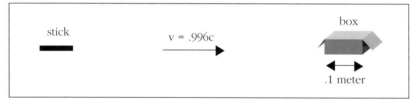

Figure 25. As seen from the box

We sullenly count out our money to Sam, while reflecting on the steep costs of higher education. With a broad smile of satisfaction, Sam explains that length is not as simple as Newton and his absolutist followers thought. The length we measure for an object depends powerfully on the state of relative motion between the object and the observer. When there is no motion of the object relative to the observer, then we measure the rest length of the object, usually denoted L_0. But if the object has a velocity with respect to the observer then she sees it smaller by a factor that depends simply on the relative velocity.[3] For example, if Sam's one-meter stick moves past him at .7c then he will measure the stick to have a length of .5 meters.

The extraordinary thing is that each measurement of length is equally valid, that is, each has an equal claim to be the "real" length. Only for the sake of convention and convenience do we favor the rest length of objects. Rest length is not truly fundamental. According to relativity, it's wrong to think that the rest length is somehow the real or fundamental length and all the other measurements are optical illusions or nature's sleight of hand. The length of an object is a truly relational property depending upon the relative motion between the object and the observer. *Length is not intrinsic, not fully independent of an observer.*

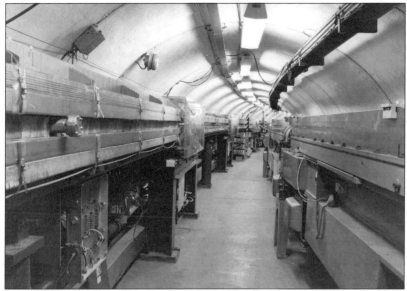

Photo by Victor Mansfield

26. Cornell University Synchrotron accelerates particles to nearly c.

Sam thinks our absolutist's views need more bashing, although he knows we will not bet with him again. Sam does the experiment repeatedly and shows that the stick gets fully inside the box for a short time. His self-satisfaction is becoming annoying.

Sam says, "Now, all velocity is relative. Right? I mean, consider a car going 60 miles per hour. To a passenger in the car the roadside telephone pole is coming at him at 60 miles per hour."

"Sure, Sam," we reply warily. "But it's really the car that is moving. The telephone pole only looks like it's moving."

"No!" Sam cries. "Each point of view is equally valid, equally correct. That is a central message of relativity. For the passenger the pole is truly moving toward him at 60 miles per hour."

Sam is now waving his arms energetically. We are becoming embarrassed because even gamblers intent on practicing their worship of chance are beginning to stare at us. After some heated debate, we finally agree that since no absolute standard of rest exists then *all velocities are relative.*

"OK, this means that a video camera fastened to the stick as it moves toward the box would see the box moving toward it at .996c," Sam says with a wicked smile on his face.

"Yeah, I guess so," we say, glad that no bet has been placed.

Sam continues, "Therefore, the camera sees the box to be one-tenth of its rest length or .01 meters long, while the stick is still one meter. (See figure 27.) OK, now here is the weird part. We saw the stick get entirely inside the box for an instant. Right? So it truly happens. You even videotaped it."

"Yeah, Sam, but what's the point?"

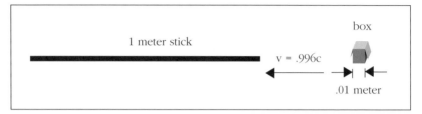

Figure 27. As seen from the stick

Sam seems to be delivering the crowning blow as he grins and says, "But how can a one-meter stick get fully inside a .01-meter box?!" Since each point of view is equally valid and gamblers and video cameras at rest with respect to Michelangelo's statue see the stick get totally inside the box, then why shouldn't the camera riding with the stick see it happen too?

"Now I am really confused. It's true that in the reference frame fixed in the casino the stick gets entirely inside the box. It's also true that the camera on the stick sees the box to be .01 meters long while the stick still is one meter in that frame. So it seems truly impossible for the stick to get inside the box in that frame, yet it must really happen."

If we absolutists think about it, this is more troublesome than the original problem of how to get a one-meter stick inside a .1-meter box. How can we resolve the paradox?

The Relativity of Simultaneity

The resolution of the paradox comes from realizing that simultaneity is also relative. In the frame in which the box is at rest (call it the casino frame) there is one instant at which both high-speed doors of the box shut and enclose the stick. Each door shuts at the same instant (simultaneously) and quickly opens at a slightly later time—again simultaneously opening.

Events that are simultaneous in the casino frame are not simultaneous in the stick frame. Simultaneity is relative, just like length, mass, time intervals, and many other physical properties. Therefore, the camera riding with the stick never sees the entire stick get in the box at one time. This is a good thing, since in this frame the stick is one meter while the box is .01 meters. (Notice I don't say "appears to be" but rather "is .01 meters." Relativity is not about appearances, but the stick's actual properties in a given reference frame.)

The relativity of simultaneity also gives us a glimpse of how deeply entangled space and time are. For example, in the casino frame the events of the doors opening are separated by .1 meters and by zero time (they are simultaneous and spatially separated by .1 meters). In the stick frame those same events are separated by a different distance (.01 meters) and they have a finite time separation (they are no longer simultaneous in this frame). In other words, a pair of events in one frame that had only a spatial separation and no time separation (simultaneous events) has in another frame both a spatial and temporal separation. Space and time for the same events get tangled together when

observing the events from different frames. In fact, relativity theory shows that space and time are so deeply intertwined that physicists stress their unity by designating them as one word—spacetime.

As I have stressed in other writings, not all is relative in special relativity. Nevertheless, space and time intervals (including zero time intervals or simultaneity) are relative to a particular reference frame, to the perspective of a particular observer. Does this justify Jung's contention that, "In themselves, space and time consist of *nothing"?* From a physicist's point of view that seems too strong and categorical, but even from this brief apocryphal tale it should be clear that space and time are not the rigid absolutes we unreflectively believe them to be. Relativity theory tells us precisely how long an object is in a particular frame, but it does not favor one frame over another. *No intrinsically preferred frames exist. Nor are there any intrinsically preferred values of length or time for a given object.* This is bitter medicine for our absolutist views. It's only a convention that we choose rest-frame values to characterize the object. Because this is so habitual we forget that these too are *relational* values—values unique to a particular frame. Many properties we believe are intrinsic to objects only have a relational being, one that depends for its value upon the reference frame in which it's observed.

One of the most interesting implications of the relativity of simultaneity is that what we call the present moment is also relative to a given reference frame. In other words, even what we call "now" is frame dependent. Let me precisely define "now" as all the

28. Spacetime Sam's sailing partner

Photo supplied with permission by the American Institute of Physics, Emilio Segrè Visual Archives.

events that happen everywhere in the universe at the present moment. This is a logical extension of our conventional notion of what the present moment means. For example, this is what we mean when we say, "She is arriving at the airport in Tokyo right now." For simplicity take a very special universe, which consists of one billion synchronized clocks distributed throughout the galaxies. Then in one frame at any one moment they all tell the same time even if they are billions of light years apart. (Of course, the signal that tells me what a distant clock reads still travels at the speed of light.) In this simple universe "now" just means the collection of identical clocks ticking off the same time at whatever moment we consider to be the present.

Consider, for example, the moment when the clocks all simultaneously read exactly noon. That collection of events is only simultaneous for one reference frame. In contrast, consider another observer who passes right by our first observer at some significant fraction of the speed of light. For this second observer very few of the clocks will read the same time—some will be before noon, some will be after noon. *Because simultaneity is relative, this second observer's now, its present moment, is a different set of simultaneous events even if the two observers are occupying the same point in space when they make the comparison.* I'll return to this intriguing relativity of the present moment toward the end of this book. Now let's turn back to synchronicity.

Does special relativity with its elastic notion of space and time support synchronicity? Not directly. Nevertheless, the notions of space and time that emerge fiom relativity are certainly more elastic, relational, less fixed, and therefore more congenial to the space and time transcending aspects so often seen in synchronicity.

To cast this point in psychological terms, we project fixity and absoluteness upon space and time when in fact there is none. Here, no "hook" even exists for our projection. True, for most nonrelativistic conditions where velocities are much less than the speed of light this mistake causes no problems, but in principle space and time are relative to a particular reference frame, to a particular observer. In that sense they are "essentially psychic in origin." Because of our absolutist habits we erect inner barriers to understanding synchronicity and lose our money to Spacetime Sam.

My emphasis in this discussion of relativity has been on the reference frame dependence of space and time, upon the extraordinary elasticity of even such things as simultaneity. However, before leaving relativity it's important to note how the objective attitude, which so powerfully characterized science since Galileo, is denied by relativity theory. So many quantities that Galileo and his followers thought were primary (size, shape, mass, etc.) we now understand as frame dependent, as intimately and deeply connected to a point of view, as no longer fully objective. As the next two chapters will show, quantum physics has gone even farther in the direction of denying the objective attitude of classical physics. We have yet to assimilate these great truths into the collective psyche. But before turning to quantum mechanics let me present a powerful synchronicity story that, among its many riches, strikingly shows how we sometimes transcend the normal modes of space and time. Here we see a living example of the relativity of space and time spoken about by Jung.

Synchronistic Interlude 4
A Dream Wedding

My example of synchronicity takes the form of a dream that prefigured an important occurrence in my life. About twenty years ago, when I was a year or two out of college, I was involved in a romantic relationship with a fellow student from India, whose culture fascinated me. The affair had gone on for about two years, and we had contemplated marriage but were unready to grapple with our families and their close adherence to widely differing religious and cultural traditions.

In mid-December my friend revisited his family for the first time in six years, promising to see me in a few weeks. January passed slowly, yet he did not return and I heard nothing from him.

On the night of February second, or early the morning of the third, a disturbing dream awakened me. This dream had two parts.

At first I was in a large banquet hall trrying to set up the tables for a celebration. It was to be my wedding, but try as I might the cups kept falling over and the tableware would not cooperate with my efforts. Amid this frustration, my philosophy teacher Anthony entered dressed as jester and began juggling large numbered cards. He held up a card bearing the number seven and informed me, "The next wedding will be on the seventh."

The scene changed and I was lying on an operating table in the hands of evil, Nazi-style doctors. They were showing me a large flip chart of colored anatomical drawings demonstrating surgery they were planning to perform. I realized that they were going to reorganize my internal organs in bizarre ways that appeared tortuous and possibly fatal. Somehow I managed to escape.

In the morning I related the dream to my close friend Jayne, who was spending the night, but neither of us had any idea what it could mean. I couldn't imagine how a wedding on the seventh could apply to me, and so for the next five days I remained in the dark, aware only of an unsettled sense of horror evoked by the second part of the dream and wondering if anything might happen on the seventh.

The following week on February 7, I received a long-awaited letter from India, addressed by a familiar hand and postmarked February 3. Inexplicably, the envelope contained a printed invitation to a wedding taking place in India on that very day. I read and reread the names of the celebrants—somehow my friend's name was the groom on the invitation, but wasn't it a mistake? I read the printed words repeatedly, trying to absorb the information while simultaneously rejecting it. Wasn't it his brother whose name I was misreading, who must suddenly have decided to get married?

My friend enclosed a handwritten letter, and in it explained that his trip home had been a difficult one. His family was not happy with his Americanized ways despite his success in academics and employment, and they put a great deal of pressure on him to remain at home. They were finally able instead to coerce him, using various threats, into an immediate arranged marriage with the daughter of family friends, a marriage he could in no way have anticipated before leaving for home. He pleaded for my forgiveness,

promising that, of course, he would always remember me, and looked forward to seeing me when he returned to the United States with his new bride in a few weeks.

I was emotionally shattered by this news and simultaneously stunned by the dream's predictive accuracy. The dream occurred on the same date that the letter was mailed, and the date announced in the dream was both the date the letter arrived and the date of the fateful wedding. Thus, not only was I suddenly given what felt like a mortal blow, but I also was faced simultaneously with powerful and precious evidence of a mental world that somehow overrules the hard, physical reality of daily existence. Until this point, "preternatural" knowledge had been either mere theory or crackpot illusion to me. Now I was forced to begin taking seriously what I had already studied in philosophy, Jungian psychology, and mysticism about the creative and projective capacity of mind.

Later, my rational and skeptical friend Jayne told me how impressed she was by the dream's predictive power and authenticity. For my part, I felt that had she not been a witness, I might have convinced myself that I must have fabricated it, no matter how vivid it seemed at the time.

As the contents of the letter finally sank in I became overwhelmingly aware of the difficult road that lay ahead. I teetered unwillingly at the cusp of a paradoxical process wherein a lover was being instantaneously transformed into an ex-lover—a paradox peculiar to the realm of Eros. I could blame nobody for this painful event: my friend had only followed family obligation; his family only wanted the best for him; and his new wife was clearly innocent of any ill will. I could only look inward and wonder at the enormity of my projection, which was being so forcefully thrown back into my face. I now had an impossible task—to reabsorb somehow all that I formerly experienced as "out there" and valued in the other, without becoming a loveless being. Intellectually I recognized the tremendous spiritual benefit in realizing the value of one's own soul as greater than any worldly object or person, but reintegrating this massive content was like dissecting the tightly interwoven threads of the fabric of my own existence.

The emotional chaos and reorganization that ensued in the following several months seemed to have been symbolized by the second part of the dream. I entered a state like that of mourning, where the world became devalued, life took on an automatic, devitalized quality, and only basic instinct kept me going. It was a lonely struggle despite the support of close friends. I felt queerly dissociated, partly identified as the subject of a trite melodrama and partly struggling to realize that there could be reason in this madness. I was also embarrassed at being the victim of circumstances for which I was in some sense responsible by virtue of my own romantic illusions. In retrospect it is difficult to acknowledge the extent to which a broken romance could have thrown me into such despair. I should have realized that this love would never have worked, and that my future needed to take a different direction. But other aspects of my life during that period also left me vulnerable: I had just moved to my own apartment and started a new full-time job. Yet the depths that I experienced suggested something further. There exists a kind of dark counter-side to the process of realizing the psyche, a side that involves a dying and decay, or alchemical nigredo necessary to the psyche's restructuring long before we can accomplish its eventual transformation to gold.

Recently Vic Mansfield challenged me to ask myself why this dream and the synchronicity of these events might have occurred. Strangely enough, our conversation

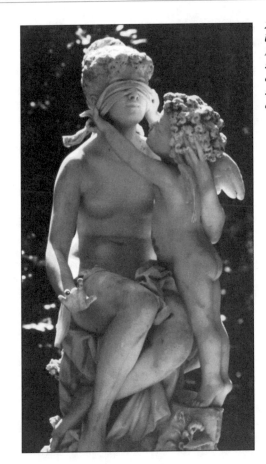

29. Eros blindfolding Psyche that she may eventually see more deeply

Photo by Victor Mansfield, taken at the Huntington Museum in Pasadena, California.

took place at a friend's wedding, where we sat at long tables, the same type as were in my dream.

Perhaps the dream was a warning, or a way of preparing me for the event to come, although the preparation did not become conscious. Or perhaps it heightened or intensified the entire experience to come. This dream announced an important change in my psychological/spiritual life, and in case the abrupt ending of my romance was not enough to provoke the change, the dream emphasized the point. But it also provided me with a vivid sign that a higher principle must be orchestrating my experience. I was not a mere victim of chance workings in a chaotic universe, but rather there was meaning to the pain and promise of a different course intended for my life. This meaning provided a sense of direction that helped carry me beyond the emotional disorganization and depression.

Finally, the dramatic experience of synchronicity itself—regardless of content—seemed to announce the sheer existence and power of psyche or soul or Self. Somehow a

single experience of this sort goes much farther in convincing one of the facthood of soul than scores of religious, philosophic, or psychological texts and reams of written descriptions of paranormal phenomena. Yet the content of the experience—as concerned with Eros—may be considered instrumental as well, serving both as catalyst to the process and as formative of the soul's unfoldment. Jung quotes Albertus Magnus as saying, "everyone can influence everything magically if he falls into a great excess . . . "[2] In other words, the excess of my romantic involvement and the intensification or canalization of energy it engendered were partly responsible for the startling revelation of the dream, which in turn added further intensification to my experience. The dream, the experience of loss, and even—in retrospect—the entire preceding romance, together seemed to have actively carved a sudden clearing in which the soul's existence and creative power could be vibrantly felt, with the chaotic emotional counterside serving as a functional opening to unconscious elements needing recognition.

It can become a lifework to understand, integrate, and express the philosophical and moral implications of such a glimpse. I would therefore like to imagine that the dream announcement of a wedding did not refer only to the actual wedding of February 7, but was a prognosticator of more lasting significance for me. Perhaps the wedding of the seventh implied my own first step toward a possible higher union, the path to which continues to demand a finely tuned articulation of emotional, intellectual, and practical living.

8 A Participatory Quantum Universe

When the history of this century is written, we shall see that political events—in spite of their immense cost in human lives and money—will not be the most influential events. Instead the main event will be the first human contact with the invisible quantum world and the subsequent biological and computer revolutions.

Heinz Pagels[1]

Useful as it is under everyday circumstances to say that the world exists "out there" independent of us, that view can no longer be upheld. There is a strange sense in which this is a "participatory universe."

John Wheeler[2]

Independent Existence as a Measure of the Real

Imagine a very dark street illuminated only by two street lights several blocks apart. One particularly dark night a man walks out of the illumination of one light toward the other light. We have no doubt that although he is not visible to us, his identity and path through the darkness are well-defined and independent of our observation. He is objective. Yes, we might have all sorts of psychological projections on him. What is this mysterious man doing on this dark street? Is he a cop? A mugger? Just an ordinary guy going home from work? Yet, whatever our psychological reaction to the man, we believe that he has a well-defined nature and trajectory between the pools of light—an objective existence. In other words, we assume that he has preexistent properties just waiting to be revealed through our observation. This is so natural to assume that we rarely articulate it. However, if we replace the person by an elementary entity such as an electron or a photon then we cannot assert that the object has a well-defined nature and trajectory between observations. Unobserved objects in quantum mechanics are intrinsically ill-defined and difficult to characterize as objects in the normal sense. They do not have well-defined pre-existent properties prior to measurement. As we saw in the previous chapter, relativity physics

challenges our absolutist views on spacetime and seriously compromises our naive realistic view about the world. In this chapter we'll see the necessity of participating in the definition of objects through measurement—a much more profound demolition of our naive realistic views of the universe.

For most of us the real, the objective, stands in its independence—essentially free from relations with us or other objects in the world. Whether we are fending off the terrors of impending psychosis or a bad dream, we seek touchstones of reality that have stability and independence. Such real objects don't radically alter their nature when we view them under slightly different circumstances, whether under a different light, from a different angle, or when we are in a different mood. On the other hand, the most terrifying beings transform their very nature when seen from a slightly different perspective—the lover turned to devouring monster, the friend to implacable fiend. Yes, we are aware that we "participate" in defining each other through relationship, but we firmly believe we each have a core of independent, objective, reality. Being called a chameleon or ingenue calls into question our sacred sense of independent identity—what we believe to be our real nature. In this shifting and whirling world of change we tether ourselves to what is independent of us, to that which has its own nature. This is what we normally mean by objective or, as Wheeler says in the quotation beginning this chapter, "the world exists 'out there' independent of us."

> "The limit, which nature herself has thus imposed upon us, of the possibility of speaking about phenomena as existing objectively finds its expression, as far as we can judge, just in the formulation of quantum mechanics."
>
> **N. Bohr**[3]

Belief in a world independent of us is one of the great impediments that surfaces in trying to understand synchronicity. If it's truly independent of us, then how could it meaningfully relate to our inner psychological states? Unable to answer this question, it's easy to consider synchronicity as merely a chance occurrence, a miracle, a freak of nature, or some form of self-delusion. Now I'll discuss a simple thought experiment that shows exactly what John Wheeler means when he says we are in a "participatory universe." Appreciating what is "participatory" about our universe does not explain the inner workings of synchronicity, nor terrify us as when a beloved turns into a vampire, but it does provide a significantly better framework for approaching an understanding of synchronicity—for removing some false projections about objectivity we have upon nature. Let me begin by examining the nature of light: first as a wave and then as a particle. This famous wave-particle duality throws us right in the middle of the mysterious quantum world.

The Wave Nature of Light

A standard piece of equipment in any undergraduate physics laboratory is an interferometer, like the one shown in figure 30. Generally the light source is a laser because it radiates a highly monochromatic or single color light that can be easily focused. Two kinds of mirrors are used: a full-silvered mirror that reflects all light incident on it, just like the one that greets us every morning in the bathroom; and a half-silvered mirror that reflects only half the light incident on it, letting the other half shine through it, like some reflecting sunglasses.

To understand the interferometer, let's start with the laser shown on the left of figure 30. The light first passes through an absorber for reducing the intensity of light shining in the beam labeled 0. This light then hits the half-silvered mirror positioned at a 45-degree angle with respect to the incident light beam. Half this incident light in beam 0 reflects downward in beam 1B to the full-silvered mirror at the bottom of the figure. (The "B" in 1B designates the beam reflected from the Bottom full-silvered mirror.) From the full-silvered mirror it's reflected back up in beam 2B, which has been displaced to the right in the figure for visual clarity. Beam 2B splits at the half-silvered mirror, half going through in beam 3B and the other half reflecting back toward the laser. The figure does not show the beam reflecting back toward the laser since we need not be concerned with it. Since beam 3B resulted from transiting the half-silvered mirror twice and was halved in intensity on each passage, it's only one quarter as strong as the original beam 0. Let's start back with beam 0 again and this time follow the half of the beam that goes through the half-silvered mirror and becomes beam 1R. ("R" for reflection off the Right full-silvered mirror.) After reflecting on the right full-silvered mirror it becomes beam 2R, which is

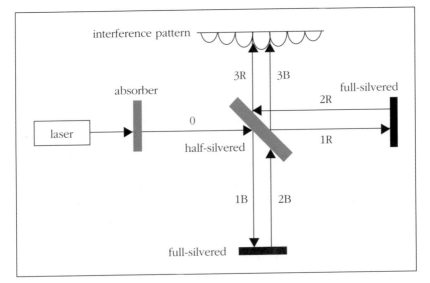

Figure 30. Interferometer

also displaced upward in the figure for visual clarity. Beam 2R splits at the half-silvered mirror with half of it reflecting up in beam 3R and the other half going back toward the laser. This beam is not shown since we are not concerned with it either. Since beam 3R is also the product of two interactions with the half-silvered mirror it's also only one quarter as strong as the original beam 0. Beams 3B and 3R form an interference pattern shown at the top of the figure, which we now investigate.

A characteristic feature of waves, whether they are water waves, sound waves, or light waves, is their ability to interfere—to add according to their phase relations. Take the case of waves being in phase—having a zero phase difference. Then two wave peaks (maximum amplitudes) arrive at the same point simultaneously and the amplitudes add. Then the total resulting amplitude is simply the sum of the individual amplitudes. This is known as constructive interference. In contrast, when waves are 180 degrees out of phase then a wave peak from one wave and a wave trough (minimum amplitude) from another wave arrive at the same point simultaneously. Then their amplitudes subtract or cancel. That is, the total resulting amplitude is the difference of their individual amplitudes. This is destructive interference. Then if the original waves had the same amplitude their difference would be zero—they would completely cancel. Designers of concert halls must avoid music bouncing off the walls and ceilings and arriving at the listeners' seats 180 degrees out of phase. Such sites of destructive interference would be better for sleeping than listening to music.

Of course, there is a whole series of intermediate cases where the phase difference is between 0 and 180 degrees. Then, there is only partial addition or cancellation. Figure 31 shows one such case. Three waves are shown: A and B are of equal amplitude, but B is 90 degrees out of phase with respect to A. Waves A and B add to give C.

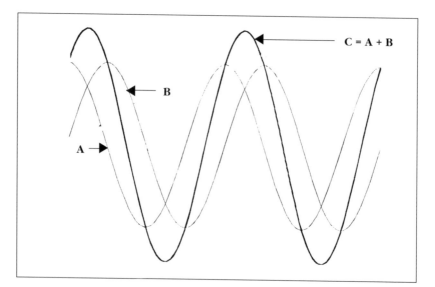

Figure 31. Waves partially out of phase

Now let's go back to the interferometer and examine beams 3B and 3R that form the interference pattern at the top of the apparatus. If the placement of the full-silvered mirrors is such that the two beams travel the same total distance in getting to a point in the interference pattern, the light waves will be exactly in phase at that point and the beams constructively interfere there. In other words, constructive interference occurs when the distance traveled by beams 1B, 2B, and 3B is equal to the distance traveled by 1R, 2R, and 3R. Where this occurs, we find a high intensity band of light represented in the diagram by a hill in the interference pattern. Constructive interference also occurs when the difference traveled by the two beams is an integer number of wavelengths. When the path lengths of the beams differ by half a wavelength then they arrive at the interference pattern 180 degrees out of phase and destructively interfere there. This gives a dark spot, shown as a valley in the interference pattern. Moving either one or both of the full-silvered mirrors shifts the interference pattern to the left or right in the figure, but does not change its basic shape. The shifts occur because moving the mirrors changes the path lengths of the beams. In practice we often record the exact interference pattern by placing a photographic plate at the top of figure 30. Such a plate would faithfully record the light intensity variations with position.

The interference pattern and its sensitivity to the placement of the full-silvered mirrors yield a paradigmatic expression of the wave nature of light. The interference pattern in this simple apparatus is exquisitely sensitive to the placement of the mirrors because the wave length of visible light is approximately equal to .005 cm, small compared with macroscopic dimensions.

The Particle Nature of Light

Ideal waves are infinite in extent and can have amplitudes of any size, while ideal particles have location but no extent and they come with fixed masses. No more contrary entities exist in nature (including Dr. Jekyll and Mr. Hyde), yet somehow we must appreciate light as having both a particle and a wave nature. Which one we come to know is our choice. We must "participate" in defining the universe. By playing with the interferometer, we can see exactly how this works.

If we use a powerful absorber in front of the laser, the light beam gets weak enough so that its particulate nature becomes apparent. We can place a photodetector, a piece of electronic equipment that counts individual photons or quanta of light energy, in the beam and put the signal through our stereo amplifier and out to speakers. Then we hear a sharp click for each detected photon. These clicks arrive randomly. Over intervals much larger than the average time between reception of the clicks we find a well-defined average, but individual clicks are completely unpredictable. Sometimes there are long pauses between clicks. Then they come piling in upon each other so fast we have trouble counting them. It's a lot like popcorn popping. However, there is one big difference. Most believe that if we could investigate each popcorn kernel in sufficient detail we could tell just when it would pop. Perhaps the exact time it will pop depends upon its skin thickness, moisture

content, and temperature history. Then its statistical scatter is just a measure of the variability of nature and our ignorance of the details. In other words, we believe that at a deep enough level its time of popping is predictable and deterministic. However, no such analysis is possible *in principle* for photons—although there is a well-defined average, their individual arrival times are completely unpredictable. The arrival time of individual photons is truly acausal, just like the decay of radioactive nuclei discussed in a previous chapter.

Place a photodetector so that it captures the photons bouncing off the full-silvered mirror at the bottom of the diagram. That is, make the photodetector capture the light in beam 2B. Then we find that, over sufficiently long times, the average photon count is exactly half the value found in beam 0. We find the same average count rate if we place the photodetector so that it captures the photons reflecting off the full-silvered mirror in beam 2R on the right. We never find a half click. All clicks are of the same strength. All this confirms that light consists of photons—indivisible chunks of identical energy— and that we have a good half-silvered mirror that reflects half the photons and transmits the other half. For a given photon we never know whether it will be reflected or transmitted, but over long time averages we get one half going each way.

A real mystery comes when we make the absorber powerful enough so that we can be sure only one photon is moving through the interferometer at a time. For example, let's say that the average time between photon arrival times in beam 0 just after passing through the absorber is 0.1 seconds. In other words, in an average second 10 photons impinge from beam 0 on the half-silvered mirror. As expected we find on average that half, or 5 photons per second, go along each arm—half to the bottom in beam 1B and half to the right in beam 1R. Since for laboratory-size interferometers the travel time for photons through the system is approximately 10^{-8} seconds, we can be sure that only one photon at a time is moving through it. Here is the strange part: When we let such a system run for a minute or so we still see a clear interference pattern. This interference pattern shifts left or right depending upon how we move either of the full-silvered mirrors. The shifting of the interference pattern with movement of the half-silvered mirrors was understandable when we were studying the wave nature of light and we were sure that light waves were traveling along both arms of the interferometer. *But how can a single, indivisible photon traveling alone through the interferometer make an interference pattern that relies on the phase relations between the beams traveling along different arms?* In other words, how can the photon interfere with itself when it only goes along one route or the other?

We can be clever and detect along which arm the photon travels. For example, we could replace the photographic plate with a bank of photodetectors that records the arrival of individual photons at the site of the interference pattern. Then we could mount the full-silvered mirrors so delicately that they jiggled or vibrated every time a photon reflected from them. In this way we could tell along which arm an individual photon traveled. In other words, we could get path information on the light's travel through the apparatus. But under these conditions the interference pattern disappears! The light pattern is just a featureless smear.

Perhaps having two delicately balanced full-silvered mirrors is a problem. We do not need both mirrors sensitive to photon passage since the photon must go one way or the other. So let's tighten up one mirror (say the one on the right). Then if we detect a photon at the interference pattern site and our delicately balanced mirror (at the bottom) does not move then we know the photon went along the other arm (the right arm). After this modification we still get the featureless smear—no interference pattern. If the mounts of the full-silvered mirrors are tightened back up so we cannot tell along which arm the photon travels, then it seems to travel somehow along both arms and generate the interference pattern in all its former glory. In short, *knowing along which arm the photon travels destroys the interference pattern; not knowing along which arm it travels seems to allow it to take both routes and generate an interference pattern.* Yet we know that photons are indivisible. They do not split and take both routes, since we never detect fractional photons.

What's going on? This is a paradigmatic example of Niels Bohr's celebrated Complementarity Principle—here manifesting through the wave-particle nature of light. Bohr was so taken with the Complementarity Principle as a way of dealing with opposites, both within and without physics, that he had the Yin-Yang symbol, the primal dualism of the East, emblazoned on his coat of arms (shown in the following photograph). Above the Yin-Yang symbol it reads, "The opposites are complementary." An interference pattern is a quintessential expression of wave properties, while knowing a trajectory of a particle such as a photon is quintessentially a particle property.

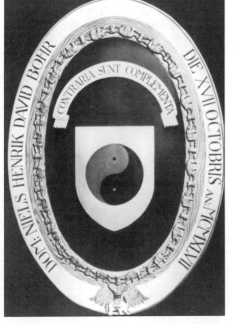

32. Niels Bohr's coat of arms

Light manifests both wave and particle behavior. Both properties are essential for an understanding of light. One property is not more fundamental than the other. We cannot reduce light's wave behavior to particle properties, nor can we reduce its particle behavior to wave properties. Nevertheless, we cannot simultaneously know both the wave and particle nature of light. We must choose either to measure the wave nature of light (its interference pattern) and forgo knowing along which arm the light traveled, or to know along which arm the photon traveled (its particle behavior) and forgo knowing its wave nature. When we study the wave nature of light, it seems to propagate along each arm. Then the interference pattern

displays its exquisite sensitivity to the position of both mirrors and we must abandon any knowledge of its particle trajectory along a particular arm. In contrast, in discovering its particle trajectory we always destroy the interference pattern and the sensitivity to the full-silvered mirrors' position. This view differs radically from our assumption of a well-defined path that we believed the man had while walking between two streets lights.

The cube shown in figure 33 below may give a more direct feeling for complementarity, although it's only a visual metaphor. If you have never played with such cubes, take a minute to concentrate on figure 33. If you stare at it for a little while you'll notice that one face seems to jump forward and the other face forms the rear surface. Stare a little longer and then the faces reverse roles. You must view the cube as having one or the other face forward. You can never simultaneously have it both ways. The two interpretations of the cube are complementary. One is not more fundamental then the other. We cannot reduce one to the other. Which face is forward depends upon the viewer. The figure is ill-defined without our perceptual involvement.

What phenomena we measure depend in large part on what we choose to measure. As Niels Bohr repeatedly stated: "I advocate the appli-cation of the word *phenomenon* exclusively to refer to the observations obtained under specified circumstances, including an account of the whole experimental arrangement."[4] In other words, you cannot say whether light is a wave or a particle without specifying the circumstance of its measurement, including the entire experimental arrangement. *Light only has a contextual nature, not one that independently exists.*

Many find complementarity a denial of the basic thrust of modem science since the founding days of Galileo and Newton. They say we have always sought to know nature independent of the details of the knowing or measuring process. All scientific knowing is a form of objectification—of know-ing an object as it exists free from the knowing act. We should know whether light is a wave or a particle and this should be independent of "an ac-count of the whole experi-mental arrangement." That we cannot, say its detractors, is a deficiency in quantum theory, not a truth about nature. In honor of these voices, some of which are the most esteemed in modem physics, let's take another look at the interferometer.

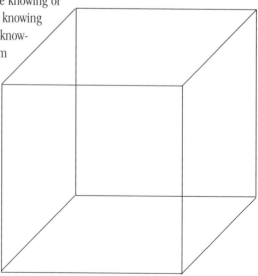

Figure 33. Cube as visual metaphor for complementarity

A Delayed-Choice Version of the Experiment

John Wheeler has developed a delayed-choice version of the interferometer experiment.[5] Here I'll present my version of such an experiment. We know how fast light travels through the interferometer and thus how long it takes to traverse the system. We could use fast electronics (the way it's done in practice) or make very long interferometer arms. Then we would have enough time to tighten or loosen a full-silvered mirror's mount *after* the light interacts with the half-silvered mirror. In other words, after the photon interacts with the half-silvered mirror we can decide whether to display its wave or particle nature. We always delay our choice of whether to study the wave or particle nature of light until the last possible instant. Then we could, for example, decide at the latest possible moment to display its wave nature (keep both full-silvered mirrors tight) and record all those detections at the interference site. On the other hand, we can record a second set of statistics of detections at the interference site in those cases when we decide (at the last instant) to know along which arm the photon traveled.

Now here is a real conceptual knot. It seems that our choice at the last possible moment determines what light did in the past. I'll make it more dramatic and consider, as Wheeler does, a system with astronomical dimensions. Let the arms be billions of light years in length. Then we have a billion or so years between the interaction with the half-silvered mirror and the full-silvered mirror. This means that my decision today effects what light did a billion years ago! This is too weird even for physicists, noted for their playful imaginations, to contemplate. How could my decision today influence the universe billions of years ago? Surely something is wrong with quantum mechanics, or John Wheeler, or both.

Careful measurements have shown that even these delayed-choice versions of this experiment fully agree with the predictions of quantum mechanics, and the physics community as a whole pays much homage to Wheeler. Neither quantum mechanics nor Wheeler are in trouble. Instead, our conception of nature is at fault. I admit to having knowingly contributed to that misconception by my description of the experiment. My descriptions encouraged the natural, yet incorrect, assumption that the photon has a well-defined trajectory as it works its way through the interferometer whether or not we know its trajectory. In other words, we assumed the objectivity of light, just like we did for our mystery man walking between the two street lights. In fact, light does not take on either a wave or a particle nature until we decide (at the last possible moment if we like) whether to measure its wave or particle nature. It's wrong to assume it's a particle before we decide what we will measure. Prior to our choice it's ill-defined. *It is simply wrong to imagine that the past already exists in full detail in the present.* The history of the universe is not written out in full detail. Such a fully defined and explicit past is an imaginal construction, a theory, a mental imputation—a giant prejudice. We can normally get away with believing in an objective past that exists in full detail in everyday life. But in the deeper quantum mechanical sense, we must actively participate in defining the universe. It's not sitting "out there" fully objective waiting for us to reveal its pre-existent, well-defined, intrinsic nature.

Galileo and classical physics believed that we provoke nature into answering our questions. Now we know that the questions we ask in part determine the answers we get. We cannot provoke nature into a monologue. Instead, *we must participate in a dialogue with nature.* As John Wheeler says:

> Spacetime in the prequantum dispensation was a great record parchment. This sheet, this continuum, this carrier of all that is, was and shall be, had its definite structure with its curves, waves and ripples; and on this great page every event, like a glued down grain of sand, had its determinate place. In this frozen picture a far-reaching modification is forced by the quantum. What we have the right to say of past spacetime, and past events, is decided by choices—of what measurements to carry out—made in the near past and now. The phenomena called into being by these decisions reach backward in time in their consequences . . . back even to the earliest days of the universe. Registering equipment operating in the here and now has an undeniable part in bringing about that which appears to have happened. Useful as it is under everyday circumstances to say that the world exists "out there" independent ot us, that view can no longer be upheld. There is a strange sense in which this is a "participatory universe."[6]

Quantum mechanics demands that we abandon some of our most cherished beliefs about the world. The prequantum vision populated the universe with independent objects performing an extraordinarily complex dance, but the music was always deterministic. Causality was the supreme conductor of the symphony. The quantum vision removes the independently existing dancers and populates the world with possibilities, tendencies, or propensities for particular dances. Here the melodies (waves) and the dancers (particles) are fully united until we call one of them forth or bring one of them into existence by our measurement. Individual notes cannot in principle be predicted. Many of the details of the symphony are not written until we listen in a particular way. Tilting our head one way we hear one refrain, tilting it another we hear an entirely different and even contradictory refrain. Prior to our listening the central themes are not yet definite, despite our beliefs about their objective nature.

In other words, particles and waves do not exist simultaneously in some definite way only waiting for us to call one of these properties forth. Prior to measurement the system is truly indefinite, lacking in independent existence. Since causality requires definite objects exchanging energy or exerting forces on each other, is it any wonder that independent existence and causality fall to the ground together in quantum mechanics?

Despite all these changes in physics since Galileo observed swinging chandeliers, I emphasize, contrary to many popular science writers, that most physicists do not think human consciousness plays a role in transforming possibilities or propensities into actualities or spacetime events. This transition can all be done with computers and "irreversible measurements"—those that are overwhelmingly unlikely to reverse themselves. For example, a photon darkens a photosensitive grain of silver bromide. There is a vanishingly small probability that the grain will reemit a photon and revert to its unexposed state. But this issue is more complex than thermodynamic arguments. As Schrödinger says: "The observer is never entirely replaced by instruments; for if he were, he could obviously obtain no knowledge whatsoever. . . . The most careful record, when not inspected, tells us nothing."[7]

I'll return to these epistemological issues in the next chapter and in the philosophic chapters toward the end of the book. But first we must examine another synchronicity experience and then discuss what many consider the most profound and far-reaching revelation of physics—the nonlocality or nonseparability revealed by modern experiments. Both the participatory nature of the quantum universe and nonlocality are crucial because they strike at the heart of our unreflective belief in a world populated by independent or separately existing entities. Appreciating synchronicity in such a world is nearly impossible.

Synchronistic Interlude 5

Learning to Trust the Inner Voice

The weekend started innocently enough. Al and Rose, their two-year-old son, my close friend Catherine, and I were going to fly in Al's single engine plane to visit friends in Massachusetts for Thanksgiving.

On the morning we were set to leave, I felt the urge to look at my astrological transits. Having studied astrology for the past eight years, I thought I had developed a good sense of when to use and not misuse this ancient art. While my prime motivation in studying astrology has always been to use it as a tool of self-understanding, I had also found it useful at certain times for choosing propitious moments for action or inaction.

As I opened the ephemeris to check my transits (the daily motion of the planets relative to the planetary positions when I was born) I was chagrined to find myself in the midst of a particularly difficult aspect—transiting Uranus conjunct my natal Mars— traditionally known for unexpected happenings, accidents, etc. I quickly told Catherine. Her immediate response was, "I'm not flying with you with that aspect! It's too dangerous. Perhaps I'll drive but no flying." Intuitively knowing she was right, I called Al and Rose to tell them of our findings and decision. I spoke with Rose who had studied astrology as long as I had. She said, "Are you going to let astrology run your life? This aspect doesn't necessarily mean something negative is going to happen. Ultimately, each individual creates his own circumstances."

Naturally, Rose knew just how to push my buttons. I had always struggled with the issues of free will and determinism and prided myself in using astrology to help me live a good life and yet not have it run my life.

On one hand, there is the intuitive knowledge and feeling that there is an ordered cosmos in which patterns and events are to some extent determined by our past actions and guided by an intelligence that includes both our ego and the world it inhabits. On the other hand, I experience myself as a free individual, with the power to create and choose my own life experiences. How can these be reconciled? Most critics of astrology say people use it as a crutch so as not to take responsibility for their actions. But I venture to say that if one honestly and openly looks at their experience, they would see that our lives are more ordered and determined than we would like to admit.

I told Rose I'd think about it and call her back. Rose's reasoning did not impress Catherine, but Catherine came up with a good suggestion: Look at everyone's chart who was going. If everyone else looked free of trouble, most likely whatever would befall me in terms of my aspects might happen internally or psychologically and not manifest in external events.

I dutifully looked at everyone's horoscope including Al and Rose's two-year-old son. Surprisingly, everyone had either a square or opposition involving Uranus, Mars, or Venus. Sometimes it was the transiting Mars or transiting Uranus, but in each case, including my own, Uranus or Mars was involved. It was no coincidence. Flying was out of the question. Four charts, all with problematic aspects to Uranus, was too much to ignore. If this was a test of free will or determinism, here I would side with determinism. In fact, when Catherine saw the astrology, she even withdrew her offer to drive.

Confident in my findings, I quickly called Rose back to tell her. While she agreed that all of us having these aspects was troubling, she still was not going to let some

outside agency run her life. I still don't exactly know what happened then. For whatever reason, I gave up all my knowledge, all my intuition, and agreed to fly.

I said good-bye to Catherine and left in the single-engine plane for Massachusetts. As we ascended, my misgivings were clear, but I had decided. I would live with it the best way possible.

The first part of the flight was fine but as we got closer to the Massachusetts's coast the turbulence got increasingly intense. Al, the pilot, didn't seem concerned, but when we hit a big air pocket and all our heads butted up against the ceiling I could see him becoming a little unglued. In fact, after we landed, Al admitted that it was the *most* turbulent flight he ever had. As I left the plane, I thought the gods had taught us a lesson. They terrorized us for going against their will, but had spared us with just a really bad flight.

The weekend went smoothly enough as we all had a great time seeing our dear friends. Sunday morning we visited the nearby Vedanta Center to see Gayatri Devi, a saintly woman, who leads the community there.

Oddly enough, her whole talk was on learning to cope with natural disasters. Her other center in California had just experienced a devastating fire. As she spoke, I felt her gaze penetrate me—as if she were trying to convey something important to me. I asked Al afterward if he had felt her staring directly at me. He confirmed my feeling. Only later would the full impact of this experience come home to me.

We said good-bye to our friends, boarded our little plane, and took off. As we climbed to about four thousand feet, this question just popped out of my mouth: "Al, if we had an emergency and you had to land the plane, where would you land'?" Al looked around and said, "Probably in that lake over there. There's no strip of land around long enough for a landing. Nothing more was said for 20 minutes until the following popped out of my mouth: "Al, what does it sound like when the engine conks out?"

Before he could answer, I learned first hand. Within 20 seconds of asking the question, the engine started sputtering, sputtering, and then finally nothing. Silence. Five thousand feet, total cloud cover, Berkshire Mountains in every direction. . . . Silence. We couldn't make radio contact with any airport.

When we broke through the clouds, we had about 60 seconds before hitting the ground. Like a flashback from 20 minutes before, a lake miraculously appeared in front of us. Al told us that our only chance was to land in the lake.

Sixty seconds were left to contemplate my fate. Why did I do it? I obviously knew not to go. All these passing thoughts became meaningless as I prepared to die—and to my mind deservedly so. I got as quiet as possible and started meditating and getting ready for I knew not what.

As we glided toward the lake, Al's first pass was somehow not right and he turned the plane sharply to make one last attempt. This time we glided right over the shoreline and Al put the plane down 30 feet from land in what was the smoothest landing of my life.

Al told us to get out on the wing, jump in the water, and swim to shore. Being a very poor swimmer, the idea of jumping into a cold lake was almost scarier for me than the engine conking out in the first place. What choice did I have? So I jumped in and started swimming. I was wearing a sheepskin coat and forgot to take it off. I almost drowned on

the way. As it turned out, if I had just stood up, I would have realized I could have walked. We were only in four feet of water! Not only that, but we could have stayed on the wing and been rescued by a boat that had heard our engine sputtering.

While getting warm in a cottage by the lake, having been given dry clothes by an extraordinarily helpful man, I was already trying to distill the meaning of these experiences. Fourteen years later, I still ponder the experience and wonder how much meaning there was for me in that cold lake.

For me, there were four synchronistic events within this experience:

1. The experience at the Vedanta Center where Gayatri Devi spoke of natural disasters and pierced me with her gaze.
2. Asking where we would land in an emergency 20 minutes before the crash.
3. Asking 20 seconds before the engine died what it was like when the engine stopped.
4. The entire astrological scenario, my denial, and the unfolding events, which had by far the most lasting impact.

Both before and after the crash, I have had experiences similar to the first three, but I had never before experienced the immediate consequences of willfully ignoring my knowledge, feeling, and in-tuition. The immediacy and power of the events, especially given the astrological warn-ing, have deeply influenced the use of my will ever since. Now, when a voice in me says wait, or don't, I step back and try to feel and understand what that voice is trying to say. I often consult my astrological indicators to verify my feelings and intuitions. I am always asking the question, "Is there something objective I should be listening to?" Astrol-ogy often helps point to the answer..

I still believe we must exer-cise basic existential freedoms in life. But I equally know that we are so intimately related to

Photo provided by the Ananda Ashrama in LaCrescenta, California.

34. Gayatri Devi

the cosmos, that we must heed the symbols embedded in the cosmos, i.e., the astrological mandala and others, when they speak to us. This speaking is a gift, a way in which the intelligence guiding both our inner and outer lives tries to help us—grace, if you will. I learned that to turn my back on it is to turn from life itself.

9 Nonlocality in Nature

But on one supposition we should, in my opinion, absolutely hold fast: the real factual situation of the system S2 is independent of what is done with the system S1, which is spatially separated from the former.

Albert Einstein[1]

A Cautionary Tale

In 1967 in Ithaca, New York my office mate, David Hollenbach, and I were grinding out our graduate work in astrophysics. Endless classes, problem sets, research projects, and a long, cold, gray spring were exacting a heavy toll on our sanity. To keep up our morale, for spring break we went on a trip to Mexico. One of the most memorable experiences of that great trip was our excursion to the Shrine of Guadalupe, the holiest site in Mexico. It must have been the special holiday commemorating the Virgin Mary's visitation to that site. Sincere pilgrims, who were largely poor Mexican Indians, thronged the entire neighborhood. The most devout ones covered the last several miles of the trip walking only on their knees while fervently praying to the Virgin.

Among the tens of thousands of pilgrims we were the only gringos. David stood out like a redwood tree among the Mexicans since he is six feet six inches tall. He was easy to find in the crowd. While at the Shrine, we wandered just outside the Cathedral gates to a fair set up for the occasion. A photographer who supplied us with costumes took the picture shown.

At the fair we paid to go inside a little tent and examine a box with glass sides about a foot or so on a side that sat on a table in the center of the tent. A well-formed and obviously alive woman's head was in the box! She was talking to us! We could not touch her head, because it was behind glass. Since she was speaking some Indian dialect, my schoolboy's knowledge of Spanish was of no use. We looked all around and under the table. We could find no wires, connections, or anything that would allow for projections of either sound or images. Picking up the box seemed imprudent, since the man running the exhibit was glowering nearby. David and I were dumbfounded. We prided ourselves on being hotshot physicists. These people were not going to pull something on us. They

111

might fool the poor pilgrims, but not us. (A quick glance at our photograph clearly shows that we were very astute observers whom they would not easily fool!) We could find no explanation for what we saw. We left the tent in exasperation, shaking our heads, finding it impossible to believe that they could put a live woman's head in a little glass box. (After reading this section and agreeing with my description, David thinks he now has some possible explanations.)

Was it what it seemed—a live head in a little glass box? Or was it some extremely clever trick? Even if it was a trick, it was very interesting in its own right, because it was done so well. On the other hand, if it was a real live woman's head in a little glass box then we have a first-class mystery here that really deserves careful

35. Gringos at Guadalupe

scientific study. It could revolutionize both biology and medicine. We wanted to decide whether this head in a box was the revelation of new knowledge about the world or just a trick based upon thoroughly understood principles. When studying anomalous phenomena, whether tricks at a Mexican fair or nonlocality in quantum physics, we must be extremely certain whether new principles or merely unexpected combinations of well-known ones are being revealed.

In this chapter I want to examine a genuinely new principle that we have carefully studied in physics during the last few decades in our attempts at understanding the conceptual foundations of quantum physics. Although my evidence for the reality of a live head in a box is scant, this new principle in physics is firmly established. In the minds of some well-respected physicists it's even stranger than a live head in a box. Furthermore, we are certain that this is a new principle, not a surprising combination of previously understood principles. To show this convincingly we'll need to be unusually careful in our analysis.

What Is Nonlocality and How Do We Know It?

Nonlocality is the inability to localize a system in a given region of space and time. Stated positively, well-studied physical systems show instantaneous interconnections or correlations among their parts—true instantaneous action-at-a-distance. For example,

consider two widely separated regions, A and B, shown in figure 36. In nonlocal phenomena what happens in region A instantaneously influences occurrences in region B and vice versa. Surprisingly, this instantaneous interaction or dependency occurs without any information or energy exchange between regions A and B. Yet the effects are strong and do not weaken with the distance between regions A and B. Now here is a strange property, but one we can study much more carefully than tricks at a Mexican fair.

Most people who study the philosophic foundations of quantum mechanics agree that nonlocality is more mysterious than the complementarity we discussed in the previous chapter. They reason that in any measurement there must be some interaction with the system measured. In classical physics, because the systems are macroscopic, we can neglect this interaction. For example, when we precisely measure the Moon's distance from the Earth by timing how long a radar signal takes to reflect from its surface, the bounced signal does not change the Moon's orbit. In contrast, quantum mechanical measurement often involves energy exchanges comparable to the energy of the object measured. For example, determining along which interferometer arm the photon traveled requires measurement interactions with energies comparable to the energy of the photon. Because of these significant energy exchanges, measurement takes on a much more central role in quantum mechanics. It also raises thorny questions about the nature of the object prior to or independent of measurement.

Psychology faces a similar "measurement" problem. In investigating unconscious contents, we inevitably transform them in the process. To expose a previously unconscious projection, for example, is to transform radically the thing known, a process central to individuation. For example, we seek to know the elusive but powerful anima, and the very act of objectification transforms her from a set of undifferentiated moods into a source of inspiration.

Because of the necessity of interaction in measurement, Einstein believed that the relationship between the properties of objects and the exact experimental situation is not as profound nor as difficult to understand as nonlocality. In the last dozen years or more we have directly learned about nonlocality through the celebrated Bell Inequality experiments, which grew directly out of Einstein's lifelong criticism of the conceptual foundations of quantum mechanics. These experiments, discussed in this chapter, reveal an interconnectedness without energy exchanges, a nonlocality, that goes beyond anything explicable by classical ideas.

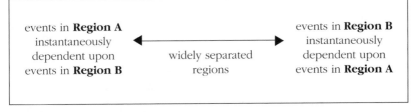

Figure 36. Nonlocality

These acausal physical connections are thus similar to synchronicity experiences, which are also without energy exchange or causality and yet imply a deep interconnectedness. In physics the connectedness, nonseparability, nonlocality, or entanglement between parts (all approximate synonyms) is so complete that the point of view of separable parts is often less fundamental, less significant, than the nonseparable nature of the system. These are truly revolutionary ideas in physics and philosophy. Synchronicity also requires us to appreciate that the meaning revealing itself in the inner and outer experiences is more significant, more real, than either our subjective state or the objective events. Such memorable experiences make us aware of a different kind of nonseparability than that between regions A and B in physics—the nonseparability between our minds and nature, something on a different level and to be discussed in more detail in the last part of this book. As Jung was well aware, the archetypal meaning revealing itself nonseparably is more important than the contingent form of the experience of that meaning.

In synchronicity we have a direct personal experience of the interrelatedness of our inner life and the objective world. This interrelatedness, so contrary to our unreflective prejudices about the world, is surely one reason for the numinosity and uncanniness of the experience. Still, this personal experience of interrelatedness in synchronicity clearly differs from nonlocality in physics. One is a psychological experience while the other is a property of photons and particles investigated in the laboratory. Nevertheless, it's accurate to say that we are examining the same principle from within two different disciplines. Both depth psychology and physics demand our retraction of one of our most persistent and powerfully believed projections on nature—its fundamental separability or independent existence. For depth psychology the nonseparability is between ourselves and the world, while in physics the nonseparability is between widely separated elements of matter. Nevertheless, the fundamental commitment to isolated and independently existing entities is denied, but in different ways, by both disciplines.

Returning to our example in physics, to establish nonlocality rigorously we need to be certain that regions A and B are truly separated from any possible exchange of information or forces, from any causal interaction. To be concrete, consider Rhine's ESP experiments where a subject turns cards in region A and another guesses their order in region B. To isolate these ESP subjects so that even a skeptical physicist would believe they were fully separated, we use the finite speed of any physical interaction. We know that no physical interaction or information can travel faster than the speed of light. Therefore, let's put one ESP subject on the planet Mars when its position makes it twenty or more light minutes away from Earth. This means that light would take twenty minutes to go from Mars to Earth or vice versa. Then let's have our first subject on Mars complete her card turning in one minute and, immediately after that one minute, have our second subject on Earth guess the sequence within the next minute. Since any information about the card sequence would take at least twenty minutes to propagate to Earth, our second subject has no way of receiving that information in time to help him guess the card sequence. This way the subjects are truly isolated from local interactions or interactions that occur at speeds less than or equal to the speed of light.

With fast electronics, physicists use the same principle to isolate parts of a quantum system in the critical Bell's Inequality experiments. But rather than talk about laboratories, let me transplant the experiment to a Tibetan monastery. In that macroscopic realm we reap the triple benefit of making things easier to understand, crashing headlong into some of our cherished philosophic presuppositions, and preparing the way for a subsequent comparison between nonlocality and emptiness in Tibetan Buddhism.

Experiments with Tsongkhapa's Bells

Quantum mechanics is unique in being the most comprehensive and well-verified theory in physics and simultaneously having the least understood philosophic foundations. Bell's Inequality and its experimental violation provide the most important deepening of our understanding of the philosophic foundation of quantum mechanics since its inception more than sixty years ago. My presentation of Bell's Inequality is partly inspired by David Mermin's papers[2] and is an expansion of some of my earlier writings.[3]

Tsongkhapa is the eminent fourteenth-century Middle Way Buddhist commentator and founder of the Gelukba order of Tibetan Buddhism. Among the Himalayan Lamas of Tibetan Buddhism he is surely the *Chomolungma* (Mt. Everest). In our tale, one day an itinerant bell salesman came to his monastery and offered him a bargain on some ritual bells—enough to equip all his monasteries. But he had to buy many bells in one lot to qualify for the deep discount.[4] Figure 37 shows an example of the bells, each of which consists of a pair of resonators suspended from a connecting cord. Striking the resonators together makes an exquisite and long lasting ring that we can follow inward in meditation and prayer.

Although the bells had an enchanting sound, their prices were so low that Tsongkhapa was justifiably suspicious. Many bells were in the best Tibetan Buddhist artistic tradition with all the orthodox iconography, but a significant fraction was of the more primitive Bön variety. Tsongkhapa also noticed that some bells were made from a cheap alloy rather than bronze. Finally, some bells were so poorly constructed that they cracked after several vigorous rings. Given this poor quality control, Tsongkhapa wanted to know about the artistic merit, bronze content, and construction strength of the bells before filling the Gelukba monasteries with them. He could visually examine the bells to learn their artistic merit, or melt them down to analyze their bronze content, or determine the construction strength of a bell by finding the force required for gross deformation. However, these tests are mutually exclusive in that we can perform only one of them on a given resonator. This follows because the materials test (melting)

Figure 37. Tibetan bells

precludes the construction strength test (gross deformation), while both melting and deforming preclude artistic evaluation.

I intentionally exclude possibilities such as first ascertaining artistic merit and then melting or deforming. With this critical constraint, the tests are complementary in the quantum mechanical sense—we cannot perform them simultaneously on the same resonator, since they require mutually exclusive experimental arrangements. They are complementary like the wave and particle attributes of light discussed in the previous chapter. This is a significant departure from our normal experience in the macroscopic world, and it's a critical assumption if my macroscopic example is to work. Such complementarity pervades quantum mechanics, but we rarely encounter it in normal experience. Nevertheless, there is a psychological analog. The psyche is an unconscious-conscious unity, but experiencing one side of this unity precludes the simultaneous experience of the other. To be unconscious precludes conscious functioning and vice versa, yet one aspect of the psyche can never subsume the other, nor can we neglect one side and get a full picture of the psyche. In this sense, the unconscious is complementary to the conscious mind. This dichotomy and the simultaneous urge for unity, propels symbolism, which links the two realms, to the forefront of Jung's concerns. I have recently developed an analysis of complementarity in the psychological realm in detail elsewhere.[5]

Another way of appreciating complementarity is to recall that we invariably transform the unconscious when elements of it become conscious. Of course, this is at the core of the therapeutic process. The temptation in psychology is to ask, "What is the unconscious like, independent of our knowing of it." By definition, something unconscious must be like nothing we could ever know in the normal sense of conscious knowing. In a similar way, we might ask, "What is the resonator's strength when I know its bronze content?" Laboratory experiment and quantum theory converge here to tell us that the strength is not well-defined when I know the bronze content. It's not just that we require mutually exclusive experimental procedures to determine the strength (gross deformation) versus the bronze content (melting). That would be only an epistemological limitation. *The issue is ontological—the system, measured or unmeasured, does not simultaneously possess well-defined complementary properties.* Within a well-specified measurement situation—say we measure bronze content—we can only consider one of the complementary properties (the bronze content) to have a well-defined value; the others (both artistic and strength) are unspecified and unspecifiable. Again, I illustrated this principle of complementarity in the wave-particle duality discussion in the previous chapter.

From the psychological side, this is similar to realizing that it's wrong to consider unconscious contents as existing like other objects of consciousness—as simultaneously being unconscious and yet being objectively knowable like other objects. Unconscious contents, like quantum objects, exist more like tendencies or probabilities for action and meaning. In his synchronicity essay Jung says, "The archetype represents *psychic probability,* portraying ordinary instinctual events in the form of types. It is a special psychic instance of probability in general, . . . "[6] (the italics are Jung's).

So let's keep the complementary nature of the artistic style, bronze content, and construction strength in mind and return to Tsongkhapa's bells. Although preliminary testing showed that the resonators always seemed paired (both resonators of a pair always passed or failed the same test), the mutually exclusive nature of the tests frustrated Tsongkhapa's desire to analyze the bells more closely. For example, complementarity prevented him from simultaneously knowing the bronze content and strength of a given resonator. In fact, as stressed above, knowing one precludes the other from having a well-defined value. *Nevertheless,*

Reprinted from *Heart of Wisdom* by Geshe Kelsang Gyatso (London: Tharpa Publications, 1986) with permission of the publisher.

38. Tsongkhapa

let's continue with the natural, but incorrect, assumption that the properties are simultaneously well-defined, even if the mutually exclusive experimental conditions prohibit our simultaneously knowing these properties. This is the unconscious projection that we invest the world with so it's worth explicitly carrying it along, if we are clear about doing so. Some rival theories to standard quantum mechanics also make this assumption, but recent experiments, like the one discussed here, have proven them untenable.

To attempt to get around or circumvent complementarity, the bell salesman suggested the following elegant experiment. From a dispatching room in the center of the monastery, one member of the matched pair of resonators was taken to a testing room on the far left side of the monastery and the other to a testing room on the far right of the monastery. (See figure 39.) In the left room one bell resonator was given either test A (**A**rtistic style), B (**B**ronze content), or C (**C**onstruction strength). Which test to administer was randomly determined and the tests are all pass or fail. Passing the artistic test means the resonator's style is Tibetan Buddhist, passing the bronze test means it's all bronze, and passing the construction strength test means it's strong. Independently and randomly in the right room one of the three mutually exclusive pass-fail tests (A, B, or C) was performed on the other matched bell resonator.

Figure 39. Testing Tsongkhapa's bells

Many in the monastery (including the bell salesman) had occult powers, *siddhis*, so extreme care had to be taken in the testing procedure. To guard against any cheating or collusion, the fully random and independent selection of tests A, B, or C in the widely separated rooms was done so that no information about test selection or results could propagate between the rooms in time for this information to be useful in any cheating scheme. Physicists of all persuasions use the hallowed locality principle (no energy or information can travel faster than the speed of light) to guarantee that the two sides are completely free of interactions. Just as in isolating ESP subjects in the previous section, we use locality to isolate fully the left and right testing rooms. For example, imagine that the rooms are ten light years apart, the tests only require one second to perform, and the independent and random test selection occurs simultaneously in each room just one second before the test is given. Therefore, even if a salesman's assistant on the left signaled the test selection there to somebody on the right, this information would take too long to travel the ten light years to be useful for arranging a cheating scam. The locality principle thus precludes information exchange or influences between the sides. The two testing rooms are thus fully isolated. (Here I assume that locality constrains *siddhis*—it probably does not.)

Because of the complementary nature of the tests, a given pair of resonators can only have two different tests performed on them; for example, test A on the left with B on the right or test C on the left and B on the right. Now with an unlimited supply of bells for the proposed experiment, they perform these mutually exclusive past-fail tests a large number of times and collect the data. I use the following convenient notation: A-B denotes giving test A (**A**rtistic style) on the left and test B (**B**ronze content) on the right, while C-B denotes giving test C (**C**onstruction strength) on the left and B on the right, and so on. The data collected naturally divide into two cases: Case 1 when the tests on the left and right happen, through the random test selections, to be the same (A-A, B-B, or C-C), or Case 2, when the tests are different (A-B, A-C, B-A, B-C, C-A, or C-B). First, examine Case 1 data and reserve Case 2 for later.

Case 1 Data: When the *tests are the same*, both resonators always have the same
artistic style, bronze content, or construction strength and it's equally
likely that they will both pass or both fail any given test. We never find,
for example, that one is bronze and the other alloy, or that one is
constructed strongly and the other weakly.

This perfect correlation between the results of tests on both sides revealed in Case 1
data (when the tests are the same on both sides) is fully expected if the resonators are
truly matched pairs. However, without some theoretical assumptions, Case 1 data tells us
nothing about what we can expect for Case 2, when the tests are different on each side.

Einstein's Interpretation of the Experiment

In this section, with some details moved into the appendix, I'll develop an
interpretation of the data based on the assumptions that Einstein so eloquently defended.
Of course, he never actually made this interpretation since the work described here was
done many years after he died. Nonetheless, it's accurate to say that Einstein's lifelong
criticism of the foundations of quantum mechanics was the motivation for much of the
Bell Inequality analysis. In fact, the idea of separating the correlated systems for testing
came from one of Einstein's earliest and most influential criticisms of quantum
mechanics.[7] In a very real sense Einstein's presence hovers over all these discussions about
the foundations of quantum mechanics.

Einstein's early criticism of quantum mechanics does not contain his clearest
formulation of the philosophic issues. The best statement of his philosophical position is
from a 1948 paper in *Dialectica*. The following quotation goes brilliantly to the heart of
the matter. It's from the translation and commentary by Donald Howard.[8] Einstein expands
upon the theme of separability discussed in the opening quotation of this chapter.

> If one asks what is the characteristic of the realm of physical ideas independently of the quantum-theory,
> then above all the following attracts our attention: the concepts of physics refer to a real external world,
> i.e., ideas are posited of things that claim a "real existence" independent of the perceiving subject (bodies,
> fields, etc.). . . . it is characteristic of these things that they are conceived of as being arranged in a
> space-time continuum. Further, it appears to be essential for this arrangement of things introduced in
> physics that, at a specific time, these things claim an existence independent of one another, in so far as
> these things "lie in different parts of space." Without such an assumption of the mutually independent
> existence (the "being-thus") of spatially distant things, an assumption which originates in everyday
> thought, physical thought in the sense familiar to us would not be possible. Nor does one see how physical
> laws could be formulated and tested without such a clean separation. Field theory has carried out this
> principle to the extreme, in that it localizes within infinitely small (four-dimensional) space-elements
> the elementary things existing independently of one another that it takes as basic, as well as the
> elementary laws it postulates for them.
>
> For the relative independence of spatially distant things (A and B), this idea is characteristic: an external
> influence on A has no *immediate effect* on B; this is known as the "principle of local action," which is
> applied consistently only in field theory.

The principle of local action embodies the idea that the velocity of light is the maximum transmission speed for any information or physical effect. Since light speed is finite, there can be "no *immediate effect.*" Bell experiments (both Tsongkhapa's and John Bell's) use the locality principle to isolate each side and prevent any collusion or cheating between test selection or results on the left and right.

More important for this discussion than locality is the "mutually independent existence (the 'being-thus') of spatially distant things, an assumption which originates in everyday thought." Today we call this Einstein separability. Objects separated in space and therefore free of interaction are considered to exist independently, to have intrinsic well-defined properties. It's upon this fundamentally independent existence that relationships are built, but the relationships are considered less real, less fundamental than the "mutually independent existence" of the relata. Einstein firmly believes that it's not possible to do physics without this assumption from daily life. The opening quotation from this chapter alludes to this point.

Let's be clear. Einstein is just formalizing a principle "which originates in everyday thought." We usually believe that if objects are free of interacting then they have a mutually independent existence. This is such an obvious truth for Einstein (and most of us) that if this "being-thus" were absent then "physical thought in the sense familiar to us would not be possible."

In the appendix to this book, I use the reasonable assumptions that Einstein articulates as locality and independent existence to derive some limits on the correlations expected for resonator pairs when the tests are different on each side (Case 2). Although the argument can be done with just simple counting, it requires some close reasoning. I invite readers with a taste for such analysis to read the appendix. Here I'll only quote the results: *Assuming only locality, mutually independent existence, and Case 1 data, then any possible population of bells must yield the same test results at least <u>one-third</u> of the time when the tests given on each side are different (Case 2).* This is a special version of Bell's Inequality.

With this theoretical analysis in hand, let's return to the monastery. There Case

40. Albert Einstein

2 data shows that tested resonators score the same results exactly *one-fourth* of the time when the test combinations are different! Since Tsongkhapa and his assistants carefully give the tests to so many resonators, they have excellent statistics. There is no doubt that the test results are the same exactly *one-fourth* of the time when the tests on each side are different—an impossibility according to Bell's Inequality showing that the minimum correlation is *one-third*. This experimental violation of the Inequality implies that one or both of the critical assumptions of locality and mutually independent existence must be wrong. It also shows that the bell salesman could not beat complementarity after all, because he could not reliably measure two properties at once with this scheme.

If we replace the resonator pairs with correlated photon pairs and the pass-fail tests with randomly selected polarization measurements perpendicular to the line of flight of the photons, then we have the actual experiments[9] violating Bell's Inequality and confirming the predictions of standard quantum mechanics. The correlations are not dependent upon distance. They grow neither stronger nor weaker with the separation between the left and right measurements.

Physicists find this analysis compelling for several reasons. First, the assumptions of locality and independent existence or Einstein separability are extremely reasonable assumptions. Einstein goes so far as to say that "Without such an assumption of the mutually independent existence (the "being-thus") of spatially distant things, an assumption which originates in everyday thought, physical thought in the sense familiar to us would not be possible." Second, the logic and mathematics of the analysis are now well-understood and they are beyond reproach. Third, physicists have repeated the original elegant and difficult experiments in a variety of forms with the same results. In short, from very fundamental principles with a minimum of reasoning, Bell's Inequality has been carefully derived and then repeatedly shown to be violated by very convincing experiments.

What Went Wrong?

Given that both the experimental protocol and the theoretical analysis are sound, what assumptions are wrong? The prevailing view assumes locality since it pervades all physics, but relaxes the demand for separability or "mutually independent existence," especially since quantum mechanics avoids this assumption and yet accurately predicts the proper correlations. So my hero Einstein is simply wrong when he says in the quotation that opens this chapter, "But on one supposition we should, in my opinion, absolutely hold fast: the real factual situation of the system S2 is independent of what is done with the system S1, which is spatially separated from the former." We may not assume that objects such as correlated photons (or resonators) have well-defined natures independent of experiments performed far away (even light years away!). Because locality holds, it's also wrong to believe in faster than light communication between the left and right sides.

If we were, on the other hand, to relax the assumption of locality and allow instantaneous action at distance then we still could not say "the real factual situation of

the system S2 is independent of what is done with the system S1, which is spatially separated from the former." With instantaneous action at a distance the "real factual situation" becomes very ambiguous if not meaningless, since something infinitely far away can instantaneously affect it—hardly what we would call having an independent existence. In standard quantum mechanics there is no instantaneous action at a distance, because there are no independently existing objects that communicate superluminally, that is, faster than the speed of light. Nevertheless, the system of correlated photons of arbitrary separation acts more like one system than any classical system. Communication from one end of a classical system to another can only happen at the speed of light or less. The experiment here shows that this type of communication could not give the measured correlations. We are seeing here a mysterious level of interconnectedness that is more interdependent, more profoundly related, than we can imagine.

In summary, nonlocality or nonseparability is asking us to revise completely our ideas about objects, to remove a pervasive projection we have upon nature. We can no longer consider objects as independently existing entities that can be localized in well-defined regions of spacetime. They are interconnected in ways not even conceivable using ideas from classical physics, which is largely a refinement and extrapolation from our normal macroscopic sense functioning. It's worth repeating that the interconnections spoken about here are not like those in classical physics, which are limited by the speed of light. These are instantaneous interconnections. These quantum correlations reveal that nature is *noncausally* unified in ways we only dimly understand. We are so used to conceiving of a world of isolated and independently existing objects that it's very difficult for us to understand what the experiments are telling us about nature. They are truly confronting us with the demand for a major paradigm shift at the foundations of science and

philosophy—one with enormous implications for fields well beyond the boundaries of science and philosophy. It will take time for this view of nature to be fully understood and to penetrate the collective psyche. Nevertheless, it certainly provides a much more congenial world within which to understand synchronicity than the Newtonian world of independently and separately existing entities acting causally upon each other within an absolute space and time.

41. John Bell

Photo supplied with permission by Media Services at CERN the European Laboratory for Particle Physics, Geneva, Switzerland.

This Bell analysis has been generalized to deal with the complication of theories that only assume probabilities rather than definite values for object properties. I have dealt with that elsewhere.[10] For the present purposes, no essential complications are involved.

Let me point out that this analysis is unusual because it's a pure negation that establishes no replacement model in the normal sense. We have explicitly assumed locality, the mutually independent existence of objects, deduced expectations for correlation, and then found experimentally that they were wrong. This denies our original assumption, but does not substitute anything concrete in its place. In fact, denying independent existence rules out a large range of possible explanations—all those involving independently existing properties. All we can say is that the correlated objects are deeply dependent, interconnected, entangled in ways we cannot explain using local interactions. This interdependence is a more profound truth about their nature than their relative independence. As I'll show in the next chapter, Middle Way Buddhism also involves a massive negation, one that also does not substitute any new reality in the place of what is negated. In fact, it explicitly denies that any substitution should take place and that this negation is the highest truth about all objective and subjective entities.

Revising Our Understanding of Mind and Matter

In this book I have been discussing the standard Copenhagen interpretation of quantum mechanics, one developed by Bohr (who headed the effort at his institute in Copenhagen), Heisenberg, Born, Pauli, and others. Even within this interpretation there are variations in the view of the relation of mind to quantum mechanics. The most conservative and most orthodox interpretation (the one I have been taking throughout) is that of Bohr who carefully distanced himself from any invocation of mind to understand the details of quantum mechanics. But despite being actively involved in formulating the Copenhagen interpretation, Heisenberg and Pauli clearly referred to the role of mind in physics. It's also clear, judging from both the literature and the discussions that occur at conferences on the philosophic foundation of quantum mechanics, that the orthodox interpretation is losing its grip on the physics community.[11] Now it's more of a standard to pay homage to and then depart from, rather than one to follow rigidly.

From the beginnings of the development of quantum mechanics there have been physicists who attempted to include some form of mind or consciousness into the foundation of quantum mechanics. They believed that quantum theory could only be understood by making explicit appeal to the functioning of mind. They were usually considered the radical fringe and out of step with the materialistic and positivistic currents of thought of the day. Today there are modern thinkers[12] who are still trying to solve the mind-matter puzzle by incorporating mind in their work at the foundations of quantum mechanics. They are generally trying to build a quantum mechanical theory of consciousness, to understand mind within quantum theory.

Although I applaud these approaches, mine is different. First, I want to draw inspiration from the contemporary view of the physical universe provided by modern

physics. I want to employ facts in physics that are nearly universally agreed upon, such as the ideas discussed in the last several chapters. For my purposes it is best not to appeal to the more controversial and less developed views on mind in some interpretations of quantum mechanics. Second, I want to employ the particular view of mind that follows from depth psychology and a modern understanding of ancient liberation philosophies. From these two inputs I then build a unified philosophic view that synthesizes the ideas from modern physics with those from depth psychology and Eastern philosophy. In other words, rather than understand mind from within quantum mechanics, I attempt to understand both the revised views of mind and matter from within a unified philosophic view.

Whichever approach we take, if we are to solve the mind-matter problem posed by thinkers, both ancient and modern, and raised in a particularly sharp empirical form by the synchronicity phenomena, we need a radical change in our conceptions of both mind and matter. As in any marriage, to attain a greater unity both partners must change, must adapt themselves to the reality of the other, so that something greater than their separate individuality may emerge. In the last few chapters I focused on the change in our notion of matter, which I metaphorically consider as the bride. In later chapters I'll discuss the revisions needed to our understanding of mind, metaphorically considered as the groom.

Synchronistic Interlude 6
The Philosopher's Stone

For as long as I can remember a question has repeated itself continuously in my mind. It is: Who and what am I? I have carried it for years through studies in psychology and philosophy and it has been the foundation for many hours of meditation.

With each new tool I find to use in this investigation, there arises a different look at the puzzle. Some answers I've found could be applied to any person asking the question, while others could only apply to me with my personal makeup.

The following story is one of the latter. You will see that anyone could read the books I was directed to read, but the way they were chosen was very specific and tailored to answer my question in a way suited to my needs at the time, in a way that I could assimilate, given my previous inquiry.

It began with a friend of mine telling me the name of Seneca Lake in Havdensvanee, or Iroquois, *Ganadasege ti karneo dei*. He told me the spirits of the lake love to hear the old name as no one says it much anymore. "They respond," he said.

I am a person who believes in the living nature of our surroundings and so, without much hesitation, decided it was a friendly gesture to go to the lake and chant its name. I frequent a particular beach, so I gathered my coat, hat, and my mother, who was visiting me, and headed to the beach one cold blustery October morning.

My mother, accommodating another of her daughter's kooky whims, chanted the old name of the lake for a while too as we walked the shoreline. At one point I felt a rush of warmth. I paused, then continued to walk. It got cold again. I backed up, there was the warmth again. It felt as if it were in a four to five foot radius. I stopped, feeling that I needed to hear or see something. I looked down at the ground and as my eyes scanned the small rocks below my feet, I saw a face looking up at me.

Photo by Victor Mansfield.

42. A stone on the beach

It was a stone with two holes for eyes, two small nostril holes, and a large hole for the mouth, open as if it were singing a song. There was a rush of recognition, a feeling of deep meeting.

I stopped chanting and picked up the smooth stone. It was the size of a plum. Not only did it have the "face" holes, but one running down its "back," from the top of the head to the base. It was warm.

My mother just stared. I could hear strains of the "Twilight Zone" theme music running in the background of her mind.

The Spirits have responded, I thought. I brought the stone home and for a few weeks kept it by my bed. At night before sleep, I would ask, "What song am I to hear?" I listened, but there was no answer.

My brother-in-law came over one night, saw the stone, and picked it up. "Interesting," he said. He put it to his lips and blew into one of the holes. The sound of air could be heard. Suddenly a loud whistle came forth. Like an ocarina, we could play the stone, producing eight different clear tones. We named it "the singing stone." I continued to ask it what I was to learn, what song was I to hear.

The answer came late one night. I had been at a philosophy class and got home around 11:30 P.M. It was a beautiful starry night, clear and cold. I spent some time outside gazing into the night sky, when I felt that I should go in and look at my bookshelf. When I got there, I was drawn to two books. One, a Native American story book, and the other by Ramana Maharshi, a Hindu sage.

I opened the first book, the words before my eyes read, "The Story of the Singing Stone." A chill ran over my body. I sat and read. It was the tale of a young woman looking for the Singing Stone, supposed to be magic for the one who found it. The tale described her adventures through the four directions searching for it. The result was this. She ends up on a bluff with her family below. They looked up and upon seeing her hold out their arms and say, "Welcome home Singing Stone."

She was Singing Stone. The Singing Stone was she herself.

The book went on to interpret the tale as addressing the question "Who am I?"

I then felt compelled to go on and pick up the second book. I opened it. The chapter title read, "Who am I?" Another chill ran through my body but this time it was accompanied by a certain sense of reverence.

The stone had answered me! And this was the song.

A joy welled up inside. I read every word of that chapter with great interest.

In the text, Ramana Maharishi suggested ways to contact the Pure Self or Silence that is the true nature of who we are. He detailed the distinction between our thoughts, the "I," and the awareness,

Photo by Victor Mansfield

43. The Singing Stone

underlying both those objects. The suggestions about how to access this Pure Self or Silence were taken by me to be the next step in my search.

This example is unusual in that the woman seemed to provoke the experience by the very intensity of her concern with the question of "Who am I," her chanting to the lake, and her imploring the singing stone. But in fact, all major synchronistic experiences arise out of a sea of emotional intensity, out of the realm of archetypal compulsions and fascinations. Therefore, Jung associated synchronistic experiences with the archetypes. He says,

> The archetypes are formal factors responsible for the organization of unconscious psychic processes: they are "patterns of behaviour." At the same time they have a "specific charge" and develop numinous effects which express themselves as *affects*. The affect produces a partial *abaissement du niveau mental,* for although it raises a particular content to a supernormal degree of luminosity, it does so by withdrawing so much energy from other possible contents of consciousness that they become darkened and eventually unconscious. Owing to the restriction of consciousness produced by the affect so long as it lasts, there is a corresponding lowering of orientation which in turn gives the unconscious a favourable opportunity to slip into the space vacated. Thus we regularly find that unexpected or otherwise inhibited unconscious contents break through and find expression in the affect. Such contents are very often of an inferior or primitive nature and thus betray their archetypal origin. As I shall show further on, certain phenomena of simultaneity or synchronicity seem to be bound up with the archetypes.[1]

Within the world, out of the most common and ubiquitous things—stones—we find a traditional symbol of the self, the divine spirit manifest on Earth or spirit within matter. This symbol is even more compelling because it has the face of a person in it, one who can sing to the owner when she applies her breath, or inspiration, to it. Accompanying photographs of the "singing stone" show just how much it looks like a very expressive face. My inspection of the beach where it was found also shows how difficult it would be to pick the small stone out from among its innumerable companions on the lake shore. Its human appearance and the events surrounding its discovery make it easy to understand how this stone is a compelling carrier of the archetype of the self. Here is an example of acausal meaning manifesting both in the inner and outer realms so that the recipient is moved along her path to individuation. The revelation of this greater meaning is always a numinous experience. As von Franz says, "Synchronistic events constitute moments in which a 'cosmic' or 'greater' meaning becomes gradually conscious in an individual; generally it is a shaking experience."[2] Or if it does not "shake," it fills the recipient with religious devotion. As the woman above said, "I had been given a gift." Or as Jean Shinoda Bolen says, "Every time I have become aware of a synchronistic experience, I have had an accompanying feeling that some grace came along with it."[3]

The Bridge to Philosophy

Having clarified the definition of synchronicity and discussed some of its chief implications and scientific challenges, it's now time to build a philosophic model for it. Is there a rational world view within which synchronicity is both natural and understandable? In such a world view what is the role of the psyche and how does it relate to the outer world, to matter? How does the pivotal aspect of meaning in synchronicity relate to these two principles? I address these questions while returning to the familiar four themes of meaning, acausality, spacetime, and unity of mind and matter. In these last six chapters I attempt to build a bridge between depth psychology and modern physics on one side and a philosophic view that rationally accommodates synchronicity on the other side.

In crossing the bridge to philosophy we encounter two major ideas: one a vast denial or negation and the other a vast affirmation. The philosophic heart of Northern Buddhism, the principle of emptiness, denies that anything, whether subjective or objective, exists independently, separately, or inherently. It's not that things don't exist conventionally and function to bring us help and harm, but they don't exist independently or inherently, as we incorrectly believe. This emptiness principle, which I review in some detail, attempts to destroy the barrier of separateness that we inveterately believe severs us from the physical world and makes synchronicity so difficult to appreciate.

I begin this philosophic section of the book by discussing emptiness in chapter 10, entitled "Middle Way Buddhism: Structure." This radical principle of emptiness has extraordinarily close ties with the physics just discussed. As we'll see, emptiness is a generalization of the denial of mutually independent existence encountered in the Bell Inequality analysis. Unlike traditional presentations of emptiness, which rely heavily on arguments that sound stylized and puzzling to Western ears, I present the philosophic, psychological, and ethical demands of emptiness without emphasizing the traditional dialectical arguments.

Photo by Victor Mansfield.

44. The bridge to philosophy

In chapter 11, "Middle Way Buddhism: Applications," I apply emptiness to both psychology and physics. I show that emptiness can help us avoid some pitfalls on the path to individuation. This view also provides a broad, radically non-Cartesian, philosophic framework within which to understand many ideas in modern physics. However, its denial of independent or separative existence is, like the preceding physics analysis, more of an antidote to our false belief in separative or inherent existence rather than a positive explanation of synchronicity.

Having discussed this vast denial, emptiness, I then go on to develop an equally vast affirmation, the idea of mentalism, a particular form of idealism, which says that all we ever experience are thoughts within our individual minds. Very briefly, mentalism declares that even the most physical of experiences, whether mountains or microbes, are thoughts within a larger mind that simultaneously unfolds the experiencing ego as a thought complex within it. Understanding mentalism requires a major expansion of our view of mind. It is only such an expanded vision of mind that allows for the possibility of unifying it with the quantum view of matter previously discussed. As we'll see, close ties exist between emptiness and mentalism. However, the unified world view of mentalism contains much richer opportunities for understanding synchronicity.

A philosophic model for understanding synchronicity begins in chapter 12, entitled "The Psychological Standpoint: Virtues and Vices," where I examine what Jung calls his "psychological standpoint." Understanding this allows me to make a psychological criticism of his position, but more important, it provides a good starting point for mentalism. Many puzzles are both solved and raised by mentalism. Some of these are answered in chapter 13, "A Philosophic Model for Synchronicity," which presents a model that accounts for the meaning, acausality, spacetime transcendence, and unity seen in the synchronicity examples throughout this book.

In chapter 14, "Weaving Harmonies and Revealing Dissonances," I interpret a famous experience Jung had in Africa as a device for integrating many of the ideas in the book. Some tensions or dissonances exist between both the theory and practice of Jung's psychology and the philosophy of liberation presented here. I explore the dissonances and suggest some ways of making harmony, although there is still some tension between the viewpoints.

The book concludes with chapter 15, "Synchronicity and Individuation," in which I apply the main themes to understanding synchronicity and its relationship to individuation. I include a cautionary note on the difficulties of interpreting synchronicity experiences.

10 The Structure of Middle Way Buddhism

In particular, there is a growing interest among the scientific community in Buddhist philosophical thought. I am optimistic that over the next few decades there will be a great change in our world view both from the material and the spiritual perspectives.

Fourteenth Dalai Lama[1]

The Crisis of a Prince

According to the tale told about the origins of Buddhism, there once was a prince with a devoted wife. But her anxiety about him had been growing for weeks. Outwardly he was as loving as ever. He did take joy in their new son. Nevertheless, he took no delight in the luxuries of courtly life, in the refined pleasures that always occupied so much of their time. His interest in ruling the kingdom had vanished. His beautiful wife first noticed his distracted look, the dark shadows haunting him with increasing frequency, after he returned from his explorations of the nearby village. The king tried to discourage him from going there, telling him there would be little of interest in a simple village. Through court gossip, she had learned that every time the prince visited the village the king first had his servants remove all the beggars, the sick, and aged.

Years earlier, when the prince grew into manhood and displayed his astounding talents, the king became convinced of the prophecies made at his son's birth: he would be either a great religious leader or a world conqueror. The king spared no effort to shelter the sensitive prince from the cruel realities of life, feeling that these would only drive him into religion. The king was grooming his son to be a great ruler, to turn his brilliance toward building their kingdom.

However, since visiting the village, the prince became increasingly withdrawn. Although he was as gentle as ever, his wife could not help noticing his heavy heart. She found it nearly impossible to make him smile. His infectious laugh that so often echoed in the stone halls of the palace was only a distant memory. Late one night, she tearfully pleaded with him to tell her what was troubling him. He confessed that in his explorations of the village, despite the king's efforts, he had seen some truly pathetic old, sick, and dying

people. Of course, he had understood as a child that our stay on earth was finite, but gazing into the eyes of a dying man he realized how much we all avoid facing the certainty of our own death, the truth that we too will grow old, weak, and racked by pain, that we will be torn away from all we love, all that we have built. He too, the gifted son of privilege, loved by his family, revered by his kingdom, will some day be forced to leave all this behind, more helpless than the day he was born. This realization threw him into an abyss of doubt and despair.

What is the meaning of this cruel reality? He must understand. In the same village, on a later visit, he met what today we call a *sadhu,* a wandering holy man, who radiated an air of wisdom and tranquillity. The *sadhu* promised him that the answer could only be found by giving up everything and living an ascetic life of meditation and detachment in the forests. Despite his great love for his wife, family, and the pleasures of courtly life, he had to leave to discover the meaning of this merciless hoax imposed on us. He was loath to cause his family pain, but his need to understand drove him out of his hermetically sealed courtly paradise.

In the forest he applied himself with his customary intensity to yoga, meditation, and austerity. Being an apt student he soon outgrew the original teacher and moved on to others. Even after many years he still had not fully answered his questions. He redoubled his efforts in fasting and meditation to the point where he nearly died of them. Realizing that excessive austerity was not the answer, he took some food to regain his strength. The few disciples he had attracted thought he had gone soft and repudiated him. Indifferent to them, he plunged deeply within himself. After a colossal struggle with his lower nature, he achieved a state of egoless being, of liberation from the bondage of ignorance and suffering, a complete transcendence of all opposites. Prince Siddhartha Gautama was utterly transformed into the Buddha—the fully enlightened one, a titan among a long line of spiritual giants of India. The religious landscape is still feeling the earthquake from his enlightenment of 2500 years ago.

Through his experiences and his forty years of teaching, he drew a group of devoted followers. After four centuries of oral tradition they wrote his message into the Pali Canon, which in turn was further developed in a variety of other writings. Buddhism evolved, splintered, and migrated all over Asia, always taking on a new coloration and new emphasis with each of its transplants, but still maintaining the original spiritual impulse. It migrated from Northern India to Tibet, China, and Japan in the North and to Burma and Thailand and beyond in the South. In our century it has even moved to the West. The evolution and transformation of Buddhism have resulted in a luxurious brocade of schools, sects, and lineages. Each provided a creative development, revitalization, and enrichment of the original spiritual breakthrough of the prince.

The life of Prince Gautama is shrouded in mythology, all of it instructive, but little of it historically certain. My imaginative description of his crisis is true to the usual story but not to be taken literally. What is much more certain are the theory and practice of Buddhism today, to which I now turn.

The Four Noble Truths and Impermanence

The Buddha's enlightenment experience and his four decades of teaching eventually produced an enormous variety of commentary and interpretation. Each school evolving from the original spiritual impulse has its own point of view. A discussion that only dealt with those doctrinal elements that are widely agreed upon in all Buddhist sects would be superficial. Instead, I'll discuss the Northern schools, in particular, Middle Way and Mind Only Buddhism. In this chapter I'll restrict myself to Middle Way Buddhism (actually the Consequence School within Middle Way Buddhism). Today this is the dominant school in Tibetan Buddhism. This school provides some direct and profound connections to both quantum physics and synchronicity. Two chapters later, I'll make some references to the Mind Only school of Buddhism that evolved out of the Middle Way school. In a sense, my presentation will echo the historical evolution of these two schools.

After all that name dropping about individual schools within Buddhism, it is fair to say that all branches revere the Four Noble Truths and the principle of impermanence, two core doctrines that sprung from the cosmic vision of the prince two and a half millennia ago. The Four Noble Truths simply put are:

1. Suffering characterizes or suffuses all experience.
2. Desire or grasping causes suffering.
3. Permanent freedom from all suffering is possible.
4. The path of intellectual understanding and meditation taught by the Buddha can permanently release us from suffering.

The Four Noble Truths make up two sets of causes and effects: First, desire causes suffering. Second, the Buddha's wisdom and methodology cause permanent cessation of suffering.

Before discussing the Truths individually, it is worth noting that Buddhism is distinctly nondogmatic. The Buddha and modern teachers such as the present Dalai Lama emphasize that we are not to believe any aspect of Buddhism merely because some authority has espoused it, but only if it is consistent with both our understanding and experience. The Dalai Lama goes even farther and says that if scientific analysis convincingly refutes a core Buddhist position then the Buddhist must give up the view. For example, "Buddhists believe in rebirth. But suppose that through various investigative means, science

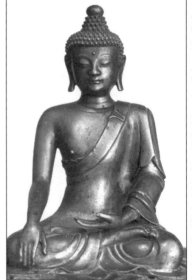

45. A seventeenth-century Chinese Buddha

Photo by Victor Mansfield, taken in Colgate University's Chapel House, taken with the permission of Professor John Carter.

one day comes to the definite conclusion that there is no rebirth. If this is definitively proven, then we must accept it and we will accept it. This is the general Buddhist idea.[2] Such an attitude is obviously appealing to modern Westerners. Nevertheless, the Dalai Lama also appreciates the limitations of science, especially in moral and spiritual matters. In the Buddhists' nondogmatic spirit, let's investigate the Four Noble Truths.

When I first studied Buddhism, it seemed like a depressing creed with its emphasis on suffering. When we are young, healthy, full of promise, and in love, it is hard to imagine that suffering characterizes *every* experience. There seems to be so much joy in various pleasures, both simple and complex. Nevertheless, a little reflection shows that even the most joyous experiences are transient and soon followed by some form of disappointment and new desires demanding fulfillment. Yes, the Buddhists agree that the attractions and delights of the world are obvious. But they insist that these pleasures give only the most fleeting satisfactions, which are inevitably and quickly followed by dissatisfaction and desires propelling us onward in our fruitless search for lasting happiness. They emphasize that even the greatest joys have buried in them the seeds of suffering. Many reflective people have realized this. For example, in Giuseppe Verdi's glorious opera, *La Traviata,* the ecstatic lovers repeatedly sing about love as *"croce e delizia,"* as having inherent in it both the suffering of crucifixion and the delights of transporting bliss. Even a loving relationship with a minimum of difficulties must face the reality, from which we desperately try to hide, that it must all end. The warm tenderness, the affection, the caring that started in such sweet desire will all be wrenched away from us by cold death.

Isn't this morose, morbid, and melancholy? The striking thing is that the Buddhists I have known and studied with, from high Tibetan Lamas to novice Chinese nuns, are uniformly the most cheerful and positive group of people imaginable. Perhaps their coming to grips with the truths of suffering and impermanence allows them to face life with a genuinely positive attitude.

Of course, from a psychological point of view our desires not only generate suffering, as the second Noble Truth claims, but they draw us into life. They help us define ourselves, differentiate our unique set of talents, and become creative individuals. However, the Buddha is not interested in the process of individuation. His insight was that all psychological development is both endless and ultimately unsatisfying. Jung himself often admitted that the contents of the unconscious are inexhaustible; we work through one projection or complex only to be immediately confronted with another. Psychological development by itself will never quench our desires and the suffering springing from them. The Buddha seeks complete and permanent transcendence of all suffering—freedom from the play of all opposites while alive. The third Noble Truth claims such a permanent superhuman state is possible.

In contrast to this permanent freedom proclaimed in the Noble Truths is the Buddhist emphasis on the impermanence of everything in the world, including ourselves. This impermanence or momentariness, this continuous transformation of everything (except enlightenment), this lack of a fixed or stable nature in all things, is doctrinally central.

As we will see, it flows from the principle of emptiness. For now it is enough to appreciate that this universal impermanence or momentariness is continuously kept in a good Buddhist's mind. They directly confront impermanence and use their realization as incentive to penetrate appearances and practice the Buddhist path. For example, the present Dalai Lama, a tireless spokesman for Middle Way Buddhism, says:

> When we die, our body and all its powers are lost. Possessions, power, fame, and friends are all unable to accompany us. Take me for example. Many Tibetans place a great deal of faith in me and would do anything I ask; but when I die I must die alone, and not one of them will be able to accompany me. All that one takes with one are knowledge of spiritual methods and karmic imprints of one's life's deeds. If throughout one's life one has practiced spiritual methods and learned the meditative techniques that prepare the mind for death, then one will maintain confidence and will be able to deal effectively and fearlessly with the experiences that occur at death.[3]

Each branch of the great tree of Buddhism has slightly different interpretations of the Fourth Noble Truth that announces that the Buddha's intellectual understanding and meditation, his wisdom and method, can free us from all suffering. In other words, the "spiritual methods" and "meditative techniques" mentioned by the Dalai Lama differ from one school to the next. I'll focus on the Middle Way school's view. They claim that the Great Healer, the Enlightened one, can cure our disease with the medicine known as

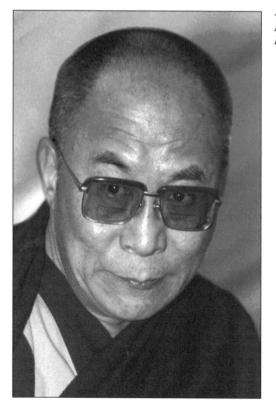

46. The Fourteenth Dalai Lama

Photo by Victor Mansfield.

emptiness and that this requires philosophic understanding, meditation, and the practice of universal compassion.

The Arrow of Inherent Existence and Middle Way Emptiness

A man walking through a lonely wooded area is shot by an arrow. He falls heavily to the ground and in his pain and panic realizes he will soon die. A Bodhisattva, or being of universal compassion, happens upon him and promptly gives aid. The Bodhisattva realizes that he must immediately remove the arrow, if the victim is to survive. This will prove a painful process, since it is deeply embedded in the man's chest. Just as he begins to withdraw the arrow the victim asks him, "Friend, who shot the arrow? Why did he shoot it? What kind of arrow is it? How is it decorated? From what direction did it come?" The victim seemed interested in everything about the arrow and its shooting except removing the deadly missile and thereby insuring his survival. Because of his delaying questions, the victim painfully expired.

My embellishment of a traditional Buddhist story from the Pali Canon illustrates the Buddhist view of the human predicament and their attitude toward philosophical discussion. They claim that a lethal arrow has struck each of us and we are repeatedly dying painful deaths. The first task is arrow removal, not spinning off into deadly mental digressions or self-aggrandizement. Philosophic analysis is only of real value for the Buddhists if it frees us from suffering. In this spirit, I'll briefly describe the arrow (you must identify it to remove it) and then discuss the technique for arrow removal in Middle Way Buddhism.

In Middle Way Buddhism, emptiness is a denial of a particular type of existence, inherent existence, something that could never be. Our false belief in inherent existence is the murderous arrow lodged in us all. Middle Way analysis first requires a careful identification of this arrow of inherent existence. If we too broadly define inherent existence, nihilism follows—then nothing exists. On the other hand, if we too narrowly define it, eternalism results—then persons and objects have an eternal nature, something vigorously denied by the Buddhist principle of impermanence. So we must carefully avoid these two extremes that the "Middle Way" considers heinous philosophic crimes. The Middle Way is not a blending of the two extremes but a thoroughgoing refutation of both.

The Middle Way Buddhists claim that fully assimilating the doctrine of emptiness frees us from the suffering of *samsāra*, from the beginningless and inevitable round of birth, aging, suffering, and death. This exalted condition of a Buddha, a fully enlightened one, means that we transcend all pairs of opposites: *samsāra* and *nirvāna* are not different. Fully assimilating emptiness transforms us from self-centered individuals shrouded in ignorance to completely enlightened Buddhas, embodiments of wisdom and compassion. At last, the philosophic panacea! What is more, as I hope this chapter will show, an elementary discussion of emptiness is not hard to understand. Then you might rightly ask, "How come there are so few fully enlightened Buddhas around?" The problem comes

in understanding what "fully assimilating" means. Although with some effort it is possible to understand emptiness intellectually, this is not enough for arrow removal and buddhahood. Deeply appreciating or fully assimilating emptiness requires an enormous transformation at all levels of our being. Relentless philosophic reasoning must be supplemented with equally rigorous meditation and combined with the immense ethical transformation required for practicing universal compassion—the fervent desire for the liberation of all sentient beings. The ideal is the Bodhisattva, the being of compassion, who seeks liberation primarily to eliminate the suffering of others. The Bodhisattva seeks altruistic service before self-satisfaction. Emptiness is the most precious of wish-fulfilling gems. However, as we might expect, the price is high—one, they tell us, requiring many lifetimes of dedication.

The fulfillment of the Fourth Noble Truth requires our personal understanding, meditative experience of the truths of Buddhism, and ethical actions that spring from our understanding and inner experience. Faith and devotion, although helpful, are no substitute for personal attainment or penetrating directly into the truth of the world and our own being. We cannot expect a supreme creator to save us. Our *karma* (the consequences or fruit of our past actions that carry over from one life to the next) got us here and only our self-effort will free us. It's true that there are deities in Buddhism you can worship, but even they are subject to karma, impermanence, and the Four Noble Truths. Even they must incarnate in the human form to obtain, through their own hard effort, the permanent attainment mentioned in the Noble Truths. They too must fully understand emptiness. So let's see if we can get a little deeper appreciation of it.

As I write this, I am looking out my office window at an old apple tree. My memories of it certainly condition my view of it—the fragrant blossoms in the spring, the juicy apples in the fall, the birds clustering about the feeder hanging from it in the winter snow. The limitations of my senses obviously condition my experience of it too. My dog has a richer olfactory experience of the tree. He does not just smell its blossoms in the spring or rotting apples on the ground in the fall. His experience consists of a much richer harvest of apple tree smells—"Hmm. . . . Must have been that young male dog from down the road who left his scent here a few hours ago." When the breeze blows through the leaves and branches he also hears higher-frequency sounds than I do. The bees playing about the spring blossoms also see ultraviolet light that my eye fails to register. The blue jay and cardinal competing for the feeder in the tree branches have yet a different relationship to the tree. Nevertheless, even accounting for my psychological associations, my personal concerns about the tree, and the limitations of my senses, I have no doubt that the tree exists independently of me, that the tree has some existence either beyond or beneath my memories, concerns, and sensory experience of it.

Yes, relativity teaches that our view of the tree is deeply dependent on our reference frame, that so many properties we believe independently exist are frame dependent. Quantum mechanics teaches that the universe is nonlocally connected and we participate in its definition. Nevertheless, we all instinctively believe that the tree must have some

independent or inherent existence that somehow transcends all these relations and limitations. Otherwise, how could my children have climbed that tree or my wife have worried about it casting too much shade on her nearby flower bed?

Stated more philosophically, we all unreflectively believe that the tree has some inherent or independent existence, that it exists "from its own side" as the Middle Way Buddhists say, despite our psychological associations, sensory limitations, and the findings of modern physics. By unreflectively I mean pragmatically, in the world of action, as when I worry about whether the rotting in its trunk will force me to cut it down next year before it falls against my house. Yes, we may hold various philosophic positions about the ultimate nature of the tree, but the unreflective, everyday, untutored view is the one to consider here. From that point of view we all believe that beneath or behind the associations, sensory impressions, and linguistic conventions surrounding the tree, there is an inherently or independently existing tree. We all believe that this inherent existence ties together all our diverse experiences of the tree and accounts for its shared objectivity—that we can all agree it is this particular tree in question, not some fantasy, but a real tree that bears fruit.

Got it? Well that inherently existing tree is just the one the Middle Way Buddhists claim never existed and could never exist! The denial of this inherently existing tree is precisely the doctrine of emptiness—that all objects utterly lack inherent or independent existence. This does not mean the tree does not exist (the extreme of nihilism), but that it lacks independent or inherent existence. If this seems shocking or absurd then you are really getting the taste of what emptiness is about. This shock is also partly due to our Western preference for affirmations such as "The supreme intelligence is God," rather than the massive negation that is emptiness. However, there is much more to say about emptiness.

Let's consider the subjective side of emptiness by way of an anecdote. A few years ago I got the strong urge to go canoeing on a nearby lake. I've always enjoyed canoeing since my childhood and the beautiful late spring day seemed to cry out for it. A friend lent me his canoe and my wife and I were soon paddling along the shoreline enjoying the beauty and peace of nature. We were both extolling the beauties of Seneca Lake and saying how conducive canoeing was to a relaxing and aesthetic appreciation of nature. Suddenly a water skier was heading straight for us at top speed. He veered to the side at the last possible moment thereby completely drenching me and my wife with cold water. Sputtering disbelief, shock, indignation, then rage—all exploded inside me. "That damn kid! If he tries it again, I'll stand up in the canoe and whack him with the paddle! How could he do that to me . . . *to me?!*" After a few moments of intense indignation I began to laugh heartily, marveling at how quickly my feelings changed from nature mystic to Attila the Hun, from the aspiring Bodhisattva to bloodthirsty monster. I also guiltily recalled how often the Buddhists emphasize the control of anger. For example, they say, "How are we harmed by our anger or hatred? Buddha has said that hatred decreases or destroys all our collections of virtue and can lead us into the lowest of the hell realms."[4]

However, the main point here is a philosophic one rather than a moral one—although in Buddhism they always closely connect. From the philosophic perspective, the Middle

Way Buddhist notes that right at the height of my indignation there was a clear experience of the I—the one we all firmly believe inherently or independently exists. Certainly I had no concern for "turning the other cheek" or for the doctrine of Universal Compassion or any such pious principles. But the critical thing is the I, the "me" believed to exist independently, standing in bold relief in the light of my indignation.

It is easy to be led astray by the anger in my story, but that is not the point. The important thing is that at these times we can most easily see the powerful sense of I or me. Perhaps another simple example will make this clear. Imagine an academic who is wrongly accused of some gross form of plagiarism. His shock and disbelief will quickly turn to indignation. "*I* would never do such a thing! *I* am scrupulously honest about that sort of thing," he might exclaim. Right at the height of his indignation there is a very strong sense of an I, one unjustly accused, honest, and thinking frantically how he can clear his good name.

This I or me that we instinctively believe inherently or independently exists is thoroughly denied in the doctrine of emptiness. The Middle Way Buddhists also go well beyond denying this coarse or low level of the ego. That is just the beginning of their no-self doctrine. They claim that *any* identifiable level of subjectivity is empty of independent existence. Tenaciously clinging to the false belief in an independently existing subject or a self is the primary cause of our suffering, of our bondage to *samsara*—the beginningless cycle of birth, aging, sickness, death, and rebirth.

For the Middle Way Buddhists, belief in inherently existing objects and subjects is the taproot of the pervasive suffering mentioned in the Four Noble Truths. Falsely believing that objects or subjects inherently exist, we ascribe more attractiveness or unattractiveness, generate more craving or aversion, to them than they actually deserve. Upon this foundation of the false belief in inherent existence we build all our emotional attachments, our chains to *samsara*. These attachments drive us endlessly toward or away from objects and people. We compulsively quest after or flee from objects we falsely believe inherently exist.

As a simple psychological example of the dangers of believing in false creations, consider projecting our shadow, the dark side of our personality, on another person. Firmly believing that those qualities independently exist in the other, we then proceed to hate them intensely. We castigate the person for qualities we actually possess and fail to see the reality before us. Because of our projection we are isolated from the truth of the other person and a realization of our profound interdependence with them. How then could we possibly practice Universal Compassion?

We may think inherent existence provides us with our most fundamental reality, but this belief in an inherently existing subject or I, this "self-grasping," is the millstone dragging us to the bottom of the ocean of *samsāra*. This self-grasping leads directly to pervasive egotism, self-love, or "self-cherishing," that is putting our own concerns and desires before all else. For the Buddhists, philosophic views, whether conscious or not, always have powerful consequences: wrong ones lead to suffering, correct ones to liberation or enlightenment. Because this false conception of inherent existence is the

root of suffering, it must be pulled out, painfully extracted, like the deeply buried arrow.

Of course, it is no easy matter to deny inherent existence in all objects and at every level of subjectivity. We have the great danger of a largely imaginary view of our attainment and only fattening our ego rather than realizing it as empty. Therefore, a competent guru or spiritual guide is usually a necessity when attempting to realize emptiness.

The major translators and commentators, such as Hopkins[5] and Thurman[6] and Tibetan scholar-monks such as Tenzin Gyatso, the Fourteenth Dalai Lama,[7] or Geshe Kelsang Gyatso[8] who teach extensively in the West, use a variety of words to describe what is denied in the emptiness doctrine or the "negatee" as they call it. They use inherent existence (*svabhāvasiddhi*) interchangeably with such terms as independent existence, intrinsic existence, substantial existence, intrinsic essence, or intrinsic self-nature to mean our most innate, unreflective, and pragmatic belief about both subjective and objective phenomena (our "philosophic fish complex"). We may divide this innate and unreflective belief in inherent existence into two pieces: First, that phenomena exist independent of mind or knowing, that "underneath" or "behind" the psychological associations, names, and linguistic conventions we apply to objects like bell or tree, something objective and substantial exists fully and independently from its own side. Such objects seem to provide the objective basis for our shared world. Second, these objects are also believed to be self-contained and independent of each other. Each object being fundamentally nonrelational, it exists in its own right without essential dependence upon other objects or phenomena. In other words, the essential nature of these objects is their nonrelational unity and completeness in themselves.

As stressed above, the denial of inherent existence does not mean that objects do not exist (the extreme of nihilism). They surely have a conventional or nominal existence and they function to provide help and harm, but they totally lack independent or inherent existence. They formalize this idea in the doctrine of the two truths. From the ultimate point of view, all subjective and objective phenomena are totally lacking in independent existence or in their own self-nature. This is the Ultimate Truth—that emptiness or selflessness of phenomena is their highest quality, their most profound nature. However, from the everyday realm of action, commerce, and spiritual practice, objects have a conventional nature; that is, they function, they are efficacious and must be dealt with on this level. For example, ultimately, Tibet is totally without inherent existence; nevertheless, when discussing its political future and that its citizens have suffered mightily, then we are to treat it as people conventionally treat things in the world. Ultimately all phenomena are empty of inherent existence, yet in practical or conventional living we must treat them with the respect conventionally granted such objects. However, always keeping their emptiness in mind, we do not become slaves to our attachments—whether to a country or a person or our own life.

Belief in independent phenomena, whether our own ego or a material possession, is the basis of our craving and aversion, which in the end can be overcome by deeply understanding the doctrine of emptiness. This personal transformation requires an

immense and radical conceptual reeducation—a renewal at every level of the personality. Arrow removal is never easy.

Although Middle Way emptiness or lack of inherent existence applies to both objective and subjective phenomena at all levels, from the gross sensible to the most abstract mental realms, here I emphasize its application to sense objects that we can more readily compare with phenomena studied in physics and psychology. Nevertheless, the same type of analysis applies to all objects and subjects.

Establishing the Lack of Inherent Existence

Several years ago I was returning graded term papers (worth about one third of the final course grade) and noticed that one student had not received a paper. "Jay, I have no paper for you. Did you turn one in?" He said, "Oh yes, I submitted it along with everyone else." I apologized profusely and told him it must be in one of my offices. I would dig it out and grade it for him by the next class. (Then I also held the rotating chairmanship of our department and thus had the chairman's office along with my own in which to spread out and create havoc.)

I searched both offices at school and my office at home and could not find the student's paper anywhere. I could even vaguely recall seeing the paper at some time, but it just would not turn up, no matter how carefully I searched. My guilt started eating at me. Writing a term paper of that size is a very big piece of work, especially for someone as careful as Jay, and I, Mr. Chaos, could not find his paper. "It must be here somewhere!" I vowed to reform my sloppy practices. Meanwhile, I would use this guilt-driven opportunity to clean out all three offices in my desperate attempt to find the student's paper. During my search I would get the clear sensation that it was going to turn up in the very next pile. I could almost see the title page now. . . . Nothing, no paper, and no evidence of my ever having had it. "How could I lose that paper?"

Defeated, I returned to the student and confessed that I could not find the paper. I asked whether he had another copy or an earlier draft. He said that the one he turned into me was the only copy. I apologized again and offered him an additional two weeks to turn his research notes into another version of the paper. Meanwhile, I would keep an eye out for the paper, despite my having lost hope of finding it.

Early one morning while I was preparing for class, Jay came into my office. He looked like he had not slept for the last two nights. Before I could even say hello he blurted out, "I lied. I never did turn in a paper. I am sorry." I'll skip the long conversation we had and what came of it. That is not the point.

The point is that in my frantic and fruitless search for the term paper I was sure that it was around somewhere, and that I would warmly embrace it with a mix of relief and satisfaction when it appeared. My vague image of the paper would be clarified and objectified. When found, the term paper would sit there and accuse me of my stupidity. In fact, my expectations instantly dissolved with the negative realization that the paper had

never existed and so could never be found. I had expectations and fantasies, but nothing to support them.

In a completely analogous way we are sure that an inherently existing object can be found, whether it is a tree or the true subject. We believe that with a diligent search it will stand out clearly before us where we can embrace it. Its essence, its self-standing nature, will shine forth. But in truth this self-standing nature is no more existent than that term paper. While something inherently existent has never been found in the past and will never be found in the future, the paper eventually did exist—although not the one I was initially seeking, but rather its replacement. (Can we truly replace something that never existed?)

The arguments denying inherent existence are extensive and occupy much of the Middle Way Buddhist literature on emptiness. Rather than review these arguments in detail, I'll boil these brain-splitters down to their essence. It turns out that they all amount to showing that inherent existence is "unfindable upon analysis." This means that when you search deeply for the object or subject believed to exist inherently, you come up with no more than I did when searching for the student's paper. Rather than find an independently existing phenomenon, these searches reveal an object or subject that is deeply and inextricably involved with its surroundings and the searcher, the person doing the analysis. (Any general object or subject can be considered a phenomenon, something we can know.)

The searches never yield independently existing objects, but rather those that are deeply dependent in three related ways. First, all phenomena are dependent upon "causes and conditions" or upon the vast network of causal factors and conditions that make a thing possible. My apple tree depends deeply upon favorable soil, light, water, disease control. For these reasons it lacks independent existence.

Second, all phenomena are dependent upon the whole and its parts and their relationships. For example, my apple tree depends upon having branches, trunk, leaves, all arranged in some well-defined way that we recognize as a tree. Consider the definition of an intrinsically existent object. Because an independent essence or self-nature must be self-contained and isolatable, by its very definition, an inherently existent phenomenon must be a partless essence. It cannot therefore be distributed over parts or shared between the whole and the parts. Yet, since we can always analyze phenomena into whole and parts, independent existence cannot inhere in them. Although we unreflectively consider inherent existence to be the touchstone of reality, its deep logical inconsistencies condemn it to nonexistence.

Third, and most profoundly, all phenomena are dependent upon imputation or mental designation. We continuously receive an immense avalanche of information that we organize, distill, and coordinate with other experiences. We cut up the seamless rush of experience into units of intelligibility (color, texture, memories, associations). Then we collect these items together and designate or name it a tree. Mind is constructive of its world, the only world we can know. We mentally designate, impute, or name that complex of sensations, memories, and expectations to be a tree. This is part of the mind's normal

job. The problem comes when the mind erroneously invests the designated object with the nonexistent property of inherent existence. In other words, we illegitimately project the false notion of inherent existence into phenomena and then suffer the consequences of this projection.

It's quite an extraordinary idea that inherent existence, what we erroneously consider the core reality of an object, is simply nonexistent and furthermore that we falsely invest objects with our projection of this nonexistent. Upon that false projection we build our cravings and aversions and keep spinning the wheel of *samsāra*. We must awaken from this ignorance if we are permanently to break out of the realm of suffering.

In truth, all objects exist only as sets of relationships or dependencies—between various objects and between the object and the knower who mentally designates them. No core of self-nature or intrinsic essence supports our names, linguistic conventions, and projections. Nothing exists "underneath" our imputations or mental designations. *Objects are none other than dependency relationships and names.* In other words, all phenomena exist as a species of dependent arising—dependent upon causes and conditions, whole and part, and mental designation. This view thoroughly denies the mind-matter split of Cartesian dualism, the core of many of our Western prejudices that make understanding the unity between mind and matter implied by synchronicity so difficult to understand.

It is natural to ask that if things lack inherent existence, if they are empty, then how can they function? How can an ultimately empty tree bear fruit that we eat? According to the Middle Way, the very emptiness of independent existence of all phenomena is what allows them to function through their relationships and be sources of help and harm. In contrast, if objects inherently existed then they would of necessity be immutable and impotent, unable to act on us or we on them. Within this ultimately empty but conventionally existent world we must win our buddhahood; and thus Buddhists call our world the "womb of the Buddhas." Philosophically we must be able to move back and forth between the ultimate and conventional truth of phenomena.

Because phenomena are nothing but their relationships, which are constantly shifting, they are continuously transforming or impermanent. Lack of inherent existence guarantees that all phenomena are impermanent, temporary sets of relations. If the reverse were true—if all objects inherently existed—then they would be frozen in their impotence and immutability.

Speaking of impotence, let's return to the poor benighted canoeist who is seething with indignation. Let's imagine that a Bodhisattva or being of compassion is hovering nearby. The Bodhisattva realizes that this is the time for the canoeist to search for the "I" that he believes inherently exists and that has been so offended by the water skier. As the canoeist shakes his fist at the skier and shouts imprecations, the Bodhisattva asks him, "Who is it that is angry?"

"Who do you think is angry? Me, I am angry!" he snorts.

"But who is that? Can you turn within and find the person who feels offended?"

Unfortunately, given my knowledge of this canoeist, he is most unlikely to be

cooperative then. Often when we most need medicine we are least able to take it. But if the canoeist could dive within and intensely seek that I, he would quickly realize that, despite the familiarity with the body, the body is not the I. Pushing in a little deeper, it would become clear that the continuously shifting feelings are not the I. Nor are any of the thoughts plaguing his boiling brain the independently existing I, which just a second ago seemed to stand out in such bold relief. In short, that sense of self that seemed so clear, which he felt was so obvious, is no more findable than the student's paper. It too never existed. The belief in an inherently existing self is a false construction that the mind imposes upon itself and suffers from. Unfortunately, according to the Buddhists, it takes us much hard experience over many lifetimes to realize this.

Within emptiness, let me briefly return to the notion of objectivity in science first discussed in chapter 5. There I discussed how the scientific attitude with its unbalanced identification with one side of the objective-subjective pair of opposites has led to a devaluation of subjective meaning. In an attempt to redress this imbalance, even national science policy-makers at the highest levels of the United States government are reevaluating funding. The worship of objectivity within science is not possible within Middle Way Buddhism, because emptiness stresses that all objects, whether the world as a whole or individual objects, are always codependent upon a knowing subject. The interdependence between subjects and objects built into the heart of emptiness implies the impossibility of either pure objectivity or pure subjectivity. That would be totally at odds with the "middleness" of Middle Way Buddhism, which establishes emptiness through both the objective methods of philosophical analysis and the subjective meditational penetration into ultimate truth or ultimate meaning.

A Western formulation of the same fruit of the combination of dialectical analysis and inner experience comes from Paul Brunton's denial of independent existence. First, like the Buddhists, he describes the mind's synthetic and constructive power. Then he notes how we illegitimately add the assumption of an independent and extra-mental nature to the object.

> We do not have a direct acquaintance with an external, material object; we have a direct acquaintance with our own perception only, the rest being a process of unconscious inference. We do not arrive at the notion of the man as a whole until we have experienced a compound of sensations such as his height, form, colour, and feel. A percept is the discrimination and combination of sensations, to which is added the assumption of extra-mental, separate, independent existence of the thing perceived. That a man is standing two feet away from our body in the domain of objectivity is an *inference* that we draw unconsciously, for the only experience which we have of him are these happenings in the eye and ear— that is, happenings which are ultimately within mind. It is only at the end of this whole process that we assume the object is in an independent, outside world. From these personal impressions our mind gets to work and makes a deduction that an outer man is there. What we really see is something mental, the existence of the material man being deduced from that of the mental experience. We do not immediately see a separate, independent, external, material man.[9]

For all Middle Way adherents, emptiness is the Ultimate Truth of phenomena. They promulgate no higher or more transcendent principle in place of the false belief in inherent existence. Emptiness is a special kind of negation. It is not one that seeks to elevate some

positive principle at the end of its negation. For example, denying that the student is a male implies the positive notion that the student is female. In contrast, emptiness is a nonaffirming negation—the mere denial of independent existence in phenomena. No higher positive principle exists. Emptiness itself is empty. Nevertheless, it frees us from egocentric life. Lacking in independent existence, my ego is intrinsically no more real, no more precious, than anything else in this world. This truly liberating realization is the foundation for the cultivation of limitless compassion for all sentient beings.

Profoundly appreciating the interdependence of all humans and their world inevitably leads to compassion. As Robert Thurman says, "The razor-sharp sword of critical wisdom cuts through the fetters of excuses that obstruct the open dynamic flow of compassion, . . ."[10] If I and my neighbor both lack independent existence, if our relationship is more fundamental, more real, than our isolated or independent existence, then how can I possibly profit at his expense? How can I attain ultimate liberation while he suffers? His suffering is my suffering. Compassion in turn empowers and deepens the understanding of emptiness. When attention turns toward my neighbor's welfare and away from myself, then I make progress toward appreciating the emptiness of the very fiend himself—my ego, my self-cherishing.

Let me give a little example. After years of ups and downs, serious meditation can all too easily degenerate into an excessive preoccupation with our subjectivity. We become obsessed with how we are doing, whether it seems easy or hard, and whether we are making progress. All our concerns spin around the ego, around the false center of our subjectivity. What started as an exercise to free us from *samsāra* becomes yet another fetter, despite our best efforts at reflecting upon the emptiness of the ego. Here is where universal compassion, the genuine concern for the welfare of all sentient beings, can help us attain liberation—a goal we are encouraged to seek primarily for the sake of others. When we sincerely perform the simple compassion exercise of offering up all the possible merit of our meditation for the relief of all sentient beings, when we really take the spotlight off our ego, then we lift an immense weight from our shoulders—the milestone of self-cherishing. Then, as the *Bhagavad Gita says,* we become entitled to the effort but not the fruits of the effort. We make a sincere effort and let go of the ego's concern with results. Of course, this is all easier said than done, but even if only partly successful, a real breeze of freedom, an open, unfettered experience of joy and compassion can actually occur if we can just temporarily remove the false sense of I from the center of our concern. Practicing compassion can actually deepen our understanding of emptiness while emptiness provides the rational support for the limitless cultivation of compassion and the divinizing of the world. *Destroying the false belief in inherent existence is the prerequisite for recognizing the world as sacred.*

Synchronistic Interlude 7

Appreciating the Feminine in Spiritual Life

I have always felt inwardly Chinese, even as a young waspy girl growing up in a small Midwestern town where Asians were encountered only in *National Geographic*. As a teenager, I forgot this inner certitude and pursued my outer life, until the Vietnam War grabbed my attention. Then, in the mid-1960s, I took a college course in Chinese Government; suddenly my mind was alive and awake. Instead of my usual mediocre grades, I was getting the highest grade on exams in a huge class. I continued to take courses in Southeast Asian and Chinese studies and was accepted to graduate school in Chinese Political Studies—but love changed my plans.

In the 1970s, I was discussing my Chinese interests with Paul Brunton, and he said, "Don't you think you were Chinese in the past?" I replied, "I've thought so, but I don't know how to verify these things. I don't really trust my opinions about reincarnation. How would I really know?" He said, "You know when you go to a place if you have lived there in past lives." I offered, with shortsightedness, "Well, I'll never go to China."

In 1989, I was visiting Honolulu, Hawaii. I avoided the tourist spots and spent my time at the gardens, art museums, local beaches and restaurants, surrounded by the Asian population of the city. I was ecstatic. I had never been anywhere with so many Asian people, and something about the energy, the aesthetic, and just the look of the people made me feel at home and at peace. I attended an inspiring lecture on the Yin-Yang symbol and vowed to study Chinese philosophy and take up the Chinese exercise called *Tai Chi Chuan*. At the end of my visit to Honolulu, I briefly met a Chinese Buddhist nun who invited me to her monastery in Taiwan where 500 nuns live. I thanked her, but told her I would never be coming to Taiwan.

At home, after several years of international travel, my husband asked me where in the world I would most like to visit. Without hesitation I said, "Taiwan." Within a few days, he read an announcement of a conference in his field being held at *Fo Kuang Shan* (Buddha Light Mountain), a Buddhist University and Monastery—of course in Taiwan. We planned to go and stay about three weeks.

I looked through my stacks of saved important papers and finally found the address the nun had given me in Honolulu. I sent her a letter, just in case her monastery was the one we were visiting, but never received a reply.

About a month before we were to leave, the head of *Fo Kuang Shan* came to our town. Unlike any other religious leaders I had seen, his entourage was all women—Buddhist nuns dressed in their robes with heads shaven. After the talk, in the milling crowd of about 100 people, one nun came and stood by me. Just on a whim, I told her about the letter I had written to the mystery nun in Honolulu. I wanted to find out if the nun in Hawaii was from the same monastery we would be visiting in Taiwan. The nun said, "But that was me—I was in Honolulu last summer, and I'm touring the mainland with my teacher this fall. I go to Yale now, and I never received your letter." I was astounded. She hadn't remembered what I looked like and I hadn't recognized her (our brief encounter in Honolulu was outside a lecture hall at night), but here we were standing together and she was answering my letter. Yes, the monastery holding the conference was hers, and she would be on leave from school and would be there. I felt guided.

In Taiwan, I immediately felt at home. We spent a few enchanted days at a mountain Buddhist retreat, Lion's Head Mountain. I walked through the mountain temples in morning mist, ate the simple Chinese vegetarian food prepared by nuns, and watched the visitors and resident nuns and priests perform their religious rituals. Joy and peace swelled in my heart. Although I could talk to no one there and struggled to make the simplest communications through copying Chinese characters from my tourist's language book, I felt a deep inner sense of communion with all that was happening.

Following our travel plans, we left Lion's Head Mountain and went to the city of Tainan, a center of traditional Chinese culture. We checked into a beautiful hotel with sweet helpful people who did everything to make us feel comfortable, including speak English. Nevertheless, within a few hours, a horrible irritability and depression started to come over me—feelings of total dissatisfaction. My poor husband tried to help and find out what was happening, but my dark mood was unbreakable. I felt such a loss of peace and such a sense of lost opportunity. Why had we left Lion's Head Mountain? It was so right for me to be there.

Finally, quite paralyzed by my dark mood, I let my husband talk me into going outside for a change of scene. I walked down the street in my dejected state, lagging about ten paces behind, dragging my feet, and looking at the ground. Finally, my husband turned back to me and asked with unconcealed exasperation, "What do you want?" Without thought, in a voice desperate and pleading, out popped: "I want a mantra." What a strange response!

Immediately, my husband pointed out a Buddhist swastika on the white wall on our left. I would never have noticed it. My odd and unexpected request for a mantra stunned me—and yet I was still intently glowering at the sidewalk. Inside the gate was a modern building with huge glass walls and open doors. Always the explorer, my husband wanted to go in. I felt bewildered, confused, and very indecisive. Being too weak to put up my usual resistance to adventure, I followed. We walked into the building to find a Buddhist temple and, as we have done in religious sites all over the world, we sat in the back to absorb the atmosphere. It was a relief to sit there. Within seconds, a black-robed woman came and started moving things around on the altar and doing other ritual preparations around the room. Soon came more Buddhist women in black robes, some nuns with heads shaved. One nun, later we knew she was the "Mother Superior," motioned for us to stand next to women gathering in rows. I wanted to stay in the back as I had at Lion's Head Mountain, but this nun was not going to allow that. She insisted we move into place with the black-robed women. She gave us books, but we motioned that we couldn't read Chinese. With hand movements, she communicated that we were supposed to follow the women in front of us. My husband was receiving scornful looks from a few of the women. He was the only man there, and we later thought that it was probably a place only open to women. Nevertheless, they were much too kind to toss the dumb foreigners out. Anyway, clearly the "Mother" was telling us what to do and we must do it.

The black-robed women began chanting prayers, and after a while, I could hear one sound being repeated over and over. I had heard the sounds before at Lion's Head Mountain, but Chinese is so hard for the Western ear, and I hadn't tried to grasp what they were saying or attempted to copy the sound. Nevertheless, here it was, over and over—and the nuns were moving from their places now, circumambulating the temple and the huge statue of the Buddha. I began to mumble the chant along with them,

trying to copy the sound, but not able to imitate the exact pronunciation. The ritual was powerful, but the scene was ridiculous—fifty black-robed chanting Chinese women, tailed by a curly-headed blond woman in a black jacket, followed by an American guy in a plaid button-down shirt.

After a half hour or so of chanting and prayer, the service seemed over. My husband and I sat quietly, waiting for everyone to leave so we could quietly withdraw. Most of the women left, but then the "Mother" returned with two nuns carrying huge wooden prayer beads and pictures of the Buddha. She gave one set of beads to my husband and one to me. I started to put the beads over my head, but "Mother" strongly disapproved. She ordered me to watch her and copy her: She began to move the beads one by one through her fingers, saying the mysterious words that I was beginning to discern: "*O-mi-to-fo, O-mi-to-fo, O-mi-to-fo.*" Dense as I am, I finally got it. I was getting my mantra! This forceful nun was insisting that I say it, correcting my pronunciation.

Then "Mother" motioned for us to follow her behind the temple to another building. We sat with four nuns and shared their simple food. Obviously we could not talk, but when I tried to say thank-you in Chinese, they corrected me saying, *O-mi-to-fo.* They kept saying the mantra to each other instead of please or thank you or hello or good-bye. I recognized the words from Lion's Head Mountain, used by the nuns in the same way. Finally, after more food and another religious service at another little temple in the complex (this time with both men and women), exhausted, we left. I was incredulous and overjoyed. This Buddhist nun had given me *my* mantra.

A few days later, we arrived at *Fo Kuang Shan,* the monastery holding the conference. Immediately, I heard all the nuns (there were hundreds of them) repeating *O-mi-to-fo* in greeting and later in religious chanting. These nuns from the Buddhist University could speak English, so they worked hard to correct my pronunciation in return for practicing English with me. They also told me I was repeating the name of the *Amitabha* Buddha—the Buddha of Eternal Light and Life. Again, I felt peaceful and joyful with the Buddhist nuns. The nun I had met in Honolulu gave me a plaque with the mantra written on it (shown in the accompanying photograph), and the younger nuns gave me a beaded mantra bracelet like they wear. By the end of the week, I had the mantra straight, both in my mind and in my heart.

Photo by Victor Mansfield

47. O-mi-to-fo

So what does the synchronistic asking for and receiving of this mantra mean? I have been meditating many years and occasionally wear a wooden beaded mantra bracelet. But I always floated from mantra to mantra and never felt that this practice had much to do with my spiritual quest. My teachers have all been men and my practices stressed my masculine side—willful meditation techniques and study. I have neglected and undervalued the feminine approach to the higher, even when these male teachers stressed the importance of devotion. Although intellectually I know mantra, prayer, chanting, or ritual are essential, I have little faith in their efficacy. I always think I have to carry the weight of my development on my own willful shoulders.

The Buddhist community in Taiwan introduced me to innumerable religious women, full of faith and obviously experiencing the joy of life—both worldly and religious. One of these women gave me the mantra, a nun who seemed to know just what my quest needed. The day after receiving the mantra, I was surrounded by hundreds of religious women at *Fo Kuang Shan*. They were practicing the repetition of *O-mi-to-fo,* and the heartfelt joy of their life filled the place. What a testimonial to the technique! As well as being extremely devotional, the nuns of *Fo Kuang Shan* study, meditate, and devote their lives to service to others. They are well educated and hold important religious and administrative positions in the religious community of both men and women. Of course, like all of us, they must have their inner struggles, but the positive feminine energy there is extraordinary and unique.

When I returned home, I read D. T. Suzuki's essay on the practice of repeating *O-mi-to-fo,* or the *Nembutsu* as it's called in Japanese. The Chinese and Japanese Buddhists practice this exercise as an alternate technique to the koan. The *Chan* or Zen *koan* practice is extremely willful and masculine. On the other hand, the Buddhist Pure Land practice of repeating the name *O-mi-to-fo* emphasizes faith and devotion, the feminine balance to the *koan*. With the repetition of the name, the practitioner is throwing himself on the mercy of the *Amitabha* Buddha (*O-mi-to-fo*) to be reborn in the Pure Land or Western Paradise where *Amitabha* Buddha presides. These two practices are the *Yin* (Universal Feminine) and *Yang* (Universal Masculine) of traditional Chinese philosophy found in Chinese Buddhism. As Suzuki says,

> *No matter how you are thinking of the Buddha, intensely or leisurely, no matter how you are invoking his name, whether loudly or softly, do not allow yourself to be constrained by any rule, but keep your mind unruffled, restful, and in silent contemplation. When it attains a state of unity undisturbed by environment, some day an accident will unexpectedly cause in you a sort of mental revolution, and thereby you will realize that the Pure Land of Serene Light is no less than this earth itself, and Amitabha Buddha is your own mind.*[1]

For the last few years, my spiritual practices have been a struggle. With lack of faith in my abilities to quiet my chaotic, unruly mind, meditation is a chore without even a sense of hope to fuel it. The *Nembutsu* stills the mind through hope and faith that something higher will take care of this ego. I don't have to do it all myself; I just have to make the effort and guide my mind back to the quieting effect of the mantra. The practice is reminiscent of the one given me several years before by Paul Brunton—"The Practice

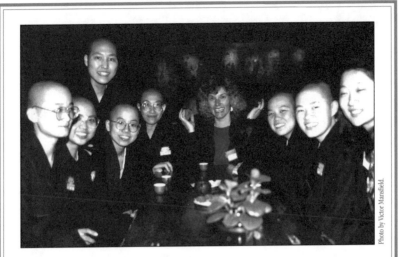

Photo by Victor Mansfield.

48. *With women of* Fo Kuang Shan

of the Presence of God" of Brother Lawrence. If the remembrance is always there, the fretful mind can attain a moment's peace.

I want to say that I followed Paul Brunton's advice years before and always do the *Nembutsu* practice now. It's not true. I'm recalcitrant and stubborn. Despite the powerful way I got the mantra and the efficacy of its practice, I tend to forget and pick it up only in desperate times. Recently, I have been desperate and writing this story and rereading Suzuki; he points out that my dispersed and agitated mind needs help beyond my will. If I hold the image of my synchronistic experience in mind—my feminine guardian angel, the nun of Tainan, and the gift she gave me—the luminous power of that moment will help me remember. I am not alone. Whenever I return to my beads and my mantra, help is found.

> *Psychologically considered, the aim of the . . . Nembutsu is to do away with the fundamental dualism which is a condition of our empirical consciousness. By achieving this the devotee rides over the theoretical difficulties and contradictions that have troubled him before. With all intensity of thought and will he has thrown himself into the deeps of his own being. He is not, however, a mere wanderer without anything to guide him, for he has the name with him. He walks along with it, he goes down to the abyss with it; though he finds himself frequently divorced from it, he always remembers it and keeps in its company.*[2]

O-mi-to-fo!

11 Applications of Middle Way Emptiness

But I do believe that this is precisely the point where our present way of thinking does need to be amended, perhaps by a bit of blood-transfusion from Eastern thought.

Erwin Schrödinger[1]

From Dante to the Big Bang as Psychological and Spiritual Metaphor

How comforting it must have been for the believer to profess with Dante in *Paradiso* XXIV, 130–47:

I believe in one God—sole,
eternal—He who, motionless, moves all
the heavens with His love and his desire;

.

This is the origin, this is the spark
that then extends into a vivid flame
and, like a star in heaven, glows in me.

God in the Tenth Empyrean Heaven emanates his love and wisdom down through the ordered planetary spheres and focuses it into us, into our moral and spiritual evolution. However, Dante and his contemporaries paid a great price for this affectionate weaving of scientific cosmology and theology. When Copernicus, with the help of Galileo, Kepler, and Newton, ejected us from our geocentric nest, Western theological and philosophic foundations trembled. Darwin added to our theological distress by teaching that our human form was merely one of many possible biological evolutions, just as our sun was merely one of the innumerable stars seen when Galileo turned his telescope heavenward. The development of classical physics was guided by the influential philosophic work of Descartes that erected a great chasm between mind and matter. (A chasm this book is trying to bridge.) Combine all this with Galileo's notion of primary and secondary qualities of objects and it is clear that without the aid of science we cannot even directly know the real nature

of the material world indifferently surrounding us. Although by the turn of our century great optimism suffused science and its technological applications, we were far from Dante's comforting deified vision. Instead, the reigning scientific view pictured us as minuscule material life forms swimming aimlessly through a vast sea of stars.

A major scientific breakthrough came in the first decade of this century. Then Einstein's special relativity, briefly reviewed in chapter 7, showed the reference-frame dependence of spacetime and many primary qualities of classical science. An equally important side of relativity, not stressed in my earlier discussion, is the invariant quantities, those that do not change from one reference frame to another. In popular treatments of relativity the frame-dependent quantities like length, mass, time, and simultaneity are held up to dazzle us. Of more significance for the evolution of theoretical physics are the invariant quantities. For example, the speed of light is the same for any observer, whether sitting on the casino floor with Spacetime Sam or riding on the rapidly moving stick.

The most important group of invariants is the laws of physics themselves. For example, in special relativity the laws of mechanics are the same in any nonaccelerating frame. We have everyday experiences of this. Consider, for example, an airplane or train moving at constant velocity. Then when walking down its aisle we need make no adjustments in our gait, in the mechanics of our walking. Because the laws of mechanics are frame invariant, it does not matter whether we are walking across our living room or in the aisle of a supersonic jet. It feels the same. However, when the plane accelerates due to takeoff, turbulence, or landing, then it badly affects our walking. Or try drinking coffee in an accelerating car, whether from cornering or braking. In his next major work Einstein addressed these problems of acceleration and gravity.

One of the great achievements in physics was Einstein's development of general relativity in 1916. (This was not his "first theory of relativity" as Jung described the special relativity of 1905.) General relativity formulates the laws of physics so that they take the same form in any reference frame, whatever the state of motion of the frame, accelerating or not. This shows that taking a heliocentric or a geocentric view is equally legitimate, equally real, and in every way equivalent to even a lunarcentric point of view. We can now formulate the laws of physics so that they take the same form in any frame and thus the physical content of those laws is the same in any reference frame. Here we must be clear about the critical distinction between physical properties and laws. Yes, the spacetime and other primary qualities spoken about by Galileo are still frame dependent, but the *mathematical laws* governing the physical phenomena are now in a form that displays their invariance, their universality for any reference frame. As a simple example, the energy is frame dependent because observers in different frames will measure different values for the same system, but the conservation of mass-energy holds for all observers. General relativity frees us to take any reference frame or point of view we wish. Our sun, our galaxy, or our supercluster of galaxies are in no way privileged reference frames. All those frames are equally legitimate for making our analysis or for doing our physics—which frame we choose is merely a question of convenience or of calculation efficiency.

Shortly after Einstein's general relativity, astronomers discovered that the stars first seen by Galileo were only in our galaxy, which is merely one undistinguished member among billions in the universe. Edwin Hubble then discovered that distant galaxies recede from us with velocities that are proportional to their distance from us. (See figure 49.) He found that in all directions, the farther the galaxy, the faster it flees from us. Does this mean that we are the center of the big bang expansion? Have we replaced geocentrism with our being the center of cosmic expansion? No. Nearly all introductory college level astronomy texts have simple arguments showing that any uniform expansion (all distances between galaxies increase by the same percentage per unit time) provides each observer in the universe with the same view of the big bang expansion. More rigorously, we know by a combination of general relativity and extensive observations that each observer sees the same increase in recession velocity with the distance of the observed galaxy. Although there is no central point from which the universe expands, each observer anywhere in the universe sees herself as the center of the cosmic expansion. Much to Dante's dislike, all privilege, all uniqueness has been removed from our position in the universe.

With this brief review in hand, let's use these cosmological developments to shed light on a few psychological and spiritual questions. From a modern psychological perspective we can see that our awareness of being the center of our own experience, of relating all thoughts, feelings, and outer and inner adventures to our ego, our personality, was merely being projected into geocentric cosmology. We were transforming our psychological experience of being the center of our personal world into geocentric astronomy. In contrast, the heliocentric view implied that the perceived motions of the sun, stars, and planets across the sky were actually due to our Earth's movement, to our rotation and revolution about the sun. The Earth's motion, rather than the heavenly body's, is what causes the illusion of a setting sun or a rising moon. This was the first major scientific revelation of the unreliability of appearances. When we appreciate this fact psychologically and realize how our inner psychological motions deeply condition and distort our experience, how our

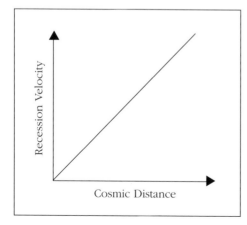

Every cosmic observer sees the same linear increase of recession velocity with distance. Yet the cosmic expansion has no center.

Figure 49. Hubble's discovery

projections shape the world, then we are beginning to break out of the egocentric position. When we learn the power of our complexes to project their own contents unconsciously then we are making the first tentative steps toward the psychological equivalent of the Copernican revolution. When we finally realize that the ego is not the true center of psychological life, that a superior wisdom is ordering our inner life of dreams and fantasies and guiding our unconscious compensations toward individuation, then we are making the transition from an egocentric to a self-centric attitude, the psychological equivalent of the transition from geocentrism to heliocentrism. This may not be as comfortable as Dante's geocentric nest surrounded by the planetary spheres bearing God's wisdom and love toward us, but this solitary journey, which relies on our individual resources rather than on a large institution like Mother Church, is the view Jung champions throughout his writings.

The individuation process, like any human endeavor, is subject to all sorts of perversions and distortions. Let me mention a seductive one and show how the previous scientific ideas combined with Middle Way emptiness can help correct it. I want to stress that this is a perversion of individuation and not its ideal realization. Nevertheless, it's surprisingly widespread and thus worthy of at least a little attention.

Through a combination of what seems like grace and our own effort, we make some steps from an egocentric to a self-centric psychological position. This transition, according to Jung, is never complete because individuation is not fully attainable, but continually unfolding out of the unbounded depths of the unconscious. Because the process is never completed, some residue of geocentrism or egocentric attitudes always gets projected on the self. With this contaminating residue, the self (or more accurately our interpretation of it) becomes just a larger version of our ego with all its vanities, self-centeredness, or self-cherishing as the Buddhists call it. Then all our concern revolves pathologically around our individuation, our dreams, our feelings, our psychological concerns, our subjectivity. Making progress in individuation convinces us that we are special, chosen, anointed by the divine, above ordinary conventions and concerns. Individuation has become narrowly personalized and devoured all other aspects of life. We haven't given up geocentrism easily or gracefully.

We may have made a great leap forward by understanding the world symbolically, by appreciating that meaning can be derived by interpreting our waking experience as a richly symbolic expression of the collective unconscious or objective psyche. However, symbolic interpretation can then reduce all persons and events to just props in my psychological drama, my individuation. Archetypal relationships displace personal relationships. Other persons merely become carriers of my projections and less a reality of their own. Our spouse or lover becomes primarily the carrier of the countersexual animus or anima and less an individual with equal reality to ourselves, with equally valid concerns, needs, and uniqueness. Our enemy becomes only a shadow projection to be dealt with in the inner world rather than a real person with a legitimate viewpoint. The homeless person begging on the street becomes only a projection of my homelessness, abandonment, and poverty rather than someone with an equal right to a quality life. Rather than face the reality of

this beggar, I see him as a mere symbol of my deficiencies, my homelessness. I use symbolism to disinfect him, distance myself from his reality and thereby absolve myself of responsibility for my neighbor and my environment. Appreciating the world symbolically has degenerated into narcissism and avoidance of responsibility. Psychologically we may have left the Earth's surface, but we certainly have not left its atmosphere.

When Einstein developed a reference-frame invariant or a frame-independent formulation of the laws of physics, each physical point of view became equally legitimate, equally real. There is no virtue or privilege, other than convenience, to choosing one reference frame over any other. The Earth is no more central to the cosmos, no more a preferred reference frame, than a giant elliptical galaxy in a distant supercluster of galaxies. This move is paralleled in Middle Way Buddhism by the emptiness doctrine, which denies inherent existence or independent existence to all persons and things. Nothing is exempt. Nothing stands free from the radical dependency on relations and our thinking. All persons and objects are equally co-interdependent, equally empty, and yet equally real conventionally. Not just quantum systems, but even the Buddha, even emptiness, lacks independent existence.

From the psychological side, emptiness seems to imply that we have relativized our importance. Now all points of view of both persons and things are of equal validity, of equal reality. However, this is wrong. Just as we know that the laws of physics are universal, the same for all points of view, all reference frames, so the Buddhists understand certain principles such as the Four Noble Truths as universal. They claim that all sentient beings, from gods to ghosts, regardless of occupation, wealth, nation, race, and gender, are subject to the suffering of cyclic existence. We are all the same in our universal desire to avoid suffering and find happiness. This truth is the foundation for compassion and moral action. Assimilating the emptiness doctrine and practicing compassion are, according to the Middle Way Buddhist, the royal road to true happiness.

50. Japanese Buddha descending the mountain

Detail of a scroll from the Kamo School, Japan, at Chapel House, Colgate University. Photo by Victor Mansfield, taken with the permission of Professor John Carter.

Our profound interdependence, our co-arising, with all persons and things, implies that we cannot erect our self as the center of the universe. Yes, it's true, just as the observer of cosmological expansion sees herself as the center of the expansion, we feel our egos are the center of our experience, the focus of our inner and outer drama. However, the Buddhists stress that our conventional ego, the focus for experience, the entity we all so deeply cherish, the one engaged in spiritual practice, is not the true mind. The true mind, like the cosmic expansion, is without a center and a spacetime location. Despite its reality and efficacy, this true mind can neither be objectified nor found in spacetime. This enlarged understanding of mind helps us break out of the narcissistic psychological dilemma and, as we will see in the next chapter, provides for the possibility of a unification with the outer world, with nature. Now we can understand the nonlocal interdependence seen in the Bell experiments as a special case of a much more general co-interdependence or emptiness that demands genuine compassion for the person underlying my shadow projection and the homeless beggar. Their suffering is my suffering. A Boddhisattva seeks liberation primarily for the sake of the numberless sentient beings subject to the universal truth of suffering. He is not just trying to flee from personal suffering. As long as others suffer, then because of our interdependence, so does the Boddhisattva, the true spiritual hero.

From the Middle Way Buddhist perspective, our development, whether individuation or the seeking of complete liberation, cannot be solely motivated by a *private* desire for meaning, peace, or end of suffering. Our happiness, our deepest fulfillment, comes through decreasing the suffering of all sentient beings. As the present Dalai Lama says, "True happiness comes not from a limited concern for one's own well-being, or that of those one feels close to, but from developing love and compassion for all sentient beings."[2] It's quite a reversal of our normal attitude, but according to the Middle Way Buddhists, the most enlightened form of self interest is a deep concern for the well-being of others. In this way, there is no tension between our spiritual development and the deep concern for others, no conflict between my highest goal and the needs of those around me. Again the Dalai Lama says, "Foolish selfish people are always thinking of themselves, and the result is negative. Wise selfish people think of others, help others as much as they can, and the result is that they too receive benefit."[3] This may fly in the face of current political attitudes in America, but it's pure Tibetan Buddhism.

Let me summarize. Just as general relativity decreased the importance of any one reference frame or point of view, so too does Middle Way Emptiness help remove our deep-seated psychological bondage to egocentrism—a bondage that all too easily turns individuation into a pathological concern with self and a corresponding devaluation of the plight of others and our responsibility to them. Yet emptiness or the lack of substantial or independent reality of any person or thing does not mean that anything goes. Just as in relativity there are universal laws. For the Middle Way the universal truth of suffering and the ultimate truth of our thoroughgoing interdependence demands that we act compassionately for the good of others and ultimately for ourselves.

Bell's Inequality Analysis and Inherent Existence

Here I'll show that when we were discussing the Bell Inequality analysis in chapter 9 we were actually focusing on emptiness in Middle Way Buddhism. To begin, return to Einstein's objection to quantum mechanics summarized in the long quotation in chapter 9. Einstein demanded that any influences propagating between objects must do so at speeds less than or equal to the speed of light in a vacuum: "an external influence on A has no *immediate effect* on B; this is known as the 'principle of local action'." For example, in Einstein's own general relativity, gravitational fields, or changes in the four-dimensional curvature of spacetime, propagate from one point in spacetime to another at the speed of light. This locality principle plays a critical role in my simple derivation of Bell's Inequality in the previous chapter and all other more general versions[4] that use it to guarantee the isolation of the two parts of the system.

Einstein believed that objects exist independently in two ways. First, they are independent of our knowing or perception. He says, "above all the following attracts our attention: the concepts of physics refer to a real external world, i.e., ideas are posited of things that claim a 'real existence' independent of the perceiving subject." For Einstein objects clearly have a mind-independent existence. Second, objects are independent of each other: "it appears to be essential for this arrangement of things introduced in physics that, at a specific time, these things claim an existence independent of one another, in so far as these things 'lie in different parts of space.' Without such an assumption of the mutually independent existence (the 'being-thus') of spatially distant things, an assumption which originates in everyday thought, physical thought in the sense familiar to us would not be possible." In other words, if we separate objects so that they do not interact as in our experiment, then they have mutually independent existence.

The Tibetan Buddhist monk-scholar, Geshe Kelsang Gyatso, echoes these same two forms of independence when he says, "If we are ordinary beings, all objects appear to us to exist inherently. Objects seem to be independent of our mind and independent of other phenomena."[5] Although Einstein speaks for Western classical science and Geshe Gyatso speaks for an ancient Buddhist tradition, at a fundamental level they are addressing the same point. (Though of course, they are arguing for opposite positions.)

Einstein's commitment to objects that exist independent of our knowing and interaction with each other, objects that as the Middle Way Buddhists say "appear to exist from their own side," is a precise description of inherent existence. In fact, it's hard to imagine how he could have described inherent existence more accurately. Thus, in doing physics in chapter 9 we were actually focusing right on the heart of Middle Way Buddhist emptiness. This tight correspondence between the core issues in the Bell's Theorem analysis and the doctrine of Middle Way emptiness is quite extraordinary. Yes, inherent existence encompasses more than Einstein considers, but in the large arena where the concerns of the arch critic of quantum mechanics and Middle Way Buddhism overlap they are both dealing with independent or inherent existence. Of course, Einstein claims this independent existence is essential for any physics ("physical thought in the sense familiar to us would

not be possible"), while the experimental violation of Bell's Inequality vigorously denies this. We have seen that the Middle Way Buddhists claim that the denial of independent existence is the Ultimate Truth, the most profound nature of the object.

I note parenthetically that with the Dalai Lama's commitment to well-established facts in science, if experiments actually confirmed Bell's Inequality, then he would have to consider giving up emptiness, the very heart of Middle Way Buddhist theory and practice. On the other hand, we should never construe findings in physics, even those as fundamental as Bell's Inequality, as a proof of a particular world view. Nevertheless, it's very satisfying to see the harmony between modern quantum theory and traditional emptiness philosophy, one confirmed in contemporary physics laboratories, the other in secluded Tibetan monasteries.

As the Buddhists always stress, a commitment to a world view based on inherent existence and separateness has immense *ethical* implications. This idea is echoed by the famous physicist, David Bohm.

> It is proposed that the widespread and pervasive distinctions between people (race, nation, family, profession, etc., etc.), which are now preventing mankind from working together for the common good, and indeed, even for survival, have one of the key factors of their origin in a kind of thought that treats things as inherently divided, disconnected, and "broken up" into yet smaller constituent parts. Each part is considered to be essentially independent and self-existent.[6]

In fairness to Einstein, I must say that, despite his commitment to inherent existence, his ethical and political actions were models for the entire scientific community. Nevertheless, philosophical world views do have ethical implications. The ideology of separateness can lead to difficulties ranging from an inability to appreciate synchronicity and paradoxes in quantum mechanics to rampant racism and nationalism with all the bloodletting that usually follows in its wake.

This ideology of separateness or the inveterate tendency to project the false notion of inherent existence into objects often comes into play in standard quantum mechanics. There the mind's tendency to turn processes into things, to cut up the flowing stream of experience into separate blocks that appear to exist inherently, is pulled up short by both theory and experiment. Philosophers call this inveterate tendency of the mind to turn processes into fixed things that appear to exist independently the inclination to *reify*. For example, although a photon is the most ephemeral of entities, erupting out of ghostly probabilities upon measurement, we tend to reify them into concretely existing entities traveling along well-defined trajectories in spacetime. All too often we implicitly assume that they are complete and self-contained, independent of distant conditions or outcomes. In the classroom, lab, or in discussions with colleagues, we usually speak about the Bell experiment as one in which "two correlated photons are sent in opposite directions." (The photons are correlated in that the outcome measured on one side is tightly related to that found at the other.) Intellectually we know that correlated light cannot be considered in this separative way, but we usually fall into this habit of thinking. We often justify it pragmatically by claiming this makes particular applications easier. In other words, we

inveterately impute inherent, nonrelational existence to light by conceiving of it as independent particle-like photons traveling on well-defined trajectories. This innate tendency is what the philosopher of science, Paul Teller,[7] calls the disease of "particularism."

As we saw in the analysis of the interferometer, although light is not a photon until observed, we normally conceive of it as an independently existing entity with a well-defined trajectory independent of measurement and distant events. Wheeler's delayed choice experiments dramatize the error of this view in chapter 8.

Although it's a radical reversal of our normal mode of functioning, Middle Way Buddhism claims that the highest truth of phenomena, their most fundamental nature, is their inherently dependent and interrelated nature. The essence of phenomena is their connectedness and relatedness, not their isolated identity. The usual mode of thinking grants objects relationships, such as correlation, but conceives of these properties as accidental to the primary nature of light as independently existent. Or as Teller would phrase it, some quantum properties (such as the nature of correlated light) are inherently related—their essential relations do not supervene or come on top of their nonrelational or independent properties.

Experiments to test Bell's Inequality show that correlation is intrinsic and primary to the light in the most fundamental sense. In that the Ultimate Truth of phenomena is their emptiness of inherent existence, they are most fundamentally codependent and interrelated. We cannot and should not seek an explanation of these correlated properties by attempting to relate inherently existing entities through connections—superluminal or otherwise. On the other hand, it would be too cumbersome always to say: "The essentially relational entity on one side, which upon measurement is designated 'photon,' is so intrinsically related to the relational entity on the other side that they must be considered holistically." But the quantum formalism with its principle of superposition expresses this in mathematical language, despite our difficulty in restraining our normal reifying or particularizing mode of thinking.

Before leaving the Bell's Inequality analysis, it's worth reminding ourselves of the essentially negative result of that analysis. As I stressed at the end of the Bell's Inequality chapter, that analysis denies the mutually independent existence of the correlated pairs but puts no other principle or description in the place of our formerly erroneous belief. Instead we are left only with notions like dependence, interconnectedness, entanglement, and so forth. In exactly the same way, Middle Way Buddhists develop emptiness as a nonaffirming negation—it denies inherent existence without in anyway replacing it with some other principle. The highest truth about phenomena is that they are interdependent and interconnected. No more can or should be said, otherwise we would be setting up another inherently existent idol that only anchors us more firmly to *samsāra*.

Many comparisons may be made between quantum mechanics and various other disciplines. However, it's rare and illuminating when emptiness, the most fundamental principle in Middle Way Buddhism, relates so intimately to the central mystery in quantum mechanics—its nonseparable nature. This connection between contemporary physics and

an ancient path to liberation, between the results of modern experimental metaphysics and the summit of Middle Way wisdom, does not prove Middle Way Buddhism is correct in any direct sense. It does offer, however, more modern and compelling examples for the explication of emptiness than such quaint examples as the "snake-rope" or "sweater made of turtle hair." More important, reflection on the nonseparability revealed in the experimental violation of Bell's Inequality may deepen our appreciation of the profound interconnectedness that exists in nature, which in turn may deepen our understanding of emptiness. Appreciating emptiness helps counter our tendency to project inherent or independent existence—whether in quantum mechanics or in considering synchronicity. An understanding of emptiness can contribute toward building a philosophic view that helps us understand nonseparability in laboratory physics and in synchronicity experiences. Such a view might heal the many divisions mentioned by David Bohm in the quotation above. It may even help secure our survival in a world that is becoming more interdependent every day even in the face of our atavistic commitment to separateness.

The Fruit of Emptiness

We are all used to the idea that the outer world can causally affect our inner state. After many days of cold rain the warm sun breaks through the clouds and my spirit soars. Seeing all the apple blossoms turn brown and fall to the ground from the late spring frost saddens me. Nothing is surprising about these causal interactions between the outer and inner world.

However, when correlated photons (or bell resonators) show some acausal connections, some instantaneous interdependence without energy exchange, then they seriously challenge my inveterate belief in separate and isolated entities. Nonlocality effects in quantum mechanics cannot be understood by causal interactions between independently existent entities. My tendency to impute inherent existence, or particularism as Teller calls it, blocks me from any understanding of the nonlocality, the essential relatedness, that is so characteristic of quantum phenomena.

My discussion of quantum mechanics has stressed the three most fundamental and disturbing aspects of quantum mechanics: its acausal nature (chapter 7), the participatory nature of the universe or its lack of full objectivity (chapter 8), and nonlocality or interconnectedness (chapter 9). Although these findings run contrary to our commonsense ideas (or projections), they are precisely what is to be expected from the view of emptiness, from the notion that the highest truth of objects is the interdependence and relatedness, their lack of an independent or objective existence. All this, of course, is in stark contrast to the old materialism enshrined in Newtonian physics and our unreflective view of the world.

In synchronicity the most unsettling and arresting aspect of the experience is the implication that there is a genuine acausal relationship of meaning between the inner and outer worlds and therefore that there is some unity between psyche and matter. As I have tried to argue, we usually operate with the assumption that our inner world exists

inherently or fully independently from the outside world, from the world that we believe surely has its own intrinsic existence, its own self-nature. It's true that the inner and outer worlds can causally relate to bring us joy or sorrow, but this is only one mode of their interaction. If we falsely believe that phenomena independently exist and only interact causally or separately, we have violated a quantum understanding of nature and shut ourselves off from appreciating at least some of our experiences as an acausal unfoldment of higher meaning. A synchronicity experience denies this limited view of separateness and causal interaction. Instead it gives us a direct experience of acausal interdependence, of meaning expressing itself in the unity of the inner and outer worlds. Because we are steeped in this gigantic prejudice of inherently existent subjects and objects, it's very difficult for us to accept these interdependencies. Despite profound intimations of meaning this prejudice encourages us to dismiss synchronicity as mere chance, as a merely fortuitous coming together of things that really have no relation, that have nothing more than an accidental relationship superimposed on their independent existence. My hope is that an appreciation of emptiness, the idea that we codependently arise with the world, will help us appreciate not only the possibility of synchronicity but its naturalness. It may also help deepen our appreciation of the view of nature emerging from modern physics that must be the starting point for any unification with mind.

The opening quotations of this chapter by Schrödinger and of the previous chapter by the Dalai Lama both encourage the idea of cross-fertilization between Western science and Eastern philosophy. These very different thinkers may be right. One of the youngest sciences, psychology, asks us to study interconnectedness to understand synchronicity while one of the oldest, physics, points us in a similar direction to understand nonlocality. Yet if we restrict ourselves to just psychology and physics we may not find a sufficiently broad framework within which to resolve the difficult questions raised. We should instead take a hint from the Middle Way Buddhists, who, rather than treating interconnectedness or interdependence as a nettling embarrassment to be explained away, consider it the highest truth about phenomena, both objective and subjective. In other words, what physicists and psychologists consider as a deeply mysterious and troubling fact about nature is the centerpiece of the Middle Way vision. Interdependence is not a strange attribute but the highest truth, the ultimate nature of all phenomena. Perhaps even more important than helping us understand quantum mechanics and synchronicity, it could aid us in cultivating a compassionate attitude, without which our very planetary survival is in doubt.

Synchronistic Interlude 8

A Reading Invitation

Although I have read many of Jung's books several times, I have never been ready for a few. One of these is *Aion*—one of the last books he worked on, and one he worked on repeatedly over the years. There are many topics discussed in this book: the coming of the age of Aquarius, the downfall of Christianity, and the many paradoxical aspects of Eros and Logos. This last topic comes into play in my synchronicity experience.

I am a counselor and use many of Jung's ideas in my work. At the beginning of the incident I am about to describe I had been in practice for six years, and was in the middle of a loving, difficult marriage—fully committed to my work, my wife, and my studies. You also need to know something of my office layout. I work at a table, near the center of a fourteen by sixteen foot room, with the west and north walls lined with bookcases. (See the accompanying photograph.) Some of these bookcase shelves are overstuffed, but most of them, including my hardback Bollingen collection of Jung's works, are neat and tidy.

One day, Kay and Don, who are both friends and clients, came in during lunch hour to set up an appointment with me. They wanted to discuss their relationship. I had consulted with each of them several times over a three-year period, although primarily

Note the distance between the table and Jung's books.

Photo by Victor Mansfield.

51. The office in question.

on matters of professional or personal growth. While we were discussing arrangements for our upcoming appointment, a book fell out of my bookcase. As this had never happened before, it somewhat surprised me. After the couple left, I went over to the fallen book and noticed it was *Aion*. I looked at the shelf and could not see how it had fallen down, but thought little more of the incident, as the contents of the book were unfamiliar to me. I meant to read it someday, but was in no hurry to do so, as I always found reading Jung a difficult task.

The appointment went as many others do, no better, no worse—I hardly remember it. Some days later the same couple appeared in my office late one Saturday night—I was still in my office, writing up notes from the previous weeks' consultations. They insisted they needed to see me again soon, to continue our discussion of their relationship. This evening intrusion was unusual, but not a unique experience for me—but they surprised me with their urgency, since their problems did not seem unusual or in crisis to me. Nonetheless, I agreed to set up another meeting, and, as I got out my appointment calendar, a book fell off my bookcase! Weird. It was the same book as before, *Aion*. This time the book fell some distance from the bookcase, almost hitting my worktable. I don't know whether Kay or Don noticed this, but I certainly did, and promised myself to begin reading the book.

I didn't get around to it, however. We had our second meeting, which went about the same as the first consultation. Later in the same month, they invited me to their house, where, in a more informal setting we continued our discussion. This felt uneasy to me, but I felt perhaps a different setting might bring things to the surface that the formality of my office might have inhibited. This setting aside of formal roles and rules opened things up. I began to see that the rich ideals the couple held for each other, and for marriage, contrasted sharply with the sterile reality of their relationship. This was an all too familiar parallel to my own marriage—something I only really recognized as our talks continued.

Several months passed, and no further developments occurred, in or out of the office. Then the couple came to me again, saying they wanted to recommence our meetings in the office. As they left the office, the now-familiar volume, *Aion,* shot off the shelf and *hit* my worktable—several feet from the bookcase. This time I took the book home and began reading it. At first I could make no connection to the couple, nor my relationship to them. But as I read on, I encountered Jung's discussion of a particular spiritual crisis one reaches when the mind "has all the answers" in a sophisticated world view/philosophy, and the heart has become confined to a few "pure" (read sterile) feelings. He calls this the polarization of Logos and Eros, a sort of standoff between the ego and the self—the ego knows what its evolution requires, and that very knowledge is its doom—as there is no more mystery left to knowledge, and no more life left to discover in the heart. Jung discusses the dangers of this position when he says:

> However, accentuation of the ego personality and the world of consciousness may easily assume such proportions that the figures of the unconscious are psychologized and the self consequently becomes assimilated to the ego. The world of consciousness must now be leveled down in favor of the reality of the unconscious. . . . room must be made for the dream at the expense of the world of consciousness. . . . the presumptions of the ego can only be damped down by moral defeat.[1]

Then I did not realize what "moral defeat" and my "having all the answers" would entail, nor how the anima might be involved, although Jung warns us:

> Whoever identifies with an intellectual standpoint will occasionally find his feeling confronting him like an enemy in the guise of the anima; . . . Therefore, anyone who wants to achieve the difficult feat of realizing something not only intellectually, but also according to its feeling-value must for better or worse come to grips with the anima/animus problem in order to open the way for a higher union, a coniuntio oppositorum. This is an indispensable prerequisite for wholeness.[2]

And he tells us later that the price for this conjunction is high:

> Where the archetype predominates, completeness is forced upon us against all our conscious strivings, in accordance with the archaic nature of the archetype. The individual may strive after perfection ('Be you therefore perfect—τελειοι—as also your heavenly Father is perfect.') but must suffer from the opposite of his intentions for the sake of his completeness.[3]

This dilemma was clearly applicable to my client's situation, as he was a perennial grad student, now working on his third Ph.D. program—all on extremely intellectual topics, like the history of the philosophy of science—while she was a graduate of Julliard, trying to make a career in classical piano performance. I also saw the same polarization/stasis in myself—my mind had settled on a particular blend of Neo-Platonic philosophy as the truth of the world, while my heart was devoted to a very formal and good-willed marriage—I believed that neither my philosophic pursuits nor my marriage should be questioned, nor were they likely to alter.

In *Aion,* Jung says there're only two resources we have in this situation. First, we must pray—yes, Jung actually says here that psychology won't do it—this is a spiritual crisis, and if the delicate living balances between the ego and the Self are to be kept healthy, we must bring in a spiritual resource. He chooses the historical Jesus, as the presence whose grace can guide the individual—I found mine in India. Either way, Jung makes it clear that an authentic spiritual power is necessary to place the psychological paradox into a meaningful context. As Jung says in his paraphrase of Ignatius Loyola:

> Man's consciousness was created to the end that it may (1) recognize its descent from a higher unity (Deum); (2) pay due and careful regard to this source; (3) execute its commands intelligently and responsibility; and (4) thereby afford the psyche as a whole the optimum degree of life and development.[4]

The second resource is human, very human. Here Jung also departs from what many consider "Jungian" dogma, by stating that we must go beyond the doctrine of psychological projection to that of Self-incarnation. That is, we see that the Self cannot express all its nature in our ego or our body, but must also manifest objectively in and as the lives of others—in particular through Eros.

> So when I say that the impulses which we find in ourselves should be understood as the "will of God," I wish to emphasize that they ought not to be regarded as arbitrary wishing and willing, but as absolutes which one must learn how to handle correctly. The will can control them only in part. . . . I should also like the term "God" in the phrase "the will of

God" to be understood not so much in the Christian sense as in the sense intended by Diotima, when she said: "Eros, dear Socrates, is a mighty daemon." The Greek word daimon *and* daimonion *expresses a determining power which comes upon man from outside, like providence or fate, though the ethical decision is left to man.*[5]

The irreducibility of the anima and animus as facts of the collective unconscious implies that they must be within the Self, as the totality of the archetypes in the collective unconscious. Since they are within the Self, and the Self must manifest all its elements as our experience of the world, anything that is an irreducible autonomous archetype must appear within our experience as existent, not merely as imaginal, and must also appear outside the ego. Thus, the anima and the animus, as archetypes of the Self independent of the ego, must appear in our lives.

For example, the Ph.D. program Don finally settled into (and eventually completed) was the very one I had abandoned when I left academics for a monastery. Also, I had left behind my classical music development (I was always in the all-state symphonic orchestra) for academics. These connections to my own life took me some time to notice—it was only after the third book incident that I began to reflect on this couple as somehow significant to me.

That significance grew. Over the next two years I continued to work with them, but their marriage could not survive. Near the end, I suggested that Don take a break by entering a retreat center for a few months to sort things out. Instead his wife did. Shortly after that my wife and I went to India, and a few weeks after our return, our marriage ended abruptly. A year and a half later, I found myself in India with Kay, and now we are married. Don has finally finished his degree, and Kay has reoriented her career toward teaching music to very young children.

There was much pain, joy, humiliation, insight, clarity, and confusion throughout this time, all started by an ordinary, mild question provoked by the odd occurrence of the falling *Aion*. By the time the incident was over, many people had changed fundamentally, and life finally began to move.

So why *Aion?* Well, that first meeting had all the elements of what came later, but no one recognized it. So, the idea was there, in the room, but not in us, not consciously, and not even repressed. No one recognized the potency of the moment—usually one does—there's an affect, a heightening of one of the functions—emotional, intellectual, sensual, intuitive, etc., which is a clue that something is up. Sometimes the affect is inverse—one gets happy about something that turns out negatively; sometimes the affect is direct—one gets depressed about something that turns out to be tough. But in this situation, there was no affect, and not even the suspicion that there should be one. So the idea was there, necessarily present in the event, but so unrecognized that it was not able to appear in the consciousness of any of us. Therefore, it had to present itself otherwise. *Aion* also held the idea that should have been in us, in at least one of us. Since we did not see it, the book was drawn into the situation, as it were—or the idea in that book needed to be present. What was the idea in the book? Well, it was the incarnation of the roles of shadow, anima, animus, as reflecting a critical state of the ego-Self relationship in all of us. That is, all four of us were devoted to some form of "spiritual" development, and individuation, pitting the ego against the Self. My first wife had chosen the path of developing Logos, locking her emotions away; Kay had chosen the path of Eros, forfeiting

her intellectual development. Don had chosen the path of Logos, holding on to a purely intellectual approach to philosophy, and I had committed myself to the path of Eros, following a feeling-approach to the Self, thus forfeiting the analytic discrimination necessary to anticipate this development. Reading *Aion* helped me recognize the archetypal setup, and, more important, the context of the ego-Self battle. My reading affected how I saw the external situation, and where I looked for clues to its resolution. Following Jung's comments it seemed both appropriate and necessary to place things in a "spiritual" context (something I usually abhor doing in life-crises, as it is too often a placebo for psychological honesty).

As for the "three times" repetition—well I think that's just the degree of my obtuseness and resistance to what was going on and what it meant—I truly had no clue as to the eventual change in relationships. I didn't think my marriage would end, nor did I think Kay and I would marry—I didn't even "notice" her as a woman—she was simply a client, as was Don. In fact, it took quite some time for any of our feelings to surface about any of us. When the feelings finally showed up, the one really helpful guide I had was that book—and what we found in India.

Jung paraphrases various medieval authors' use of the starfish as a symbol of the self. He says,

> This [starfish] generates so much heat that it not only sets fire to everything it touches but also cooks its own food. Hence it signifies the inextinguishable power of true love. . . . This fish glows forever in the midst of the waters, and whatsoever it touches grows hot and bursts into flames. This glow is a fire—the fire of the Holy Ghost.[6]

12 The Psychological Standpoint: Virtues and Vices

All the same, every science is a function of the psyche, and all knowledge is rooted in it. The psyche is the greatest of all cosmic wonders and the sine qua non of the world as an object.

C. G. Jung[1]

Consciously Experiencing Projections

In the spring of 1970 I attended several psychology workshops, one a month long, at the Esalen Institute in Big Sur California. There, shafts of sunlight penetrate the fog-enshrouded Pacific revealing mountains tumbling into the surf. The sharp staccato clicks of sea otters hammering their abalone shells open with rocks pierce the roar of the surf. Natural hot spring baths, crimson suns gliding into the Pacific, patchouli-scented massage oil—all these images float easily to mind. However, the most memorable experience from those times came from a simple group exercise conducted away from the overwhelming natural beauty.

We randomly chose partners and sat directly in front of each other at a distance of a couple of feet. Then without speaking or moving we fixed our eyes on a spot between our partner's eyebrows and concentrated intently. We were not given any hints about what to expect, but just told to concentrate and keep our thoughts quiet, our mind still. We were to do this concentration with intensity for about twenty minutes.

I had some experience with concentration so this exercise was not difficult. Initially, nothing unexpected happened. For the first ten or so minutes it was just a challenge to keep intensely focused on the woman in front of me without psychological discomfort. Since the group had been doing serious psychological work together for days, this was not hard.

Suddenly the woman's face transformed into that of my mother! It was clearly my mother's face, steadily gazing back at me. This was deeply disturbing. When my concentration lapsed so did the appearance of my mother's face. I collected myself from the shock and refocused on the point between my partner's eyebrows. In a few minutes

52. Big Sur, near Esalen Institute

this attractive woman's face turned into a wrinkled crone with a menacing glare. I stared back at that hideous face in fascinated disbelief. Weird though it was, I plunged ahead. In a minute or more I suddenly saw my face staring back at me as though I were looking into a mirror. If I became too absorbed in the images or my emotional reactions and failed to concentrate on the point between the eyebrows, my partner's normal face returned. I had to maintain a delicate balance between stern concentration on the point and receptivity to the images of the unconscious.

In this experience the psyche manufactured a world out of its own substance, out of imagination, and projected it into the outer world in space and time. Usually projection is an entirely unconscious process and thus all the more compelling, distorting, and emotionally unsettling. Because this exercise allowed me a conscious glimpse of the process, it was particularly worthwhile.

The unconscious continually projects compelling images, whether they be expressions of the shadow, the anima, or the wise old man. Jung described my experience quite literally when he said, "Projections change the world into the replica of one's own unknown face."[2] It's a major psychological event, often an important milestone in individuation, when we recognize and withdraw a projection. Then what we believed was objective is seen as our own psychology being reflected back to us by emotion-laden images of the outer world.

Only when we clearly see this is the compulsion and distortion of the projection broken. It's like those shafts of sunlight knifing through the early morning Big Sur fog. We are astonished at how our vision and action were clouded, how we were emotionally pulled this way and that by our fantasies projected outward. How the psyche deceived us and yet educated us, obscured truth and revealed it! It is like a psychological reflection of the cosmic principle of illusion, *Māyā,* which in Hinduism both veils and reveals *Brahman,* the absolute; both obscures and unfolds reality. In psychology, projection veils the object projected upon and reveals the subject projecting. The removal of a projection frees us from the object, increases our self-knowledge, and restores to us the emotional energy and psychological attributes we had formerly projected. Like a drowning man gulping fresh air, we relish our freedom from the compulsive power of the old projection, the old illusion, and celebrate the reclaimed talent or content.

Experiences like these had happened to me before this concentration exercise, but the exercise allowed several powerful projections to be made, emotionally experienced, and withdrawn within minutes. It was a vivid realization of how the psyche manufactures our world, which we then take as objectively real. Unfortunately, as long as we have a psychology we are always projecting and living out our fantasies.

Because it was so easy to see I was projecting, my example is misleading. While caught in a projection we are fully convinced that the offending or attracting quality is definitely in the object. We have not the slightest doubt that the quality is where we see it—in the outer world—where we have no control over it. My example would have been better if I completely believed that the woman was a menacing crone, if I were possessed with the idea that she was a withered, witch-like old woman out to harm me. Of course, then I could not have seen it dissolved so quickly and appreciated it as a projection—and not been able to use it as an example.

Jung and the depth psychology community had daily experiences with the power of the psyche to create our world. This clinical experience is a major source for Jung's "psychological standpoint," the subject of this chapter. Because this standpoint is the framework within which Jung attempts to understand synchronicity, I'll present it in some detail. I also offer both a psychological and a philosophic critique of the standpoint. Discussing the strengths and weakness of Jung's view prepares the way for my attempt to tie the psychology, physics, and Buddhism together into a unified model for synchronicity.

Jung's Psychological Standpoint

In ultimate or philosophic questions Jung always tried to maintain an empirical and phenomenological stance, what he called the "psychological standpoint." He repeatedly said that his primary concerns were to help patients, hold to what was empirically knowable, and eschew all metaphysical claims. Beyond articulating the psychological and empirical force of his ideas, he felt that it was neither his role nor duty to frame a fully articulated philosophic position for his views. Of course, both because of the depth of his ideas and the richness of his inner experiences, maintaining this stance was not easy. As

the editor of his autobiography and close associate, Aniela Jaffé, points out in the introduction to *Memories, Dreams, Reflections,* there are two Jungs: the empirical scientist that appears in the *Collected Works* and the religious Jung who in his autobiography "speaks of God and his personal experience of God."[3] In this chapter I begin formulating a philosophic model for synchronicity by starting with Jung's psychological standpoint, an expression of his empiricism. Although Jung never intended it as a fully articulated philosophic position, it clearly expresses important aspects of his philosophic position that he maintained throughout his life. Jung's psychological standpoint

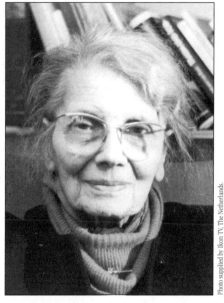

53. Aniela Jaffé

forms a good starting point for my model. In a later chapter I'll return to the religious Jung.

Jung describes the psychological standpoint in many places, but one of the best is the following:

> So far I have based my reflections on the realistic standpoint of scientific thinking, without ever questioning the foundation on which I stood. But in order to explain briefly what I mean by the psychological standpoint, I must show that serious doubt can be cast on the exclusive validity of the realistic standpoint. Let us take as an example what a naive mind would consider to be the realest thing of all, namely matter. We can make only the dimmest theoretical guesses about the nature of matter, and these guesses are nothing but images created by our minds. The wave-movements or solar emanations which meet my eye are translated by my perception into light. It is my mind, with its store of images, that gives the world colour and sound; and that supremely real and rational certainty which I call "experience" is, in its most simple form, an exceedingly complicated structure of mental images. Thus there is, in a certain sense, nothing that is directly experienced except the mind itself. Everything is mediated through the mind, translated, filtered, allegorized, twisted, even falsified by it. . . .
>
> What we know of the world, and what we are immediately aware of in ourselves, are conscious contents that flow from remote, obscure sources. I do not contest the relative validity either of the realistic standpoint, the *esse in re,* or of the idealistic standpoint, the *esse in intellectu solo;* I would only like to unite these extreme opposites by an *esse in anima,* which is the psychological standpoint. We live immediately only in the world of images.[4]

For Jung the psyche, the realm of the imagination, the functioning mind, is the only reality we directly and immediately experience. Whether we are experiencing the subtlest aesthetic response or the dentist's drill, all experience is "an exceedingly complicated

Photo supplied by Ikon TV, The Netherlands.

structure of mental images." We never directly experience anything but mental images, thoughts, ideas. We are totally contained within the cocoon of the psyche, the unconscious-conscious whole.

> **"We live immediately only in the world of images."**

For Jung this assertion is an empirical fact, one we come to by direct experience, by introspection. It requires neither subtle philosophic argument nor leaps of faith. We examine experience, whether waking sense experience, dreams, or fantasies and realize that all we ever directly know are images in the mind. The sound of the dentist's drill, my fear, that piercing, sharp, excruciating pain are, in the most fundamental sense, all of the same nature—potent images in the mind.

Saying that all experience is a complex of images shimmering in the psyche does not rob experience of any of its vividness. Stones are just as hard and heavy, pains and joys just as acute—but it does elevate the psyche to its proper station and removes any possible material underlay from immediate experience. Any objects we can know, whether sensed in the outer world or felt in the inner world, are the psyche concretized into images in space and time of the psyche's own making. Therefore Jung says in the opening quotation of this chapter, "The psyche is the greatest of all cosmic wonders and the *sine qua non* of the world as an object."

Jung is willing to grant the commonly accepted world view that some matter underlies my sense experience. An objective, material world surely exists for him. For Jung, material

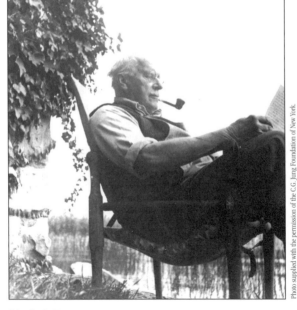

54. C. G. Jung

drills, teeth, nerves, and so forth, exist "underneath" or "behind" our perceptions. When perceptions are valid they connect to this material "reality." Nevertheless, we never directly experience these material objects. We know only the images they generate in the mind that "flow from remote, obscure sources." What the material world is in itself or in its essence we cannot say, for, "We can make only the dimmest theoretical guesses about the nature of matter, and these guesses are nothing but images created by our minds." Some unknown and ultimately unknowable substrate underlying our sense perceptions presumably accounts for the commonality of our experience—that we can, for example, agree it's a sunny day. For many the need for an objective world is obvious proof of the existence of some extra-mental or extra-psychic world, some "matter," which gives our experiences stability and shared objectivity. As Jung says, "Although there is no form of existence that is not mediated to us psychically and only psychically, it would hardly do to say that everything is merely psychic."[5]

For Jung, this matter, along with the ultimate nature of mind, is forever unknowable in itself. We can make neither of them a direct object of experience. Not only is matter inaccessible, but mind cannot know itself directly either. We can know outer objects like trees or rocks or inner objects like pain or pleasure, but the mind cannot know itself directly without images. The subject in perception cannot know itself nakedly or purely, cannot be the sole object of perception, for this would not allow for the threefold division of subject (ego), object (thing known), and the relationship (the knowledge) between them that characterizes all experience. According to Jung, "As we have immediate experience only of a reflected state, which is *ipso facto* conscious and known to an ego-complex that represents our empirical personality, it follows that any other kind of consciousness—either without an ego or without contents—is virtually unthinkable."[6]

Because of Jung's psychological standpoint he asserts:

> We delude ourselves with the thought that we know much more about matter than about a "metaphysical" mind or spirit, and so we overestimate material causation and believe that it alone affords us a true explanation of life. But matter is just as inscrutable as mind. As to the ultimate things we can know nothing, and only when we admit this do we return to a state of equilibrium.[7]

So the psychological standpoint admits the primacy of the psyche. However, as Jung goes to great lengths to show in perhaps his best theoretical essay, "On the Nature of the Psyche," the psyche is bounded on one end of the spectrum by inscrutable matter and at the other end by a transcendental mental principle, spirit, which is equally unknowable. Although the archetype is primarily of the nature of spirit,[8] synchronicity experiences forced Jung to hold that archetypes partake of the extremes of both spirit and matter. That is, the archetype *per se* is ultimately irrepresentable and transcendental (and thus psychoid), and it underlies both spirit and matter. The irrepresentable and thus transcendental archetypes structure both matter and psyche and form the girders upon which the psyche, "the greatest of all cosmic wonders," is built. Therefore, in a decidedly nonempiricist fashion he asserts:

Since psyche and matter are contained in one and the same world, and moreover are in continuous contact with one another and ultimately rest on irrepresentable, transcendental factors, it is not only possible but fairly probable, even, that psyche and matter are two different aspects of one and the same thing. The synchronicity phenomena point, it seems to me, in this direction, for they show that the nonpsychic can behave like the psychic, and vice versa, without there being any causal connection between them.[9]

Because the unity underlying psyche and matter is transcendent, not available to immediate experience, Jung is either reticent or vague about it, although he does mention the medieval notion of the *Unus Mundus*—a subject I expand upon in the next chapter. Although he frequently mentions that synchronicity experiences point toward an underlying unity, such as the *Unus Mundus,* most often he firmly holds to the psychological standpoint, an amalgam of empiricist and metaphysical claims, summarized in figure 55. On the left in the figure is the unknowable material realm that merges into the psyche, the conscious-unconscious totality that is at least potentially knowable. On the right is the transcendental mental or spiritual realm, which is essentially unknowable like matter. The three realms do not overlap. One merges into the other in some unspecifiable manner. The irrepresentable psychoid archetypes structure the psyche and are rooted in both spirit and matter.

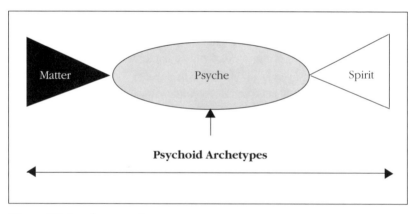

Figure 55. Jung's cosmology

Psychological Liabilities of Jung's Standpoint

Despite my immense appreciation of Jung, I must point out some serious deficiencies in his psychological standpoint. In doing so I fondly recall my late teacher, Anthony Damiani, saying, "If I criticize these giants it's on bended knee." I'll try to proceed in that spirit.

The psychological standpoint can lead to real complacency and smugness. Once we recover from the shock of realizing that we live only in a world of images, in a psychic world, it's natural to take this standpoint against any ultimate assertion—whether scientific, philosophical, or mystical. Jung reasons that since we can only know images

in the psyche, we can have no assuredly true knowledge about anything alleged to be beyond the psyche. So all ultimate statements, whether scientific, philosophical, or religious, are merely a playing out of psychological archetypes, fantasy conditioned by structures in the psyche. As Jung says, "our metaphysical concepts are simply anthropomorphic images and opinions which express transcendental facts either not at all or only in a very hypothetical manner." For Jung, *psychological* man has become the measure of all things, both earthly and transcendent. If Copernicus removed us from the center of the universe, Jung's psychological standpoint puts us back in the center, but this time imprisoned in the psyche. From this standpoint Jung inevitably falls prey to charges of psychologism, treating genuine metaphysical principles as psychological. However, as Jung tries to make clear, this charge is not fair. For example, in the *Mysterium Coniunctionis* Jung says,

> Psychology cannot advance any argument either for or against the objective validity of any metaphysical view, I have repeated this statement in various places in order to give the lie to the obstinate and grotesque notion that a psychological explanation must necessarily be either psychologism or its opposite, namely a metaphysical assertion. The psychic is a phenomenal world in itself, which can be reduced neither to the brain nor to metaphysics. [10]

Nevertheless, exclusive commitment to the psychological standpoint protects its adherent from the strenuous work of seriously evaluating transcendent claims. For example, within psychology we can only study the "God Image" as Jung calls it, but never God directly. We must remain silent about truth claims underlying such a psychic content. From the psychological standpoint we must remain agnostic about the possibility of ascending beyond the psyche through yogic practices. As the following discussion will show, Jung believed that such transcendence is only an archetypal theme, a desire for ecstatic release. Therefore, according to Jung, the great philosopher-sages, whether Plato and Plotinus in the West or Buddha and Adi Shankara in India, are only expressing archetypal urges when they speak of transcending human limitations and overcoming the world of opposites by attaining union with the Divine.

Perhaps we can be more gracious to Jung and say he was epistemologically modest and in the relatively hostile intellectual climate within which he worked, his standpoint was the price of scientific respectability. This desire to remain within the circle of current scientific and empirical respectability juxtaposed to Jung's own experiences—synchronicity among them—resulted in a tension between the psychological standpoint and his more metaphysical writings. However, I'm not interested in judging the charges of psychologism that many have leveled against Jung nor in assessing how great the tensions were between the scientific and metaphysical Jung. Instead I want to show how the psychological standpoint encourages the smugness mentioned above. Let me provide an example of this danger inherent in the psychological standpoint.

In 1944, at nearly seventy years old, Jung wrote "The Holy Men of India," [11] an introduction to a book written by his late friend, Heinrich Zimmer, about the great Asian Indian sage, Ramana Maharshi. Ramana was a towering spiritual figure and an exponent

of unqualified nondualism. The claim was that he had transcended all pairs of opposites and continuously experienced pure consciousness without content, all the while maintaining contact with the empirical world of multiplicity—a *jivan mukta*—fully liberated while in the body. (One of Ramana's books is mentioned in the "singing stone" synchronicity example, Synchronistic Interlude 6.) Jung begins the essay asking if his late friend, Heinrich Zimmer, forgave Jung for not visiting Ramana when he had the opportunity during his visit to India. After turning this idea over a bit Jung says,

> Perhaps I should have visited Shri Ramana. Yet I fear that if I journeyed to India a second time to make up for my omission, it would fare with me just the same: I simply could not, despite the uniqueness of the occasion, bring myself to visit this undoubtedly distinguished man personally. For the fact is, I doubt his uniqueness; he is of a type which always was and will be. Therefore it was not necessary to seek him out. I saw him all over India, in the pictures of Ramakrishna, in Ramakrishna's disciples, in Buddhist monks, in innumerable other figures of the daily Indian scene.[12]

Here is the smugness of the psychological standpoint in action. Since, according to the psychological standpoint, we cannot transcend the psyche, Ramana was only expressing an archetypal theme, living out the timeless myth of transcendence. For "he is of a type which always was and will be. Therefore it was not necessary to seek him out." Believing him to be a "type," a timeless archetypal longing for release, not a real bursting of the bonds of the psyche, Jung decided not to visit Ramana. A meeting with a genuine *jivan mukta,* who has completely transcended the opposites of the psyche while in the body, might have been a confrontation with the limits of Jung's psychological standpoint. Was Ramana really a *jivan mukta?* Is such a state possible? My study of his life and works seems to confirm this exalted status and those in a better position to know clearly saw him as one of the greatest examples of Indian spirituality of the century. Jung knew his reputation. It does not matter for my point whether Ramana truly transcended the psyche; he was surely worthy of careful scrutiny as a unique spiritual phenomenon who may have truly transcended the psychological standpoint. In the entire Zimmer introduction Jung is clearly on the defensive.

Perhaps the reader thinks I am being unfair to Jung or that this statement is taken out of context. However in 1947, three years after the essay "The Holy Men of India," Jung defended his criticism of Ramana to a Dr. Mees who wrote to him about it. Jung answered Mees in a letter saying,

> I consider a man's life lived for 65 years in perfect balance as most unfortunate. I'm glad that I haven't chosen to live such a miracle. It is so utterly inhuman that I can't see for the life of me any fun in it. It is surely very wonderful but think of being wonderful year in year out! Moreover I think it is generally much more advisable not to identify with the self. I quite appreciate the fact that such a model is of high pedagogical value to India.[13]

Here Jung advises us not to "identify with the self." This may be sound advice for life in the psyche, for psychology, but Ramana is a representative of Indian Advaita Vedanta. That tradition understands that the psyche is a much lower level reality than the supreme self. In fact, all phenomena, both subjective and objective, are understood to be ultimately

illusory in comparison to the Supreme Self. In Advaita Vedanta such identification with the transcendent Self, which is of the same nature as the absolute, is the natural and inevitable result of the spiritual quest. It's true that such identification is "utterly inhuman" if we define the human by bondage to psychic life and its opposites. On the other hand, such a dissolution of the ego's obstruction of our true nature permits the full flowering of compassion—the highest expression of humanism. How could Jung trivialize such an extraordinary achievement by complaining it does not have "any fun in it"? In any case, Jung certainly did not believe Ramana was worth any special trip. Towards the end of the same letter Jung says,

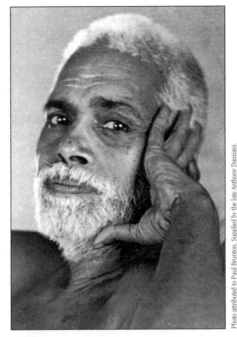

56. Ramana Maharshi

Photo attributed to Paul Brunton. Supplied by the late Anthony Damiani.

I had a chance, when I was in Madras, to see the Maharshi, but by that time I was so imbued with the overwhelming Indian atmosphere of irrelevant wisdom and with the obvious Maya of this world that I didn't care any more if there had been twelve Maharshis on top of each other.[14]

To anyone who has studied both depth psychology and Indian thought, Jung's attitude here is a deep disappointment. As Dr. Marvin Spiegelman[15] has impressed upon me, students of both these traditions suffered a great loss because of Jung's smugness. If Jung had visited Ramana Maharshi, then interaction with this spiritual giant might have transformed Jung and his ideas. Even if he did not feel that Ramana challenged his fundamental ideas then Jung probably would have given us a much deeper psychological understanding of Ramana. In either case, we descendants of these great men are poorer for their not having met.

Can Mind Be Separated from Matter?

The previous section psychologically criticized Jung's psychological standpoint. This section seeks to extend his position philosophically and prepare for the extensions to his ideas discussed in the following chapters.

According to Jung, "We can make only the dimmest theoretical guesses about the nature of matter, and these guesses are nothing but images created by our minds." Since Jung consistently characterizes matter as unknowable in its essence, he never takes a firm stand about its nature. Here I'll try to show that we are wrong to "not contest the relative validity . . . of the realistic standpoint."

I showed in previous chapters that what many consider matter's defining or essential characteristic—its inherent existence or "being-thus" as Einstein calls it—has been denied by experimental physics, independently of the formulation of quantum mechanics. This "theoretical guess about the nature of matter"—or, more properly, a projection upon nature—was not only "dim" but clearly wrong, as recent labors in physics have revealed. It's debatable whether Jung would have agreed with Einstein's realism, although most who profess a belief in matter would find it a natural view—at least before recent work denied it. It's less important to understand Jung's exact view on matter (if he had one) than to examine what follows from a "commonsense" belief in matter considered objective, that is external to or independent of mind. Let me stress, the notion of matter criticized in this section and the next is not the view of matter that emerges from quantum mechanics, but more like the old Newtonian-Cartesian one to which most of us unreflectively subscribe.

The general question arises: How, given that we live in the cocoon of the psyche, can we ever verify that the actual properties of mind-independent matter truly correspond to our elaborate theories about matter? Since we can never break out of our psychic placenta, and "every science is a function of the psyche, and all knowledge is rooted in it. . . . the *sine qua non* of the world as an object," how can we contact the purported womb of matter? Although most believe they need matter to account for the shared and objective nature of the world, as Jung stresses, it is entirely unreachable in its nakedness, its properties are never directly verifiable—by the very nature of the psychic or mental world within which we live and generate theories of nature. As Max Planck, the initiator of the quantum revolution said, "All ideas we form of the outer world are ultimately only reflections of our own perceptions. Can we logically set up against our self-consciousness a 'Nature' independent of it?"[16]

Let me say it another way. If we believe that some mind-independent material object underlies our perception, whether a tree in the woods or tissue under a microscope, how can we ever compare our image of the tree or tissue with the purported material underlay to determine if our perception is adequate to the material reality? The alleged material reality must forever be outside my experience, never directly observable, never comparable to my immediate image and so never an object of knowledge. This is the very thorny problem of the verificationist theory of truth in the philosophy of science. Some verificationists argue that our scientific theories are better and better approximations to the real nature of the material object. Those opposing this view argue that this is in principle unverifiable. They claim that all we can hope for in a theory is internal consistency and an increasingly powerful empirical adequacy of its predictions—the coherence theory of truth. It's not necessary to review these debates in more detail. It's enough to realize that any purported womb of matter, within which we are supposed to live, is always out of our reach, both now and in the future.

Many problems follow from positing a mind-independent matter. Mind and matter, as commonly understood, are two of the most dissimilar principles imaginable. Therefore, since we live only in a mental world, which precludes direct contact with matter, it then becomes an article of unreasoned faith that matter exists external to mind. Yes, our

commonsense view suggests that mind-independent matter is an obvious truth, but reflection reveals it's more like a piece of superstition, a gigantic and unfounded prejudice. What is more, if we say matter gives rise to or provides the basis for our mental experience then we are unconsciously invoking a magical interaction between mind and matter, two of the most disparate principles conceivable. Superstition and magic are not just relegated to our poor benighted ancestors, but haunt those believing in objective matter.

Our unconscious use of the verb *exist* compounds our false beliefs in matter. We unthinkingly consider existence to mean being in space and time and known by a human perceiver with all the limitations and constraints of human consciousness. Take the example of the triceratops shown in figure 57. It seems like a good example of something existing independent of human consciousness, since no humans were around when it existed. However, when we think of worlds populated with dinosaurs and no humans, we actually imagine a world existing just like our own in space and time with all the usual sense properties, but merely with humans removed. When the artist reconstructs an image of a triceratops he creates one that would be perceived by a human if one had been there. Any world, even those claimed to be without humans, must be conceived, imagined, conjured, or created in thought by us with whatever evidence we choose, be it bones or the equations of general relativity.

The only world we can imagine or conceive is one given to perception—a knowable world. You might ask, "Well, how else are we to conceive of uninhabited worlds?" The answer is that we have no other way than to picture it forth in our imagination just because the image in our mind is the only world we can ever know. An unperceived world is by definition unimaginable, unknowable, and, by the proper use of the term, nonexistent. As Paul Brunton says, "The things of experience are not different from the act of knowing them. Hence the world exists in our thoughts of it."[17] Or from the scientific side, Schrödinger says, "Mind has erected the objective outside world of the natural philosopher out of its own stuff."[18] Or from the psychological side, Jung says, "The psyche is the greatest of all cosmic wonders and the *sine qua non* of the world as an object." Simply put, there is no consistent notion of the world as object without conceiving of it as known.

What does the triceratops appear like to its mate, or a flea on its back, or a reptile underfoot? Even these views would perforce be some diminution or variation on a human perspective. We could conceive of no other. Despite the mythology of science as provider

Uncopyrighted drawing from Designer 4.0 drawing program courtesy of Micrographx Corporation, Richardson, Texas.

Figure 57. A human's image of a triceratops

of an objective account of nature, all objects and their properties coordinate closely with their perceiver—without which they are nothing. How then can we legitimately speak about mind-independent worlds? The Middle Way Buddhists strenuously argue that the subject and its world must arise together in codependence upon each other. The interdependence of mind and the world is an expression of their emptiness, their lack of inherent existence. In synchronicity experiences we even get empirical evidence of the interdependence of our psyche and its world. When we study dinosaurs or the big bang or make testable predictions, we are exploring the consistency, coherence, and adequacy of the principles of science. We are not merely exploring our psychology, but nature, of which our mind is a critical and integral part. We cannot study some inherently existing or mind-independent material world. In fact, the problem of how we can know a mind-independent world is a false problem, since neither the functioning mind nor the known objects have independent existence.

Paul Brunton emphasizes the impossibility of a world preceding the mind in time. Referring to the materialist view he says,

> It forgets that each individual knows only its own world, because it knows only its own sensations, and that the identity between a Man's consciousness and the world of which it is conscious, is complete and indissoluble. We must place the mind inseparably alongside of the world. The world does not precede it in time. . . . it is the constructive activity of the individual mind which contributes toward making a space-time world possible at all. An uninhabited world has never existed outside the scientific evolutionary theory.[19]

The next chapter will explain why the individual mind only "contributes toward making a space-time world." This is not solipsism, as the next chapter will show. To anticipate briefly that discussion, it's because a higher intelligence thinks the world into us and our individual mind gives it the particular space and time form of human perception.

The Physiologist's Gap

Let me discuss a related epistemological problem by returning to Jung's description of the psychological standpoint. There he says, "The wave-movements or solar emanations which meet my eye are translated by my perception into light." It would have been more accurate to say they are translated *into* my perception of light. In any case, Jung always accepts the commonly held view that physiological excitations from extra-mental sources turn into perceptions. We see this in his essay, "Spirit and Life." There he speaks continually about the physiological basis for perception. For example in discussing the response generated by touching a hot object he concludes, "But what happens in the spinal cord is transmitted to the perceiving ego in the form of a record, or image, which one can furnish with names and concepts. On the basis of such a reflex arc, that is a stimulus moving from without inward, followed by an impulse from within outward, one can form some idea of the processes that lie beneath the mind."[20]

However, a serious philosophic problem occurs here. No doubt physiology plays a central role in perception, but the electrochemical processes in the nerves and brain are not what we perceive. Nobody perceives electrochemical brain process, no matter how sophisticated the latest models are. As Jung clearly understood, we live only in a world of images full of color, light, sound, and feeling, not one of neurons, neural networks, and complex brain activity. Yes, the body and psyche are interdependent, but it's a grave mistake to overlook what Paul Brunton[21] calls the "physiologist's gap," that unbridgeable gulf between material impulses in the brain and the imaginal world, the perceptual image. We never experience retinal excitations, nerve impulses, networked functioning of large sections of the brain; we see sunsets, touch the face of our beloved, smell damp earth, taste chocolate, and hear string quartets.

Several scientists concerned with the philosophic foundations of physics appreciated this yawning gap between neurological process in the brain and experienced perceptions. Consider for example, Erwin Schrödinger, one of the greatest physicists of this century, and the most profound philosopher among the great founders of quantum mechanics. He says:

> I have gone into some detail here, in order to make you feel that neither the physicist's description, nor that of the physiologist, contains any trait of the sensation of sound. Any description of this kind is bound to end with a sentence like: those nerve impulses are conducted to a certain portion of the brain, where they are registered as a sequence of sounds. We can follow the pressure changes in the air as they produce vibrations of the ear-drum, we can see how its motion is transferred by a chain of tiny bones to another membrane, and eventually to parts of the membrane inside the cochlea, composed of fibres of varying length, described above. We may reach an understanding of how such a vibrating fibre sets up an electrical and chemical process of conduction in the nervous fibre with which it is in touch. We may follow this conduction to the cerebral cortex and we may even obtain some objective knowledge of some of the things that happen there. But nowhere shall we hit on this "registering as sound," which simply is not contained in our scientific picture, but is only in the mind of the person whose ear and brain we are speaking of.[22]

Material brain process and living perceptual images are essentially different. We seriously err if we gloss over the problem of how a material impulse, no matter how complex, could ever transform itself into a perceived image. However, Jung says, "In this way we can form an idea of the nature of the psyche. It consists of reflected images of simple processes in the brain."[23] Yet, neither Jung nor any modern researcher in neuroscience can explain the transition from neurons to knowledge, to "reflected images of simple processes in the brain." Because the realm of mental images and physical processes in the brain are qualitatively so utterly disparate, an unbridgeable gap yawns between the mental world and the material world—

> "But nowhere shall we hit on this 'registering as sound,' which simply is not contained in our scientific picture, but is only in the mind of the person whose ear and brain we are speaking of."

between the imaged world we experience every waking moment and the world given to us by Galileo, Newton, and their followers. If you start as Jung does with a belief in external matter and the recognition that we live only in a world of ideas and images, then anyone attempting to understand perception must come to this uncrossable gap between matter and mind.

In discussing this problem of how a material electrochemical impulse is translated into a sense datum or a perception, the highly respected modern analytical philosopher, Hilary Putnam, said:

This is an explanation?

An "explanation" that involves connections of a kind we do not understand at all and concerning which we have not even the sketch of a theory is an explanation through something more obscure than the phenomenon to be explained. . . . every single part of the sense datum story is supposition—theory—and theory of a most peculiar kind. Yet the epistemological role "sense data" are supposed to play by traditional philosophy required them to be what is "given," to be *what we are absolutely sure of independently of scientific theory.* The kind of scientific realism we have inherited from the seventeenth century has not lost all its prestige even yet, but it has saddled us with a disastrous picture of the world. It is high time we looked for a different picture.[24]

58. Erwin Schrödinger

Photo by Francis Simon. Supplied with permission by the American Institute of Physics, Emilio Segrè Visual Archives.

I fully agree with Putnam that we need a "different picture" of the world. The one bequeathed to us by the giants of seventeenth-century science and still surprisingly alive in Jung's psychological standpoint is "disastrous," as I have tried to point out in this chapter. Following a long tradition in both the East and the West of which Brunton and Schrödinger are a part, I'll offer a different picture, a different philosophic solution, to this dilemma in the following chapters. Now it's enough to appreciate that making brain processes causative of mental process is incorrect. Surely, brain process and mental processes correlate, but *material* process cannot translate into mental images. Brain states may be necessary for many *mental* states but they are not sufficient to explain our perceptions.

As Paul Brunton puts it: "It is just as logical to say that the mind uses the brain as a writer uses a pen, that the body is merely instrumental and the limitations or changes in the instrument naturally modify or alter the mentality expressed.[25]

Synchronistic Interlude 9
Experiencing the Higher Self

We often feel limited to experiencing our lives as a linear continuum. From birth to death one event follows another linearly whereas, from a higher point of view, all our life exists at once. Some Native Americans believe that in the dream world we can access various times in our lives—either future or past—and experience an episode out of the linear sequence. For example, the seeds of my life-changing synchronistic event were contained in a dream that took place before the synchronistic event. This dream mirrored the future synchronistic experience and hinted at my subsequent contribution to this book. Unbridled by the restrictions of my normal waking consciousness, my dream allowed me to jump into two distinct time frames in the future, the essence of which blended into the imagery of the dream that follows:

> I was late for an important meeting at Wisdom's Goldenrod. Goldenrod was many miles from me and I panicked when realizing I could not possibly be there on time. Just then an inner voice asked, "Why don't you fly?" "Of course," I thought as I tipped forward and lifted off the ground. I arrived at my destination as quickly as a thought and found myself looking down upon a waiting group of people below me. Slowly I descended and landed next to Vic Mansfield. He looked at me with disapproval and chastised me in a stern voice. Addressing me by name he said, "You shouldn't do that in public!" I was embarrassed for I knew he was right.

I find it fascinating that many years later I am contributing to Vic's book. In this book my contribution involves a synchronistic experience based upon an event in which I defied gravity and was suspended in air and, true to form, Vic feels that remaining anonymous is appropriate. He does not want me to fly in public!

The "I" that flew in my dream and in waking life is not the little "I" that identifies with the body, but the collective or universal "I" of which we are all a part and which is accessible to us all. I was just fortunate enough to have experienced it directly for myself. Therefore it is appropriate that I relate this experience anonymously as a part of a whole much greater than individual consciousness.

Higher reality has a way of breaking out unexpectedly. I was on my way, by foot, to the university. Approaching an intersection to a busy four-lane highway, I waited to cross. Seeing it was clear, I started to walk and was halfway across when quite suddenly—as if out of nowhere—a speeding car turned onto the highway from a side street. The impact of the collision tossed me way up into the air. For a brief moment my body defied the natural laws that govern the universe. Those provisional rules and organizing powers that hold life together in measurable dimensions were suddenly suspended as was my body as it levitated above the automobile. The woman behind the wheel clutched her head in agony as she watched my figure bounce off the hood of her silver car and fly up into the air before her.

As if in a dream, I was viewing the accident from another perspective. My new center of consciousness was far above what was happening below. In a flash of insight I realized I had moved out and above to see and hear—not with physical eyes and ears for certainly those were left behind in the hovering form below me. I experienced reality directly in a

cool detachment that transcends crisis, seeing through the one who sees—the Overself. Until that moment I had only intellectually accepted the idea of the timeless, changeless, hidden observer—the Overself—the true Self that indwells within us all. This immanence of the universal being found in a particular center transcends the death of the body and personality. Then I found myself witnessing the accident through this higher Self. What a paradox to exist outside who I habitually thought I was. That more physical self, my body, remained motionless, elevated, and out of danger until the swerving car came to a full stop—then it fell to the ground.

The driver got out of her car and ran over to me. By then I found myself back inside my body. Disoriented, I opened my eyes and looked up. "Are you all right? Can I help you?" Focusing upon the concerned face looking down at me, I gradually adjusted to my new location. The impact had been so forceful that it knocked off my shoes, which had fallen in an adjoining lane of traffic. As the driver went to fetch my shoes, I reoriented myself to the heavy mass I was again attached to and gently stood up checking to see if everything was intact. I was amazed to find that only small bruises appeared on my little finger and left hip, and yet another part of me remained detached. Returning with my shoes, the driver and a passenger, who was in the car with her, helped me over to the side of the road. We exchanged all the necessary information, following the usual procedure after an accident. I explained that I lived only a block away from the site of the accident and could walk back home on my own and report the accident. I, and my body, walked away from that accident physically unharmed. On another level I was deeply stirred and yet simultaneously at profound peace. My peaceful state soon gave way to a wonderful state of elation and childlike joy. The world was more vivid. I had never seen the world and its inhabitants as so beautiful. This extended into a higher state of functioning. I contacted resources unknown to the woman I was before the accident.

That afternoon I went to the university where I taught a group critique in a graduate art seminar. I felt profound love for everyone around me. Our exchange was inspired and it was as if my energy flowed out and washed over my students. They too opened to some new dimensions within themselves. For three hours we were enchanted and found ourselves engaged in a discussion of profound meanings and insights.

Upon returning home I lay down to rest, my head full of images. Then the intellect, the part of my mind that judges and categorizes experience, began to sort through the events of the day. My rational mind insisted that I was in shock. Obviously during the accident I was experiencing a traumatized state where normal reality slowed to a series of stills—like individual frames in a motion picture. Time and movement were distorted. What else could possibly explain my suspension in midair? As for my out-of-body experience, shock would account for that illusion as well. The fear of such terrible pain would have made me unconscious of my body. I felt the light diminish and narrow and a shadow cross over me.

I wept uncontrollably as my treasured glimpse of a higher reality was being pulled away from me like the mother's breast from a newborn infant. I pleaded from the depths of my soul to be able to hold on to the gift I had been given, "Oh please, please don't let me lose this!" At the very moment of my deepest despair a synchronistic experience unfolded that was the answer I pleaded for with every fiber of my being. There was a knock at my door. Quickly drying my tears, I went to answer it. I opened the door to find a stranger, a woman who said she lived in the neighborhood near my newly rented house.

Detail of a painting by the author of this synchronicity story. Photo by Victor Mansfield.

59. Detail of a painting by the artist—an early flying machine.

She asked me how I felt after being hit by the car. She explained that she had witnessed the accident and told everybody at work all about it because she had never seen anything like it in her life. "Why?" I asked. "Why you went up in the air and didn't come down!" she exclaimed. There it was! I had been given the answer I needed. The woman at my door was an objective observer who validated my experience.

For a moment in time a mysterious force allowed my body to defy gravity and separated my consciousness from my physical body so that I could look down on the event from above. What a gift, to know through actual experience that I am not just my body. My ordinary life was lifted above the physical laws that seem to govern it and the door opened a crack to another reality. Now in my higher moments, there are occasions when my inner vision surfaces to pierce the mask of reality. I perceive the world to be a mirage of projected thought-forms, a swirl of impressions, as its illusion of firmness gives way and starts to dissolve. My moment of transformation and breakthrough into an alternative self-awareness has indelibly changed my perception of myself in relation to the universe. On the surface I have returned to my life and continue onward as I was before the accident. The pull of old habits and my old ways of coping seemingly bind me to this material universe. The difference now is I am in this world—but no longer completely of it. Distancing myself is more natural. Now that the door has been opened, it is possible to find my way back into the stance of the impersonal observer, the Overself. This shift in awareness portents a wholeness existing beyond the perceptible world. The glimpse from an acknowledged central nucleus of myself, having seen through the eyes of the one who sees, has made me conscious of that core of awareness and its nonlocal nature. I now realize I am not exclusively tethered to my body. Consequently the boundaries that separated the internal and external world are beginning to fade.

The last two synchronicity stories with books shooting off bookcases and a body floating in air present special difficulties for a physicist. Were the normal laws of physics interrupted or suspended in these synchronicity events? I am certain that the protagonists accurately described their experiences. There probably is enough room within the descriptions to argue against a violation of known physical laws.

If we strictly apply Jung's understanding of synchronicity as an acausal manifestation of meaning in both the inner and outer world, then we are not to believe that the archetypes or the unconscious caused these extraordinary events. Here cause is used in the way Jung and physicists would use the term. Since causality is not involved, this seems to imply that we violate no physical laws in synchronicity. On the other hand, when knowledge outside the normal sensory channels is obtained in synchronicity this might violate known physical laws. At this stage in our understanding I believe we must leave unanswered the question of whether synchronicity violates the known physical laws—although my preference is to say that it does not.

13 A Philosophic Model for Synchronicity

The only form of thing that we directly encounter, the only experience that we concretely have is our own personal life. The only completed category of our thinking, our professors of philosophy tell us, is the category of personality, every other category being one of the abstract elements of that. And this systematic denial on science's part of personality as a condition of events, this rigorous belief that in its own essential and innermost nature our world is a strictly impersonal world, may conceivably, as the whirligig of time goes round, prove to be the very defect that our descendants will be most surprised at in our boasted science, the omission that to their eyes will most tend to make it look perspectiveless and short.

William James[1]

Mind as World Creator

Early one morning two men rudely awakened me by loudly talking on my front lawn. They startled me and I could not imagine why they were being so inconsiderate. What could they possibly be doing at this early hour at my house, which is in a remote location in the country? I got out of bed to look cautiously out on the front lawn, visible from the window near my bed. Everything was still. Only my heart was beating fast. As it often happens here in the country, a palpable sense of peace blanketed the hillside. The low early morning sun glistened on the dewy grass. A few song birds flitted among the trees. Where are those guys? I heard them only a second ago. I searched the yard from other windows. Not even a breeze was stirring. My wife rolled over in bed and sleepily asked me what was the matter. I couldn't answer.

I recalled that the dog, our big noisy black Lab, had not made a sound this morning. If he had heard just a fraction of what I did he would have exploded in a frightening and prolonged roar. But his hearing is better than mine. What's going on? . . . I must have been dreaming—could it be? The voices were so loud and immediate, so real in every sense of the word. But the dog didn't bark and there was not the slightest trace of anyone near the house. I tried to reconstruct it all and eventually had to admit that I must have been dreaming, despite the vividness and compelling reality of the two voices.

The intruder dream is a common archetypal theme that you have probably had yourself. Interesting as it may be psychologically, I only want to consider the dream from the point of view of the theory of knowledge, epistemologically—like the discussion of the early Christian going to the lions in an earlier chapter. From this point of view, here is a powerful example of the mind's ability to create a reality out of its own substance and project it into a space and time of its own making. All this was done with the utmost reality, despite there being no material substrate to the intruders. As any powerful nightmare shows, the mind has the power to create an entire drama out of its own substance and endow it with as much reality as any waking experience. This intruder dream was so vivid and compelling that I couldn't even consider it a dream. It overflowed into waking life. Some would call it a hypnagogic vision—those peculiar experiences that erupt from the transition between sleep and waking or waking and sleep. Whether we call it a vision or a dream doesn't matter. The essential point is that it shows the mind's power to create a convincing world entirely out of its own substance. My careful search and especially my dog's silence convinced me that the intruders must have been a mental fabrication. Reason had to prevail over image, since nothing intrinsic to the experience could help me distinguish it from waking consciousness.

Fortunately for me this is a rare experience, but it dramatizes the mind's creating, projecting, and reality-investing powers. To use Buddhist language, I fully believed that those men inherently or independently existed, that they existed from their "own side," that they were real—as real as could be. In fact, my mind fabricated them out of its own imaginal substance and then imputed or projected inherent existence onto its creation.

The previous chapters used arguments from psychology, physics, and philosophy to question the existence of a mind-independent world. Those arguments were largely negative in that they tried to remove false views. In this chapter I'll be more constructive and try to sketch an expanded view of mind, one that simultaneously encompasses all levels of subjectivity and objectivity. With hints from the epistemological analysis of dreams, I'll more fully develop the idea that the mind creates its own waking world and invests it with the false belief in its independent reality. However, this does not deny an objective content to our experience or suggest that our minds are free to create whatever they wish. I'll deal with such issues later. Now let's just concentrate on the spectrum of phenomena illustrating the mind's fabricative power, from psychological projections and hallucinations to dreams. I'll stress dreams because they are the most dramatic examples of the mind's constructive power.

Who has not awakened in cold terror from some dreams or reveled in warm desire in others? Yet, where is that fearsome monster or that object of lust? Each element of the dream, including the dream protagonist and her body, have their existence solely in the mind of their creator, in the mind of the dreamer. No external material basis for any elements of the dream exists. They are all just fabrications of the dreamer, imagination spun out convincingly in a space and time of its own creation. As long as we remain in the dream, it's a self-consistent and convincing reality.

In psychological projections, hallucinations, and dreams the mind completely forgets it's the creator of the appearances. It objectifies its contents, its images, but never itself. For example, in dreams a world with apparent objects and subjects unfolds, but the dreaming mind, the creative principle providing the whole show, never objectifies itself. I argued that this inability of the mind to objectify itself dooms all purely objective studies of mind to partial views.

In psychological projection, some objective component usually exists upon which we hang our personal attributes. Yes, the person we hate for being a braggart or a liar may in fact be one. But my distortions and emotional compulsions toward him make it impossible for me to decide how much of these attributes are truly in the person and how much are in me. Projection inherently obscures my vision of the world. Hallucinations have even less of an objective component, while dreams usually have no objective component at all and yet they completely express the mind's ability to populate a world with apparently objective and convincing persons and things.

Neither projections, hallucinations, nor dreams on their own prove that the everyday waking world is solely mental, but they do graphically illustrate the manufacturing power of the mind. Employing these phenomena, let me pursue the idea that the entire world is only mental, that no material underlay exists, and that the notion of a mind-independent or inherently existent world is the most insidious of projections, as the Middle Way Buddhists would say.

Although this philosophic position is not fashionable in modern academic philosophy, it's an old one in both the East and the West. For example, in Buddhism, the Mind Only School grew directly out of the Middle Way School. Mind Only, as the name implies, says that we can experience mind only, that all objects, no matter how physical they seem, are only various kinds of thought without any mind-independent world underlying them. The Mind Only School accepts much of the analysis of phenomena by the Middle Way School. It agrees that all objects are dependent upon causes and conditions, whole and parts, and mental designation. Mind Only especially emphasizes the Middle Way School's point that mental designation or imputation is the most important mode of dependency of phenomena. Focusing on the point that it is impossible to contact directly a world separate from mind, Mind Only argues that it is useless to assert the existence of such a nonmental world. Although I don't rehash the traditional arguments of Mind Only in this chapter or review the lively debates between Middle Way and Mind Only, I have given arguments in the previous chapter and will present more in this one that a Mind Only Buddhist would like. In general, I use the Middle Way Buddhist position, like Jung's psychological standpoint, as a convenient platform or jumping off point from which to build a mentalist view—one similar to but not identical with Mind Only Buddhism.

Let me be clear about how the Mind Only Buddhists and I use the word "mental" or mind. We do not contrast mind with matter, for whatever we might mean by matter is included within the category mind as just a particular form the mind can take. Of course, this is easier to understand if we take a quantum view of matter as potentialities for

manifestations in a spacetime that is deeply dependent upon the reference frame, potentialities that are exquisitely observer dependent and nonlocally interconnected. However, despite the recent quantum discoveries, most of us still carry around a Newtonian view of matter, one that suffers the inveterate projection of independent existence, as the Buddhist would call it. Because this more primitive or instinctual view of matter is the usual obstacle to our understanding of mentalism, most of my remarks in the following discussion are directed against this old view of matter. Of course, the arguments also apply to the much more insubstantial quantum matter. For either view of matter, as I argued in the previous chapter, a mind-independent world or mind-independent matter is an incoherent notion. However, this does not mean that all sorts of objects from galaxies to gladiolas do not exist external to my body. We can more easily avoid this error if we recall that the mind is not confined to the brain and that the body is as much a complex of ideas within mind as the gladiola is.

In the West, Bishop Berkeley and his many successors developed a very similar view to the Mind Only School. I'll try to show that a particular form of Idealism can be rationally upheld and that one of the many benefits of such a position is that it offers a possible explanation of synchronicity. It also anchors psychological and spiritual development in a cosmic principle, mind, which is as much an object of attention for scientists as for psychologists or philosophers.

The World Given from within the Mind

Jung might not agree with my idealistic view, my mentalism, although several places within his writing offer opportunities for extending his psychological standpoint into mentalism. For example, consider Jung's philosophically revealing statement about the self, made during repeated questioning in the Tavistock Lectures about whether the self was of the dimensions of the universe. He said:

> This is really a philosophical question, and to answer it requires a great deal of the theory of cognition. The world is our picture. Only childish people imagine that the world is what we think. The image of the world is a projection of the world of the self, as the latter is an introjection of the world. But only the special mind of a philosopher will step beyond the ordinary picture of the world in which there are static and isolated things. If you stepped beyond that picture you would cause an earthquake in the ordinary mind, the whole cosmos would be shaken, the most sacred convictions and hopes would be upset, and I do not see why one should wish to disquiet things. It is not good for patients, nor for doctors; it is perhaps good for philosophers.[2]

I agree with Jung that a foray into epistemology is required to answer the questions at issue. We have already done much of this work. Recall that in the previous chapter about Jung's psychological standpoint he says "We live immediately only in the world of images." This clarifies what Jung means by saying, "The world is our picture." From the physics discussion we know that we ordinarily believe in a "world in which there are static and isolated things." But such a world populated with independently existing things has been contradicted scientifically and argued against philosophically by many, including

the Middle Way Buddhists. As Jung tells us, since all immediate experience is only complicated images in the mind, all we ever directly experience of the world is our mental picture of it. Or, as William James says in the opening quotation, "The only form of thing that we directly encounter, the only experience that we concretely have is our own personal life."

Let me amplify "The image of the world is a projection of the world of the self." Since all we can directly experience are images, the "image of the world" includes *all elements* of our experience from our most delicate intuitions to the ground on which we walk. The hard chair under me and my dog's silky ear are as much images as a childhood memory or last night's dream. But from where do these images arise? The "world of the self" is the unconscious wellspring of our individual life, an inner world we cannot fully objectify—for which reason Jung develops the symbolic method. For Jung, the archetype of the self is the intelligent organizing principle expressing itself in our inner and outer life. I understand his sentence to mean that the entire world is not given from without the mind but from within the mind, specifically from the self. As Paul Brunton says, "When we believe that we are experiencing the world outside, we are really experiencing the self inside."[3]

The world of sense knowledge is surely external to our bodies. For example, my desk is clearly external to my body. However, rather than sense experience originating outside our body and somehow crossing the yawning physiologist's gap, the entire world image, *including our body,* comes from within the depths of our mind—from the "world of the self." The previous section discussed the power of the mind to externalize its thoughts into a space and time of its own making and then erroneously consider them as independent objects. So the mind surely has this power of convincingly externalizing or objectifying its thoughts and believing wholeheartedly in their independent reality. All these—objective persistence, externality, independence—are the mind's powerfully held ideas. Although the world surely has some objectivity and persistence, that does not prove the existence of an independent material world external to mind. Let me delay the ontological question of what accounts for the givenness or objectivity and persistence of the world for later and focus here on the idea that the world wells up from the depths of the mind rather than the external realm of matter.

If we believe with Jung that we only experience a world of mental images, what sense does it make to speak of external to the mind? No matter how we conceive of this alleged world external to mind, we immediately bring it into mind by our very conceiving it. I tried to make that clear in the epistemological discussion of the dream about early Christians going to the lions. There I discussed that while in the dream it was impossible even to consider abstractly something outside the dreaming mind. No matter how you attempted to imagine something outside the dream, it was impossible because it's immediately incorporated in the self-contained dream world. So too with our conceptions of a world external to the waking mind. Anything we know must be within mind.

Space and time, as Kant showed long ago, are modes of the mind's functioning, not intrinsic to the object. For example, when the mind perceives dream images, it necessarily

puts them into a space and time of its own making. In general, to have any experience, whether dream or waking, the mind must know its contents by placing them in a space and time created for that purpose. *It's therefore wrong to apply these spatial categories of thinking to the mind itself and discuss it as a thing extended in space that has an inside and an outside like a box.* To speak of inside and outside mind is really to talk nonsense, to make meaningless sounds. Since we are here bumping up against a powerfully held belief about the world, against "common sense," let me appeal to Einstein's relativity for help in explaining how the mind is a uroboros—a completely self-contained whole.

I opened chapter 7 with a quotation from Jung's synchronicity essay that says, "In themselves, space and time consist of *nothing*. They are hypostatized concepts born of the discriminating activity of the conscious mind, and they form the indispensable coordinates for describing the behavior of bodies in motion. They are, therefore, essentially psychic in origin." That chapter discussed the physicists' view of space and time that differs drastically from our usual notions. The analysis did not prove that "space and time consist of *nothing*" nor that they are "essentially psychic in origin," but it did move in that direction. If space and time are not intrinsic to the world but are instead modes employed by the mind or psyche to order and manifest its experience, then it's wrong to apply those very constructions or modes to the maker of them, to the mind or psyche itself. The mind is not in space with an outside and an inside. For the same reason we cannot limit the mind by time, as having a true beginning or an end. In this way we get some insight into how synchronicity can transcend the normal constraints of space and time and how the various mystical and religious traditions can admit of the body's birth and death, but not the beginning or end of mind.

In special relativity Einstein unified the three dimensions of space with time to get the four-dimensional spacetime continuum. Of course, operating only in a three-dimensional world, we have great difficulty imagining the four-dimensional spacetime continuum. Here we must be heirs to Galileo and appeal to mathematics to show us that we must treat time on the same footing as any spatial dimension. We must further realize that space and time are completely entangled in each other. For example, in the relativity chapter we discussed the simultaneous closing of the high speed doors on spacetime Sam's box in the casino reference frame. For an observer in a different frame these events are not simultaneous, both space and time separate them—space and time are truly entangled into four-dimensional spacetime. Now with that quick review of special relativity let me give a one-sentence definition of general relativity, short enough for a bumper sticker: Matter curves four-dimensional spacetime and curved spacetime tells matter how to move. For example, the concentration of matter known as our sun curves the four-dimensional spacetime in its vicinity. This curvature then guides the planets in their orbits in four-dimensional spacetime. All talk of forces and action-at-a-distance have been replaced by the local influences of curved four-dimensional spacetime on moving objects.

The big bang model of the universe is one of the most beautiful applications of general relativity. In it the universe is a continuous expansion of curved four-dimensional

spacetime. Yet beginning astronomy students invariably ask, "What space is the universe expanding into? What is outside the expanding spacetime continuum?" "What happened before the big bang?" The answer is, as in the question of what is outside or prior to mind, that the big bang happens everywhere simultaneously. Nothing exists outside the universe. There is nothing to expand into and no time before the big bang. The universe is all there is. As the depth psychologists would say, it's an example of the archetypal *uroboros,* symbolized by the self-contained snake or dragon eating its own tail, shown in the drawing. In exactly the same way, nothing exists outside the mind. With no outside, what sense can we make of inside? *The contents of mind are all that can exist for us.*

Speaking about the world being given to us from within is therefore just as bad as saying it comes from without the mind—if I use "within" as implying a spatial description, or implying there is a "without." Therefore, when I say the world is given to us from within, I mean from within the depths of the mind or out of the essence or core of the mind. Unfortunately such words as *depths* or *core* also have an unwanted spatial connotation, which I disavow. With that understanding we can still ask what is so troubling about the idea that the world of experience is given to us from "within," or out of the depths of mind, rather than "external" to mind. True, it violates our notoriously bad intuitions about the world, our projections upon the world. The confirmed devotee of the psychological standpoint might argue that I can know nothing certain about the essence of mind or matter. Therefore, it's equally likely, and equally undeniable, to assert that the world believed external to the mind is the source of sense knowledge, or, that the perceptual world is given from within the depths of the mind. However, this timid agnostic position offers no solution to the verificationist's dilemma of being forever cut off from the alleged

Drawing commissioned from Terry Howley, of Ithaca, New York.

60. Uroboros

source of knowledge (the independent material world). Nor does this agnostic position solve the problem of the physiologist's gap. Finally, it offers no help in understanding the unity implied by synchronicity.

Given that we only experience a world of images, that any supposed matter is, by its very nature, unreachable, that a world external to mind is truly inconceivable, that the physiologist's gap is uncrossable, and that mind can project its thoughts as a seemly external world—there is no justification for clinging to the fallacy of a world external to mind or a mind-independent matter. We live solely in a mental world for, as Paul Brunton says, "there are no things apart from the thoughts of them."[4] Physics has been forced to accept a nonlocal and interconnected quantum world, whose manifestation requires our participation. This revolution occurred despite the philosophic preconceptions of its practitioners. Similarly, despite our preconceptions, the unity between the inner and outer worlds implied by synchronicity phenomena challenges our belief in a world external to mind. The philosophic arguments, physical analysis, and psychological experiences of synchronicity all encourage us to abandon the pervasive projection of inherent existence, the false belief in a world external to mind.

Avoiding Some Misconceptions

When the mind projects the image of the world, it also constructs our empirical personality or ego along with our body as part of that world. When Jung says, "The image of the world is a projection of the world of the self," that self is the mind unfolding as the imaginal world along with the empirical personality experiencing it—the ego. In my interpretation of Jung's sentence, which is heavily influenced by the unity between the inner and outer world implied by synchronicity, the body and soul or body and psyche are certainly distinguishable. Yet, they are in essence of the same stuff—thought. We thus have at least one example of what Jung might mean when he said, "The synchronicity principle possesses properties that may help to clear up the body-soul problem."[5]

Jung rightly claims that the ego must always be associated with some known content. However, the true knower is not the ego, the empirical personality, the distorted surrogate for the self. If the ego were the true knower then it would not be possible to know the ego as an object within consciousness, for the knower cannot know itself objectively. Rather, the true knower is the more encompassing mind that projects the world, but finds no place within the manifest world for itself. The beautiful sunset and my ego with its aesthetic response are distinguishable parts of the image presented by my individual mind. The ego is just as much a content as the sunset. Analogously, the dreaming mind projects a dream world with an empirical dream ego that has experience within the dream. The dreaming mind thinks both dream objects and dream Vic's ego, along with his dream body, into existence. Although we cannot localize this dreaming mind in the dream, it's the true knower, both presenting and knowing the images. Simply put, the mind can objectify images and empirical personalities, but never itself.

Let me try to forestall a natural misconception that arises in this view of mentalism.

All my use of dream epistemology and the idea that the world is given from within does not imply that the waking world is a dream or an illusion or purely subjective. The waking world is as real as it can be. All the joys and sorrows of this world are just as undeniable as they ever were. The objects are just as hard and substantial as ever, yet this does not deny their purely mental character, that all objects and subjective states are solely constructions in thought. I'll discuss in a few pages in what sense the world is not subjective and how we can share it between us. For now it's enough to realize that all the discussion so far does not lead to an illusory world. As Paul Brunton says, "The world is neither an illusion nor a dream but analogically *like* both."[6]

Let me try to prevent another natural misconception. We must appreciate that mind is a continuum. There are different levels of mind with different powers, but only *one mind.* For example, an aspect of mind can contact what Jung called "absolute knowledge," that spacetime transcendent knowledge of events not accessible to our normal mode of mental functioning. This higher aspect of mind only differs in its manifestation and powers from the mind that reads this sentence and tries to discover its meaning. If we fail to appreciate mind as a unity with a multiplicity of powers then all sorts of misconceptions can arise. For example, we might incorrectly believe that it's the limited mind associated with our individual personality, our ego, that bodies forth the cosmos from the most distant galaxies to the submicroscopic world. In fact, the ego and its world are brought forth together out of the larger mind. Yet, we should not fall into the trap of fracturing the unity of mind into several distinct and separate minds. Then we guarantee the ego's exile from its larger creative source. We are forever cut off from our higher good. The finite loses its tether to the infinite. Instead, the goal is to appreciate that right here in the most mundane experiences all the powers of mind are present. The infinite always accompanies the finite. Or as William Blake says in "Auguries of Innocence,"

> To see a world in a grain of sand
> And a heaven in a wild flower,
> Hold infinity in the palm of your hand
> And eternity in an hour.

An Exercise in Personal Reflection

Sometimes philosophic argument, even if correct, leaves us cold. Let me try the following little exercise that relies more on imagery and personal experience than analytical philosophy. Although I try to do it with personal experiences, it's inspired by a philosophic argument given by Paul Brunton.[7] After you get the drift of what I'm doing you can try it with your own experiences. You might even supplement your musings with a glance at the family photo album. If it contains some old pictures of you, they can help bring even more feeling to the argument.

One of the earliest experiences I can vividly remember is delighting in my grandfather's rabbits. Long, soft, furry ears and timid, twitching noses, they hopped all around me in the dim light of the rabbit hutch. Different family members would take me into the hutch

frequently because the rabbits so obviously delighted me. One day my grandfather, whom I loved dearly, came to get one of my friends for the cooking pot. The blood was so red, the twitching stopped so quickly; I was stunned and horrified.

Let me jump forward several years to eighth grade. Then my mother convinced me, against my will, to attend a ballroom dancing school. I held those young ladies at arm's length, diligently watched my feet lest my oversized shoes land atop some delicate toe, maneuvered tensely around the dance floor, and perspired with excitement under my hot jacket and tie. Lessons over, I went outside and took a deep breath of the cool night air. I had more than beautiful memories of fox-trotting with lithe young girls. I could still smell the intoxicating mix of their perfumes clinging to my jacket. I have never recovered from the release of sweet desire occasioned by that voluptuous bouquet.

Several of us went to a drug store for Coca-Colas. I played with my tall ice-filled glass while trying to converse smoothly with those young flowers still exuding perfume. I put the long straw in my mouth and lifted the glass. I got confused about the need for tilting glasses and drinking with straws and poured the Coke down my necktie and white shirt. I wanted to crawl under the table or at least escape into the cool, dark night.

Next let me look toward the future by imagining myself twenty years from now. Assuming I'm still alive, the lines in my face will be more numerous and deeper, my jowls heavier, and hairs will be growing out of my ears. Perhaps I'll be wiser, calmer, and more compassionate or maybe more confused, agitated, and bitter.

As for the past, where are my old furry friends, the rabbits? Where are those beautiful young girls swirling in the warm night air? Where is my embarrassment as the icy liquid pours down my chest? Clearly, these are all memories, images, feelings—in short, they are all thoughts. No matter how vivid the horror, how sweet the desire, how hot the embarrassment, now they are all memories—thoughts.

What about my future as a wrinkled, jowly old man? Since the future is yet to be, it can only be in the imagination, in thought. All future possibilities are just as much in thought as my past memories. Also, notice that we cannot truly observe the present. When we try to observe the present it inexorably slips into the past. Trying to grasp the present transforms it into history, into the world of memory images. (In addition, as I discussed in relativity, even the idealized notion of the present used in physics is deeply dependent upon a particular reference frame—it's hardly universal.) Since the present is only an infinitesimal transition point within my particular reference frame, a transition without duration between the imagined future and the remembered past, all experience is mental. All experience of our own personality and the world is none other than imaginal.

Even if I could walk back into the rabbit hutch (which is long gone), adjust my eyes to the dim light, smell rabbits, and even cradle a distant descendent of my friends of five decades ago, this would only be a complex series of images. The softness, the smells, and the sights are just images in the psyche, thoughts in my individual mind—nothing more and nothing less. I might *believe* that some independent entity exists underlying my sense reports, but that is never an object of my perception, never directly experienced by me in any way. I am imprisoned by my sense reports, which upon examination are none other than mental images and thoughts. Belief in some "real" material object that underlies

my sense reports is a gigantic prejudice, an unwarranted metaphysical assumption, an unreasoned article of faith. As Hilary Putnam says in discussing the physiologist's gap, "The kind of scientific realism we have inherited from the seventeenth century has not lost all its prestige even yet, but it has saddled us with a disastrous picture of the world. It is high time we looked for a different picture."[8]

Nevertheless the world does have objective or given contents that are not subject to our will. We actually share some things among ourselves. How can we understand this without invoking the discredited idea of mind-independent matter?

Accounting for the Objective

We need to account for the shared objectivity of the world, its obvious presentedness independent of the ego's will. Many traditions, both Eastern and Western, that subscribe to the idealism outlined above invoke some superior mind, cosmic intelligence, World Mind, or World Soul that presents us "internally" with the idea of the world. Differences of detail exist among the several traditions, so I'll follow the formulation given by Paul Brunton[9] and Anthony Damiani,[10] who call their version of idealism, mentalism.

The world presented from within has a nonspatial and nontemporal form, like the psychic impulse that unfolds as a dream image. The mental impulse generating and organizing a dream, be it fear or desire, is nonspatial and nontemporal, yet the individual dreamer's mind unfolds this psychic ground plan into a full-bodied space and time dream adventure. In a similar way, the individual mind receives the World Soul's impulse and projects it into space and time as a content of its imagination. Psyche must always produce its images in some form of space and time, but a higher intelligence provides the essential content, not matter existing in spacetime.

This grander principle or cosmic intelligence accounts for the shared and persistent nature of the world. For example, imagine looking at an apple tree with me. The World Soul internally gives our minds the ground plan for the tree that we agree persists and is shared by us. Our individual mind gives each of us the particular space and time form of the tree modified by the peculiarities of our individual psychosomatic structure. Your body (also part of the World Soul's input) has a different geometric relation to the tree, our bodily limitations differ (my eyes are different from yours), and our psychological associations vary (you have bad memories of falling out of an apple tree as a child). All these and more are aspects of the presentation of our individual minds. The individual mind receives the given content (the tree and our psychosomatic structures) and provides us with objectivity, space and time form, and our psychological distortions. As Brunton says, "The world is the invention of Universal Mind. But the latter functions in and through the human mind. What it presents is common for all men."[11]

Perhaps a simple technological metaphor will help. Consider the digitally based High Definition Television now under development. The program is encoded into a long string of zeros and ones or offs and ons. The broadcast signal is received by the TV set, decoded, amplified, and displayed as a high-resolution image with sound. The digital signal is just a complex string of yes-no bits, nothing like the animated images and sound we perceive.

Nevertheless, this digital bit string contains all the information for shape, color, movement, and sound. Analogous to the bit string, the nonspatial and nontemporal mental impulse is broadcast to each of us by the World Soul. Analogous to the television receiver, our individual mind takes the impulse, decodes and projects it into spacetime with color, movement, sound, and the rest of the sense functions.

Of course, the analogy breaks down in several important ways. For example, the bit string is in space and time while the mental impulse provided by the World Soul is not. Even more peculiar, our psychosomatic organism is contained in the mental impulse. It's not that our body-mind complex preexists in space and time and receives signals from the World Soul. Instead, the information for the receiver-decoder-amplifier, our psychosomatic organism, is part of the mental impulse, just like the dream Vic and his body are part of the psychic impulse that unfolds as the dream.

Although never systematic about it, Jung also appeals to some superior principle. For example, throughout his writing Jung sprinkles references to the *Unus Mundus,* the unitary ground underlying both psyche and matter. Although he never gives a detailed discussion of this unitary principle, he in large part postulated this principle based on synchronistic experiences. For example, "This principle [synchronicity] suggests that there is an interconnection or unity of causally unrelated events, and thus postulates a unitary aspect of being which can very well be described as the *Unus Mundus.*"[12] The chief aspect of the *Unus Mundus* is that it's a unified potential world, logically (not temporally) prior to our world of experience. The *Unus Mundus* is not yet broken into concrete objects in spacetime. Jung describes it as, "the potential world of the first day of creation, when nothing was yet 'in actu,' i.e., divided into two and many, but was still one. . . a potential world, the eternal Ground of all empirical being, just as the self is the ground and origin of the individual personality past, present, and future."[13]

Photo by Victor Mansfield

61. Paul Brunton

What does Jung really mean by this mysterious notion of the *Unus Mundus?* It makes so many appearances in his later works, yet it receives little definition or description. His most detailed treatment of it is in the final chapter of his last and most magisterial work, *Mysterium Coniunctionis,* where he discusses the three levels of union with the *Unus Mundus* sought by the adept. Perhaps a simple psychological example may help in understanding this principle. My example is an adaptation from one often given in seminars by Anthony Damiani.

Consider the state we occasionally attain on gently waking from deep dreamless sleep. Imagine the mind is still, completely quiet, without any thoughts or feelings. We are fully aware, yet have no body-based identification, no sense of personal identity, no sense of egoity—just choiceless awareness. The world is presented as a seamless whole without our being separated out from it by desires and expectations. Objects appear, but the world is still unified, peaceful, and not cut into objects opposing a body-based subject. We may not fully attain this state, but we at least get a hint of it occasionally when we gently wake from dreamless sleep. In this state we do not know where we are, or even who we are, but only that we are. Because the personal sense of "I," the ego, along with reified objects, has not yet been brought into being by our thinking, we have not shattered the mind's native unity and no opposition exists between ourselves and the world. We are in a unified potential state from which many possible experiences could flow. Now if we can transpose this description to the cosmic principle informing us, to the *Unus Mundus,* we may get some hint about what it might mean to say it's "the potential world of the first day of creation, when nothing was yet 'in actu,' i.e., divided into two and many, but was still one . . . a potential world, the eternal Ground of all empirical being, just as the self is the ground and origin of the individual personality past, present, and future."

Although my clear preference is to understand the *Unus Mundus* as a mental, or more properly, spiritual principle, Jung tries to maintain neutrality about whether this is a material or mental principle. In discussing the *Unus Mundus* he says:

> Though we know from experience that psychic processes are related to material ones, we are not in a position to say in what this relationship consists or how it is possible at all. Precisely because the psychic and the physical are mutually dependent it has often been conjectured that they may be identical somewhere beyond our present experience, though this certainly does not justify the arbitrary hypothesis of either materialism or spiritualism.[14]

By now it should be clear where my views differ from Jung's quotation. Let me not repeat that. Instead, let's ask, if this view of World Soul or *Unus Mundus* giving us our objective experience rather than Newtonian matter is correct, why does it seem so contrary to our common sense beliefs? In Hinduism they say ignorance by its very nature is inscrutable and so we cannot explain it. Nevertheless, I will attempt some analysis.

Start by recalling that all ordinary knowing, where a content relates to an ego, is a form of objectification. To know any content in the normal objective mode we must make it distinct from the subject, from the light of awareness shining through the empirical personality. Even depth psychology in attempting to know our subjectivity does so

symbolically, which is a particular form of objectification. Of course, as I stressed, the natural sciences are fully committed to knowing in the objective mode. This exclusive commitment is in large part responsible for our difficulty in understanding some of the most important findings of both relativity and quantum mechanics—to say nothing of the nature of mind.

When the mind objectifies its world, it necessarily leaves itself out of the picture, since its very nature is unobjectifiable. Schrödinger calls the process "objectification." He says, "Mind has erected the objective outside world of the natural philosopher out of its own stuff. Mind could not cope with this gigantic task otherwise than by the simplifying device of excluding itself—withdrawing from its conceptual creations. Hence the latter does not contain its creator."[15] We then become so fascinated with objects that the true subject, which Schrödinger calls the "Subject of Cognizance," then falls to the background, especially so because it cannot exist in the "real world" of objectively existent objects, the domain of science.

Because we cannot objectify the true subject, physics can never, at least as far as it maintains its objective attitude, address the relationship between the subject and the object. Several eminent physicists and philosophers are unclear on this point. In other words, science's exclusive commitment to the objective mode makes the deeper nature of mind inaccessible to it. Since mind projects our world image, then as long as we stay in the image we will never know the projector—the source.

The true subject (which truly transcends the categories of subject and object) becomes so entangled and enamored with one aspect of its own creation, the psychosomatic complex known as the ego, that we as the encompassing individual mind or soul forget our true nature and status. This is truly a loss of soul. Just after the opening quotation for the previous chapter that celebrates the psyche as the "greatest of all cosmic wonders" Jung goes on to say: "It is in the highest degree odd that Western man, with but very few— and ever fewer—exceptions, apparently pays so little heed to this fact. Swamped by the knowledge of external objects, the subject of all knowledge has been temporarily eclipsed to the point of seeming nonexistence."[16]

It's as if we are watching our High Definition TV and in viewing the projected image become so engrossed in the travails and triumphs of the protagonist that we begin to identify with her. The identification becomes so complete that her pains and joys become ours. Then all the aversions and grasping of the TV protagonist become so real we forget that we are investing this electronic image with meaning and life beyond its digital signal.

This condition of soul loss, of neglecting the true subject, then provides the foundation for errors like believing that there is a mind-independent world residing external to mind that somehow generates our perceptions. As Schrödinger says, "The world is given but once. Nothing is reflected. The original and the mirror-image are identical. The world extended in space and time is but our representation (*Vorstellung*). Experience does not give us the slightest clue of its being anything besides that—as Berkeley was well aware."[17] Schrödinger is denying a preexistent material world in spacetime that somehow secondarily gets reflected into the psyche. Acoustic waves that impinge on our inner ear do not generate

the sound that after many transformations we hear. The sound is the hearing. The perception is the thing. It's not a reflected image of "simple processes in the brain," a result of some underlying matter, despite what Jung might say. Yes, the brain and its complex states coordinate with the perceptions, but the brain and all the associated knowledge of it are just as much within the charmed circle of the mind as our most intimate fears and fantasies.

A Model for Understanding Synchronicity

My brief discussion of the ageless debate between the materialists and dualists on one side and the idealists or mentalists on the other is not going to still this venerable controversy. Nor does my discussion of mentalism answer all the philosophic questions raised by such a view. My goal is not to provide an exhaustive (or exhausting) analysis of any of the topics embraced in this book, whether they be depth psychology, physics, or idealist philosophy. Instead I want to discuss how these different disciplines illuminate and support each other and my view of synchronicity.

From the physics side, I am taking the quantum view of matter as sets of acausal potentialities for manifestation in a frame-dependent spacetime, potentialities exquisitely observer dependent and nonlocally interconnected. From the psychological side, I am taking synchronicity as a genuine phenomenon and trying to understand how the world external to our body (but not our mind) can be so subtly and deeply interwoven with our innermost psychic states. Depth psychology provides us with abundant evidence that a superior intelligence takes a particular and specific interest in our psychological and spiritual development. Many examples in this book attest to that. To understand all this within a modern scientific world view is a considerable challenge. I suggest that appreciating all experience as mind created and that mind-independent material objects are figments of our imagination, projections on a mental world, has positive explanatory value that can help us meet the challenge. Let me try to do that by returning again to the four themes of meaning, spacetime, acausality, and the unity implied by synchronicity.

1. MEANING IN SYNCHRONICITY

The archetypal meanings acausally connecting the inner and outer worlds in synchronicity play a prominent role in any understanding of the phenomena. I hope that the variety of synchronistic experiences presented in this book makes it clear that they are a numinous expression of transcendent meaning that unfolds in both the inner and outer worlds. Synchronicity is soul-making, a revelation of the cosmic self or soul as meaning, an instruction through acausally connected events in both the inner and outer worlds. If we have the inner eyes to see, the self is providing us with both the necessary experience and meaning required for our transformation, our individuation. In the mentalistic interpretation, the physical world and psyche are seen to be ultimately of the same nature, rooted in the larger mind's functioning, and thus meaningful interconnections are possible

and even natural. Perhaps within this unified world view we can get a deeper appreciation of synchronicity by appealing again to the epistemological analysis of dreams.

From the point of view of the archetypal complex unfolding and giving meaning to the dream it's no surprise that the dream subject meaningfully relates to the dream objects. In fact, the psychological understanding of dreams aims precisely to ferret out this meaning and the interrelationship of the dream images to the abstract underlying reality of the archetypal complex. Analogously, in waking consciousness if no inert material underlay exists, but the world is really a display of a cosmic intelligence, of units of meaning, then why should it be an utter surprise that our inner life and outer experience are deeply interconnected? After all, the inner and outer are merely contrasting colors of the same image—different thought forms within the World-Image. As the psychological complex noncausally orders and makes meaningful various parts of the dream, so also does the archetype structure both the inner and outer waking world. If the inner world and the extra-body world are all of the same stuff—mind—and of the same source—our higher self, the cosmic principle at the center of our being—it would be a surprise if these worlds did not meaningfully connect with our development. Perhaps it's only our inability to appreciate the true nature of the world that makes synchronicity such a rarity. Maybe if we could more fully appreciate the truth of mentalism we could then be continuously aware of synchronicity, what Jung calls general acausal orderedness. Then the interconnections would naturally express themselves in a variety of ways from nonlocal physics to synchronicity.

The idea that a superior intelligence is bodying forth this entire world with us as egos in it, places individuation in a larger context and makes it more intelligible. Then individuation is concerned with more than achieving wholeness by dealing with the opposites. Now there is a higher octave of meaning if we can understand that our individual mind is the creator of the empirical world with all its alluring objects and bitter disappointments, the world within which the ego suffers, learns, and dies. As mentalism stresses, the World Mind provides the contents of our world, including our psychosomatic nature, to our individual mind. Mind-independent matter is a chimera.

2. SPACETIME TRANSCENDENCE OF SYNCHRONICITY

Space and time, as relativity shows, is neither fixed nor absolute, but dependent upon the observer's reference frame. Jung claimed that "In themselves, space and time consist of *nothing* . . . They are, therefore, essentially psychic in origin."[18] In Jung's Kantian view, space and time are not intrinsic to the object or the world but are products of the psyche's functioning. The mentalist agrees that our individual mind gives the abstract contents provided to it by the World Mind the particular spacetime form necessary for objective knowledge and the ego's evolution. So in harmony with Jung's view, the mind provides us with space and time. In other words, the individual mind employs these forms for our experience. This implies that the very forms or modes of experience do not bind the mind that employs them. Therefore a higher aspect of mind has access to knowledge not available to a content within mind, to the spacetime bound ego. Such knowledge Jung

calls "absolute knowledge"—that space and time transcending knowledge so dramatically revealed in some synchronicity experiences—is understood by Jung as a revelation of the transcendent wisdom of the self. Jung called these revelations "subjectless simulacra" or archetypes, because at this level, prior to the categories of space and time, no empirical personality exists.

The individual mind employs the categories of space and time in its manifestation of our experience just as the dream mind displays its images in a space and time of its own creation. This does not deny the empirical validity of waking space and time, but it does imply that our individual mind has a mysterious aspect, function, or power not limited by the spacetime categories. Through contact with this higher mind, our ego can get glimpses in synchronicity experiences of information transcending the normal limitations of space and time.

From a religious and mystical point of view this aspect of mind logically prior to the functioning of space and time is our true immortality. This unobjectifiable essence of mind is not immortal in the sense of being an indefinite prolongation of time, but a complete transcendence of space and time. Since we can never know this octave of mind objectively, we seek it in meditations without form, without any images, in the very silent depth of our being. These meditations seek at least a temporary eclipse of the separated, body-based ego and a mergence into the infinite. These experiences must transcend the limitations of the psyche—something, as the next chapter will show, Jung believes is impossible.

3. THE ACAUSAL NATURE OF SYNCHRONICITY

Within my interpretation it's possible to understand why synchronicity is acausal. For inspiration I return briefly to physics. Consider the coffee in my cup with wave motion on its surface. A classical physicist knowing the position and velocity of each point on the liquid surface can predict with complete certainty the condition of the surface at any later time. We can accurately predict how all the waves and ripples that now appear will evolve by reflecting off the sides of the cup and interfering with each other. This classical system is deterministic: the same initial conditions always give the same spacetime evolution. In quantum mechanics, prior to any particular measurement the wave function or probability distribution also evolves deterministically. That is, if we specify a system's wave function at a given time and the system evolves *without any measurement,* then quantum mechanics predicts with full certainty and precision the exact wave function at any later time. When a system is free of measurement interactions, we can predict the wave function's evolution just as precisely and completely as the evolution of waves in my coffee cup. However, in the classical case we have physical waves of coffee, while in the quantum case we only have *probability waves,* nonphysical possibilities for measurement, potentials for manifestation into spacetime events.

Although we say that the unmeasured possibilities evolved deterministically, this can be misleading since determinism usually refers to objective facts and events, to well-defined entities evolving in spacetime. The probability waves are certainly not objective facts, events, or well-defined objects, but potentials or possibilities for facts and events. Perhaps

it is more accurate to say that the unmeasured quantum system's potentials evolve completely lawfully rather than deterministically which has all the unwanted Newtonian connotations.

In quantum mechanics it's the advent of a unique or particular measurement, made from a given reference frame, that gives rise to the unpredictable or acausal events. The intrusion of a specific measurement creates a drastic transition from lawful evolution of probabilities to an unpredictable spacetime event. It's not possible to say which of the possibilities will actualize, which of the potentialities will become physical events. If we could, nature would not be truly statistical as we know it to be. In fact, in the participatory quantum universe our particular measurement intervention unavoidably leads to the statistics. Although the most likely possibilities break into spacetime events most often, no well-defined causes exist for particular spacetime events occurring in a measurement. They are truly acausal.

With these ideas from physics let's return to Jung's description of the *Unus Mundus,* the unified potential world, the principle logically (not temporally) prior to our world of experience. Jung describes it as, "the potential world of the first day of creation, when nothing was yet 'in actu,' i.e., divided into two and many, but was still one . . . a potential world, the eternal Ground of all empirical being."[19] This "potential world, the eternal Ground of all" is analogically like the wave function prior to measurement. Just like the unobserved quantum system, the *Unus Mundus* consists of unified possibilities or potentialities for manifestation, not concrete objects in spacetime. Jung sees the archetypes in a similar way. He says, "The archetype represents *psychic probability.*"[20] (Italics are Jung's.) In quantum mechanics it's only when an individual observes that an acausal spacetime event manifests. Our participation through measurement generates acausality. Analogously, when a unique center of consciousness, a specific individual, actualizes a possibility in the *Unus Mundus,* acausality enters our world. *Introducing a particular perspective, a finite center of consciousness, inevitably brings acausality into the transition from possibilities to actualities.* In giving objective existence to possibilities in the *Unus Mundus,* in co-creating the world, our individual mind inevitably brings a specific point of view, a specific psychosomatic center with all its history and uniqueness. This always entails an expression of acausality. In synchronicity experiences we get a glimpse of the unity of the *Unus Mundus,* but our glimpse of it comes through a particular center of consciousness, our individual mind, and therefore its acausal nature is assured.

4. UNITY IMPLIED BY SYNCHRONICITY

In describing his psychological standpoint Jung said, "that supremely real and rational certainty which I call 'experience' is, in its most simple form, an exceedingly complicated structure of mental images. Thus there is, in a certain sense, nothing that is directly experienced except the mind itself. . . . We live immediately only in the world of images."[21] When we take Jung's empiricism just a little farther, we realize that not only is matter impossible to experience directly, but as mind-independent, it is an incoherent notion.

Then we have prepared the way for a fully mentalistic view of ourselves and the world. Then the grand unification occurs because the "substance" of both the blue sky and my inner experience of the blues are the same—ideas within my individual mind, actualizations of the possibilities within the *Unus Mundus*. Because of our ingrained habits of thought, our unconscious predispositions, our projections of inherent existence upon nature, we have great difficulty accepting this idea. Nevertheless, it can be supported by rational analysis, glimpsed in synchronicity, and, according to many traditions both East and West, experienced in higher meditations.

The following synchronicity story vividly displays this unified wisdom of the self, this higher knowledge, manifesting and guiding us, bringing meaning in the midst of pain.

Synchronistic Interlude 10

Applying Lessons

Several times in a two-week period, I dreamed the same dream. The scene was high on a rugged, stark mountain—well above the timberline, but not quite at the peak. Many people, men and women, most of them quite old, had assembled there, toward the right of center and slightly above me on the mountain. All of them were dressed in black, most in simple full-length black robes. All were somber, silent, and somehow mutely expectant . . . though they didn't seem really awake. I remember particularly the worn and angular face of one elderly woman among them.

Though now it seems I actually recognized none of the faces even then, in the dream I took this to be an assembly of my whole family . . . the whole family line, as it were. Somehow the family members I would recognize were also there, but I do not actually recall seeing any of the familiar faces.

To the left—and, again, slightly above me on the mountain—I saw my father, who was then forty-one. He was in a frisky, devil-may-care mood, jocular, fearless—somewhat mischievous. He was full of the kind of "bravura" I remember from a photograph of him as a young and flashy bomber pilot early in World War II.

Farther to the left of him was a sharp ledge that jutted out, almost like an inflexible diving board, over a steep precipice. He sauntered out onto that piece of ledge, almost gleefully, and started jumping up and down on it as if to say to all assembled: "This doesn't scare me at all, does it scare you?"

The out-jutting piece of ledge cracked and collapsed, and my father fell with it into the yawning abyss. I saw only the beginning of his fall, and then woke up every time. Though I'm not certain now (nearly twenty years later) that my memory of the feeling I

62. World War II bomber pilot

Photo from the family album of the author of this synchronicity story.

had when I awoke is honest, I do recall it now as a mixture of dramatic and unwelcome impending change, great mystery, and uncertainty. What I do remember is that after I had returned to sleep and then awakened the next morning, I did not remember either the dream or having awakened from it in the night. Until later.

It's probably important to note here that my father had been feeling a good deal of work-related stress, enough to have requested and undergone a thorough medical exam shortly before this time. His doctor, however, had been very positive: if he lost ten pounds, he'd probably be in as good physical shape as when he first entered military service at nineteen.

My relationship with my father had never been an "easy" one. He used to remark occasionally, for example, that "you can't choose your family, but you can choose your friends." He had not gotten along well with his own family, and no better with my mother's. Nevertheless, he was both loved and admired by many people both in his civilian job and in his continuing affiliation with the Air Force as a major in the Air National Guard.

It had been quite clear to me for years that he would like for us to be friends; but it had also been equally clear that, for whatever reason, I just hadn't shown him whatever it was that would make him genuinely feel that friendship-feeling toward me. He was, quite simply, a perfectionist in his own way: doing something well was for him just a first step; the next, and probably more important one, was making it look easy. In terms of our relationship, it worked out so that it always seemed to me that no matter how hard I worked at something I thought would please him—or how well others thought I had done it—his first remarks were always about how I could have done it better. It always cut me to the marrow of my bones, because I always knew he was in fact right. At the feeling level, I can't really remember feeling even a moment of outright affirmation from him before a conversation we had when I was fourteen.

It happened one Friday evening, after he came home from work. The topic wasn't important. But it was the first time I ever felt he was really interested in what I had to say. It was the first time I knew and felt that he actually thought well of me and respected my ability to form an intelligent opinion and follow through on it. It was a complete surprise, but he was talking to me like he talked to his . . . friends.

The next day, I stayed overnight with my then-best friend. In the morning my friend and I went out in front of his house and started playing catch with a baseball. The phone rang. During its first ring, I remembered all the earlier dreams . . . and something considerably more.

For the first time, I remembered having had and awakened from the recurrent dream throughout the past two weeks. And I remembered having had it again the night before, that same Friday . . . or early Saturday morning . . . but with a different ending. This time I had not awakened as my father fell, but had watched him fall all the way to the bottom. And this time I had not awakened from sleep.

I knew. I went to the phone, and before hearing anything said, "I know," though I really had no idea how it was that I knew. As I said that, I heard my mother, with great difficulty through sobs she was trying to suppress, struggling to get out the words: "Your daddy died this morning."

I said, "Yes, I know. I'll be right home."

On the way home I felt a mixture of shock and an awareness of great, perhaps incomprehensible, mystery. Other than that, all I recall feeling was vacancy and a sense of everything being in a state of suspended animation. It wasn't until later, when I was at home doing the first chore my mother had asked me to take care of, that the anger came on. In the basement, taking laundry out of the washing machine to hang outside, I began to feel rage at what seemed to me the unfairness of what my mother was going through upstairs. Once outside, hanging clothes on the line, my eyes were drawn toward the sun. And then the rage crystallized: every fiber of my being wanted to race through the sky, pierce the very center of the sun, get my hands on the throat of whoever/whatever caused or allowed this, and make it explain.

The rage lasted, as a constant and underlying state of my whole psychological being, for nearly seven years.

During that time, I became increasing preoccupied with trying to understand, and make more frequent, more lasting, my contact with whatever it was within me that had acted both in the prophetic dream and in the moment of knowledge that came during that long ring of my friend's phone. I knew that something in me really knew. I paid much more attention to my dreams, learned to wake slowly in the morning so as to remember them, and to cultivate a mental posture that was increasingly receptive to intimations from within. More and more I looked toward this "within-ness" for reliable information, rather than toward the kind of outer, acquired "training-knowledge" that could allow someone to be as blind to what was actually going on as my father's doctor had been.

Before long, I began seeing connections in my daily life between images recalled in the morning from dreams and events that took place in my life during the day. Much of what happened in my waking life was actually anticipated—almost literally—in my dreams. It didn't take long to catch on to the next step.

I found that if I didn't like what happened in the dream, I could make sure that the same thing didn't happen in my waking life: I simply had to be very careful not to do or say what I had done or said in the dream when the same situation arose in my waking life. I never knew what the alternative would be, but I learned that I could often avoid the outcome that the dream had prefigured.

After some time, this ability disappeared. Yet not before I had developed a conscious attitude toward how to approach events. I had realized that my inner attitude and behavior are powerful factors in determining the outcome of situations that arise in my life. It's as if the outer "situation" is raw material that gets shaped into a final outcome by how the individual responds to it: change the response, change the outcome. So, rather than trying to work at solving problems by rearranging the outer things, I worked at solving them by making more conscious—and choosing more carefully—my own inner, subjective posture toward them.

14 Weaving Harmonies and Revealing Dissonances

[E]very time a thought comes up you say, "NO!" Cut it right off. That's a very famous exercise in most of the Eastern traditions, where they tell you: every time a thought comes up, cut off its head. Don't let it come in. Cut it off, cut it off, keep cutting it off. It's very strenuous, but after a few months you begin to get a little success here and there and you begin to feel the quietness around you.

Anthony Damiani[1]

I say to whomsoever I can: "Study yoga—you will learn an infinite amount from it—but do not try to apply it, for we Europeans are not so constituted that we apply these methods correctly, just like that.

C. G. Jung[2]

On the Road with Jung: Co-Creating the World Psychologically

As mentioned earlier, there is some strain in Jung between the cautious, empirical scientist and the man granted so many extraordinary inner experiences. I have considered Jung the empiricist by examining his psychological standpoint. Here I'll discuss a famous experience Jung had in Africa. In this section I interpret it from a depth psychological perspective. In the following section I view the same experience from a mentalist perspective.

One of the last pieces of writing Jung did was in the summer of 1959 when he wrote about his memorable trip to Kenya and Uganda in late 1925. About the Athi Plains he writes:

From a low hill in this broad savanna a magnificent prospect opened out to us. To the very brink of the horizon we saw gigantic herds of animals: gazelle, antelope, gnu, zebra, warthog, and so on. Grazing, heads nodding, the herds moved forward like slow rivers. There was scarcely any sound save the melancholy cry of a bird of prey. This was the stillness of the eternal beginning, the world as it had always been, in the state of non-being; for until then no one had been present to know that it was this

world. I walked away from my companions until I had put them out of sight, and savored the feeling of being entirely alone. There I was now, the first human being to recognize that this was the world, but who did not know that in this moment he had first really created it.

There the cosmic meaning of consciousness became overwhelmingly clear to me. "What nature leaves imperfect, the art perfects," say the alchemists. Man, I, in an invisible act of creation put the stamp of perfection on the world by giving it objective existence. This act we usually ascribe to the Creator alone, without considering that in so doing we view life as a machine calculated down to the last detail, which, along with the human psyche, runs on senselessly, obeying foreknown and predetermined rules. In such a cheerless clockwork fantasy there is no drama of man, world, and God; there is no "new day" leading to "new shores," but only the dreariness of calculated processes. My old Pueblo friend came to my mind. He thought that the *raison d'être* of his pueblo had been to help their father, the sun to cross the sky each day. I had envied him for the fullness of meaning in that belief, and had been looking about without hope for a myth of our own. Now I knew what it was, and knew even more: that man is indispensable for the completion of creation; that, in fact, he himself is the second creator of the world, who alone has given to the world its objective existence—without which, unheard, unseen, silently eating, giving birth, dying, heads nodding through hundreds of millions of years, it would have gone on in the profoundest night of non-being down to its unknown end. Human consciousness created objective existence and meaning, and man found his indispensable place in the great process of being.[3]

In Africa Jung found his own myth, equivalent in value to the myth that gave his Pueblo friend a "fullness of meaning." Here we are touching on the central myth that meaningfully structured Jung's entire life. Obviously, if we can understand Jung's experience we can get a much deeper appreciation of both the man and his work. To have understood how "Human consciousness created objective existence and meaning, and man found his indispensable place in the great process of being" is surely a profound experience. Here I'll comment upon this role for the psyche as co-creator, as the giver of perfection to the world by making it objective, from within Jung's psychological standpoint.

For Jung there is a material world (the first creation) existing outside the psyche and somehow giving rise to the images in the psyche (the second creation), the objective world experienced in space and time. According to Jung, when a human does not know the world, it is in a state of "non-being." The necessity of someone being "present to know that it was this world" may seem like a peculiar use of the term "non-being," but recall that Jung believed that psyche was necessary for making the world into an object, for setting up the relationship of knowing between the empirical subject, the ego, and the imaged object. In "On the Nature of the Psyche," he says, "The psyche is the greatest of all cosmic wonders and the *sine qua non* of the world as an object."[4] Without our experiencing the world psychically, as an image displayed in space and time in the psyche, it remains unobjective, in a state of "non-being." Until lit by human consciousness with all its excellences and limitations, it is not "*this* world" (my italics). Only in human consciousness is it "the world as an object." If for Jung space and time are "essentially psychic in origin" then our spaced and timed view of the world comes from its being known psychically, not because space and time are intrinsic to the world.

Jung describes the first creation as "unheard, unseen, silently eating, giving birth, dying, heads nodding." Being unknown psychically, such a world exists only in "the

profoundest night of non-being down to its unknown end." For us, if it's unknown psychically it might as well not exist. We must be clear that Jung's description of the "first creation," the world unknown psychically, must be symbolic, because describing it as "heads nodding . . . is to picture it *as we know it,* as an object in psyche. Since the world is not objective until known psychically, it's not possible to use anything but symbolic language to speak about the unknown, unobjective world of the "first creation."

Although Jung does not refer specifically to his experience in Africa, around the same time he was writing this part of his autobiography, he was completing the *Mysterium Coniunctionis*. There he gives a philosophic description that clearly applies to his Africa experience and confirms my interpretation of his experience on the Athi Plains. He writes:

> All the worlds that have ever existed before man were physically *there.* But they were a nameless happening, not a definite actuality, for there did not yet exist that minimal concentration of the psychic factor, which was also present, to speak the word that outweighed the whole of Creation: That is the world, and this is I! That was the first morning of the world, the first sunrise after the primal darkness, when that inchoately conscious complex, the ego, the son of darkness, knowingly sundered subject and object, and thus precipitated the world and itself into definite existence, giving it and itself a voice and a name.[5]

Jung's reflection in his mid-eighties on his experiences in Africa when he was fifty, where he first became fully aware of his life myth, is for me a high point of both his autobiography and the *Mysterium Coniunctionis* because it places the idea of meaning in a broader setting. In the second chapter of this book I reviewed Jung's notion of meaning in terms of unconscious compensation and individuation. Even at that early stage in the discussion there were hints of the profundity of meaning, as for example when Marie-Louise von Franz says that individuation is the task of finding *"one's own* connection with the universal Meaning."[6] For Jung, the psyche's role as co-creator of the world through objectification, through sundering the native unity of subject and object, is the highest octave of meaning. Ultimately, our individuation episodes are all pieces of a puzzle or mosaic teaching us this great truth. Here the teaching materials are not texts, papers, and exams, but the joys and sorrows of life, the frustrations, fears, and satisfactions of earthly existence. These are the materials the psyche uses to teach us about its dignity, its status as a co-creator and perfector of the world. Here is where "Human consciousness created objective existence and meaning, and man found his indispensable place in the great process of being."

On the Road with Jung: Co-Creating the World Philosophically

In this section I'll take the same Africa experience and interpret it from a mentalist viewpoint. This helps distinguish the psychological standpoint from the mentalist view. However, mentalism neither negates the psychological interpretation nor diminishes the importance of the psyche.

As stressed in the two previous chapters, from a mentalistic viewpoint, the world is not existent in spacetime or given or presented unless it's known by some individual mind. Jung seems committed to this view, yet he is not consistent. For example, he says in the *Mysterium*, "All the worlds that have ever existed before man were physically *there.*" But "physically *there*" must imply some objective existence, in fact it even sounds like existence in physical space and time, and thus it contradicts his understanding that "he himself is the second creator of the world, who alone has given to the world its objective existence."

No such confusion exists for the mentalist who holds that the all-encompassing functioning of mind simultaneously images the ego and the empirical world into manifest existence. For him it's incorrect to consider the great herds before the advent of man existing *as we would know them,* that is "silently eating, giving birth, dying, heads nodding through hundreds of millions of years." Yes, the herds and their world could have some existence for themselves, but it could only be as a content within what we *imagine* to be their version of mind. That view of their world is, of course, a *construction within our mind.* Whatever kind of existence we want to grant the world before humanity, we must conceive, conjure, or image it in our minds and thus bring it into being as a content of mind. A purely material world, a world without any mind is both inconceivable and unimaginable and surely not within a spacetime of the psyche's creation, not "physically *there.*"

The mentalist differs from the psychological standpoint, since Jung posits a material world existing outside psyche, the "first creation." In contrast, the mentalist says that all possible worlds, both inner and outer, psychic and material, are a vast complex of thought within mind, that matter is just one kind of thought. The world does have some existence independent of us. We do not live in solipsism. The World Soul or World Mind is the ultimate guarantor of the world's facthood and evolution. Nevertheless, *our experience* of the world whether immediately given in a beautiful sunset or created in our theories of earth prior to humanity is still only known as a content within our mind. The uninhabited world prior to humanity is as much a content in mind as the satisfaction Jung obtained from finding his own life myth.

In the mentalist interpretation, our co-creation comes from thinking the abstract content provided by the World Soul into objective spaced and timed existence in our individual mind or psyche. The thing is the thought. There is only one presentation to mind, only one creation shared between us and the World Soul. No preexistent material world gets taken up by psyche and known as an object by an ego. As Schrödinger says, "The world is given but once. Nothing is reflected. The original and the mirror-image are identical. The world extended in space and time is but our representation (*Vorstellung*). Experience does not give us the slightest clue of its being anything besides that—as Berkeley was well aware."[7] Of course, this exalted role for our individual mind should not be confused with the ego's activity, since individual mind thinks the ego into existence along with the world that appears objectively to the ego. The cosmic principle of mind does give dignity, even majesty, to humanity. However, truly contacting this principle requires a penetration beyond our personality, beyond our psychology, into the very ground

of our being. And, since the mind is the creator of objectivity, mind can never be an object, hence the need for objectless meditation.

Perhaps the epistemological use of dreams can help illustrate our co-creation of the world. Imagine I fall asleep with anxiety. Then I dream of taking two final exams and realize that I have neither studied for them nor do I even know where they are being given. I search frantically for the room in which the final exams are being given. In this example the abstract and formless anxiety is the essential content of the dream, the primary meaning, not existing in dream space and time. The concrete and fully formed spacetime dream images of two final exams, my lack of preparation, my frantic search for the rooms, are the secondary objectification of this anxiety. The primary content or meaning (analogous to the abstract anxiety) is the World Soul's input. This content is truly objective, since it provides the continuity and communality of our experiences. However, the World Soul's primary input (like my anxiety) although real, is not concretely existent, not in space and time, not a complex of images in the psyche. As Schrödinger says, "The world is given but once. Nothing is reflected." Only when my individual mind, my functioning imagination, my psyche, or my soul, embodies the World Soul's abstract input, clothes it in spacetime images, makes it objective to the ego, do we have the world of our normal experience.

Within a mentalist context, speaking of first and second creations is also possible. Then the first creation occurs when the mind constructs a spaced and timed image of the world prior to the ego-object split. Sometimes in pronounced aesthetic or creative moments when the mind is very quiet, when the incessant inner dialogue dies down, when our desires and expectations ebb, we have an experience of the world presented in space and time but not broken into seemingly independent objects opposing an ego. The sense of personal identity, of ego knowing objects, is largely gone. In its place is a unified world, often accompanied by a memorable peace. In the previous chapter I tried to give a feeling for this state of mind by describing waking up from a deep sleep without any thoughts. This state usually does not last long. The old mental habits then break up this unified world into the familiar ego expressing all its aversions and desires in a world cut into particular objects—the second creation. Although the first creation is often the goal of mystical consciousness, both these creations are still contents within individual mind.

Within mentalism we can understand what it means for the Buddhists to say that the world is the womb of the buddhas. We are not inconsequential psychic beings wandering in a vast, indifferent material world, not "a brief epidemic of microbes" as Robert Frost describes us. Instead, the unified world flowering in our individual mind is the school in which our egos learn the deeper truth of our being, our roles as co-creators and perfectors of the world. In synchronicity experiences, along with the particular unconscious compensation being embodied, we dramatically experience the essential unity of the inner and outer world, of psyche and matter, and its infusion with acausal meaning—fragments of the universal meaning. There we experience the interdependent nature of the ego and its world. Assuming we understand the experience correctly, we don't mistake the "cosmic meaning of consciousness" for the ego's activity within that

experience. Instead we understand that the ego and what we unreflectively call the material world are contrasting colors of one world image, thought into spacetime form by our individual mind.

Tensions and Dissonances

In most of this book I have been attempting to display the harmony and complementary relations among depth psychology, physics, and idealistic philosophy. Occasionally, such as when discussing the psychological standpoint and especially Jung's attitude toward Ramana Maharshi, tensions and dissonances surfaced. In this section I reveal more dissonances among some major themes. I hope this discussion will simultaneously sharpen our appreciation of the harmonies and provoke us into deeper reflection about the differences.

Many, including some Jungian analysts, think no conflict exists between Jungian psychology and the spiritual path laid out in several versions of Asian Indian spirituality. However, my reading of the literature and my personal experience with the practitioners and the practices of both depth psychology and spirituality tell me otherwise. (The opening quotations of this chapter illustrate the point.) There is a conflict of both ultimate goals and methods between depth psychology and Indian spiritual traditions such as Buddhism and Hinduism (Vendānta), which promise liberation from the psyche and all its opposites. (For conciseness I call these liberative philosophies.) I don't have complete answers to how Jungian psychology fits with these traditions. Yet, despite Jung's admonition against yoga mentioned in the opening quotation of this chapter, I, and a growing number of others, attempt to live by the light of both depth psychology and liberative philosophies with their emphasis on meditation. So for many of us, this is more than just an interesting intellectual concern. Although the issue requires a much more extended discussion than given here, completeness demands at least an explicit acknowledgment of the tensions.

1. DIFFERENCES IN PRINCIPLE

To appreciate that some higher intelligence is guiding our life, call it the archetype of the self if you like, is a great source of inspiration and comfort. However, attaining a vital realization of this truth obviously requires more than just removing a few projections and interpreting a few dreams. This requires a lifetime effort, or according to the Buddhist, many lifetimes of psychological and spiritual effort. For Jung, the process of individuation is like the pole star, something to guide us, but we never actually reach the destination. On the other hand, liberative philosophies hold out the goal of transcending the psyche and all its opposites, of attaining enlightenment, of reaching a state where one is continuously conscious that all experience is uninterruptedly spiritual. Even if we consider individuation as a preparation for liberation, big differences exist between the process of individuation and enlightenment, between taking guidance from the psyche and transcending the limitations of the psyche. Individuation, realizing the guidance of the self, is like finding a trail in the trackless desert of the psyche. On the other hand, liberation,

being aware of the endless manifestations of the psyche while continuously maintaining our true status as a fragment of the divine, is like setting up a permanent camp in an oasis. We are aware of the endless expanse of desert, but not subject to its hardships, to the endless play of the opposites.

For a brief comparison with individuation it's useful to divide the path to liberation into two parts. First comes the penetration into the divine stillness of our innermost being, knowing through identity the *unobjectifiable* subject—the true subject. Not being objective, we cannot relate to the true subject like other contents of thought. Yet this awareness at the core of our being lights up all experience. The enormous meditation effort that brings us into contact with this principle culminates in the attainment of a completely formless thought-free state—*nirvikalpa samādhi*. Being completely without form, this state transcends the psyche.

Anthony Damiani makes a clear distinction between the psyche, the realm of dazzling forms, and the formless spiritual. In *Looking into Mind* he describes the true spiritual glimpse without form. In a conversation with his students, he says:

> During the glimpse there is no time-space continuum. There is no form of thought. You are in utter and absolute silence. If you bring in the slightest breath, the least preference, then you have heaven and hell all over again. It calls for absolute silence.
>
> A lot of people who have experiences of the psyche think it's the soul. I made that mistake quite a few times. The psyche is not the soul. The psyche is not emptiness. The psyche is the living form of the organism, whether it's endowed or embodied or whether it's in the realm of the psyche itself, in the subtle realm. It's not the spirit at all. It's not the Overself.
>
> . . . You will always recognize a psychic experience because there is some form involved—no matter how subtle, no matter how angelic it appears, it's a form. In a spiritual experience of the Overself, none of this is there. So if you get the feeling, for instance that some divine being has come down and placed a kiss on your forehead while you're meditating, it is psychical, not spiritual. And there is no end to the different kinds of psychical experiences you can have.[8]

The second stage of the spiritual journey requires that the attainment in the first stage, the thought-free awareness, be brought into the phenomenal world. In the second stage the adept must maintain continuous awareness of the divine while working selflessly in the world for others. The Asian Indians call this state, attained for example by Ramana Maharshi, *sahaja samādhi*—the perfect nondual state or the condition of being fully liberated while alive, being a *jivan mukta*. In Buddhism this is the state of Buddhahood—full enlightenment. Here is the complete transcendence of the opposites. Now *samsāra* and *nirvāna,* appearance and reality, multiplicity and unity, action and stillness, and all the manifold oppositions of life are overcome in

63. Anthony Damiani

liberation. In contrast, the problem of the opposites was central to Jung's work and he always held that we could not completely overcome them as these traditions maintain. For example, Jung says, "Everything requires for its existence its own opposite, or else it fades into nothingness. The ego needs the self and vice versa."[9] For Jung, transcending all the opposites is impossible. Harmonize one pair and another is sure to present itself to us. Without this continuous tension of the opposites there is no life. As Jung says, "Complete liberation means death."[10]

2. DIFFERENCES IN PRACTICE

To clarify further the difference between depth psychology and liberative philosophies, let me briefly turn to Jung's technique of active imagination and contrast it with some advanced forms of meditation. As the quotation by Jung that opens this chapter shows, Jung does not believe that meditation is appropriate for the Western mentality. Instead he believed that cultivating active imagination could allow us to develop a healthy and creative dialogue between the primordial opposites: the conscious mind and the unconscious, between the ego and the archetypes. Active imagination is often learned in Jungian analysis to deepen the process and give a person a technique that allows them to carry on this dialogue between the conscious and unconscious for the rest of their life. It's a technique that allows a person to carry on the process of individuation independently of an analyst. In short, besides paying attention to dreams, active imagination is for Jung the most important psychological technique for dealing with the opposites. Given this importance, it's surprising how little Jung wrote about active imagination. His best references are in the final chapter of his last major work, the *Mysterium Coniunctionis* and in his essay in volume 8 entitled "The Transcendent Function." Barbara Hannah's *Encounters with the Soul: Active Imagination*[11] and Marie-Louise von Franz's *Psycho-Therapy*[12] are also useful references.

In the *Mysterium,* Jung tells us that we can start with either a dream or fantasy image or even a feeling. The idea is to concentrate intently on the image and allow it to transform itself into a dramatic fantasy. "A chain of fantasy ideas develops and gradually takes on a dramatic character: the passive process becomes an action. . . . In other words, you dream with eyes open."[13] However, for this process to be more than merely inner entertainment we must become actively engaged in it. We need to develop a dialogue with the unconscious to bring some harmony between the opposing polarities of consciousness and the unconscious. As Jung says,

> he cannot remain indifferent to the plot and its dénouement. He will notice, as the actors appear one by one and the plot thickens, that they all have some purposeful relationship to his conscious situation, that he is being addressed by the unconscious, and that *it* causes these fantasy-images to appear before him. He therefore feels compelled, or is encouraged by his analyst, to take part in the play and, instead of just sitting in a theatre, really have it out with his alter ego.[14]

Conversations are set up between the fantasy figures and the ego. We develop a genuine dialogue to unearth the "purposeful relationship to his conscious situation." In fact, Jung

regards the entire alchemical process as an exemplification of active imagination. For example, later in the *Mysterium* he says, "In short, the alchemical operation seems to us the equivalent of the psychological process of active imagination."[15]

Contrast this dialogue with traditional yoga meditation techniques (both Hindu and Buddhist). Here the idea is not to follow out the thoughts which flow continuously into our mind, whether in normal daily activities or during meditation. In beginning meditation they always tell us just to notice the thoughts, let them go by, but do not give them any special attention, do not animate them with our interest. Within this view the mind is a merciless machine that continually brings up problems and anxieties, troubles and desires, which keep us bound to *samsāra*—the painful play of the opposites. The last thing we want is a dialogue with our thoughts in meditation. As we develop some concentration, we can become more willful and vigorous in quieting the mind. Anthony Damiani, whom I have already quoted as encouraging us to ignore all formed experiences in meditation, gives a dramatic example of this more willful approach that dispenses with all objects or props for meditation.

> [E]very time a thought comes up you say, "NO!" Cut it right off. That's a very famous exercise in most of the Eastern traditions, where they tell you: every time a thought comes up, cut off its head. Don't let it come in. Cut it off, cut it off, keep cutting it off. It's very strenuous, but after a few months you begin to get a little success here and there and you begin to feel the quietness around you. In Zen monasteries that's one of the favorite practices. It's called the Hua T'ou exercise, and it's really very simple and very direct.
>
> Imagine this: after a rain, you're outside looking at the earth and, all of a sudden, a worm pops up. You've probably seen that. In a similar way, you keep looking at your mind. Now it's quicker if you do this during meditation because that gets you started on the right track. But once you've learned the trick, then you could do it while you're washing clothes or dishes or sweeping or anything of that nature. And the trick is something like this. In the same way as when we spoke of looking at the earth after a rain, you're looking into your mind. You're looking very intensely into that darkness. You're looking and you're looking, just in case a thought comes up. If a thought comes up, you're going to cut it right down. You are not going to let it come up. Just like when that little worm pops up, you're going to cut off its head, you're not going to let it come out. So in the same way, you keep looking into your mind. A thought comes and you stop it.[16]

There are no thoughts or objects to meditate on in this approach. In this objectless meditation we stare directly into the emptiness of mind, into the silence, and cut off all interfering thoughts, fantasies, and feelings. We carry the same vigilant approach of cutting off thoughts during meditation into such mundane activities as dish washing.

On the other hand, depth psychology cultivates images in the psyche through active imagination or some other technique so that we may obtain guidance from the psyche, so that we may discern the image's purpose. But the liberative philosophies seek to still the ripples of thought so that the unobjectifiable awareness, whether we call it Buddha mind or *atman*, may shine through the finite personality. These philosophies believe that, despite the intellectual paradoxes entailed, the finite can meet the infinite, that we can overcome the opposites.

Liberative philosophies tell us to cultivate a quiet mind, because it's only through the silence that the infinite can manifest, that we can appreciate our co-creation of the world and our inmost divinity. As Jung was well aware, this idea is not solely an Indian view, but one held by some of the greatest mystics in the West. For example, Meister Eckhart, whom Jung quotes occasionally, describes how we incarnate the divine word only in a self-contained and unitary soul—one without the slightest ripple of thought. He says,

> Let us take first the text: "Out of the silence, a secret word was spoken to me." Ah, Sir!—what is this silence and where is that word to be spoken? We shall say, as I have heretofore, [it is spoken] in the purest element of the soul, in the soul's most exalted place, in the core, yes, in the essence of the soul. The central silence is there, where no creature may enter, nor any idea, and there the soul neither thinks nor acts, nor entertains any idea, either of itself or of anything else.[17]

Now Jung says such a state of silence is the dissolution of the person: "In as much as it exists, we do not exist."[18] Eckhart would agree that the supreme consciousness must possess us and not the other way around and that truly when it occurs "we do not exist." Such a nonexistence of the lower self is a prerequisite for the incarnation of the infinite. But this does not imply total annihilation, for after all, the Buddha or the *jivan mukta* then works in the world encouraging his followers to attain a similar realization.

In summary, both theory and practice in Jungian psychology differ from the liberative philosophies. Jung tells us the tensions of the opposites must always energize us while the liberative philosophies tell us that the ultimate goal is complete transcendence of all opposites. Jung suggests that active imagination is the technique we should employ for developing a dialogue with the unconscious—"dreaming while awake"—the antithesis of cutting off thoughts. Yet Jung says, "For the European, it is sheer poison to suppress his nature, which is warped enough as it is."[19] Or later in the same essay he says, "I do not apply yoga methods in principle, because, in the West, nothing ought to be forced on the unconscious."[20] On the other hand, the liberative philosophies want us to ignore entirely the productions and forms of the psyche, to suppress entirely the functioning mind. As Damiani says, "Cut it off, cut it off, keep cutting it off."

Are Accommodation and Harmony Possible?

Perhaps if Jung were working today, with the great increase in interest in liberative philosophies and the torrent of scholarship available on them, he would feel differently about the relationship of these traditions to depth psychology. This is certainly possible. Although I have stressed the differences between depth psychology and liberation, both Brunton[21] and Damiani[22] have made substantial efforts at combining psychological development with ultimate spiritual attainment, combining individuation within the opposites with liberation from the opposites. Rather than review their extensive theoretical discussions, I'll restrict myself to suggesting one practical way of dealing with the dissonance.

Anyone who has had significant experience with meditation knows that pushing hard into the silence of mind can cause all sorts of unpleasant eruptions from the unconscious.

The deficiencies and defects of the personality, the unresolved psychological conflicts that under normal circumstances would merely lie dormant in the unconscious, can be forced up into consciousness. Learning to concentrate the mind usually has a calming effect. However, there are inevitably periods when attempting to go deeper is like flushing skunks out of their dens. Then these unearthed affective contents cause great psychological agitation and make meditation extremely difficult. They can also lead to all sorts of excesses and imbalances so commonly found in spiritual communities that emphasize meditation. My experience is that more meditation is not necessarily curative of the problems generated by meditation; however, here depth psychology can truly come to the rescue. It can give us insight, bring order to the chaos, and generally disarm the contents by helping us integrate them into consciousness. Of course, this is both an intellectual and an emotional process.

For example, it's possible that the willful "cut it off" approach in meditation advocated by Damiani could result in the eruption of very unpleasant images or feelings. This is more likely when vigorously pushing the meditation practice. Let's say some objectification of the shadow is forced up into consciousness, what some traditions call the "dweller on the threshold." This unsettling experience is not easy to cut off once it occurs. The heroic way would be to eliminate willfully any further reactions to the image. Any time those negative feelings or thoughts came up, either in or outside meditation, we forcefully cut them off, nip them in the bud. However, few can do this, few have the strength to slay the dragon before it exits the cave.

Under these conditions, to get on with meditation we may have to confront the dragon, not with the sword of beheading, but with our knowledge of depth psychology. Then we might even engage the dragon in a dialogue through active imagination to discover its intent and consciously and constructively integrate that power into our lives. With the concentration skills learned in meditation we could hold the image steadily and vividly in mind, a prerequisite to letting it speak to us. As anyone knows who has done active imagination, you cannot begin this discipline without a reasonable ability to concentrate. If we cannot hold the image or feeling firmly and vividly in mind then the process cannot even start. We just spin around in a chaos of images without any real transformation occurring. Therefore, the concentration skills learned in meditation can be invaluable aids to active imagination. In turn, the psychological integration that can occur through active imagination can bring the necessary ego strength and calmness of mind required for deeper objectless meditation, which seeks to penetrate directly to the unobjectifiable awareness without images or contents.

However, I must sound a warning alarm. Depending upon the ego's strength, the type of image or feeling to be dealt with, and the person's circumstances, it may be extremely dangerous to attempt active imagination, especially with the increased concentration abilities learned in meditation. The images or feelings may take us over, get actualized in daily life when we only wanted to understand them or tease out their intent through dialogue—not live them out. If, for example, tremendous rage comes up in meditation, it's possible that concentrating on this feeling in active imagination may help provoke

some very harmful outburst of that rage. We might not have the necessary ego strength and insight to understand the purposeful relationship of this rage to our conscious situation. Rather than integrate the energy we might compulsively act it out when we least want to. Under these circumstances mental hygiene demands that we "cut off" the thought rather than have a dialogue with it. On the other hand, Jung taught us that just pushing contents into the unconscious does not make them go away. Instead they fester and gain more freedom to erupt in uncontrolled ways beyond the ego's guidance. For these reasons, a sensitive analyst is often a necessity for the intelligent use of active imagination. This also may be why Jung wrote so little about such an important technique.

Because active imagination and objectless meditation are so different in principle and practice there is also a lesser danger that if we practice them simultaneously they may cancel each other out. Because they are as different as waves and particles in physics, we must understand them as complementary, as not possible simultaneously, but alternative methods for grasping the whole. If we get them tangled, they work against each other and cancel. When we should be dismissing thoughts and going deeper, we might start following them out, energizing them with our attention, and letting them speak to us. Then we are thrown from the swift horse of attention by every alluring thought erupting from the unconscious. On the other hand, if we begin active imagination with the one-pointed concentration required to hold the images steadily and endow them with the necessary psychic energy, but then don't let go enough to allow them opportunity to speak, there is no success in active imagination. Here we are suppressing fantasy when we should be letting it flower, although in a controlled environment, in a container or in an alchemical retort fashioned by a disciplined concentration.

Although Jung would be unlikely to agree with my ordering of priorities, I'm suggesting that depth psychology be put at the service of spiritual practice. In the synchronistic interlude that follows we don't learn a general procedure for how to balance these disciplines, but we do see one person attempting to grapple with these issues. Although the synchronistic aspect is not as striking as in some other stories in this book, the experience directly addresses the concerns of this chapter. It underscores the importance of balancing the Dionysian passions of depth psychology with the Apollonic ascent of liberative philosophies.

Synchronistic Interlude 11
Learning to Balance

I have been practicing objectless meditations, as described above, for more than two decades. I have attained neither proficiency nor great powers of concentration, nevertheless, it's one of my most worthwhile activities. My involvement in Jungian psychology is at least as old as my practice of meditation. Over the last two decades I have also become increasingly aware of the tensions between Jung's ideas and the goals and practices of objectless meditation, between individuation or psychological wholeness and self-realization in the sense of liberation from all pairs of opposites.

Another piece of background information: I had the great good fortune to have several extended visits with the late Paul Brunton (called PB by himself and others). When I spent time with PB in his seventies and eighties, he radiated a Himalayan spirituality through the personality of a reserved Englishman. He had a dry sense of humor, an Apollonic approach to philosophic mysticism, an extraordinary calm, and a nearly inhuman detachment from the usual turbulence of life. No doubt PB had other sides, but these qualities most impressed me then.

A few years ago, while collaborating with a Jungian analyst on some scholarly work, I visited his home in California several times. He in turn would visit me when on the East Coast. On one of my visits he said upon retiring after our work one evening, "I hope you have some good dreams." Of course, from a Jungian analyst, this is more than a polite way of saying good night. During our visits he and I often discussed our dreams from the previous night over breakfast. The dreams sometimes contributed directly to our scholarly collaboration. I often shared my perplexity with him about the relationship between depth psychology and liberative philosophy. Just after he wished me good dreams, the following vivid dream occurred.

> My wife and I had been drinking much wine. She was especially jovial. Her laughing was easy, full, and carefree—voluptuous to the point of being loud. I was also quite drunk, but admonished her to be quiet and get sober because we were going to visit PB. We both knew our condition and behavior were completely at odds with PB's deep peace, so we tried our best to shape up as we went to our meeting under a cloud of guilt for our libations.
>
> We came upon PB sitting on this large roofed-in porch that wrapped itself around a huge Victorian mansion. As we approached, I noticed the beauty of the detailed wooden railing along with PB's great serenity. He was working on some writing when we approached.
>
> PB greeted us cordially and told us he was going to teach us a new form of meditation. He instructed us to take all our clothes off. My wife, PB, and I all undressed without embarrassment. PB demonstrated the new meditation technique. We all did it together. We stood on our left foot, drew our right heel up to our right buttocks, and interlocked the fingers of both hands together under our right shin. All three of us assumed this posture and hopped nakedly around on the beautiful Victorian porch.

I awoke laughing and completely mystified at this bizarre dream. When my wife awoke, I demonstrated the new meditation technique. She soon was hopping around with me. In a little while I showed the new meditation to my friend the analyst, who, despite his wide-ranging studies in religion and mysticism, admitted that he had never heard of such an esoteric technique. After hopping and laughing about the new California-

Drawing commissioned from Terry Howley of Ithaca, New York.

64. "New meditation technique"

style meditation, my analyst friend recounted the following dream he had the same night.

> He was walking in the country with a group of Jungian analysts. He was engaged in a friendly conversation with the late Dr. X, who had come back from the dead. He felt bad because the other Jungians either could not see Dr. X or they were ignoring him.

I'll not attempt to discuss what this dream means for my friend. The critical symbol is the late Dr. X, a central figure in a major Jungian Society in California, who died many years ago. Completely unbeknownst to my friend, Dr. X was an early student of PB's. In fact, PB strongly encouraged Dr. X to become a Jungian analyst. Recently I learned that Dr. X had also made some preliminary efforts at writing about the relationship of Jungian psychology to the spiritual path laid out by PB and others. This side of Dr. X was unknown to my friend. From the synchronistic point of view, my friend's dream served as the objective correlate meaning-fully relating to my PB dream. We both realized that the synchronicity of the two dreams underscored their importance.

I have thought hard about this haunting dream and still do not feel I fully understand it. Nevertheless, let me offer some ideas about it, leaving aside the meaning of my friend's dream. The tensions of the opposites play themselves out throughout my dream. My wife and I are drunk on wine and boisterous in stark contrast with PB's deep serenity. With my background the unconscious could easily have chosen a variety of intoxicants, but it chose wine. As Jung says in the *Mysterium*, "This imago [*Dei*] is the true quintessence and the 'virtue' of the philosophic wine. The latter is therefore an apt synonym, because wine in the form of a liquid represents the body, but as alcohol it represents spirit, which would seem to correspond with the 'heavenly virtue.'"[1] Here then is a symbol uniting both body and spirit. Our worship of Bacchus or Dionysus, as the Greeks called him, the god of ecstatic union, contrasts not only with PB, but with the stateliness of the Victorian porch. Given PB's Apollonic and exalted spirituality, the idea of him getting naked and hopping around on one foot is impossibly incongruous—almost sacrilegious. In fact, although the accompanying drawing is both accurate and beautiful, I initially found it quite shocking.

For the moment, put aside the ludicrous nature of the image and look at its positive and integrating side. This meditation requires nakedness or lack of pretense and protection. It also requires a dynamic balancing on one foot at a time—something especially difficult for devotees of Bacchus. PB, the calm detached sage, did not scold or

drive out the revelers, but instead taught them a balancing meditation. Another aspect pointing to integration occurs because PB seemingly violated his own austere spirituality to demonstrate the naked hopping meditation and do it with us. Finally, in contrast to most advanced meditation techniques where we aim for loss of body consciousness, this meditation was very physical—a spiritual technique emphasizing the physical. The meditation was more like a sacred dance or an athletic form of spiritual introspection, suitable only for the physically fit. It also seems significant that the hopping was on the left foot, which according to traditional ideas emphasizes the irrational and unconscious, the Yin side of my nature. In summary, the naked hopping PB image unites Dionysus with Apollo, the passions of depth psychology with the austere heights of liberative philosophy.

Perhaps the dream's message is that I must learn to balance dynamically the Dionysian with the Apollonic, the depth psychological with the austere philosophy of liberation. Just as the early Greeks worshipped Apollo for eight months of the year at Delphi and then Dionysus for the remaining four, I must somehow learn to balance these forces in my life. The dream may also be suggesting that I have a much too narrow appreciation of who PB truly was.

The synchronistic aspect of the event, namely my friend's dream with Dr. X in it, supplements and confirms this meaning. Dr. X was attempting in his life and writings to balance depth psychology and all its passions with the austere spiritual demands of PB. In my experience the same meaning manifested in the inner psychological event (my dream) and my friend's dream—which though subjective for him, was objective for me.

Although my tentative interpretation of the experience encourages me to seek some harmony between the Dionysian demands of depth psychology with the Apollonic discipline of liberative philosophy, the details are not clear and the balance is elusive. Besides all this, perhaps the dream was also poking fun at my ponderous and overly serious attitude toward meditation. Nevertheless, I hop along contemplating the dream and trying to find my balance.

15 Synchronicity and Individuation

Because all human existence, including even our outward experience, is ultimately mental, there is no other way to genuine and durable human happiness than that which is for all human beings the ultimate one, that irradiation of the thought-bereft mind, that inner peace which passeth (intellectual) understanding, which Saint Paul called entry into the kingdom of heaven.

Paul Brunton[1]

The Demand for New Attitudes

From the Heart

"As Mrs. Nakamura stood watching her neighbor, everything flashed whiter than any white she had ever seen. She did not notice what happened to the man next door; the reflex of a mother set her in motion toward her children. She had taken a single step (the house was 1,350 yards, or three-quarters of a mile, from the center of the explosion) when something picked her up and she seemed to fly into the next room over the raised sleeping platform, pursued by parts of her house.

Timbers fell around her as she landed, and a shower of tiles pommelled her; everything became dark, for she was buried. The debris did not cover her deeply. She rose up and freed herself. She heard a child cry, "Mother, help me!," and saw her youngest—Myeko, the five-year-old—buried up to her breast and unable to move. As Mrs. Nakamura started frantically to claw her way toward the baby, she could see or hear nothing of her other children."[2]

From the Head

On August 6, 1945 at 8:15 a.m. in Hiroshima, Japan, the explosion of a fission bomb buried Mrs. Nakamura and her children. Its energy release of the equivalent

of 12.5 kilotons of TNT came from the fissioning or splitting of uranium 238 nuclei. This bomb was approximately ten thousands times more powerful than any previous conventional bomb and about a hundred times less powerful than today's thermonuclear bombs. Through a combination of the initial radiation, shock wave, fires, and radioactive fallout, 140,000 (±10,000) people were killed in Hiroshima. Three days later at 11:02 a.m., a plutonium 239 fission bomb released the energy equivalent of 22 kilotons of TNT on Nagasaki killing 70,000 (±10,000).[3] These bombs ended World War II.

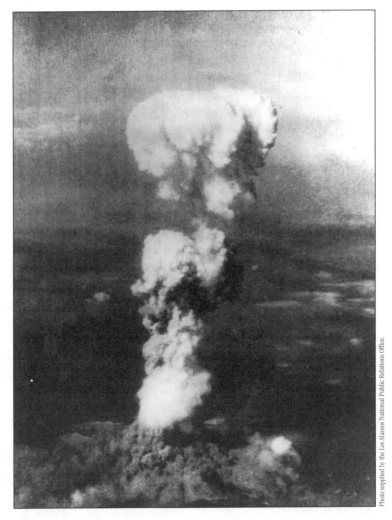

Photo supplied by the Los Alamos National Public Relations Office.

65. The bombing of Hiroshima

For nearly a half century nuclear weapons have hung over our heads by a hair like the sword of Damocles. Unfortunately, because our nuclear sword has been with us so long we are weary of it and complacent toward it.

Thanks to technological progress one missile can now accurately deliver multiple, independently guided warheads, each much more powerful than the antique bombs of 1945. Anyplace in the northern hemisphere can be hit within about twenty minutes of launch time from ground-based missiles and in about seven minutes from submarine-based missiles. Such "progress" makes it easy to imagine several monstrous scenarios that would dwarf Hiroshima and Nagasaki. I am grateful for the modest steps that the former Soviet Union and the United States have taken toward disarmament, but thanks to nuclear proliferation, and even the possibility of nuclear terrorism, there is no relief from our nuclear nightmare. The knowledge of nuclear weapons manufacture is so widespread that any determined country of even modest means can build one and deliver it in a small van. In 1945 we were blasted into the nuclear age and we cannot turn back.

When the first nuclear weapons fell on Japan, many realized that fundamental changes were required for humanity to survive. However, a great split in the world psyche, the iron curtain, drawn at the end of the World War II and dramatically dismantled a few years ago, graphically symbolized the cold war and blocked the needed transformation. The technological advances since those days make the problem more insistent and fortunately the end of the cold war gives us another chance to effect the needed changes—even if the problem has become more complex because of technological advances and nuclear proliferation. We are being given another chance and there is some hope.

I agree with Marvin Spiegelman when he says, "I have long thought that the atom bomb, with its enormous destructive energy released by 'splitting' of the nucleus, was an apt symbol for the general split in the world psyche, our unconscionable separation between reason and faith, science and religion, spirit and instinct."[4] No doubt our age suffers mightily from these forms of splitting and others, such as the tensions between the head and the heart (illustrated in the bombing descriptions on the previous page), conscious-unconscious, East-West, individual-collective, male-female. Of course, all ages, all cultures, suffer from some form or other of deep division. As long as we have egos we will suffer from the opposites, from splitting of one kind or another. Or, as the Buddhists say, as long as we have not assimilated the ultimate truth of emptiness, or our deep interdependence with both nature and each other, then we suffer as the Four Noble Truths proclaim. What makes our present condition unprecedented is that science has brought us the power to annihilate our enemy and, as the students of "nuclear winter" tell us, even life on the entire planet. This is still true today in our post cold war era as it was at the height of the cold war.

In the fall of 1993 the *New York Times*[5] reported that Russia has a "Dead Hand" technology. This is an elaborate technology that provides for a full-scale nuclear retaliation by Russia even if we have annihilated all its military leaders in a prior nuclear blast. The *Times* reports in some detail how the technology can launch targeted warheads without any significant human intervention. What worries the analysts is that malfunctioning of

such complex technology is a real possibility. A malfunctioning of any of the simple machines that make up the larger complex machine can annihilate human life on this planet—the ultimate technological nightmare. Such realities make it clear we live in a very different environment than any previous age and that we require a radically new adaptation to it.

Jung teaches us in one of his best theoretical essays, "On Psychic Energy," that when our personal environment changes, then our old attitudes that permitted harmonious adaptations to it are no longer adequate. The inability to adjust to the new environment dams up our libido, our psychic energy. The libido cannot flow harmoniously along the old familiar paths. We cannot obtain satisfaction or nourishment from our old ways of functioning. Jung tells us, "These symptoms indicate a damming up of libido, and the stoppage is always marked by the breaking up of the pairs of opposites."[6] Along with exaggerating the opposites this damming creates a devaluation of the old conscious attitudes. Our old attitudes seem useless—even counterproductive. Now we don't know how to function in the new environment. Then the excess energy, which formerly flowed harmoniously outward in the old adaptation, is now directed into the unconscious. This regression of libido into the unconscious brings up primitive, archaic, and generally undifferentiated and affect-laden psychic contents—the "slime" of the unconscious as Jung calls it. Nevertheless, depth psychology repeatedly shows that somewhere in this noxious slime are the seeds of new development. If we can identify and cultivate these seeds, they can develop into the new attitude that permits a wholesome adaptation and flow of libido along fresh and satisfying channels. The longer we cling to the old attitudes, the more painful our regression, the more disagreeable the slime, and the more suffering before we realize a new attitude and creative adaptation.

Let me try to apply these insights from depth psychology to our present historical era, to a wider arena than personal psychology. Even the most hardened observer of history admits that thanks to nuclear weapons, the most poisonous fruits of modern physics, we have a radically different environment and a new adaptation is demanded. The nuclear powers can no longer solve conflicts through full-scale war. Our energy, our collective libido, cannot flow along the accustomed channels. This damming of libido may be contributing to the "breaking up of the pairs of opposites" so powerfully symbolized by the destructive power released in the splitting of the atom. This regression of libido into the unconscious is at least partly responsible for the increase in rabid nationalism, racism, totalitarianism, and intolerance—to mention a few primitive and affect-laden manifestations of the slime of the unconscious. Of course, the longer we cling to our old attitudes, the greater the suffering. A fundamentally new set of attitudes is demanded if we are to survive as a species, let alone creatively adapt to the changing environment.

Could it be that the old ideology of separateness based upon the belief in independently existing entities that came out of classical physics contributed to our present troubles? Of course, we have had the deepest divisions and feelings of separateness since Cain slew his brother Abel. Nevertheless, chapter 9 quoted the physicist David Bohm as saying:

It is proposed that the widespread and pervasive distinctions between people (race, nation, family, profession, etc., etc.), which are now preventing mankind from working together for the common good, and indeed, even for survival, have one of the key factors of their origin in a kind of thought that treats things as inherently divided, disconnected, and "broken up" into yet smaller constituent parts. Each part is considered to be essentially independent and self-existent.[7]

The Dalai Lama would heartily agree with Bohm and use the same words to argue that our belief in inherent or independent existence is at the root of all our suffering. Ignorance, whether as unconsciousness or an incorrect philosophic view, has moral consequences.

Is it possible that the same modern physics that gave us fission and then fusion bombs may also hold some clues to a new attitude that might help us heal and survive? Is there a new symbol to replace the splitting of the atom, to indicate some healing in the world psyche? I have tried to show that both relativity and quantum mechanics, each in their own way, give us an utterly different world from the one Bohm describes as "inherently divided, disconnected, and 'broken up' into yet smaller constituent parts." Nonlocality or nonseparablity in our participatory quantum universe has especially dazzled those working on the philosophic foundations of quantum theory. This recent work presents us with a radically interconnected and interdependent world, one so essentially connected at a deep level that the interconnections are more fundamental, more real than the independent existence of the parts of the quantum system. The great beauty of this result is that it emerges from experiment and analysis that are independent of the theoretical structure of quantum mechanics, the best physical theory in history. Therefore, this result is much more profound and of more lasting value than, for example, some finding intimately tied to a peculiarity of quantum mechanics that might get overturned in the next generation of theory. Therefore we know that nonlocality and acausality must be found in any empirically adequate theory of nature. This understanding helps remove some of our most firmly held, yet false, projections upon nature, some of which certainly stand in the way of the new orientation required.

Yet we have not fully assimilated the meaning of nonlocality in quantum mechanics, let alone applied this new understanding to wider areas. There is a further difficulty because nonlocality is a much more abstract idea than splitting or dissociation, which is all too easy to understand, and therefore, nonlocality is harder to symbolize. No powerful icon is available like the gruesome mushroom cloud, and thus it is much more difficult to apply these abstract ideas in a wider arena. Nevertheless, it would be magnificent if we could realize, as in nonlocal quantum mechanics, that the interconnections between people, races, and countries are more fundamental, more real than the independent existence of our little egos, nationalities, or nations. Given the realities of our world, such a revolution in outlook seems visionary in the extreme. However, an equally extreme need exists for fundamental changes in attitude if we are to survive in our nuclear era. But history teaches us that any big change in attitude, any fundamental shift in the collective psyche, whether the Copernican Revolution that Galileo championed at his peril or our new understanding

of nonlocality, takes time—sometimes an agonizing amount of time—before it's fully understood in physics and then felt in wider circles. Nevertheless, quantum nonlocality is clearly of fundamental importance and it will bear fruit in helping us develop new attitudes that will permit a healthier adaptation to our nuclear environment. Perhaps it's one of the seeds in the slime that will help us develop the required new orientation.

From the psychological side we may also get a helpful clue from synchronicity. Case material and analysis show that the old view of a separate material world guided by strict causal laws standing independent of our inner world is inadequate for understanding synchronicity. As always in psychology, it's much more difficult to provide the kind of convincing arguments that we can mount in physics to demonstrate a new idea. However, we have learned much since Jung published his pioneering study of synchronicity a decade after Hiroshima and Nagasaki. Since then we have grown to appreciate more fully the idea that transcendent meaning can manifest acausally both in the inner and outer world. As I have stressed throughout this book, modern physics neither proves the reality of synchronicity nor explains it. Rather, modern physics does provide a much more accurate and receptive world view that can more easily accommodate the principle.

In the past we have been too quick to judge a culture by its technological prowess, its attainments in the material realm. If you could dazzle a culture with the might of your "fire sticks" or rifles then they obviously had little to teach you. In that sense Tibet before the invasion of the Chinese Communists (also about a decade after Hiroshima and Nagasaki) has nothing to teach us, for they only employed the wheel in prayer wheels, not for transportation or machinery. However, more recently we have come to appreciate the richness and depth of their "inner technology." Their view of emptiness has an especially contemporary ring despite its ancient roots. Rather than consider interdependence that expresses itself in nonlocal physics or in synchronicity experiences as an oddity, the Middle Way Buddhists consider this property to be the ultimate truth of all subjects and objects. Nonlocality and synchronicity fit snugly within emptiness, which positively stated implies a deep form of interconnectedness or codependency of all entities. Perhaps the greatest blessing for the larger world that has come from the genocide practiced upon the Tibetans has been our exposure to their companion ideas of emptiness and universal compassion. Maybe this is an example of how the seeds of new development are found within the slime of psychic regression.

Building upon both the Mind Only School of Buddhism (which grew out of the Middle Way tradition) and Jung's psychological standpoint, I have tried to develop mentalism. This form of idealism suggests a comprehensive understanding of synchronicity. I have tried to show how mentalism can address the four key issues raised by synchronicity of meaning, acausality, spacetime transcendence, and unity. In this view we replace the Cartesian dualism, which has so hindered our understanding in both philosophy and science, with a unified view of man and nature. This is one in which both man and nature are aspects of the World-Image presented to our individual minds though the agency of a World Mind. Now the interdependence so ubiquitous in quantum mechanics and depth

psychology finds its rationale in the appreciation that our most immediate experience, our own mind, gives us *both* the inner and outer world, from our most intimate intuitions to the farthest galaxies.

Perhaps mentalism can provide the seeds needed to overcome the cruel materialism that finds such fertile ground today. My hope is that within the synergy of depth psychology, modern physics, and idealist philosophy, lie the seeds and the healing balm to help us develop the new attitudes for guidance in our nuclear age. With this possibility in mind, I'll attempt to draw out some implications of mentalism and connect it more intimately with synchronicity.

Uninterrupted Spiritual Experience

If, as Jung and the mentalists tell us, the world is a projection of the self, then all experience has the self's meaning inherent in it. If we are sufficiently perceptive then all experience can reveal the designs of the self, the next step in the soul's revelation. The outer world is not indifferent or opposed to our development and quest for meaning, but is one element in its revelation. Just as attention to our dreams aids psychological development, so too if the inner and outer worlds are expressions of the same higher mind then attention to the meanings invested in the outer waking world also aids our development. In this way all experience has meaning, all experience has a role to play in the soul's unfolding. Understanding our joys and sorrows in this light is a form of divinizing life, of appreciating the immanence of the divine. As Paul Brunton says, "Here psychological analysis of experience seems to cross the border into religion. For mind is a real thing, not a no-thing. It exists in its own right. *More, all experience is an uninterrupted spiritual experience, whatever man has done to degrade it.*"[8]

Paul Brunton, noted for his understatement, is being truly emphatic by italicizing this remark. But how are we to understand this sentence, especially considering the words "*all*" and "*uninterrupted*"? Does this mean that even a person suffering an extraordinary barbarism of modern life such as a prison camp or political torture is having "*an uninterrupted spiritual experience*"? When exalted by a scene of majestic beauty in nature or a particularly lyrical musical passage it's easy to appreciate that as a spiritual experience, one lifting us beyond the usual turmoil and collisions of the psyche. But what about the extreme cruelties we inflict upon each other? In Buddhism the first of the Four Noble Truths, the very core of the doctrine, asserts that true suffering pervades all life. A quick scan of any of the news media confirms this fact. So again, how can such suffering be "*an uninterrupted spiritual experience?*"

The question needs answering on two levels. First, for the unenlightened ego there is only the first Noble Truth—all life is tainted by suffering. At this level the pain and suffering of daily life do not reach beyond themselves to any deeper truth. We suffer like the mouse tortured by my cat—or worse, because, unlike the mouse, we add psychological anguish to physical suffering. Buddhism and other great traditions offer us respite from

suffering, but it's a brute fact nonetheless. The emptiness doctrine never denies the reality of suffering. Second, for the adept who truly understands all experience as a revelation of his mind, which in turn is expressing the World Soul, then, and only then, is all experience uninterruptedly known as spiritual. Most of us find ourselves between these two extremes, perhaps closer to the unenlightened than we like. Without a glimmer of understanding, without some hint of purpose and meaning in experience, our ego never gets beyond the first Noble Truth—true suffering permeates all life. Occasionally, even in the midst of great suffering, it's revealed that this pain has meaning, that this experience is ultimately instructive, revelatory. Here is an experience of redeeming grace. Of course, the exact meaning or significance for the individual is unique and often difficult to discover. Nevertheless, pain is the greatest of spiritual messengers, initiating us into the process of individuation, the beginning of the search for meaning, the foundation for a spiritual life. Several synchronicity stories underscore this point.

Compassion from Empirical Experiences of Unity

One of the great gifts of a synchronicity experience, besides the specific unconscious compensation, is the empirical revelation of unity between the inner and outer world. It's intellectually satisfying to understand how the experimental refutation of Bell's Inequality proves that the quantum world is deeply interdependent with nonlocal connections and that causality is only a partial truth. It's also valuable to understand some arguments above, whether from Middle Way Buddhism, or the more general philosophic arguments for a completely mental world. However, an empirical experience of the unity of the inner and outer world is often the most convincing. As the woman in the "Dream Wedding" synchronicity story wrote, "Now I was forced to begin taking seriously what I had already studied in philosophy, Jungian psychology, and mysticism about the creative and projective capacity of mind." According to Marie-Louise von Franz the experience of unity is both the most essential and impressive aspect of synchronicity. She says:

> The most essential and certainly the most impressive thing about synchronicity occurrences . . . is the fact that in them the duality of soul and matter seems to be eliminated. They are therefore an *empirical indication* of an ultimate unity of all existence, which Jung, using the terminology of medieval natural philosophy, called the *Unus Mundus.*[9]

So-called "primitive" societies, such as Black Elk's Oglala Sioux, lived closer to this "ultimate unity of all existence" (at least before the destruction of their tradition). In such societies there was often an appreciation that we connect to the universe through the World Mind which dwells at the core of each individual mind. This indwelling of the infinite mind within our finite mind guarantees our fundamental unity with each other and the universe. Such a realization always issues in deep concern for others and a desire for genuine peace—both personal and social. Black Elk, who uses the term *Wakan-Tanka* for World Mind, describes this beautifully when he tells us,

> The first great peace, which is the most important, is that which comes within the souls of men when they realize their relationship, their oneness, with the universe and all its powers, and when they realize that at the center of the universe dwells *Wakan-Tanka,* and that this center is really everywhere, it is within each of us. . . . But above all you should understand that there can never be peace between nations until there is first known that true peace which, as I have often said, is within the souls of men.[10]

Black Elk's peace "within the souls of men" echoes this chapter's opening quotation by Paul Brunton who speaks of the "inner peace which passeth (intellectual) understanding, which Saint Paul called entry into the kingdom of heaven." Various traditions, both East and West, share this idea that we must build true world peace upon an understanding of our fundamental unity and that from our own inner peace flows true world peace. For example, the present Dalai Lama echoes this when he says, "Everybody loves to talk about calm and peace whether in a family, national, or international context, but without *inner* peace how can we make real peace?"[11]

Unfortunately this peace emanating from the vision of a unified world is directly available to few of us, and even then it's usually sporadic. Nevertheless, if we can rationally appreciate that both the outer and inner worlds—nature and ego—are expressions of the cosmic self, then we might effect a philosophic unification of the world; one built upon reasoned analysis and supported by synchronistic experience, nonseparability in quantum mechanics, and the great mystical traditions. Such a transformation requires removal of many of our deep projec-tions upon nature and ourselves and a massive psychological reorientation. I believe that this experience of unity is the meaning of the third and final level of conjunction with the *Unus Mundus* spoken about by Jung at the end of the *Mysterium Coniunctionis,* one rarely attained, but always held out as a goal.

A world view built upon interconnection and inter-dependence is not only useful for effecting a phil-osophic unification of the world, but according to the Tibetan Buddhists, it's essen-tial for developing the peerless virtue of compas-sion. Wherever the Dalai

66. His Holiness the Dalai Lama

Photo by Don Farber of Santa Monica, California. Used with permission.

Lama goes, whatever audience he addresses, whether Buddhist scholars or a national television audience, he always em-phasizes the principle of universal compassion. He tirelessly encourages the practice of compassion. A realization of emptiness or interdependence demands that we express it in the practice of compassion, while such practice deepens our understanding of emptiness. The Dalai Lama describes this most enlightened form of self interest:

> Each of us has responsibility for all humankind. It is time for us to think of other people as true brothers and sisters and to be concerned with their welfare, with lessening their suffering. Even if you cannot sacrifice your own benefit entirely, you should not forget the concerns of others. We should think more about the future and benefit of all humanity.
>
> Also, if you try to subdue your selfish motives—anger, and so forth—and develop more kindness and compassion for others, ultimately you yourself will benefit more than you would otherwise. So sometimes I say that the wise selfish person should practice this way. Foolish selfish people are always thinking of themselves, and the result is negative. Wise selfish people think of others, help others as much as they can, and the result is that they too receive benefit.
>
> This is my simple religion. There is no need for temples; no need for complicated philosophy. Our own brain, our own heart is our temple; the philosophy is kindness.[12]

Does the Dalai Lama make it sound too easy? How does one actually *practice* compassion? Aren't there some rules or at least guidelines for actualizing compassion, for bringing it into daily life? Although detailed exercises and prescriptions for practicing compassion exist in Tibetan Buddhism, the deeper answer is that *compassion is not a set of rules.* Instead compassion is a state of mind rooted in the awareness of our profound dependence upon each other and our surroundings—in other words in the appreciation of emptiness. From this understanding flows a reverence for all sentient beings and our environment. For this reason alone, it's clear why the Dalai Lama has such a deep concern for environmental issues.

A mere intellectual understanding is never enough to embody these profound spiritual truths. The complete transformation of our nature requires lifetimes of philosophic study, meditation, and practice. Liberation, Buddhahood, or sagehood—I use the terms interchangeably—is a rare attainment of spiritual giants. Thankfully they throw ladders down to us struggling midgets.

Pitfalls in Synchronicity

If we cannot immediately attain the highest conjunction with the *Unus Mundus* spoken about by Jung, then perhaps the view presented here is at least helpful in providing intellectual support for developing symbolic intuition, for reading meaning in the objective world. Many people do this unconsciously. If experiences go smoothly then we believe that we are in harmony with the *Tao;* conversely, when we meet obstacles on every side then it seems we are out of step, at odds, with the designs of the self. If the world and my ego are an unfolding of the soul then in principle it's possible to intuit symbolic meaning in all experience. All life is teaching me if I can cultivate the sensitivity to its meanings, properly

interpret its promptings. Since waking life is an unfolding of the self, we can symbolically interpret important waking experiences like a numinous dream.

However, reading meaning from experiences in the outer world, cultivating symbolic intuition, or developing a sensitivity to synchronicity experience, is treading on slippery ground, especially when we are first trying to differentiate these talents. It's all too easy to turn trivia into cosmic occasions of meaning. Divine revelations and epiphanies then become a dime-a-dozen—a typical syndrome in mental hospitals. There the mad are always receiving divine revelations from the most trivial and inane occurrences. James Hillman warns that psychologically primitive manifestations of the archetype of the self, just like primitive eruptions of the anima, can lead to a variety of errors and foolishness:

> The question of what is trivial and what is meaningful depends on the archetype that gives meaning, and this, says Jung, is the self. Once the self is constellated, *meaning* comes with it. But as with any archetypal event, it has its undifferentiated foolish side. So one can be overwhelmed by displaced, inferior, paranoid meaningfulness, just as one can be overwhelmed by Eros and one's soul (anima) put through the throes of desperate, ridiculous love. The disproportion between the trivial content of a synchronistic event on the one hand, and on the other, the giant sense of meaning that comes with it, shows what I mean. Like a person who has fallen into love, so a person who has fallen into meaning begins that process of self-validation and self-justification of trivia which belong to the experience of the archetype within any complex and form part of its defense. It therefore makes little difference, psychodynamically, whether we fall into the shadow and justify our disorders of morality, or the anima and our disorders of beauty, or the self and our disorders of meaning.[13]

Since our capacity for self-delusion and ego aggrandizement is endless, we need to proceed with the utmost rationality and balance—just those character traits in shortest supply. Unfortunately, almost no guidelines exist here except perhaps the cultivation of humility, but even that I can turn into a source of pride! Where are we to turn?

The problem is still more complex, because interpreting a synchronistic experience is at least as difficult as interpreting a big dream. Interpreting our own dreams is difficult because they are often expressing a major unconscious compensation and therefore the interpreter, the ego that needs the compensation, is in the worst position to make the interpretation. Even if the interpretation is simple and straightforward our lopsidedness prevents us from seeing the truth and instead we often fashion an incorrect interpretation based on our psychological problems. All these dangers and difficulties apply at least as much to interpreting synchronistic experiences, to extracting the acausal meaning of the connections between the inner and outer. Not only can we impose meaning on events when none exists, but we are predisposed to make the wrong interpretations even when genuine meaning is manifesting in a synchronicity experience.

However, despite our tendencies to distort and twist symbolic interpretations, Marie-Louise von Franz claims that there is an internal logic and objective meaning within an archetypal interpretation, what she calls "necessary statements." This objective element can help us interpret our experience if we are sufficiently disciplined and sober—or if we are fortunate to have a good relationship with an experienced therapist or spiritual friend. She gives an example,

A man who suffered from a psychotic idea that he was the savior of the world attacked his wife with an axe in order to "exorcise the devil out of her." She called for help. At the very moment when a policeman and a psychiatrist entered the house the only lamp, which lit up the passage where they all stood, exploded. They were plunged into darkness covered with glass splinters. The sick man exclaimed "See . . . this is like it was at the crucifixion of Christ! The sun has eclipsed." He felt confirmed that he was the savior. But if we amplify this symbolism correctly with "necessary statements," i.e. with "disciplined imagination," there appears a completely different meaning: a light bulb is not the sun, that symbol of a numinous source of cosmic consciousness; it only symbolizes a "little light" made by man, i.e., his ego-consciousness. So the event means a "blackout" of that man's ego-consciousness, the disruption of his ego, which is exactly what happens in the beginning of a psychotic episode. When I saw the man and his wife two days later, I saw the meaning and was able to show it to them, which had a positive, sobering effect on the poor man. The correct interpretation of a synchronistic event is essential and can only be done by a sober and disciplined mind which keeps to the necessary statements and does not run off into arbitrary assumptions.[14]

Added to all these dangers is that even one powerful synchronicity experience can be an inflating experience. The little voice says, "Surely, I must be a very advanced and chosen person if the world is meaningfully arranging itself for my benefit, my education." Rather than the ego becoming a servant of the higher, integrally related to the world, the world becomes assimilated by the ego. The Copernican Revolution is stood on its head.

> "The correct interpretation of a synchronistic event is essential and can only be done by a sober and disciplined mind which keeps to the necessary statements and does not run off into arbitrary assumptions."

Nearly identical problems also appear at a spiritual level. Since our own ego is the unsurpassed master of self-delusion, Paul Brunton encourages us to develop philosophic discipline and a relationship with a capable guide. He says,

The pathway of the mystical goal is strewn with human wreckage. Why? Several reasons would be needed to give a complete answer but one of the most important is this: Between the state of ordinary man and the state of the matured mystic there lies a perilous and deceptive psychological region which has been given various names in mystical literature. It has been called the astral plane, the intermediate zone, the hall of illusions, and so on. The early efforts of all aspirants in concentration, mediation, self-conquest, and study, bring them into this region. But once here their egoism becomes stimulated by the subtle forces they have evoked, their emotional nature becomes more sensitive and more fluid, their imaginative power becomes more active and is less restrained. The consequence of failure to negotiate these changes properly is swollen vanity, superstitious credulity, emotions run riot, and imagination gone wild. The safeguards against all this are first, submission to the philosophic discipline and second, submission to competent guidance.[15]

Some Spiritual Fruits

Involvement in depth psychology can give us a continuous and living experience of the reality of the psyche and its powers. Psychology teaches us that what we formerly

thought was the flimsiest of realties—thoughts, images, and feelings—constitute our world, both in substantial fact and significant purpose. Although differences exist between depth psychology and mentalism, they wholeheartedly accord on this point. Because of the power of thought and the force of images, we have a great responsibility to guide the productions of mind or psyche. We cannot just live out our shadow, pursue every anima projection, or follow any impulse from the psyche. Individuation requires us to investigate the psyche with great diligence, question its images as to their intent, and take our lead from them. Then we need to embody our insights and ideals in the reality of daily life. I believe that it's only from the wholeness achieved in individuation, from knowing the heights and depth of our own personality, that we can make a balanced and fruitful attempt to attain liberation—the transcendence of all opposites, the complete embodiment of wisdom and compassion, the consummation of our humanity.

The liberative philosophies bid us cultivate a quiet mind, one free from any thoughts, for it is only in the silence that we can experience the highest octaves of the mind, the unobjectifiable core of our being. Of course, this accounts for the emphasis in these traditions on objectless meditation. At this stage we are not to succumb to the sirens of the psyche. Like Odysseus we must bind our selves to the mast, but here the mast of attention, to evade the alluring images in the psyche. We want inactive imagination not active imagination, the formless not the formed. But as I suggested in the previous chapter, at least for beginners like me an alternating and complementary fusion of depth psychology and liberative philosophy seems most satisfying and productive.

Both disciplines give us an appreciation of the constructive power of thought and impress upon us the importance of our mental attitudes and habits. Although the World Mind or Cosmic Soul imposes its master image upon us from within, we still have some freedom to construct our response to it. Although it's often difficult, we can still choose how we respond to events. If we persist in viewing ourselves as the victim, the abandoned child, the plaything of our shadow, or captive of any of the fearful beasts in the psychological zoo, then because of the constructive power of thought we will truly be that victim, that fearful child, that beast from the unconscious. In contrast, if we turn the immense fabricative power of the mind in a positive direction, we will reap the appropriate benefits. Of course, this does not mean that we can neglect our psychological difficulties and just imagine ourselves to be Buddhas. There are no quick fixes in spiritual life. Nevertheless, we can take a lesson from Paul Brunton when he says,

> When the mind-essence is recognized as the true ground upon which the whole structure of this "I" has been built, it will also be recognized as something which is never born and consequently never dies, as what is and shall be. It can then be seen that if all our memories involve time, they also involve as a background the existence of something in them which is out of time. This view of immortality as belonging to the higher individuality of Overself rather than to the lower personality will then replace the former one, which is ultimately doomed to suffer the anguish of frustrated desire whereas the true view bathes a man in increasing peace the better it is understood. When man continues firmly and unfailingly to identify himself in thought with this, his higher individuality, quite naturally he comes to share its attitude. And from this attitude the belief, "I shall die eventually" is entirely absent. To imagine is to create. That which a man thinks, he becomes. Rightly thinking himself immortal, he consequently attains immortality.[16]

Appendix.
A Nontechnical Derivation of
Bell's Inequality

Using the notation developed in chapter 9 and Einstein's assumptions discussed there this appendix develops an interpretation of the experiment. In Case 1 the tests are identical on the left and right, both resonators pass or fail the tests together, and they score equally well on all three tests. From this perfect correlation we can infer with certainty that, at least when the tests are the same for both, the resonators have the same characteristics. Since the bells are matched pairs of resonators, this correlation is hardly surprising. Quality control was bad in Tsongkhapa's time, but still the resonators were paired—at least when the tests were the same as in Case 1 data.

We can infer more than this because the resonators never "know" until it is too late to be of any use whether they are both taking the same test or not. (We used locality to establish the complete isolation of one independent and random test selection on one side from that on the other.) Next employ the critical separability assumption: "the ('being-thus') of spatially distant things." Although separability is simple and reasonable (the philosophic fish swims in it), here is the pivotal assumption. Separability or mutually independent existence, with the isolation of the resonators and the perfect correlation for test combinations A-A, B-B, and C-C, implies that the resonators must always have identical attributes for the artistic style, bronze content, and construction strength, although we can only perform one test at a time on a resonator. We deduce this from Case 1 data and the assumptions by noting that if the pair did not always have identical attributes, it would occasionally happen that one resonator passes an artistic test while the other fails—something that never occurs.

Now since the resonators always have identical attributes, if we make a different measurement in the left and right rooms we are in effect simultaneously measuring two properties of the resonators—something standard quantum mechanics claims is impossible. (Maybe the bell salesman really has a clever scheme that defeats complementarity and satisfies Tsongkhapa's need for more detailed analysis!)

I use the following shorthand notation for the relevant property set of the resonators: a + b + c + means a resonator will pass all three tests, artistic, bronze, and construction while a + b − c + means that the resonator will pass the artistic test, fail the bronze test,

and pass the construction test. (Uppercase letters as in A-B or C-C are for test selections in the left and right rooms while lowercase letters as in a+ b- c+ are for attributes of a given resonator.) Then there are eight possible property sets: a + b + c +, a + b + c −, a + b − c +, a − b+ c+, a − b − c −, a − b − c +, a − b + c −, and a + b − c −. *Assuming locality and mutually independent existence, analysis of Case 1 data shows that both members of each pair of resonators always have the same property sets.* With these assumptions they must be fully matched pairs. Now discuss Case 2 data.

Case 2 Data: The tests in each room are *different*. The testing combinations are A-B, A-C, B-C, B-A, C-A, and C-B. Then one-fourth of the tests give the same results (both sides pass or fail.)

Our task is now to deduce what results should follow from our assumption for Case 2. I first analyze the *possible* outcomes of the experiment and thereby provide a framework for evaluating the data. Correlation Table 1 shows the six test combinations for Case 2, when the tests differ in each room, and the corresponding correlation results for the eight property sets. The six columns correspond to the testing combinations while the eight rows correspond to the property sets. Each entry in the table is either an "S" or a "D" indicating that the property set for that test combination gives either the **S**ame (both pass or fail) or **D**ifferent test results.

Correlation Table 1

Property Sets	Test Combinations					
	A-B	A-C	B-C	B-A	C-A	C-B
a + b + c +	S	S	S	S	S	S
a + b + c −	S	D	D	S	D	D
a + b − c +	D	S	D	D	S	D
a − b + c +	D	D	S	D	D	S
a − b − c −	S	S	S	S	S	S
a − b − c +	S	D	D	S	D	D
a − b + c −	D	S	D	D	S	D
a + b − c −	D	D	S	D	D	S

For example, the property set for the resonators is a + b + c − and the test combination is A-C then the test results are different (the resonator on the left passes while the one on the right fails). This is indicated by a "D" in the table. I encourage you to check a few entries to be sure they are correct.

We can make an already easy counting task even easier if we realize there is much redundancy in the table. The redundancy results from our only being interested in whether the test results were the same or different on each side. In other words, we do not discriminate between getting + + or − − , they both yield S, nor between + − or − + , which both yield D. So the entire table is just three duplicates of any one quarter of the table. For example, the upper left quadrant is identical to the lower right quadrant and so on.

Having laid out Table 1 we can do some simple counting. I take two cases to bracket the extreme possibilities of interest. Since the test selections are independent and random for a given property set, the six test combinations must occur equally often; after all, this is what a random selection of test combinations means.

First, assume a *uniform population* of bells—each property set is equally likely. In other words, in a uniform population it is just as likely that a bell will have a property set a + b − c as a + b + c + or any other property set. With this uniform population each entry in the table has an equal statistical weight. The same number of D's as S's occurs in any one quarter of it. Thus if we tested a large group of bells from this uniform population, they would give the same test results exactly one half of the time.

Second, to complete the analysis, assume a *nonuniform population* with no resonators having either a + b + c + or a − b − c − property sets, but the other sets are equally represented. This eliminates those property sets that always give S's for all test combinations. For every remaining property set, in a given quarter of the table there is one S and two D's. Thus resonators with these property sets (our nonuniform population) will always score the same results only one-third of the time. If you think about it for a moment, you'll see that this nonuniform population gives the minimum number of sames or "S's."

Since any other population must lie between these extremes, any combination of property sets will give the same results at least one-third of the time when the tests are different. Getting less than one-third is not possible. Assuming locality and mutually independent existence, then any mix of attributes must yield the same results at least one-third of the time when the tests on each side are different. This is a special version of Bell's Inequality.

Notes

Chapter 1: Introduction

1. C. G. Jung, *The Structure and Dynamics of the Psyche, Collected Works, Volume 8* (Princeton, NJ: Princeton University Press, 1978), p. 419. For compactness this type of reference will henceforth be denoted: Jung, "Synchronicity: An Acausal Connecting Principle," CW 8, 1978, p. 419.

2. Steven Weinberg, *The First Three Minutes* (New York: Basic Books, 1977), pp. 131–32.

3. Ibid., p. 154.

4. Black Elk, *Black Elk Speaks, Being the Life Story of a Holy Man of the Oglala Sioux,* as told through John G. Neihardt (New York: Pocket Books, 1959), p. 2.

5. Jung, "Psychology and Religion," CW 11, 1969, p. 83.

6. Gerhard Adler and Aniela Jaffé, eds. *C. J. Jung Letters,* vol. 1, trans. R. F. C. Hull (Princeton, NJ: Princeton University Press, 1975), p. 395.

7. Werner Heisenberg, *Physics and Beyond* (Cambridge: Cambridge University Press, 1971), p. 101.

8. *The Poetry of Robert Frost,* ed. E. C. Lathem (Barre, MA: Imprint Society, 1971), p. 352.

9. John Bell, "On the Einstein-Podolsky-Rosen Paradox," *Physics* 1 (1964): 195.

10. Wolfgang Pauli, "The Influence of Archetypal Ideas on the Scientific Theories of Kepler," in C. G. Jung and W. Pauli, *The Interpretation of Nature and the Psyche* (New York: Pantheon Books Inc.,1955), p. 210.

11. Albert Einstein, *Albert Einstein, the Human Side: New Glimpses from His Archives,* H. Dukas and B. Hoffmann, eds. (Princeton, NJ: Princeton University Press, 1981), p. 38.

Chapter 2: Individuation and Unconscious Compensation

1. Jung, "General Aspects of Dream Psychology," CW 8, 1978, p. 253.

2. Ibid., p. 253.

3. Jung, "On the Nature of Dreams," CW 8, 1978, pp. 289–90.

4. Marie-Louise von Franz, *Psyche and Matter* (Boston: Shambhala Publications, 1992), p. 258.

5. Jung, *Mysterium Coniunctionis,* CW 14, 1974, p. 546.

6. Jung, "General Aspects of Dream Psychology," CW 8, 1978, p. 241.

7. Jung, "Synchronicity," CW 8, 1978, p. 493.

Chapter 3: Synchronicity: Acausal Connection through Meaning

1. Robert Aziz, *C. G. Jung's Psychology of Religion and Synchronicity* (Albany, NY: State University of New York Press: 1990), p. 1.

2. Police, *Synchronicity* (Hollywood, CA: A&M Records, 1983).

3. Marie-Louise von Franz, *Psyche and Matter* (Boston: Shambhala Publications, 1992).

4. The interview took place in 1990 and constituted the first hour of a three-hour program entitled "Passions of the Soul" by Ikon Television, P. O. Box 10, 1200 JB Hilversum, Holland.

5. Jung, "On Synchronicity," CW 8, 1978, pp. 525–26.

6. von Franz, *Psyche and Matter*, p. 231.

7. Jung, "Synchronicity: An Acausal Connecting Principle," CW 8, 1978, p. 439.

8. Aziz, *C. G. Jung's Psychology of Religion and Synchronicity.*

9. Ibid., p. 64.

10. Michael Fordham, "An Interpretation of Jung's Thesis about Synchronicity," *British Journal of Medical Psychology* 35 (1962): 210.

11. See Jung's synchronicity essay for a group of references on these and related experiments. See also note 13 below.

12. Jung, "Synchronicity: An Acausal Connecting Principle," CW 8, 1978, p. 482.

13. Robert Jahn and Brenda Dunne, *Margins of Reality: The Role of Consciousness in the Physical World* (New York: Harcourt Brace Jovanovich, 1987).

14. Jung, "Synchronicity: An Acausal Connecting Principle," CW 8, 1978, p. 435.

15. von Franz, *Psyche and Matter*, p. 257.

16. Jung, "Synchronicity: An Acausal Connecting Principle", CW 8, p. 516.

17. Ibid., p. 516.

18. von Franz, *Psyche and Matter,* p. 267.

19. Marie-Louise von Franz, *Number and Time,* trans. Andrea Dykes (Evanston, IL: Northwestern University Press, 1974).

20. Any bound quantum system (one with finite size) will have quantized energy and other quantities. This quantization simply follows from the imposition of this spatial boundedness upon the solutions to the fundamental equations of quantum mechanics. This is not an example of acausal "just-so-ness."

21. Jahn and Dunne, *Margins of Reality.*

22. Jung, "Synchronicity: An Acausal Connecting Principle", CW 8, p. 432.

23. Aziz, *C. G. Jung's Psychology of Religion and Synchronicity,* pp. 60–61.

24. C. G. Jung, *Memories, Dreams, and Reflections,* ed. Aniela Jaffé (New York: Vintage Books, 1963), p. 314.

25. Jung, "Synchronicity: An Acausal Connecting Principle", CW 8, p. 448.

26. Ibid., p. 485.

Chapter 4: Synchronicity: Examples and Analysis

1. Jung, "Synchronicity: An Acausal Connecting Principle," CW 8, 1978, p. 482.

2. Anthony Damiani, *Looking into Mind* (Burdett, NY: Larson Publications, 1990) and *Standing in Your Own Way: Talks on the Nature of Ego* (Burdett, NY: Larson Publications, 1993).

3. Jung, "Synchronicity: An Acausal Connecting Principle," CW 8, 1978, p. 482.

4. Ibid., p. 506.

5. Jung, "On the Tibetan Book of the Great Liberation," CW 11, 1969, p. 476.

6. Jung, *Mysterium Coniunctionis,* 1974, CW 14, p. 548.

7. As quoted in Max Born's essay, "Einstein's Statistical Theories," in *Albert Einstein: Philosopher Scientist,* P. A. Schilpp, ed., Library of Living Philosophers, vol. 7 (LaSalle, IL: Open Court, 1949), pp. 175–76.

Chapter 5: From a Medieval to a Modern World View

1. Dante Alighieri, *Divine Comedy,* Paradiso I, 103, trans. Allen Mandelbaum (Berkeley: University of California Press, 1982).

2. Galileo Galilei, *The Assayer* (1623), translated in Stillman Drake, *Galileo* (Oxford: Oxford University Press, 1987), p. 70.

3. Adapted from M. A. Orr, *Dante and the Early Astronomers* (Port Washington, NY: Kennikat Press, 1969), Figure 38.

4. Richard Tarnus, *The Passion of the Western Mind* (New York: Ballantine Books, 1993), pp. 193–94.

5. Stillman Drake, *Galileo* (Oxford: Oxford University Press, 1987).

6. Stillman Drake, *Galileo at Work* (Chicago: University of Chicago Press, 1978), p. 14.

7. Stillman Drake, *Galileo: Pioneer Scientist* (Toronto: University of Toronto Press, 1990), p. 5.

8. Drake, *Galileo,* p. 70.

9. Daniel Dennett, *Consciousness Explained* (Boston: Little Brown and Company, 1991).

10. Ibid., p. 70.

11. Jeremy Hayward and Francisco Varella, eds., *Gentle Bridges: Conversations with the Dalai Lama on the Sciences of Mind* (Boston: Shambhala, 1992), p. 147.

12. Erwin Schrödinger, *What is Life & Mind and Matter* (Cambridge: Cambridge University Press, 1967), p. 137.

13. Vaclav Havel, "The End of the Modern Era," *New York Times,* 1 March 1992, p. E18.

14. Daniel Kleppner, *Physics Today,* August 1993, p. 11.

Chapter 6: Causality and Acausality in Nature

1. Niels Bohr, "Discussions with Einstein on Epistemological Problems in Atomic Physics," in *Quantum Theory and Measurement* (Princeton, NJ: Princeton University Press, 1983), p. 26.

2. C. G. Jung, "Foreword to the 'I Ching,'" CW 11, 1969, p. 590.

3. Abner Shimony, Lecture and supplied notes on "What Philosophers Should Know about Bell's Theorem," American Philosophical Association Meeting, Boston, January 1987.

4. David Bolter, *Turing's Man, Western Culture in the Computer Age* (Chapel Hill, NC: University of North Carolina Press, 1984).

5. Pierre Simon de Laplace, *A Philosophical Essay on Probabilities,* trans. F. W. Truscott and F. L. Emory from the Sixth French Edition (New York: Dover Publications, 1951), p. 4.

6. James Gleick, *Chaos: Making a New Science* (New York: Viking, 1987).

7. C. G. Jung and W. Pauli, *The Interpretation of Nature and the Psyche* (New York: Panthenon Books, 1952), originally published in German as *Naturerklärund und Psyche* (Studien aus dem C. G. Jung-Institut, IV) by Rascher Verlag, Zurich, 1952.

8. Ibid., p. 136.

9. Max Planck, *Where is Science Going?,* trans. J. Murphy (New York: W. W. Norton & Co. 1932), p. 117.

10. Niels Bohr, *Atomic Theory and the Description of Nature* (Cambridge: Cambridge University Press, 1961), p. 116.

11. Niels Bohr, "Discussion with Einstein on Epistemological Problems in Atomic Physics," in *Albert Einstein: Philosopher-Scientist*, ed. P. A. Schilpp, Library of Living Philosophers, vol. 7, (LaSalle, IL: Open Court, 1949), pp. 200–241.

12. Albert Einstein, B. Podolsky, and N. Rosen, "Can Quantum-Mechanical Description of Physical Reality Be Considered Complete?," *Physical Review* 47 (1935): 777.

13. Bohr, "Can Quantum-Mechanical Description of Physical Reality Be Considered Complete?," p. 696.

14. Jung, "Synchronicity: An Acausal Connecting Principle," CW 8, 1978, p. 515.

Synchronistic Interlude 3

1. H. V. Gunther, *Tibetan Buddhism in Western Perspective* (Emeryville, CA: Dharma Publishing, 1977), pp. 119–120.

Chapter 7: Elasticity of Space and Time

1. Jung, from a letter to Dr. Carl Seelig, Feb. 25, 1953, in *C. G. Jung Letters*, vol. 2, trans. R. F. C. Hull (Princeton, NJ: Princeton University Press, 1975), pp. 108–9.

2. Jung, "Synchronicity: An Acausal Connecting Principle," CW 8, 1978, pp. 435–36.

3. $L = L_0(1-(v/c)^2)^{1/2}$, where v is the relative velocity between the object and the measuring apparatus.

4. Mansfield, "Relativity in Mādhyamika Buddhism and Modern Physics," *Philosophy East and West* 40, no. 1 (1990): 59.

Synchronistic Interlude 4

1. Jung, "Synchronicity: An Acausal Connecting Principle," CW 8, 1978, p. 448.

Chapter 8: A Participatory Quantum Universe

1. Heinz Pagels, *The Cosmic Code: Quantum Physics as the Language of Nature* (New York: Simon and Schuster, 1982), p. 98.

2. John Wheeler, "Law without Law," in *Quantum Theory and Measurement*, eds. J. Wheeler and W. Zurek (Princeton, NJ: Princeton University Press, 1983), p. 194.

3. Niels Bohr, *Atomic Theory and the Description of Nature* (Cambridge: Cambridge University Press, 1934), p. 115.

4. Niels Bohr, "Discussions with Einstein on Epistemological Problems in Atomic Physics" in *Quantum Theory and Measurement*, ed. J. Wheeler and W. Zurek (Princeton, NJ: Princeton University Press, 1983), pp. 45–46; originally published in *Albert Einstein: Philosopher-Scientist*, ed. P. A. Schilpp, The Library of Living Philosophers, vol. 7 (LaSalle, IL: Open Court, 1949), pp. 200–41.

5. Wheeler, "Law without Law," pp. 190–96.

6. Ibid., p. 190.

7. Erwin Schrödinger, *What is Life? & Mind and Matter* (Cambridge: Cambridge University Press, 1967), p. 176.

Chapter 9: Nonlocality in Nature

1. Albert Einstein, "Einstein on Locality and Separability," trans. Donald Howard, *Studies in History and Philosophy of Science* 16, no. 3, (1985): 186.

2. D. Mermin, "Bringing Home the Atomic World: Quantum Mysteries for Anybody," *American Journal of Physics* 49 (1981): 940.

3. V. Mansfield, "Tsongkahapa's Bells, Bell's Inequality, and Mādhyamika Emptiness," *Tibet Journal* 15, no. 1 (1990): 42–66.

4. There is anecdotal evidence suggesting that this salesman was an early incarnation of the famous Irish physicist, John Bell. This is still an open question.

5. V. Mansfield and M. Spiegelman, "The Opposites in Quantum Mechanics and Jungian Psychology: Part I, Theoretical Foundations," *Journal of Analytical Psychology* 34, no. 1 (1991): 267; V. Mansfield, "The Opposites in Quantum Mechanics and Jungian Psychology: Part II, Applications," *Journal of Analytical Psychology* 34, no. 1 (1991): 306.

6. Jung, "Synchronicity," CW 8, 1978, p. 480.

7. Einstein, Podolsky, and Rosen, "Can Quantum-Mechanical Description of Physical Reality Be Considered Complete?," p. 777.

8. Einstein, "Einstein on Locality and Separability," pp. 187–88.

9. Alain Aspect, Jean Dalibard, and Gérard Roger, "Experimental Test of Bell's Inequalities Using Time-Varying Analyzers," *Physical Review Letters* 20 (1982): 1804.

10. V. Mansfield, "Mādhyamika Buddhism and Modern Physics: Beginning a Dialogue," *International Philosophical Quarterly* 29 (1981): 940.

11. For a recent review of the mind-matter discussion within quantum mechanics see the book, *Mind, Matter, and Quantum Mechanics* by Henry P. Stapp (Berlin: Springer Verlag, 1993).

12. Stapp, *Quantum Mechanics,* reviews several recent approaches and compares them with his own.

Synchronistic Interlude 6

1. Jung, "Synchronicity," CW 8, 1978, pp. 436–37.

2. von Franz, *Psyche and Matter,* p. 272.

3. Jean Shinoda Bolen, *The Tao of Psychology: Synchronicity and the Self* (San Francisco, CA: Harper & Row, 1979), p. 7.

Chapter 10: The Structure of Middle Way Buddhism

1. Tenzin Gyatso, *A Policy of Kindness* (Ithaca, NY: Snow Lion Publications, 1990), pp. 71–72.

2. Ibid., p. 68.

3. Tenzin Gyatso, *Essence of Refined Gold by Sonam Gyatso, the Third Dalai Lama,* commented upon by Tenzin Gyatso, trans. Glenn Mullin (Ithaca, NY: Gabriel/Snow Lion, 1982), p. 69.

4. Kelsang Gyatso, *Meaningful to Behold* (London: Tharpa Publications, 1986), p. 122.

5. Jeffrey Hopkins, *Meditation on Emptiness* (London: Wisdom Publications, 1983); Robert Thurman, *Tsong Khapa's Speech of Gold in the Essence of True Eloquence* (Princeton, NJ: Princeton University Press, 1984).

6. Thurman, *Tsong Khapa's Speech of Gold in the Essence of True Eloquence.*

7. Tenzin Gyatso, *The Buddhism of Tibet,* trans. J. Hopkins and L. Rimpoche (London: George Allen and Unwin, 1975); T. Gyatso, *Transcendent Wisdom,* trans. B. A. Wallace (Ithaca, NY: Snow Lion Publications, 1988).

8. Kelsang Gyatso, *Heart of Wisdom* (London: Tharpa Publications, 1986).

9. Paul Brunton, *Relativity, Philosophy, and Mind,* vol. 13 of The Notebooks of Paul Brunton (Burdett, NY: Larson Publications, 1988), pp. 25–26.

10. Thurman, p. 171.

Synchronistic Interlude 7

1. D. T. Suzuki, *Essays in Zen Buddhism: Second Series* (New York: Samuel Weiser, 1976), p. 153.

2. Ibid., p. 192.

Chapter 11: Applications of Middle Way Emptiness

1. Schrödinger, *What is Life? & Mind and Matter*, p. 140.
2. T. Gyatso, *Policy of Kindness*, p. 112.
3. Ibid., p. 58.
4. Jarrett, "On the Physical Significance of the Locality Conditions in the Bell Arguments," *Nous* 18 (1984): 569.
5. K. Gyatso, *Heart of Wisdom*, p. 29.
6. David Bohm, *Wholeness and the Implicate Order* (London: Routledge & Kegan Paul, 1983), p. xi.
7. Paul Teller, "Relational Holism and Quantum Mechanics," *British Journal for the Philosophy of Science* 37 (1985): 71.

Synchronistic Interlude 8

1. Jung, *Aion*, CW 9, 2, 1975, p. 24.
2. Ibid., p. 31.
3. Ibid., p. 69.
4. Ibid., p. 165.
5. Ibid., p. 27.
6. Ibid., pp. 128–29.

Chapter 12: The Psychological Standpoint: Virtues and Vices

1. Jung, "On the Nature of the Psyche," CW 8, 1978, p. 169.
2. Jung, *Aion*, CW 9ii, p. 9.
3. Jung, *Memories, Dreams, Reflections,* ed. Aniela Jaffé (New York: Vintage Books, 1963), p. xi.
4. Jung, "Spirit and Life," CW 8, 1978, pp. 327–28.
5. Jung, "On the Nature of the Psyche," CW 8, 1978, p. 215.
6. Ibid., p.189.
7. Jung, "Basic Principles of Analytic Psychology," CW 8, 1978, p. 342.
8. Jung, "On the Nature of the Psyche," CW 8, 1978, p. 215.
9. Ibid., p. 215.
10. C. G. Jung, *Mysterium Coniunctionis,* CW 14, 1974, p. 468.
11. Jung, "Holy Men of India," CW 11, 1969.
12. Ibid., p. 577.
13. Jung, *C. G. Jung Letters,* 1906–1950, vol. 1, p. 477.
14. Ibid., p. 478.
15. Marvin Spiegelman, private communication, March, 1993.
16. Max Planck, *A Survey of Physical Theory,* trans. R. Jones and D. H. Williams (New York: Dover Publications, 1960), p. 53.
17. Brunton, *Relativity, Philosophy, and Mind,* part 3, p. 8.
18. Schrödinger, *What is Life? & Mind and Matter* (Cambridge: Cambridge University Press, 1967), p. 131.
19. Brunton, *Relativity, Philosophy, and Mind,* part 3, p. 22.
20. Jung, "Spirit and Life," CW 8, 1978, p. 322.
21. Brunton, *Relativity, Philosophy, and Mind,* part 3, p. 22–24.

22. Schrödinger, *What is Life? & Mind and Matter*, p. 171.
23. Jung, "Spirit and Life," CW 8, 1978, p. 323.
24. Hilary Putnam, *The Many Faces of Realism* (La Salle, IL: Open Court, 1987), p. 8.
25. Brunton, *Paul, Relativity, Philosophy, and Mind*, part 3, p. 13.

Chapter 13: A Philosophic Model for Synchronicity

1. William James, "Psychical Research," in *The Will to Believe and Other Essays in Popular Philosophy and Human Immortality* (New York: Dover Publications, 1956), p. 327.
2. Jung, "The Tavistock Lectures," CW 18, 1976, p. 60.
3. Paul Brunton, *Relativity, Philosophy, and Mind*, part 3, p. 26.
4. Ibid., part 3, p. 25.
5. Jung, "Synchronicity: An Acausal Connecting Principle," CW 8, 1978, p. 506.
6. Brunton, *Relativity, Philosophy, and Mind*, part 3, p. 53.
7. Paul Brunton, *The Wisdom of the Overself* (New York: Samuel Weiser Inc., 1972), pp. 105–6.
8. Putnam, *The Many Faces of Realism*, p. 8.
9. Ibid., chaps. 1–8.
10. Damiani, *Looking into Mind*.
11. Brunton, *Relativity, Philosophy, and Mind*, part 3, p. 51.
12. Jung, *Mysterium Coniunctionis*, CW 14, 1974, pp. 464–65.
13. Ibid., p. 534.
14. Ibid., p. 537.
15. Ibid., p. 131.
16. Jung, "On the Nature of the Psyche," CW 8, 1978, p. 169.
17. Schrödinger, *What is Life & Mind and Matter*, p. 146.
18. Jung, "Synchronicity: An Acausal Connecting Principle," CW 8, 1978, p. 436.
19. Ibid., p.534.
20. Jung, "Synchronicity: An Acausal Connecting Principle," CW 8, 1978, p. 515.
21. Jung, "Spirit and Life," CW 8, 1978, pp. 327–28.

Chapter 14: Weaving Harmonies and Revealing Dissonances

1. Damiani, *Looking into Mind*, pp. 83–84.
2. Jung, "Yoga and the West," CW 11, 1969, p. 534.
3. Jung, *Memories, Dreams, Reflections*, pp. 255–56.
4. Jung, "On the Nature of the Psyche," CW 8, 1978, p. 169.
5. Jung, *Mysterium Coniunctionis*, CW 14, 1974, pp. 107–8.
6. von Franz, *Psyche and Matter*, p. 258.
7. Schrödinger, *What is Life & Mind and Matter*, p. 146.
8. Damiani, *Looking into Mind*, pp. 208–9.
9. Jung, "The Holy Men of India," CW 11, 1969, p. 584.
10. Jung, *Letters*, vol. 1, p. 247.
11. Barbara Hannah, *Encounters with the Soul: Active Imagination* (Santa Monica, CA: Sigo Press, 1981).
12. Marie-Louise von Franz, *Psycho-Therapy* (Boston: Shambhala Publications, 1993).

13. Jung, *Mysterium Coniunctionis,* CW 14, 1974, p. 496.

14. Ibid., p. 496.

15. Ibid., p. 526.

16. Damiani, *Looking into Mind,* pp. 83–84.

17. Meister Eckhart, *Meister Eckhart: A Modern Translation,* trans. Raymond B. Blakney (New York: Harper & Row, 1941), p. 96.

18. Jung, *Letters,* vol. 1, p. 247.

19. Jung, "Yoga and the West," CW 11, 1969, p. 533.

20. Ibid., p. 537.

21. See for example, Paul Brunton, *Advanced Contemplation, The Peace Within You,* vol. 15 of The Notebooks of Paul Brunton (Burdett, NY: Larson Publications, 1988) and *The Ego,* vol. 6 of The Notebooks of Paul Brunton (Larson Publications, Burdett, NY, 1987).

22. Damiani, *Standing in Your Own Way: Talks on the Nature of Ego,* pp. 173–80.

Synchronistic Interlude 11

1. C. G. Jung, *Mysterium Coniunctionis,* CW 14, 1974, p. 478.

Chapter 15: Synchronicity and Individuation

1. Brunton, *Relativity, Philosophy, and Mind,* part 3, p. 125.

2. John Hersey, *Hiroshima* (New York: Alfred A. Knopf, 1985), pp. 12–13.

3. Eisei Ishikawa, and David Swain, trans., *Hiroshima and Nagasaki: The Physical, Medical, and Social Effects of the Atomic Bombings.* The Committee for the Compilation of Materials on Damage Caused by the Atomic Bombs (New York: Basic Books, Inc., 1981), p. 113.

4. Marvin Spiegelman, "Psychology and Religion: A Psycho-Ecumenical Perspective," unpublished preprint, p. 4.

5. *New York Times,* Op-Ed, Friday, October 8, 1993, p. A35.

6. Jung, "On Psychic Energy," CW 8, 1978, p. 32.

7. David Bohm, *Wholeness and the Implicate Order* (London: Routledge & Kegan Paul, 1983), p. xi.

8. Brunton, *Relativity, Philosophy, and Mind,* part 3, p. 38.

9. Marie-Louise von Franz, *C. G. Jung: His Myth in Our Time,* trans. William H. Kennedy (London: Hodder and Stoughton, 1975), p. 247.

10. Black Elk, *The Sacred Pipe: Black Elk's Account of the Seven Rites of the Oglala Sioux,* recorded and edited by Joseph Epes Brown (New York: Penguin Books Ltd., 1977), p. 115.

11. Tenzin Gyatso, *Kindness, Clarity, and Insight,* trans. Jeffrey Hopkins (Ithaca, NY: Snow Lion Publications, 1985), p. 62.

12. Sidney Piburn, ed., *The Dalai Lama: A Policy of Kindness* (Ithaca, NY: Snow Lion Publications, 1990), p. 58.

13. James Hillman, "Peaks and Vales," in *Puer Papers,* ed. James Hillman (Dallas, TX: Spring Publications, 1987), p. 63.

14. von Franz, *Psyche and Matter,* p. 272.

15. Paul Brunton, *The Sensitives (the Dynamics and Dangers of Mysticism)* (Burdett, NY: Larson Publications, 1987), p. 234.

16. Brunton, *Wisdom of the Overself,* p. 158.

Bibliography

Alighieri, Dante. *Divine Comedy*. Translated by Allen Mandelbaum. Berkeley, CA: University of California Press, 1982.

Aspect, Alain, Jean Dalibard, and Gérard Roger. "Experimental Test of Bell's Inequalities Using Time-Varying Analyzers." *Physical Review Letters* 20 (1982): 1804.

Aziz, Robert. *C. G. Jung's Psychology of Religion and Synchronicity*. Albany, NY: State University of New York Press, 1990.

Bell, J. S. "On the Einstein-Podolsky-Rosen Paradox." *Physics* 1 (1964): 195.

Black Elk. *Black Elk Speaks, Being the Life Story of a Holy Man of the Oglala Sioux*. Told through John G. Neihardt. New York: Pocket Books, 1959.

————. *The Sacred Pipe: Black Elk's Account of the Seven Rites of the Oglala Sioux*. Recorded and edited by Joseph Epes Brown. New York: Penguin Books Ltd., 1977.

Bohm, David. *Wholeness and the Implicate Order*. London: Routledge & Kegan Paul, 1983.

Bohr, Niels. "Can Quantum-Mechanical Description of Physical Reality Be Considered Complete?" *Physical Review* 48 (1935): 696.

————. "Discussion with Einstein on Epistemological Problems in Atomic Physics." In *Albert Einstein: Philosopher-Scientist*, Library of Living Philosophers, volume 7, edited by P. A. Schilpp. La Salle, IL: Open Court, 1949.

————. *Atomic Theory and the Description of Nature*. Cambridge: Cambridge University Press, 1961.

Bolen, Jean Shinoda. *The Tao of Psychology: Synchronicity and the Self*. San Francisco, CA: Harper & Row, 1979.

Bolter, David. *Turing's Man: Western Culture in the Computer Age*. Chapel Hill, NC: University of North Carolina Press, 1984.

Brunton, Paul. *Relativity, Philosophy, and Mind*. Volume 13, The Notebooks of Paul Brunton. Burdett, NY: Larson Publications, 1988.

————. *Advanced Contemplation, The Peace Within You*. Volume 15, The Notebooks of Paul Brunton. Burdett, NY: Larson Publications, 1988.

————. *The Ego*. Volume 6, The Notebooks of Paul Brunton. Burdett, NY: Larson Publications, 1987.

————. *The Sensitives (the Dynamics and Dangers of Mysticism)*. Volume 11, The Notebooks of Paul Brunton. Burdett, NY: Larson Publications, 1987.

————. *The Wisdom of the Overself*. New York: Samuel Weiser Inc., 1972.

Damiani, Anthony. *Looking into Mind*. Burdett, NY: Larson Publications, 1990.

————. *Standing in Your Own Way: Talks on the Nature of Ego*. Burdett, NY: Larson Publications, 1993.

Dennett, Daniel. *Consciousness Explained.* Boston: Little Brown and Company, 1991.

Drake, Stillman. *Galileo.* Oxford: Oxford University Press, 1987.

———. *Galileo at Work.* Chicago: University of Chicago Press, 1978.

———. *Galileo: Pioneer Scientist.* Toronto: University of Toronto Press, 1990.

Eckhart, Meister. *Meister Eckhart: A Modern Translation.* Translated by Raymond B. Blakney. New York: Harper & Row, 1941.

Einstein, Albert. *Albert Einstein, the Human Side: New Glimpses from His Archive.* Edited by H. Dukas and B. Hoffmann. Princeton: Princeton University Press, 1981.

Einstein, Albert, B. Podolsky, and N. Rosen. "Can Quantum-Mechanical Description of Physical Reality Be Considered Complete?" *Physical Review* 47 (1935): 777.

Fordham, Michael. "An Interpretation of Jung's Thesis about Synchronicity." *British Journal of Medical Psychology* 35 (1962): 210.

Franz, Marie-Louise von. *C. G. Jung: His Myth in Our Time.* Translated by William H. Kennedy. London: Hodder and Stoughton, 1975.

———. *Number and Time.* Translated by Andrea Dykes. Evanston, IL: Northwestern University Press, 1974.

———. *Psyche and Matter.* Boston: Shambhala Publications, 1992.

———. *Psycho-Therapy.* Boston: Shambhala Publications, 1993.

Frost, Robert. *The Poetry of Robert Frost.* Edited by E. C. Lathem. Barre, MA: Imprint Society, 1971.

Galilei, Galileo. *The Assayer (1623).* In *Galileo,* translated by Stillman Drake. Oxford: Oxford University Press, 1987.

Gleick, James. *Chaos : Making a New Science.* New York: Viking, 1987.

Gunther, H. V. *Tibetan Buddhism in Western Perspective.* Emeryville, CA: Dharma Publishing, 1977.

Gyatso, Kelsang. *Heart of Wisdom.* London: Tharpa Publications, 1986.

———. *Meaningful to Behold.* London: Tharpa Publications, 1986.

Gyatso, Tenzin. *The Buddhism of Tibet.* Translated by J. Hopkins and L. Rimpoche. London: George Allen and Unwin, 1975.

———. *Essence of Refined Gold by Sonam Gyatso, the Third Dalai Lama.* Commented upon by Tenzin Gyatso, translation by Glenn Mullin. Ithaca, NY: Gabriel/Snow Lion, 1982.

———. *Kindness, Clarity, and Insight.* Translated by Jeffrey Hopkins. Ithaca, NY: Snow Lion Publications, 1985.

———. *A Policy of Kindness.* Edited by Sidney Piburn. Ithaca, NY: Snow Lion Publications, 1990.

———. *Transcendent Wisdom.* Translated by B. A. Wallace. Ithaca, NY: Snow Lion Publications, 1988.

Hannah, Barbara. *Encounters with the Soul: Active Imagination.* Santa Monica, CA: Sigo Press, 1981.

Havel, Vaclav. Op-Ed. *New York Times* (October 8, 1993): A35.

———. "The End of the Modern Era." *New York Times* (March 1, 1992): E18.

Hayward, Jeremy, and Francisco Varella, editors. *Gentle Bridges: Conversations with the Dalai Lama on the Sciences of Mind.* Boston: Shambhala, 1992.

Heisenberg, Werner. *Physics and Beyond.* Cambridge: Cambridge University Press, 1971.

Hersey, John. *Hiroshima.* New York: Alfred A. Knopf, 1985.

Hillman, James. *Loose Ends: Primary Papers in Archetypal Psychology.* Dallas, TX: Spring Publications, 1975.

———. *Puer Papers.* Edited by James Hillman. Dallas, TX: Spring Publications, 1987.

Hopkins, Jeffrey. *Meditation on Emptiness.* London: Wisdom Publications, 1983.

Howard, Donald. "Einstein on Locality and Separability." In *Studies in History and Philosophy of Science* 16, 3, (1985): 187–88.

Ishikawa, Eisei, and David Swain, translators. *Hiroshima and Nagasaki: The Physical, Medical, and Social Effects of the Atomic Bombings*. The Committee for the Compilation of Materials on Damage Caused by the Atomic Bombs. New York: Basic Books, Inc., 1981.

Jahn, Robert, and Brenda Dunne. *Margins of Reality: The Role of Consciousness in the Physical World*. New York: Harcourt Brace Jovanovich, 1987.

James, William. "Psychical Research." In *The Will to Believe and Other Essays in Popular Philosophy and Human Immortality*. New York: Dover Publications, 1956.

Jarrett, J. "On the Physical Significance of the Locality Conditions in the Bell Arguments." *Nous* 18 (1984): 569.

Jung, C. G. *Aion. The Collected Works of C. G. Jung,* vol. 9, II. Princeton: Princeton University Press, 1975.

———. *Archetypes and the Collective Unconscious. The Collected Works of C. G. Jung,* vol. 9, I. Princeton: Princeton University Press, 1977.

———. *C. J. Jung Letters,* vols. 1 and 2. Edited by Gerhard Adler and Aniela Jaffé. Translated by R. F. C. Hull. Princeton, NJ: Princeton University Press, 1975.

———. *Memories, Dreams, Reflections*. Edited by Aniela Jaffé. New York: Vintage Books, 1963.

———. *Mysterium Coniunctionis. The Collected Works of C. G. Jung,* vol. 14. Princeton: Princeton University Press, 1974.

———. *Psychology and Alchemy. The Collected Works of C. G. Jung,* vol. 12. Princeton: Princeton University Press, 1977.

———. *Psychology and Religion. The Collected Works of C. G. Jung,* vol. 11. Princeton: Princeton University Press, 1969.

———. *The Structure and Dynamics of the Psyche. The Collected Works of C. G. Jung,* vol. 8. Princeton: Princeton University Press, 1978.

———. *The Symbolic Life. The Collected Works of C. G. Jung,* vol. 18. Princeton: Princeton University Press, 1976.

Jung, C. G., and W. Pauli. *The Interpretation of Nature and the Psyche*. Princeton: Princeton University Press, 1955.

Mansfield, Victor. "Madhyamika Buddhism and Modern Physics: Beginning a Dialogue." *International Philosophical Quarterly* 29 (1981): 940.

———. "The Opposites in Quantum Mechanics and Jungian Psychology: Part II, Applications." *Journal of Analytical Psychology* 34, 1 (1991): 306.

———. "Relativity in Madhyamika Buddhism and Modern Physics." *Philosophy East and West* 40, 1 (1990): 59.

———. "Tsongkahapa's Bells, Bell's Inequality, and Madhyamika Emptiness." *Tibet Journal* 15, 1 (1990): 42–66.

Mansfield, Victor, and J. Marvin Spiegelman. "The Opposites in Quantum Mechanics and Jungian Psychology: Part I, Theoretical Foundations." *Journal of Analytical Psychology* 34, 1 (1991): 267.

Mermin, N. D. "Bringing Home the Atomic World: Quantum Mysteries for Anybody." *American Journal of Physics* 49 (1981): 940.

Orr, M. A. *Dante and the Early Astronomers*. Port Washington, NY: Kennikat Press, 1969.

Planck, Max. *Where is Science Going?* Translated by J. Murphy. New York: W. W. Norton & Co., 1932.

Putnam, Hilary. *The Many Faces of Realism*. La Salle, IL: Open Court, 1987.

Schilpp, P. A., ed. *Albert Einstein: Philosopher-Scientist,* Volume 7, Library of Living Philosophers. La Salle, IL: Open Court, 1949.

Schrödinger, Erwin. *What Is Life? & Mind and Matter.* Cambridge: Cambridge University Press, 1967.

Simon, Pierre de Laplace. *A Philosophical Essay on Probabilities.* Translated by F. W. Truscott and F. L. Emory from the Sixth French Edition. New York: Dover Publications, 1951.

Spiegelman, Marvin. "Psychology and Religion: A Psycho-Ecumenical Perspective." Preprint, 1993.

Stapp, Henry P. *Mind, Matter, and Quantum Mechanics.* Berlin: Springer Verlag, 1993.

Suzuki, D.T. *Essays in Zen Buddhism: Second Series.* New York: Samuel Weiser, 1976.

Tarnus, Richard. *The Passion of the Western Mind.* New York: Ballantine Books, 1993.

Teller, Paul. "Relational Holism and Quantum Mechanics." *British Journal for the Philosophy of Science* 37 (1985): 71.

Thurman, Robert. *Tsong Khapa's Speech of Gold in the Essence of True Eloquence.* Princeton: Princeton University Press, 1984.

Weinberg, Steven. *The First Three Minutes.* New York: Basic Books, 1977.

Index

A

absolute knowledge, 20

acausal orderedness, 30–33

 example, 31–32

acausality. *See* quantum mechanics; acausality *and* synchronicity;

 finite center of consciousness, 202

 modern physics, 78–80

action-at-a-distance, 112, 190. *See* nonlocality

active imagination, 214–15

 dangers, 217

 meditation, 216–18

Advaita Vedanta, 174

Africa. *See* Athi Plains

Aion, 161–65

Air Force, 205

Air National Guard, 205

Albertus Magnus, 96

alchemical opus and individuation, 18

American Journal of Physics, 67

Amitabha Buddha, 147, 148

anger, spiritual implications, 137

ants in synchronicity, 71

Apollo, 11, 218

 and Dionysius, balancing, 219–21

apple tree, 2

 example, 136–37, 195

Aquinas, Thomas, 54

archetypal dreams, 14

archetype

 parallel with wave function, 81–83

 per se, 171

 psychic probability, 116

 psychoid, 6, 171

 self, 17–19, 189

 synchronicity, 127

armor, psychological, 44

arrow of inherent existence, 135–40

artificial intelligence (AI), 64–65

Asian Indian spirituality, 212

astral plane, 233

astrology

 in synchronicity, 108–10

 medieval Church, 55–56

 synchronicity experiment, 33

astrophysics, 2, 15

Athi Plains

 mentalist perspective, 209–12

 psychological perspective, 207–9

atman, 215

Attila the Hun, 137

"Auguries of Innocence," Blake's, 193

Aziz, Robert, 22, 27

B

Bacchus, 220

balancing Dionysius and Apollo, 221

beast from the unconscious, 234

Beatrice, Dante's, 55

being-thus. *See* independent existence

Bell's Inequality. *See* Tsongkhapa's bell experiment

 derivation, 119–21, 235–37

 experiments, 113, 155

 implications, 121–23

 locality, 156

 negation, 156–59

 pure negation, 123

 reasons why compelling, 121

 relation to emptiness, 156–59, 158

 results, 237

 significance, 8, 75

Bell, John, 8

Berkeley, Bishop, 188

Bhagavad Gita, 72

big bang. *See* cosmology, modern

big crunch, 12